The Shell Guide
to the
Great Paintings
of England

The Shell Guide
to the
Great Paintings
of England

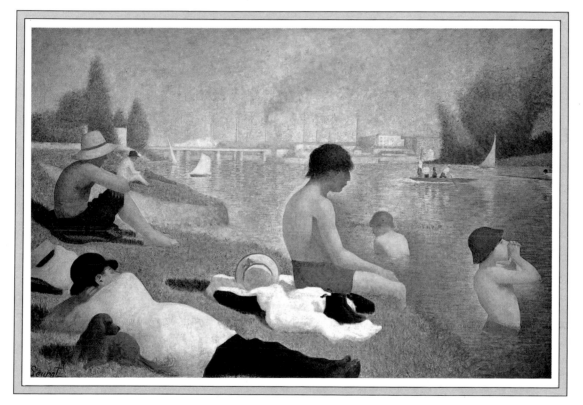

Compiled by Nigel Viney
Introduced and edited by David Piper

ANDRE DEUTSCH

Title page: Seurat, 'Une Baignade, Asnières' (*National Gallery*)

First published 1989 by
André Deutsch Limited
105—106 Great Russell Street
London WC1B 3LJ

The name Shell and the Shell emblem are registered trademarks.

Shell UK Ltd would point out that the contributors' views are not necessarily those of this company.

The information contained in this book is believed correct at the time of printing. While every care has been taken to ensure that the information is accurate, the publishers and Shell can accept no responsibility for any errors or omissions or for changes in the details given.

A list of Shell publications can be obtained by writing to:

Department UOMC/O
Shell UK Oil
PO Box No. 148
Shell-Mex House
Strand
London WC2R ODX

ISBN 0 233 98466 6

Set by Setrite Typesetters Ltd, Hongkong.
Colour reproduction by Tenon and Polert Ltd, Hongkong.

Printed in Italy

Contents

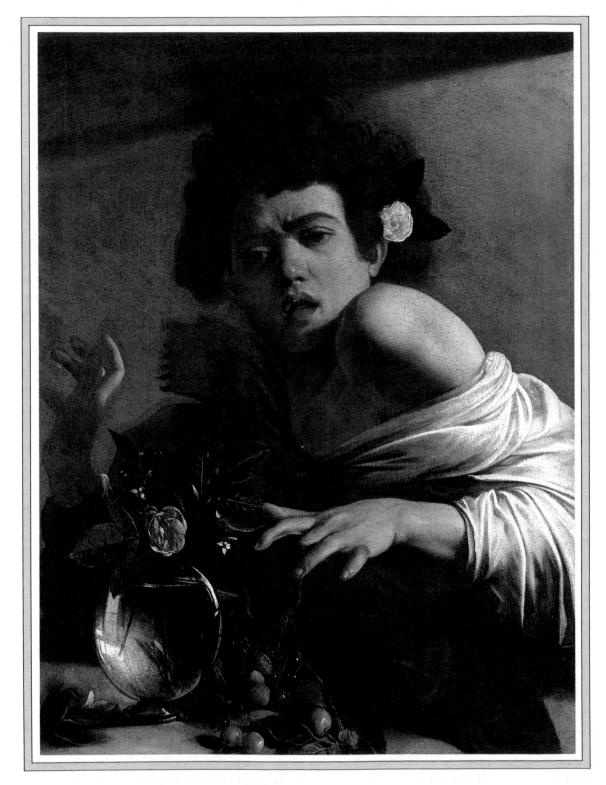

Caravaggio: 'Boy Bitten by a Lizard' (*National Gallery*)

Foreword

THE BOOK

The aim of this book is to identify the finest paintings to be seen in England and direct the reader to the collections (both galleries and houses) where they are on display. The collections are arranged in alphabetical order, with addresses, telephone numbers, and road directions. In addition, there are maps, a general index, an artists index and an index by county.

The Maps These are to be found on pages 263−74.

The Index by County This lists the collections by county so that, wherever you are, what is accessible can be seen at a glance. It is to be found on pages 279−82.

The Artists Index This is a separate list of all the artists in the book, complete with biographical notes and page references to their paintings. This can be found on pages 283−306.

The General Index This is to be found on pages 307−18. It lists all the historical figures, major paintings and artistic movements mentioned in the text and refers the reader to the pages on which they are described.

The Collections

Opening Times It is always advisable to check opening times with galleries, houses and indeed any locations listed in this book. Very few places are open every day of the week. Some houses indeed are open only on one afternoon a week for a brief period in the summer months. Open-

ing times vary from year to year, and sometimes from month to month. If disappointment is to be avoided, checks must be made.

Two books published by British Leisure Publications — *Historic Houses, Castles and Gardens open to the Public* and *Museums and Galleries in Great Britain and Ireland* — do give opening times, but you will need to have the current issue (usually published in March of each year). The National Trust publish a guide to their own properties annually, giving times and dates of opening, among many other details.

Where none of these guidebooks is to hand, the information can be gained readily at local offices of the English Tourist Board, or at local libraries. Where all else fails, it is possible to telephone the place itself; the relevant numbers are given in the text.

Wheelchairs Ramps and other arrangements for those in wheelchairs, though happily on the increase, are by no means universal. (Not unnaturally, galleries find it easier than houses to adapt their buildings.) Information on this is often given in the annual publications listed above, but it is advisable to check by phone.

Charges Houses always make a charge for entry; galleries generally do not. The charge varies from year to year, and can be discovered in the same way as can the opening hours.

Members of the National Trust are afforded free entrance to National Trust properties, though in a few places there is a charge for car parking. The Historic Houses Association and English Heritage confer the same privilege on their members at their properties. Properties belonging to these bodies are marked NT, HHA, and EH respectively.

Guides and Custodians Galleries usually have uniformed custodians, many of whom are well informed. Most country houses also have custodians, often wearing badges, one to every room open to the public; these usually have a list of the contents of the room which enables them to identify pictures.

Some houses, however, operate the system of the guided tour. This is indicated by the letters GT. While guided tours are no doubt necessary in large houses with relatively few visitors, they are not a happy arrangement for those interested in pictures: parties are usually large and cumbersome; time is often cut short; it is sometimes difficult to hear what the guide is saying; and the information given by the guide is very often what the visitor has just read in the guidebook while waiting (sometimes for up to an hour) for the tour to begin.

Guidebooks etc. In country houses, guidebooks range from elaborate and expensive booklets, sometimes very large in format, and often full of colour illustrations, to a single sheet of duplicated information, included by some houses in the price of the ticket. The National Trust produce exemplary booklets, which are sensible in size, extent and price, scholarly and well-written. By no means all these booklets give helpful information on the pictures in the house; some indeed ignore the pictures completely. Postcards are usually on sale. However, the quality of reproduction is, on the whole, lamentably low, and all too often there are none available of the pictures in the house.

In the galleries, there are few selective guidebooks, but the quality of the postcards is higher. Both in the galleries and country houses, the slides tend to be rather better than the postcards.

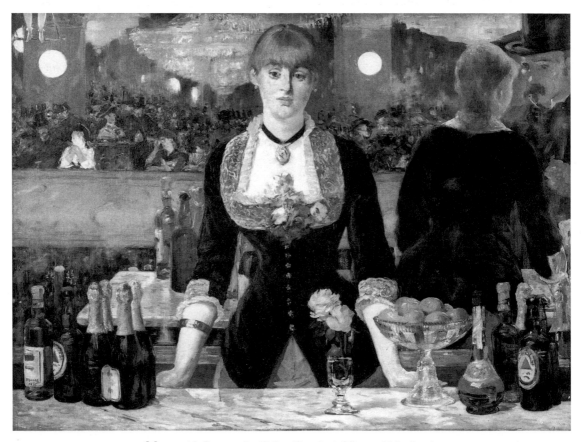

Manet: 'A Bar at the Folies-Bergère' (*Courtauld Institute*)

Restrictions Stiletto heels are often banned, both in houses and in galleries. Cameras too are often not allowed, as are food, drink, and ice-creams. In some houses, children are banned, and Longleat is the only place listed in this book that welcomes dogs within its walls. Some houses even look askance at a visitor with a notebook!

Refreshments Food and drink of some kind are nearly always available at country houses; details are given in *Historic Houses, Castles and Gardens open to the Public*. Not many galleries offer the same facilities. Where they exist, the quality of the refreshments can be high.

Visibility Galleries have, at least, the intention of displaying the pictures on their walls in such a way that they are clearly visible to those who want to see them. It is true that they do not all succeed equally well in this aim, but, for the most part, visibility is not a problem in galleries.

The same, however, cannot be said of country houses. Few of their rooms were designed solely for the purpose of displaying pictures; lighting is very often grossly inadequate; ropes and other barriers sometimes make it difficult to get an adequate view. Experienced visitors to such houses carry a haversack containing a powerful small torch and binoculars.

Authentication With the honourable exception of those properties in the care of the National Trust, and a handful of others such as Corsham and Bowood, country houses are notorious for taking far less care over attributions than do galleries. Zuccaro's name, for example, frequently appears on the labels of Elizabethan portraits in country houses, but not a single picture by Zuccaro is authenticated by anything other than tradition.

While care has been taken in this book not to perpetuate the more obvious howlers, it has plainly been necessary to take most attributions at face value. Nor is it suggested for a moment that this is an easy matter for owners of houses: a picture in a house in Cumbria, bought seventy years ago as a Velazquez, has been examined in recent years by four experts, each of whom has confidently suggested a different artist's name as the true painter (none of them, alas, suggesting Velazquez).

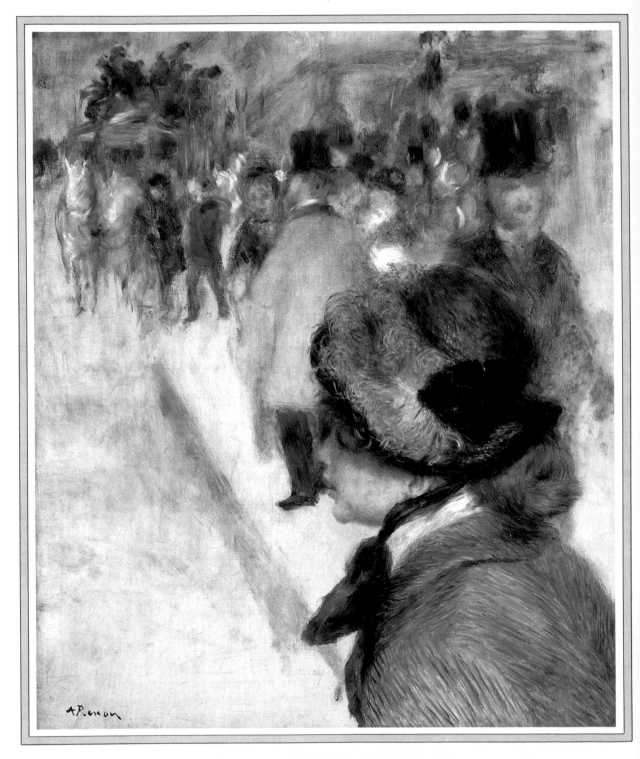

Renoir: 'Place Clichy' (*Fitzwilliam Museum*)

Introduction

This book is addressed to the amateurs of painting. Amateurs, in the correct sense of the word, are those who have opened, or wish to open, eyes and mind — and heart, with all the generous emotions traditionally sited in that vital and capacious organ — to the pleasures that the pursuit and contemplation of fine paintings can bestow. It is offered as the equivalent of a directory, a signpost, to indicate where they can find what is likely to interest them among those English collections that are open to the public. It covers the great national, metropolitan, collections and the various and richly rewarding smaller institutional or private ones in London. It covers too those, great and small, in provincial towns and cities; and also those in country houses that, though many of them are still occupied by the families who in some cases have been there for centuries, are now open to the public.

The area involved is confined to England, leaving Welsh, Scottish and Irish collections for a separate investigation. The entries are arranged alphabetically, by the titles of the collections. There are also maps to show where you can find them. The entries have been compiled by Nigel Viney, who in an extensive campaign over two years has sought out the best paintings from the best collections.

THE FIRST PORTRAITS

Collections of works of art accumulated through the Middle Ages in Britain in the temples of Catholicism, its churches and monastic institutions. The church, sponsored by benefactions of the pious, was both patron and curator, but with very different aims of course from those of the modern museum or private collection. Art was part of the service and celebration of God.

Though the churches and cathedrals mostly survived the religious, Protestant, reformation in Henry VIII's reign, the tradition of patronage was shattered. So also, more literally, was evidence of the splendour of English medieval art, as the surges of iconoclasm in Edward VI's time, and sporadically thereafter until the last horrific destruction of images following the Puritan triumphs of the Civil War in the mid-seventeenth century, mutilated much of the sculpture, painting and glass in English churches. One of the promulgations of this hard line in 1559, immediately after Elizabeth's accession, even enjoined that 'no person keep in their houses any adored images ... pictures, paintings and other monuments of feigned miracles, pilgrimages, idolatry or superstition'.

Very largely because of this, active patronage of painters within England concentrated for three hundred years, 1500−1800, most extensively on portraiture. Even though in the last years of that period the great English landscape tradition was founded in the work of native painters, Wilson and Gainsborough, it was portraiture, 'face painting', that provided the bread and butter for most English artists. Sadly the richer sustenance of the cake, for the most successful portrait painters, went to foreign immigrants. Almost without exception, the dominant painters in London were of foreign stock, until well on into the eighteenth century. No English-born painter before Hogarth has been found worthy of representation in the English National Gallery, and the only ones who, in their lifetimes or after, were to receive any significant

approbation elsewhere in Europe, were miniaturists.

Miniature portraiture was the one branch of the art in which England produced the finest of their kind in the persons of Hilliard and of Samuel Cooper. Though their miniatures do not feature in this book, which is restricted mainly to consideration of easel paintings, those interested in British painting should not neglect their work. The national collection of miniatures is housed in the Victoria and Albert Museum, but miniatures are also to be found elsewhere, most especially in the National Portrait Gallery, and the Fitzwilliam Museum at Cambridge.

The standard achieved otherwise by English painters took a long time to approach that expected of their own painters by Continental clients. The benefits of the English Channel are not to be despised — least of all as recently as 1940-44 — but while a formidable barrier against military invasion, the Channel has often been also an obstacle to the acceptance of new ideas from the mainland. Before the Reformation, the quality of the relatively few portraits that survive is stubbornly provincial, and reveals little awareness of the achievement over the water of the van Eycks and their followers, let alone that of the major Italian painters of the fifteenth century. A handful of images of English sitters painted abroad are in startling contrast — the Petrus Christus of Edward Grimston (on loan from the Earl of Verulam to the National Gallery); Sir John and Lady Donne as donors in the Memlinc altarpiece formerly at Chatsworth (National Gallery). Even for Henry VII, the outstanding likeness from his lifetime was taken by a visiting Continental court painter, Sittow (National Portrait Gallery).

In Henry VIII's reign, the situation promised otherwise, when in 1526 Holbein arrived from Switzerland for a couple of years. He bore an introduction from Erasmus to Thomas More, and in his work demonstrated a supreme synthesis of the monumental grasp of form characteristic of the finest work of Italian painters of the High Renaissance, and the Northern particularity of which the greatest practitioner was Dürer. In his second stay, till his death from the plague in London in 1543, his genius was employed by the King and the court. The image of the King himself was recorded, even created perhaps, by Holbein. That grand frontal straddling image is now known only by the cartoon for it (National Portrait Gallery), but it has dominated posterity's conception of Henry VIII. Sir Walter Raleigh no doubt had it in mind

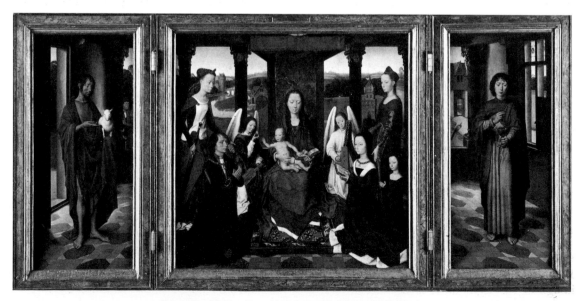

Memlinc: 'The Donne Triptych' (*National Gallery*)

when about 1620 he commented that 'if all the Pictures and Patterns of a merciless Prince were lost in the World, they might all be painted again to the Life, out of the Story of this King'.

Holbein's English work can now be studied best in the Royal Collection at Windsor, where there is also his famous series of preliminary drawings for portraits, and in the National Gallery. Two of his most complex compositions — the More family group, and that painting of Henry VIII, with his father and mother, and his third wife Jane Seymour, mother of the male heir, (forming a superb assertion of the establishment of the Tudor dynasty) — fell victims to fire. It is however a little melancholy for the English to think that three of Holbein's visual documents of outstanding national importance should now have found homes elsewhere: the great portrait of More himself, and that (damaged, but still a most potent clenched characterisation) of his prime destroyer, Thomas Cromwell, are both in New York (Frick Collection), while the only surviving painting of Henry VIII, universally acknowledged as from Holbein's own hand, was sold from Althorp to the Thyssen collection in Lugano as recently as the 1930s.

None of the resident painters following Holbein in the task of portraying the Tudor monarchs, even up to the death in 1625 of the first of the Stuarts to succeed to the throne, James — the Sixth of Scotland, but First of England — approached anywhere near Holbein's stature as artist. Mary I sat to the leading Mannerist court painter of the North, the Fleming Antonis Mor, and Elizabeth I to a leading Florentine, Zuccaro, in 1574/5. The visits of both artists were brief, however; the only evidence of Mor crossing the Channel are the three versions of his portrait of Mary, and Zuccaro's stay was a matter of some six months. Drawings of Elizabeth and the Earl of Leicester by him are in the British Museum, but no painted portrait that can certainly be attributed to him survives in England, though the suggestion that the so-called 'Darnley' portrait of Elizabeth (National Portrait Gallery), an austere image of the right date, is by Zuccaro seems to be attracting some support. The vivid evidence of a few portraits of Englishmen travelling abroad, such as the head and shoulders of Sir Henry Lee by Mor (National Portrait Gallery), puts the local talents at considerable disadvantage — and what would not I give to discover the lost portrait for which Sir Philip Sidney sat to Veronese in Italy in 1574?

On the other hand, subsequent fashions in art (and interior domestic decoration) have consigned portraits of the Tudor period somewhat unfairly to oblivion. When they were recovered by still later generations, from back passages or attics, even the family portraits had lost often both the name of the sitter and that of the artist. In such cases, the tendency was always to baptise the portrait with the name of a celebrity of its period and to attribute it to the best known painter of the time. Thus by the nineteenth century, many country houses had so-called portraits of Queen Elizabeth — any lady in a ruff would do — very often spoken of as 'The Zuccaro'. (Similarly, for the Restoration period any portrait of a voluptuous young woman would attract the names of Nell Gwyn, if the decolletage was sufficient, and Sir Peter Lely. I believe no original of Nell Gwyn from Lely's own hand has yet been certainly identified.)

However, despite the fact that obviously the best artists on the Continent would tend to stay there as long as they were gaining a good living and receiving their meed of praise, while the underemployed lesser artists might seek a warmer welcome from patrons, less sophisticated in arts, across the water in Britain, (there were also religious refugees, from Catholic Flanders especially) the immigrants included some talents of considerable accomplishment, if not genius. Amongst them were the Fleming Scrots (painter of Edward VI); Hans Eworth, in whose hands the Elizabethan 'costume piece' was first formulated; and, towards the end of the century and beyond, the families of the Gheeraerts and the de Critzes. Marcus Gheeraerts the Younger's name has been abused almost as much as has Zuccaro's by attachment to paintings of the period that had nothing to do with him. His own work, though normally within the framework of a staid and stiff formula common throughout Europe at the time for court portraiture, could

13

also convey a sensitive and moving characterisation in the faces.

The styles in which such painters worked tend to be seen now, foreign-born though its best practitioners were, to show a very English variant on international Mannerism, emphasising the linear quality and presenting reflections of grand social rank in which the decorative qualities were predominant. The images are what Bernard Berenson defined as effigies, rather than portraits of a profounder artistic and plastic quality. As such they reached a supreme pitch of almost heraldic stylisation, in an astonishing group of whole-length portraits now associated with an obscure painter, Larkin, in the second decade of the seventeenth century. Formerly in the family of the Earls of Suffolk, these can now be seen at the Ranger's House, Blackheath, and should not be missed. Their ideal habitat would be in one of the Long Galleries, which became a fashionable element in the great Elizabethan 'prodigy' houses that successful courtiers commissioned all over the country. Their function is indicated in a letter from Viscount Brindon to Robert Cecil (builder of Hatfield) acknowledging receipt of a portrait in 1609: 'to be placed in the gallery I lately made for the pictures of sundry of my honourable friends, whose presentation thereby to behold will greatly delight me to walk often in that place where I can see so comfortable a sight.'

Production of portraits had increased markedly through the second half of the sixteenth century, in response partly to an ever increasing expectation of space and comfort in the well-to-do people's living quarters. The largest collection was no doubt that brought together by John, Lord Lumley, long since almost entirely dispersed but known from a famous inventory of 1590. Portraits predominated almost to the exclusion of other kinds of painting: portraits of the kings and queens of England; of Lumley ancestors (including imaginary portraits of the more remote ones of whom authentic likenesses did not exist — Lumley liked to trace his family tree back to Adam); portraits of friends and celebrities, extending even to world celebrities: Dante, Petrarch, Boccaccio. The Earl of Leicester also had a very large collection, and at Hatfield the Cecils, Earls of Salisbury, accumulated a notable gathering, still to be seen there, though the surviving long gallery that retains the most vivid impression of what it must have been like originally is in Bess of Hardwick's house, the fabulous Hardwick Hall 'more glass than wall'. There several of the portraits are reasonably identified with those listed in an inventory of 1601.

The Lumley inventory of 1590 is however the first to record — though unfortunately only sporadically — the names of painters of portraits. It is however an indication of an interest in the paintings as such, of an appreciation of artistic quality besides that of genealogy and of historical importance. The name of Holbein is prominent, and one of his portraits in the Lumley collection was the famous Christina of Denmark now in the National Gallery, and another was that cartoon of Henry VIII and his family, now in the National Portrait Gallery.

THE FIRST COLLECTORS

Part of Lumley's collection went after his death to Thomas Howard, Earl of Arundel and Surrey. Arundel was in many ways not only the first but the ideal pattern for many English collectors of the seventeenth and eighteenth centuries. His passion for works of art and antiquities probably flared into life during his first continental tour in 1609; in later journeys of 1613 and 1615 he and his wife became widely known on the continent as collectors on a very grand and comprehensive scale. John Evelyn described him as the 'great Maecenas of all polite arts'. His organisation was elaborate: he employed the English ambassadors abroad to seek out treasures for him — notably Carleton at The Hague, Sir Henry Wotton in Venice and Cottington in Spain; in the Middle East he had his own roving private agents. In painting, his taste lay towards the Venetians, but he had an especial passion for Albrecht Dürer and for Holbein: the series of Holbein portrait drawings, now in the Royal Collection at Windsor, belonged to him. He

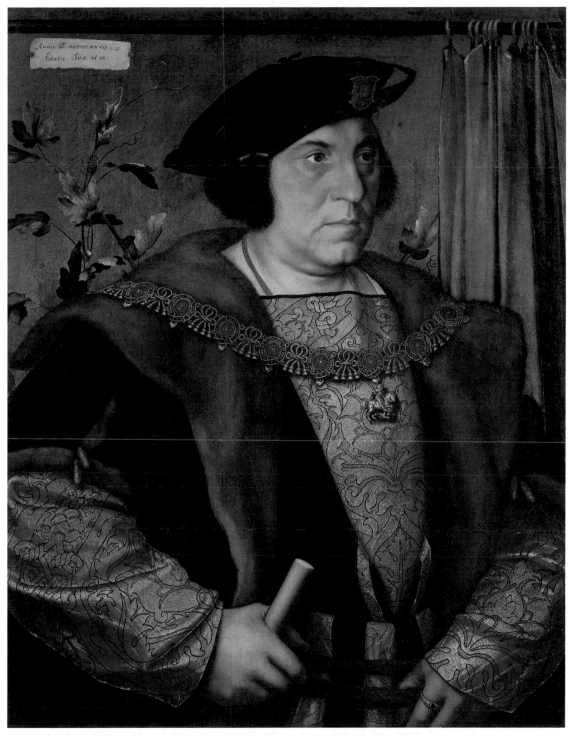

Holbein: 'Sir Henry Guildford' (*Windsor Castle*)

patronised eminent living artists, sitting at least twice to Rubens for his own portrait, and importing artists to England such as the great etcher Wenceslaus Hollar. He and his wife were probably also responsible for van Dyck's first visit to England.

At the beginning of his career, he was rivalled as a collector by George Villiers, Duke of Buckingham, favourite of King James and of Charles I, and described as the most handsome man in Europe. Buckingham also sat to Rubens and bought other works from Rubens's own collection. Arundel and Buckingham exerted a decisive influence on the taste and connoisseurship of the man who was arguably the greatest of all English collectors, Charles I. The nucleus of Charles I's collection came to him by inheritance upon the death of his brother Prince Henry in 1612, but it expanded rapidly. When he was only 21, we find him rejecting a picture commissioned from Rubens on the grounds that it was largely painted by studio assistants: on the grounds, that is, of quality. He instructed his agent to rebuke the painter, and to produce instead something that would redeem his reputation and be fit to be seen amongst the many excellent works of all the best masters in Christendom already in Charles's possession. In the course of his quest for a Spanish bride, Charles sat to Velazquez in Madrid in 1623. His quest was fruitless, and the portrait sadly is lost. What Charles did bring back from Spain, however, were several remarkable paintings by Titian, and Titian's example is echoed all the way down the story of English portrait painting. It is seen especially in the work of van Dyck, who had already become profoundly aware of the Venetian's work in Italy, and bought for himself one of Titian's great masterpieces, 'The Vendramin Family', now in the National Gallery.

In 1628, one of Charles's agents in Italy, Daniel Nys, accomplished one of the major coups of the collection when he bought for the King the bulk of the famous Gonzaga collection from Mantua, in spite of the competition of Cardinal Richelieu. This included a number of Titians — 'The Twelve Emperors', 'The Entombment', 'The Supper at Emmaus'. The most important items were 'The Triumph of Julius Caesar' by Mantegna, which now hang in the orangery at Hampton Court, being one of the rare works, significantly enough, that Oliver Cromwell reserved from the sale after the King's death. Two years later, acting on the advice of Rubens, Charles bought his greatest treasure, the series of seven cartoons by Raphael, 'The Acts of the Apostles', (on permanent loan from the Royal Collection to the Victoria and Albert Museum). These had been sent by Pope Leo X to Brussels as designs for a set of tapestries; the weavers kept the designs as hostage against payment for the tapestries, which in fact never came in full. The King was also interested in Northern art — he owned examples of Rembrandt before 1640 — but his personal taste was most passionately engaged by the Italians.

Charles was, however, also profoundly interested in contemporary painting. He brought over the Gentileschis, father and daughter, from Italy. In 1628 he invited the Caravaggiesque Utrecht painter, Honthorst. In 1629/30 Peter Paul Rubens came to London as the diplomatic representative of the Infanta Isabella, Regent of the Netherlands. Rubens found time for painting as well as diplomacy; he painted and gave to Charles the great 'Minerva Protects Pax from Mars' (now in the National Gallery). He also painted the ceiling, with its apotheosis of James I, for Inigo Jones's famous Banqueting House at Whitehall, whence Charles was to step to his death on the scaffold less than twenty years later. Then in his spirited landscape, 'Triumph of St George', he endowed St George with Charles's features and the rescued maiden, St Cleodolinda, with those of his queen Henrietta Maria (Royal Collection).

The name that will be for ever most closely associated with Charles I is Anthony van Dyck, who settled in London in 1632 and worked there mostly until his death in 1641. Perhaps in the whole history of painting, even allowing for Titian and Charles V, or Velazquez and Philip IV, there never have been royal artist and patron, painter and sitter, so ideally suited to one another. Stylistically, van Dyck was not one of the greatest of innovators: he always both reflects and is overshadowed by the greater virility of his master, Rubens. Nevertheless, it was

van Dyck who revealed and established the movement, colour and panache of the Baroque in England, while the very contrasts in his nature — the heroic strength and the almost feminine elegance, the sensuousness combined with the curious cold aloof melancholy — seem to appoint him predestined painter of Charles I and of the whole of that brilliant and doomed Cavalier court.

In the canvas showing the King's head from three angles (Windsor Castle), you see the face that all Englishmen associate with van Dyck, the face of Charles the Martyr, murdered by Cromwell, or of Charles the Tyrant, justly executed for crimes against the people — depending on which side you are: that long melancholy face, those remote grey eyes. It is curious that Mytens, when he painted the King earlier, showed dark, almost brown eyes, and it can be demonstrated that van Dyck made the face longer than it really was. Yet it is van Dyck's version, invested with a romance that lives and is part of English history, that the scepticism of prosaic historians has yet to dispel. That canvas was commissioned by Charles, to be sent to the greatest sculptor of the age, Bernini. It is said to have made the sculptor shiver: it seemed to him a face so doomed. From it he made a bust of the King, but it was destroyed in a fire.

After the execution of Charles in 1649, his unmatched collection was, with some exceptions, dispersed by sale. Although a fair proportion of the paintings were bought by Englishmen at the sale, and were recovered for the Royal Collection after the Restoration of Charles II in 1660, many of its masterpieces were bought by the great collectors from abroad: Philip IV of Spain, the Archduke Leopold Wilhelm, Queen Christina of Sweden, Cardinal Mazarin and Eberhard Jabach of Cologne. Most of those that survive are now, still often bearing the King's cypher branded on the back, scattered through the great public collections of Europe. In the course of formal visits abroad, Queen Elizabeth II often visits Continental national collections; the courtesy of some curators, who have pictures in their care turned round so that she can see evidence of Charles I's ownership in the initials

C R branded on their backs, is believed not to be one of the pleasures of travel abroad that she appreciates the most.

But although this collection was dispersed, the taste that had informed it was not lost, and we find it recurring again and again till the end of the eighteenth century and beyond, though few of course had the opportunity to collect on such a scale as Charles I. Meanwhile the patronage of living artists in England continued to concentrate on portraiture: English families of sensibility took care that they should go down to posterity painted by the best painters available.

Immediately after van Dyck's premature death in 1641, his successor as painter of the court, William Dobson, was in fact both English, and, though obviously aware of van Dyck's vision, nevertheless gifted with an individual character of great quality. Dobson's counterpart — for the Parliamentarian, 'Roundhead' protagonists — was Richard Walker, ironically an avowed, and a stylistically servile, follower of van Dyck, not at all averse to settling a head of the regicide

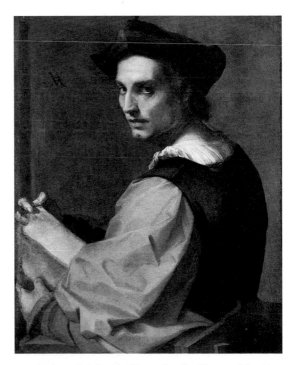

Andrea del Sarto: 'Portrait of a Young Man'
(*National Gallery*)

17

Oliver Cromwell on to a body that had been used by van Dyck for Charles I.

Subsequent generations of painters in England were to continue to refer back to van Dyck. To begin with the best of them were still immigrants from abroad: Sir Peter Lely (Dutch) in the Restoration; after his death in 1681, Sir Godfrey Kneller (German) until as late as 1720. Those two names the visitor will find echoing through the older collections in country houses, attached to portraits of disturbingly various quality. At their best, Lely and Kneller produced work of a calibre which, while not rivalling the achievement of earlier giants such as Rembrandt or Hals or Velazquez, stands comparison with the best of the society portraitists on the Continent of the time. Their reputation has suffered from reliance on assistants, and the overproduction, in Kneller's case almost on conveyor belt lines, of repetitions and copies of very mechanical quality. At the same time their influence on lesser artists was such that their names have become attached to countless portraits executed in imitation of their styles by very minor painters. Still, van Dyck was always an inspiration for the greatest talents as well as less happily for pedestrian imitators. Hogarth's sign over his studio in Leicester Square was a head of van Dyck; Reynolds produced many variations on his designs; Gainsborough rivalled van Dyck's fluency and elegance of paint, and is said to have murmured, on his death-bed, to Reynolds: 'We shall all go to Heaven and van Dyck is of the company'.

However, the visitor, to country-house collections especially, will deprive himself of many lesser pleasures if he concentrates on recognising and attending to masterpieces only. A moment's attention before works by Cornelius Johnson from van Dyck's time can be quietly satisfying; so too those by Dobson, Soest, John Riley, Closterman, and Dahl, later in the seventeenth century. Even portraits by the still often scorned portraitists of the early Georgian era — Jervas, Hudson — can merit scrutiny, while Ramsay, though often using another to paint the draperies, is a very considerable artist. Neither should associative interests be scorned — thus, though the Harcourt family collection has long since been stripped from the major family house at Nuneham Courtenay, and much dispersed by sales and the trading-in to the Government of paintings in lieu of tax, in the smaller family house at Stanton Harcourt, together with the Chardin, the Rubens, and the van de Velde, you will find, so comfortably hanging in the book-lined study, a very late and very good Kneller portrait of Alexander Pope, while over the lawn is Pope's Tower, where he once sat and wrote. This may well arouse more than a mere flicker of emotion. So too, in a different mode, may the charming, if less than great, painting of a little dog that its master, the 3rd Earl Harcourt, saved when it fell down a well, though with fatal consequences for himself.

THE GRAND TOUR

Though the mainstream of so many older collections was of family portraits, the dominant interest of the seventeenth-century collectors was no longer genealogical as with Lord Lumley, but aesthetic. Almost always these collections refer back to one focal point: Italy. Sir Henry Wotton, writing in panegyric to King Charles in 1644, said that 'Italy ... (the greatest mother of Elegant Arts) may seem by your magnificence to be translated into England'. The collections are so often in part an expression of that northern longing for the Mediterranean tradition, the classical culture, or simply the heat and light of the Italian sun.

The custom which most fuelled this longing was the Grand Tour, which at the end of the century was becoming de rigueur for any gentleman of any claim to culture. It might last anything up to two to three years — a few indeed never came back from it. Italy was the goal, and the young men travelled as embryonic connoisseurs, to see, to learn the rudiments of taste, often accompanied by a tutor who told them what and where to see, and above all how to see it. Appreciation of the arts, the correct arts, had by now become an essential for all men of fashion.

A fairly early example was Thomas Coke,

setting out in 1712, aged 15. He was to be away for six years. In Italy, besides such pursuits as fencing, dancing, the study of civil law, he fell for the arts: 'I am become since my stay in Rome, a perfect virtuoso, and a great lover of pictures, even as far as to encroach on the kindness of my Guardians as to buy some few.' The interest persisted and expanded into a lifetime passion and when, as Earl of Leicester, he built one of the grandest of English Palladian houses, Holkham in Norfolk, he stocked it with Claude (seven in the Landscape Room), with Gaspard Poussin, Salvator Rosa, and other Italian works, not least the best surviving witness of a lost Michelangelo masterpiece 'The Battle of Cascina', (and a superb collection of drawings).

The philosopher sage of this generation was the 3rd Earl of Shaftesbury (author of the *Characteristicks*), who was passionately concerned with the arts, not purely for their own sakes, but on educational grounds, for the formation of character. For Shaftesbury, a moral man was a man of taste. 'The Science of Virtuosos,' he said, 'and that of Virtue itself become in a manner one and the same.' This moral approach to painting was popularised by the painter Jonathan Richardson: 'Supposing', observed Richardson, 'two men perfectly equal in all other respects, only one is conversant with the works of the best masters and the other not: the former shall necessarily gain the ascendant and have nobler ideas, more moral virtue, more piety and devotion than the other; he shall be a more ingenious and a better man.' Richardson, who himself owned the largest collection of Italian drawings of his day, laid down the rules of connoisseurship, and published in 1722 a widely read guide to the sights of Rome, though he himself had never been to Rome. In 1712, Shaftesbury had commissioned from the painter Paolo de Matteis, in Naples, a large canvas of the 'Choice of Hercules' (now Ashmolean Museum). This he subsequently had engraved for reproduction with his discussion of the 'Judgement of Hercules' in his *Characteristicks*. It served to illustrate, as exemplar, the kind of 'history', 'mythological' or 'epic' painting that Shaftesbury hoped to encourage in England, for both patrons and native artists. For him,

portraiture was the lowest of the branches of painting, based on slavish imitation, requiring no imagination.

So, armed with comfortable foreknowledge that he would return home a more ingenious and a better man, the young gentleman of the eighteenth century set out on horseback or by coach across Europe to Rome. In Italy he would experience the correct emotions in front of the correct pictures; he would also find that some of these pictures were for sale. But at this stage he would buy little, for he would probably be on an allowance from his father or guardians, as was Thomas Coke; in most cases his buying would be done later, through his own roving agents if he were rich enough, or from the collections bought abroad by the new class of speculative dealers, and brought home to be sold by auction in London. One cannot pretend that all young English gentlemen reacted in the correct and ideal fashion; there were a large number who did the Grand Tour with their eye on less cultivated pleasures. But generally speaking, the Englishman of high fashion in the eighteenth century was expected to show signs of intelligent interest in the arts, especially in the Old Masters.

The first forty years of the eighteenth century was a curious period in the arts: the collectors were innumerable, foreign pictures poured into the country, yet the native painters were not taken seriously. Major collectors bought pictures labelled rightly or wrongly as Raphael, Maratta, Dolci, Carracci, but never works painted by their own countrymen. This contrast was marked and savagely attacked by the first genius of the English Renaissance of painting, William Hogarth. A famous engraving by him, used for the catalogue of an exhibition in 1731, shows a monkey-like connoisseur, examining three dead trees through a magnifying glass: the trees represent painting, sculpture and architecture, which have been extinct for hundreds of years, and the connoisseur imagines that by watering them he will resuscitate them, instead of nourishing the living plants, the artists of his own day. Hogarth himself suffered enough from this neglect, for he was unable to sell his masterpiece, the famous series of paintings, 'Marriage à la Mode' (now National Gallery).

Hogarth's work answered of course more to the Dutch taste, and it was another thirty or forty years before the work of artists such as Teniers or Jan Steen was to become fashionable. Horace Walpole spoke for one aspect of mid-eighteenth-century taste when he called the Dutch 'drudging mimicks of Nature's most uncomely coarseness.' Rembrandt had some popularity, enough at least to make the forging of drawings in his manner worthwhile, but even he did not appeal to most of the intellectual and fashionable collectors. 'I love *la belle Nature*,' said Lord Chesterfield, one of the supreme arbiters of what was done and what was not done in society. 'Rembrandt paints caricatures.'

The taste of the average collector was remarkably clear, and defined by a set of rules: in Horace Walpole's opinion 'all the qualities of a perfect painter never met but in Raphael, Guido Reni, and Annibale Carracci'. Substitute Michelangelo for Guido and this still had much in common with opinions held by Sir Joshua Reynolds thirty years later. Walpole's opinion is written in the preface to the catalogue of the collection formed by his father, the great Prime Minister, Sir Robert Walpole. Sir Robert's patronage of contemporary British artists was not all that enterprising, but his collecting was superb, and rather on the same scale as that of some American millionaires. It may be that his main interest lay in creating a superb decor for himself, rather than in the intrinsic virtue of the works of art that composed that decor, but it was still a very remarkable collection of paintings. It was sold *en bloc* in 1779 to the Empress Catherine of Russia, as predatory a collector as had been Charles I of England a century and a half earlier.

Some relatively modest collectors showed more individuality. The famous physician, Dr Mead, was remarkably catholic in taste. He owned pictures by Holbein and Rubens, Rembrandt and Frans Hals, Claude and Canaletto, van Dyck and M.Q. de LaTour. Watteau, mortally ill with consumption, came to see him in London in 1719, and painted two pictures for him. Later in the century we find Dr William Hunter, another physician (this profession holds a very distinguished place in the annals of British

collections), acquiring three pictures by Chardin, a hundred years before this artist was fully appreciated. Mead's collection was dispersed at his death; Hunter's however, including Chardin and Rembrandt, was bequeathed by the doctor to Glasgow University, where it still is. The interests of more aristocratic collections can still be seen richly illustrated in surviving collections at such houses as Chatsworth and Alnwick, Woburn or Petworth, and others now dispersed have yielded many of their masterpieces of painting to the National Gallery, though perhaps more to the great galleries of the United States.

LANDSCAPE AND ENGLAND'S GOLDEN AGE

I have indicated that the less discriminating collectors were perhaps less interested in paintings in themselves than as objects of suitable adornment for their houses. In the eighteenth century, the building of great houses, a reflection of the booming wealth and prosperity of the country as a whole, accelerated enormously. The century saw in architecture a vigorous movement starting in the huge massive Baroque of Vanbrugh, embracing in its scope the austere Palladianism of Lord Burlington, the bursts of those strange English expressions of Rococo, the Gothic revival as at Strawberry Hill and the Chinoiserie as at Kew Gardens, and closing with the dominant Neo-classic designs of Adam and Nash.

The one thing common to this variety in architectural style, was the setting in which, in the country, the houses were put. The formal, even geometric, garden designs of an earlier age gave way to landscape gardening. What the French still call *le jardin anglais* was born, reverting as it were to Nature. To Nature, that is, as the eighteenth century understood it, for it found Nature had shortcomings. Both Sir Uvedale Price and William Gilpin, who were the great authorities on the picturesque and landscape gardening at the end of the century, regretted 'that there are so few perfect compositions in nature'. For the garden, the whole countryside

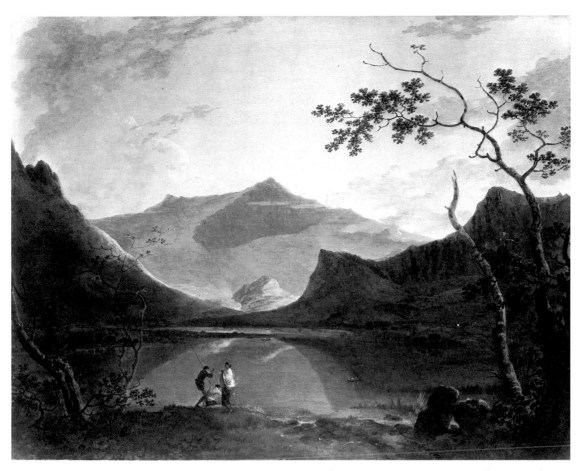

Wilson: 'Snowdon from Llyn Nantle' (*Walker Art Gallery*)

as far as it could be viewed from the garden, was considered as a work of art, in terms of composition, of colour, of light and shade. Where these were faulty, clumps of trees were moved, set up or uprooted, lakes were dug. The standards by which picturesque gardens and parks were assessed were supplied largely by the three painters, Claude, Salvator Rosa, and Poussin (perhaps more often Gaspard Poussin, or Dughet, rather than his now more famous brother-in-law, Nicolas). The whole appreciation of landscape could be expressed by reference to these three, and a fortunate letter writer of 1756 found them all three at one point in the Lake District, later to be the cradle of the English Romantic School of Poetry. He found beauty, horror and immensity united ... 'to describe these three perfections, as they are joined at this particular place [Keswick] would require the united powers of Claude, Salvator and Poussin. The first should throw his delicate sunshine over the cultivated lakes, the scattered cots, the graves, the lake, the wooded islands. The second should dash out the horror of the rugged cliffs, the steeps, the hanging woods and foaming waterfalls; while the grand pencil of Poussin should crown the whole with the majesty of impending mountains ...'

All these three painters, though the strict theorists never placed landscape in the highest category of art, were beloved and sought out by the collectors. They influenced of course not only the landscape gardeners, but also some of the greatest of English painters, particularly Richard Wilson and Turner.

A very different landscape artist who made a

great appeal to England was the Venetian, Antonio Canaletto. The English extended their passion for portraiture of themselves to that of landscape and of urban architecture: although they fell easy victims to the idealised visions of Claude and Salvator, they retained also their addiction for exact topographical pictures. Canaletto gave them this realistic portrait quality, but he threw in for good measure the eye and the skill of hand of a great master. He was aided in his relationship with his English clients by his friendship with Joseph Smith, the English consul in Venice. Smith seems in fact almost to have acted as Canaletto's business manager, but he was also patronising other Venetian painters. Smith commissioned a huge set of religious compositions from Sebastiano Ricci and his nephew Marco Ricci, and also helped Zuccarelli and the pastellist Rosalba Carriera. Nor was he indifferent to the Dutch: he owned two Rembrandts and a Vermeer, 'The Lady of the Virginals', now in the Royal Collection, though this of course was not recognised as by Vermeer, then completely unknown, but was attributed for more than a century to van Mieris. But the emphasis of his collection was undoubtedly on Canaletto, and covered every period of the artist's work, though mostly from the time before the artist's sojourn in England, 1746—56, which Smith doubtless encouraged. The curious gaps in his collection were of Tiepolo and of Guardi, but Smith was typical of his generation in thinking Guardi to be no more than a flashy imitator of Canaletto. George III acquired a great deal of Smith's collection in 1762, and the clustered displays of Canaletto's work, most formidably at Woburn, can be somewhat overwhelming.

Canaletto's work done in England is of uneven quality, but at its best can equal that of his Venetian masterpieces. The two views from windows in the London house of his first patron there, the Duke of Richmond (and still in the family collection at Goodwood) are perhaps outstanding, but he also painted many subjects on the Thames theme, and travelled further afield, as for the brilliant series of Warwick Castle (two are in Birmingham City Art Gallery). He seems however never to have turned his hand to portraiture of people. To see themselves invested with Italian and classic glamour, the 'Grand Tourists' had to seize the opportunity when they were actually in Italy. This they did with great appetite, especially when in Rome, sitting to Mengs, the leading practitioner of the neo-classic theories of the German art historian Winckelmann, and then to the ultra-fashionable Pompeo Batoni, who painted some 200 portraits of the British 'milords' of which many can still be admired in the possession of the descendants of the sitters.

By the mid-eighteenth century however British art was entering on what many still think of as its 'Golden Age', heralded in the 1730s and 1740s by Hogarth, the first British-born artist to attract considerable attention on the Continent, even if primarily through the engravings of his remarkable series of story-telling paintings. He was though also of course pioneer of a new form of a typically English, often relatively informal, branch of portraiture, the small-size conversation piece, while his life-size painted portraiture too offered a fresh liveliness and attracted patronage from more bourgeois clients. He could also, as in the famous painting of Thomas Coram, demonstrate brilliantly how a forthright, essentially unflattering characterisation could be presented with all the conventional Baroque trappings of a van Dyck. Conversation pieces, as practised by followers such as Arthur Devis, with a naive almost dollshouse charm, down to the very sophisticated groups by the German immigrant Zoffany, illustrate most vividly the prosperous aristocracy and land-owning classes and increasingly the more middle-class well-to-do.

From 1768, the founding of the Royal Academy provided the basis for a new professional and social status for artists. It had an annual exhibition for displaying their wares, to the public at large and potential clients in particular, and a school in which young artists could receive a sound training, both practical and academic.

In its first President, Sir Joshua Reynolds, the Academy was blessed with a painter, learned in the work of the great masters of the past and capable of digesting their achievement. Though unsuccessful in his wish to lead and establish a

great British school in what was then considered the highest branch of the art, 'history' or 'epic' painting, he did succeed, in all the variety (so much envied by his rival, Gainsborough) of his portraiture, in lifting that lowly branch into the realm of high art. Gainsborough, in contrast, was as it were the lyric genius, a magician of fluid line and colour — and also of a new, specifically English, vision of landscape. The thrust of English patronage remained however overwhelmingly on portraiture, and many patrons still felt that if they wanted landscapes and subject pictures, it was only Continental paintings that were really desirable. Perhaps relatively few were sensitive to quality of handling paint and line, and copies, whether or not acknowledged as such, of old masters were preserved and presented in their collections. Gainsborough's living therefore depended on portraits, and Richard Wilson, who gave up portraiture to become the finest of English classical landscapists, declined into an alcoholic haze of near-destitution.

By the mid-nineteenth century, however, the major English portrait painters — Reynolds, Gainsborough, Romney, Lawrence especially, but also others less well-known now, like Hoppner, Beechey, the Americans Copley and West — had achieved standards of quality that meant the more sensitive connoisseurs could hang their work alongside that of the older Continental masters without a qualm, while the practitioners in other branches of painting were demonstrating an accomplishment, in some cases of revolutionary originality, indeed genius. Not all, though, received the recognition they deserved.

Stubbs, considered by most of his clients rather as an excellent recorder of their favourite horses than as an outstanding artist, was hardly elevated to recognition as a great painter before the mid-twentieth century. That archetypal English eccentric, William Blake, also captured few conventional collectors with his visionary genius. Even Constable and Turner did not have exactly an easy ride. Constable attracted more serious attention from fellow artists in France than in England to begin with, while Turner, who in his earlier works had deliberately challenged the

Old Masters, from Claude to the Dutch landscapists, in development of their styles, left many of his early admirers blinking and dazzled, in incomprehension of his later celebrations of colour and light. Turner though had his loyal patrons, notably the 3rd Earl of Egremont at Petworth, where you can still see enchanting evidence of the return that patron received from the artist for his support.

A new breed of patrons was also emerging now: the industrialists, businessmen, financial operators, tycoons who pioneered or followed sharp in the wake of the Industrial Revolution. They mostly remained, for all their success, obstinately loyal to the places in which their success had been founded, the major new urban industrial towns and cities of the Midlands and the North — Birmingham, Manchester, Liverpool; Bradford, Leeds, Newcastle. Sometimes they were sensitively cultured — Wedgwood, at one extreme, pioneer in the manufacture of upmarket ceramics, patron of Stubbs and of Wright of Derby; Roscoe, a self-taught lawyer at Liverpool, buying early Italian art long before it became fashionable. When the Pre-Raphaelites, in the ferment of their precocious youth, shocked visitors to the Royal Academy, they soon found clients in the North and the Midlands, starting with the University printer at Oxford, Combe.

THE LONDON GALLERIES

Meanwhile, a most important development was consolidating: the growth of the museum, the art gallery, open to the public, and under institutional management and so endowed with a hope of perpetuity which, though not infallible, was more secure than private family fortunes.

The first institutional collection of paintings to open to the public (or a select portion of it) were the state rooms of the Foundling Hospital in London, now known as the Thomas Coram Foundation for Children. It was largely sponsored by Hogarth, who in 1740 gave his masterpiece, the most informally formal portrait of

Thomas Coram, founder of the Hospital, encouraging colleagues to do likewise, the purpose being to raise funds for the hospital. The hospital was demolished in 1926, but the handsome Governor's Court Room and staircase were incorporated in the charity's new building in Brunswick Square. Besides works by Reynolds, Hogarth, Wilson and Ramsay, it includes a delightful view by the young Gainsborough of the approach to the Charterhouse.

That was of course a small collection (and still, most pleasantly, is so). The first gallery of art of international scope was the Dulwich Picture Gallery. This began in 1626 when Edward Alleyn, actor, bequeathed to Dulwich College thirty-nine pictures which were in-

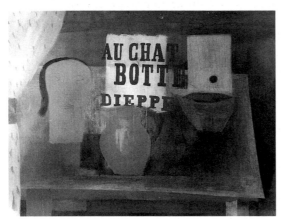

Ben Nicholson: 'Au Chat Botté'
(*Manchester City Art Galley*)

creased by the gift of 239 pictures given by William Cartwright, actor and bookseller, in 1686. There was a strong theatrical element (including what could be a self-portrait of Shakespeare's colleague, Burbage). The next addition however not only was a cash endowment but 371 paintings, many of a very different calibre, bequeathed by Sir Peter Bourgeois RA in 1811. These include outstanding representation of Rembrandt, Rubens, van Dyck, Murillo, Claude, Poussin and Cuyp. Later benefactions increased the range and richness. Bourgeois's collection had been brought together by the dealer Desenfans, originally commissioned to stock a National Gallery in Warsaw. That fell

through, and as a result the erstwhile tranquil village of Dulwich, though now indissolubly knit into the web of London, has an art gallery that would serve to endow very well a capital city with a remarkable nucleus. The appeal, still potent today, to a benefactor, of ensuring a permanent memorial for himself, is underlined in Dulwich's case by the inclusion of a mausoleum for Bourgeois, and for Mr and Mrs Desenfans, actually in the gallery. The building itself is a fascinating example of an early but very sophisticated essay in gallery-design, by Soane.

In 1824, ten years after Dulwich opened, the National Gallery itself was established, finding its permanent home on Trafalgar Square in 1838. England was late, compared with Austria, France, Holland, Spain and others, in setting up a national art collection, but the acceptance by Parliament of the principle that art is more than a luxury, a *bon-bon* even, for rich men but a necessary nourishment for civilised man, has always been slow and generally grudging (and not all artistic opinion was in favour — Constable disapproved of the concept). The actual precipitation was achieved really by Sir George Beaumont — baronet, well-to-do, with an informed and sensitive eye for art (himself an amateur painter of some distinction) and a strong sense of public duty. His successful gambit was to offer a gift to the nation, provided the public purse responded by a modest expenditure on a highly desirable purchase that had become available. J. J. Angerstein, a successful banker, collector, patron of Lawrence, left instructions that his collection, including masterpieces ranging from Raphael to Hogarth, Claude (five) and Cuyp, Rembrandt and Rubens to Sebastiano del Piombo, be offered to the Government at a relatively modest price. Beaumont's offer of his own collection, as a gift, provided the Angerstein offer was taken up, tipped the balance. The formidable standard of quality set by this start has, as at Dulwich, been matched by many benefactions, but also by inspired buying by some subsequent Directors, notably Sir Charles Eastlake during his tenure (1855—65). It has not generally been acknowledged by much noticeable generosity by subsequent govern-

ments (of whatever party), but agonised campaigns of fund-raising have been eased by the voluntary efforts of the National Art-Collections Fund and other charitable Trusts.

The state's acceptance of the National Gallery had however established that art, and paintings in particular, made available to the citizenry at large, constituted an amenity of modern civilisation that it was proper, indeed perhaps desirable, for the British national exchequer to admit into its budget. From the 1850s onwards, museums and art galleries began gradually to proliferate.

Early impetus was provided by the energy and imagination of the Prince Consort. Both he and Queen Victoria were interested patrons of painting (and indeed practising amateurs themselves). Albert was fascinated precociously by early Italian and especially German painting, before those schools had attracted much attention (many of his purchases were given after his death by the Queen to the National Gallery). The Royal Collection had already been enhanced during the reign of George III and especially by George IV (delighting in the Dutch School), while, soon after Victoria's accession, the State Rooms at Hampton Court had been opened to the public, and something of the quality of the Collection's range and variety became gradually more visible. This trend has continued by slow degrees, so that now not only Hampton Court — its Italian holdings especially, including the great Mantegna 'Triumph of Julius Caesar' sequence — but also Kensington Palace and Kew Palace, display paintings to the general public, some of major interest, while the Raphael Cartoons have been so long on loan to the Victoria and Albert Museum that most people assume they belong to the Museum. Since the war, bomb damage at Buckingham Palace itself (never open to the public) has produced one happy result: the construction there of the Queen's Gallery, in which selections from the Royal Collection are shown, changing yearly. Though the displays are not always of paintings, drawing on furniture and the inexhaustible riches of the drawings at Windsor, there are usually splendid masterpieces to be seen.

Albert was much involved with the Great

Exhibition of 1851, the profits of which helped to fund the development of the great campus of museums that now are at the heart of South Kensington. The Prince's own initial venture was characteristically didactic and 'improving' — a 'Museum of Manufactures' developed into a 'Museum of Ornamental Art', whence by degrees evolved the Victoria and Albert Museum, claimed now with some confidence as 'the greatest decorative art museum in the world'. The original aim of its collections, to act as exemplar, pattern book, and inspiration to industrial design has waxed and waned and now revives again, but the Museum's holding of superb examples of what is more usually described as 'fine art' rather than decoration or design, has accrued magnificently, if haphazardly. Here is the national collection of miniature portraits. Here too is work by Boucher, by Gainsborough and Reynolds. The representation of Victorian genre painting is of highest quality, mostly given by one of a new breed of collectors, John Sheepshanks, a successful textile manufacturer from Leeds — but the range also extends to an astonishing Degas theatrical painting. Here, perhaps for some above all, is John Constable, in the family collection in which you can come closer to his genius at work in the wealth of drawings, oil sketches, preliminary studies and finished work, than anywhere else.

The V & A though has become an Empire. Osterley Park House, away to the west in its park at Isleworth, is under V & A administration; Robert Adam's remodelling of an Elizabethan mansion, has been restored as far as the splendid sequence of state rooms is concerned, and is essential visiting for the Adam fan. For its paintings, it depends mostly on loans from the V & A, though the inset paintings by Zucchi are integral with the original decoration. Still to the west, though rather closer in than Osterley, is Ham House, also administered by the V & A. This offers house and interior (and indeed garden, somewhat controversially replanted to seventeenth-century formality, abolishing Repton landscaping introduced in the eighteenth-century), that still offer a rare and important example of grand seventeenth-century domestic decor, carefully conserved and re-

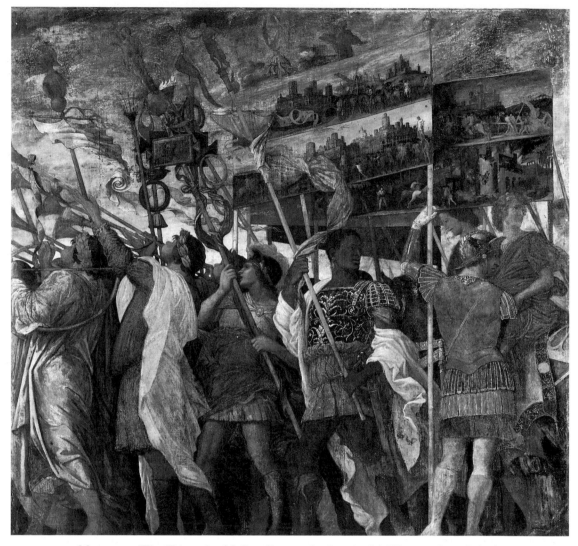

Mantegna: 'The Triumph of Julius Caesar: the Standards' (*Hampton Court Palace*)

stored, as installed by the Duke and Duchess of Lauderdale in the 1670s, the contents documented in contemporary inventories. Especially notable are the Lelys and J. M. Wrights, but the ensemble is scarcely less interesting for the wealth of documented work by minor painters of the time.

British portrait painting is most comprehensively illustrated in the National Portrait Gallery, which is not merely adjacent to the National Gallery but actually abuts on it. Generally known as the N.P.G., the Gallery was founded to celebrate, in their likenesses, the great men and women of British history. The criterion for the admission of a portrait is not its artistic value but its sitter's historical importance. Within the Gallery, the conspicuous failure of great men and women to find the best painter, or even a good painter of their time, to record themselves is only too often evident. Some austere critics find that the mixture of good and bad or indifferent paintings detracts from the value of the good. For me, the contrary is true: the good stand out all the better, and breed a compassion in the eye that turns from them to the bad, causing me to reconsider my standards

and even perhaps to find, in an indifferent work of art, an honesty of approach in human terms that can be very touching. The good is anyway present in considerable strength, by artists such as Holbein, Hilliard, Mytens, van Dyck, Lely, Kneller, Hogarth, Reynolds, Gainsborough, Stubbs, Wright, Zoffany, Lawrence, Rossetti, Watts and Sargent.

Portraits of the living used not be to accepted, and the 'ten-year rule' meant that a decade should elapse after death before anyone could qualify. Thus, it was hoped, the historical calibre of the sitter would have a little time in which to find its true, or at least seemingly true level. Fame can be a fickle and fragile endowment. In these last years, this caution has been abandoned: live celebrities are collected. Portraits in some cases are even commissioned by the Gallery, and in the 1980s the annual exhibition of finalists for the Players Portrait Award has been a very positive encouragement for the continuation of the national tradition in portraiture.

The recent increase in acquisitions has all but burst the Gallery at the seams. This has not been helped by the government's parsimony in not allocating to the Gallery the very suitable, easily adaptable, building formerly occupied by the National Dental Hospital. They sold it off to a property developer for replacement by an hotel. Some alleviation has been found, however, by hiving off parts of the collection to carefully selected country houses. Thus most of those Tudor portraits for which there is no room in London are hung very suitably in the superb Elizabethan mansion, with its long gallery, at Montacute in Somerset. Late seventeenth-century representatives are at Gawthorpe Hall. Early eighteenth-century ones are in the handsome Georgian house at Beningbrough in Yorkshire. Few will object to this development, and the pros must surely outweigh the cons, even though these properties are not so accessible, and not open all the year round, as are the London headquarters.

I have dwelled at some length on the National Portrait Gallery partly out of affection (having worked there for half my museum career), but also because it illustrates the English passion (vice, according to some) for portraiture and crystallises it in very concentrated form. A national portrait gallery, maintained by the state, is a peculiarly Celtic-Anglo-Saxon institution — there is also a Scottish one, and in the 1960s the United States of America started up theirs — but there is nothing in Europe that is quite equivalent. Collections of portraits were made in the sixteenth century — most famously by Paulo Giouio in Italy. Portraits were also engraved and published in book form, in the seventeenth century — notably by Lord Clarendon as illustrations to his history of his times. Later in the eighteenth century, a system of classifying English historical engraved portraits was published by an assiduous clergyman, James Granger, and proved an inspiration to many collectors. It was through the family habit of recording each generation (at least of the heads of the family) that the background was provided on which the accretions of those with artistic inclinations could accumulate.

The National Portrait Gallery was founded in 1856, inspired by an aristocratic but academically highly respectable historian, Earl Stanhope: it found its permanent home, in a building funded by a private sponsor, W. H. Alexander, on condition that the Government provided a site, in 1896. Five years earlier, Sir Harry Tate (of Tate's sugar cubes) funded the Gallery on Millbank that bears his name, on condition again that the Government provide the site, and he set it on its way by the gift of his own collection of contemporary High Victorian art. It has grown with the help of five enlargements of its building, into the national collection of British Painting on the one hand, and the national collection of Modern Art on the other. The latest extension (by James Stirling, 1987) brings at last Turner's bequest of his own work to the nation into one home (apart from a handful of oil paintings in the National Gallery). The British School representation is generally comprehensive at a high level; it shades off, in the twentieth century to merge with Modern Art, European and American, where the quality and coverage are inevitably controversial.

The job of the Director of the Tate is hazardous, as he is considered fair game for (sometimes virulent) attacks by critics and artists of opposing

views, and by mystified members of the public. Whatever is said, it is incontestable that, whatever its strengths and weaknesses, it is one of the most important venues for contemporary art in the world. A major problem is space, so that only a small proportion of the whole can be shown, a situation not improved by an ambitious programme of major loan exhibitions. It is now being alleviated to some extent by the introduction of the 'Tate of the North', a capacious satellite exhibition space in premises adapted in the superb dock warehouses at Liverpool, which is to be used, not for exercising the 'second eleven' from the Tate stores, but for a changing display of its best pictures.

The Tate is very popular (controversy no doubt stimulating interest) and usually humming with young people. It caters for a wide social range. It has a dining room where you need to book in advance (there is a very good wine list) and be equipped with a well-heeled credit card, but also there is a good inexpensive coffee bar. If you are lucky, coming down the steps into a misty but still sun-shot gathering dusk, the Thames may even stage a live Whistler, or a Monet for your dazzled eyes.

The Tate's 'Recent Acquisitions' is usually a good, succinct pointer to what is new on the contemporary art scene, though the amateur will be keeping up to date on that in the various galleries, commercial or otherwise, that are not included in this book, as they do not have permanent collections and generally show only temporary exhibitions. The Institute of Contemporary Art is the traditional venue to '*épater le bourgeois*' in its perhaps misleadingly traditional Nash site on the Mall. The Arts Council Galleries are: first, very concrete, on the South Bank, the Hayward Gallery; second, the charming little pavilion, The Serpentine. The Whitechapel Art Gallery has a high international reputation for pioneering contemporary art. The dealers congregate on the Bond Street axis, in St James's, and off Sloane Street. They also spring up in the most unlikely places. The traditional art exhibition of the London 'season' (which does perhaps just still exist) is the annual Royal Academy Summer Exhibition — showing over a thousand works, to the sniffs of the critics and

pleasure of thousands of visitors.

Individual enterprise in museum creation has always occurred sporadically. An early instance was the establishment by Sir John Soane, the architect, of his own house in Lincoln's Inn Fields and his collections therein, as a museum, by virtue of a Private Act of Parliament that he had promoted in 1833. Opened to the public in 1837, after his death, it survives, a most desirable retreat for an hour or so (though not on Sundays and Mondays) for anyone battered beyond bearing by London's restless turmoil. Amongst the fascinating miscellany, ranging from the sarcophagus of Seti I, a mock monument to Mrs Siddons's pet dog and a host of architectural subjects, you can find the originals of Hogarth's 'Rake's Progress' and his 'Election' series (bought by Soane from Garrick's sale), and work by Canaletto, Turner and others. It is an essentially personal collection, idiosyncratic and fascinatingly articulated in the fastidious contrivances of Soane's own handling of the interiors of his house (now being restored to its original colour). A drawback to its availability as a museum is that its display, still virtually as arranged by Soane, is very dense within relatively small spaces: in a room at the Soane, a dozen visitors is a frustrating crowd, and entrance numbers have to be controlled. On the other hand, if you chance upon it almost empty of visitors, it is one of the most mysterious and haunting museums in the country.

The Wallace Collection was bequeathed to the nation, and the condition of the bequest, that nothing be added to it or removed from it has thus far been loyally observed. Brought together mainly by the 3rd and 4th Marquesses of Hertford, and finally by the latter's illegitimate son, Sir Richard Wallace, it remains in Hertford House. Though any intimate family flavour has largely evaporated by now, it retains more of the atmosphere of a grand town house rather than that of a traditional museum. Its holdings are staggering. To Hertford House you go to flesh out the relatively meagre representation of French eighteenth-century painting in the National Gallery: Fragonard, Watteau, Lancret, Oudry, in their finest vein, but, most characteristically perhaps, Boucher. The Dutch

holdings again supplement in quality those in the National and at Apsley House, but the variety is astonishing, from Rembrandt, Hals, and Rubens to Titian and Canaletto, Poussin, Velazquez and major English portraitists. It is especially strong in Bonington. It manages so far, even with the best collection of French furniture outside France, and the famous armour, to remain relatively uncrowded by visitors, and if you go early it may seem you own the place, as its clocks tick and chime. This is by any standards, a major collection, and though many of the paintings will be familiar from reproductions, you will not have seen the originals elsewhere, as its constitution does not allow the Wallace to lend.

Of comparable quality is the Iveagh Bequest in the Adam mansion Kenwood on Hampstead Heath, though in quantity relatively minute. At Kenwood, there is above all what is for me Rembrandt's greatest self-portrait, but also van Dyck, a real Vermeer, Hals, Cuyp, and Reynolds, Romney, and Gainsborough (his 'Countess Howe' arguably the finest Gainsborough anywhere).

Besides the Wallace and Kenwood, the other individual collection of paintings to offer comparable peaks of quality is that held by the Courtauld Institute, scheduled to arrived in its new home in Somerset House on the Strand in late 1989. The most famous element in this is the founding collection given by the industrial magnate Samuel Courtauld, of Impressionist and Post-Impressionist painting, which many feel surpasses that in the National Gallery. The Cézannes may not cover the same range of the artist's career as in the National, nor the Monets, but the quality of almost every painting is of the highest, including Daumier, van Gogh, Gauguin, Cézanne, Toulouse-Lautrec, Rousseau, Camille Pissarro, Manet, Degas. These are supplemented by important later benefactions, and though they do not match the Courtauld gift in popular appeal, for the academic purposes of the Institute of the History of Art, a Department of the University of London, they are no less relevant. Indeed they include masterpieces from the Master of Flémalle, Bruegel, and the early Italians. The Seilern bequest includes thirty-two

paintings by Rubens, but also Tiepolo and Kokoschka in strength. The twentieth-century representation has been greatly increased by the most recent benefactions from Lillian Browse and the late Dr Alastair Hunter. In their old home in Woburn Square, the Galleries have been able show only some twenty percent of their treasures. United at last with their parent teaching and research Institution, they hope to show, at Somerset House, some eighty percent.

Almost as important, for the amateur of great paintings, is Apsley House, the home of the 1st, the Iron, Duke of Wellington, very central at Hyde Park Corner and once known as No. 1, London. It is now the Wellington Museum. This includes the extraordinary loot captured by Wellington from the French after the Battle of Vittoria (1813) and gifted to him by the King of Spain. Here is Velazquez, Goya, Steen, de Hooch, Rubens, Lawrence, Wilkie and many others amongst the Wellington memorabilia.

Several later collections of National status also include paintings. The Imperial War Museum on the site of the Bedlam (the old hospital for the insane) was founded in 1917. It includes, perhaps unexpectedly, one of the finest collections of British painting in the first half of the twentieth century — the work of the Official War Artists: major work by Nash, Spencer, and others. This collection has been barely visible owing to lack of space, but a new extension has recently been completed, greatly improving access. The National Maritime Museum (1934), based on Inigo Jones's elegant Queen's House at Greenwich, includes some very important historical portraiture, and the most representative holding of marine painting in Britain. There are also several other outstanding institutions listed in this book, with a major emphasis on art and exceptional concentrations of fine, indeed great, paintings, within the London perimeter.

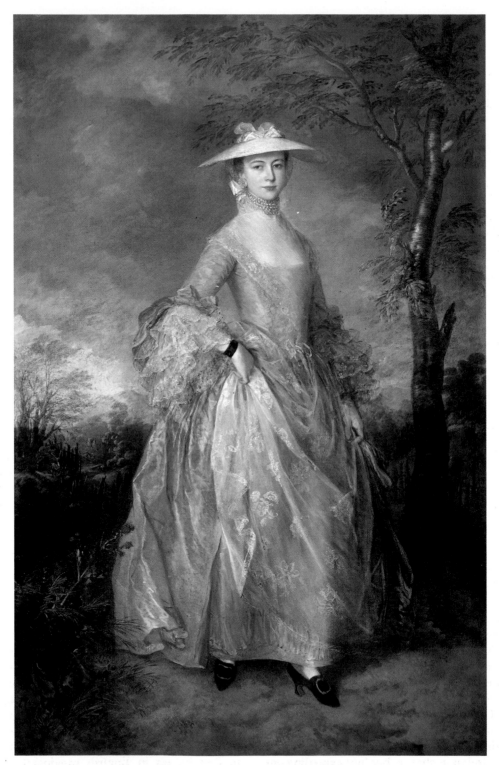

Gainsborough: 'Countess Howe' (*Kenwood*)

THE MUNICIPAL AND
UNIVERSITY MUSEUMS

To lump the English galleries, other than those in London, under one heading may seem derogatory, but it remains true that London has always been, since the sixteenth century at least, the hive of activity for the most talented artists, because that was where court and government, finance and fashion — in short, artistic patronage and sales — were centred. Provincial centres, or 'schools', flourished for a time but never for long. Bath, with its fashionable, constantly renewed, spa society in the eighteenth century caused Gainsborough and others to settle there for a while. Crome and Cotman remained loyal to Norfolk and Norwich; there were individual schools in Liverpool and Birmingham; Joseph Wright was loyal to Derby; Cornwall has long been a magnet. Yet, almost inevitably, artists of talent and ambition aimed at London where their work could be seen, where the Royal Academy was, and where the major loan exhibitions, the dealers, the auction rooms were to be found.

I prefer (perhaps being provincial-born and sensitive always to a pejorative overtone, especially as used by art critics and historians, in the use of the adjective 'provincial') to think of the collections to be found elsewhere than in London, not as provincial but, in that charming Scottish usage, as 'outwith London'. And they are many of them, ranging from a room above a municipal library, to major collections, mostly so in the major cities that mushroomed in the Midlands and the North following the Industrial Revolution, but always with startling surprises awaiting the visitor in unexpected places that are omitted from the itinerary at one's peril.

The spread of municipal museums was foreshadowed and surely prompted, by two Acts of Parliament. The first in 1845 was to enable 'Town Councils to establish Public Museums of Art and Science ... for the instruction and entertainment of the inhabitants'. This permitted an admission charge, but 'not exceeding one penny', and was superseded by a second Act in 1850 that stipulated that entry should be free.

Local councils were authorised to maintain the museums out of the rates. So it is that — till the time of writing at least — the visitor can still enter almost all municipal museums without paying.

The irony, that municipal museums should remain free while the tendency of the national institutions seems to be moving steadily towards charging, seems to have escaped many national Boards of Trustees, and certainly has bounced off the obduracy of the Treasury and Parliament who refuse to provide adequate core-funding for these institutions which their predecessors accepted as a national duty. There is a deal of loose rhetoric now about the 'national heritage', and a Minister for the Arts has spoken even of the 'hysterics' of the 'Arts lobby'. The right of free entrance to at least the national museums is however part of one of the most valuable inheritances left to us by the Victorians, as in the case of the public libraries, free access for anyone who wanted it, to learning and the cultural inheritance of the past. To limit that is to impair the quality of life.

Some of the most important provincial art collections owed much to earlier groupings of cultural interests in the larger conurbations, based on a solid material prosperity of the Industrial Revolution leavened by a spirit of enquiry and experiment expressive of the Age of Enlightenment. The Leicestershire Museum and Art Gallery is an admirable example of this (although it may seem to be slipping towards admission charges, 'requesting' — though not yet 'requiring' — 'voluntary contributions').

Leicester Borough Council, following submissions by the Leicester Literary and Philosophical Society, the Mechanics Institute and the Athenaeum, acted in 1847, two years after the Museums Act, by founding the Leicester Town Museum. By 1885, expansions embracing both an Art School and Art Galleries were under way. Though first acquisitions of paintings were mainly of High Victorian narrative and genre, a very enterprising policy was implemented from 1930 on. The first major Impressionist paintings to find homes in English provincial galleries came to Leicester — fine work by Pissarro, Sisley, Degas. Then, most adventurously, during

the war, they developed a unique interest in German Expressionism, and the Leicester collection of Marc, Nolde and Feininger, has become the most important in Britain. Nor is the British School neglected, especially that great favourite of many provincial galleries, the Camden Town Group. In acknowledgement of Leicester's traditional relationship to fox-hunting, there are also the sporting paintings of the highly talented local family, the Ferneleys. Since the war, the old master representation has strengthened remarkably — Italians from Lorenzo Monaco to Beccafumi and Pittoni; fine seventeenth-century Dutch paintings, and most recently the French school, with the discovery of a previously unknown Georges de la Tour, which emerged from a local private collection. Meanwhile the Literary and Philosophical Society still flourishes alongside the art and the museum.

A special category outwith London is that of those university museums that have holdings of painting.

The Ashmolean in Oxford was the earliest, in 1683, but became concentrated on art and archaeology, with all the University's art collections brought together under one roof, only by about 1900. These were the University's collections, and not those of the colleges. Christ Church for instance has a formidable collection of its own, based on a bequest by an eccentric mid-eighteenth-century military man, General Guise. The old master drawings there, together with the Ashmolean's major strength in Raphaels and other great masters, make Oxford an essential port of call for students of drawing, but drawings are not readily accessible to the general public, though in both cases a selection is usually on view. Guise's old master paintings are of high importance, though variable in quality and in condition, mostly Italian with famous work by the Carraccis, and supplemented by later additions of early Italian work from an enterprising diplomat, Fox-Strangways (later Earl of Ilchester) who also benefacted the Ashmolean, notably with its most famous masterpiece, Uccello's 'A Hunt in the Forest'. The Ashmolean strengths are in the early Italian — including a painting generally if not quite universally accepted as being by Giorgione,

the Uccello and a famous Piero di Cosimo; a good representation of later artists, from Bronzino to Claude and Poussin, Watteau and Tiepolo; and a rich representation of Pissarro benefacted by the family.

Cambridge University's Fitzwilliam Museum has always been an art museum. In 1816, its founder the Earl Fitzwilliam died, leaving his collections — including notably music manuscripts — of art to the University of Cambridge 'for the purpose of promoting the increase of learning and other great objects of that noble Foundation'. He added an endowment to build a museum which, initially designed by Basevi, opened to the public in 1848. As benefactor, Fitzwilliam was almost ideal: a representative, but a most sensitive and learned one, of the traditional aristocracy; a great traveller, assiduous in his buying; and, in his case, all the more admirable by siring no children to dispute the direction of his gift. He set a standard of quality, including major paintings by Titian, Veronese and Palma Vecchio, fine Dutch pictures, and what was then the best collection of Rembrandt's prints in Britain. As it now is, the Fitzwilliam demonstrates that subsequent benefactors have responded over and over again to the standards he set.

During the Directorship of Sir Sydney Cockerell (1908-37) it expanded and was shown in a mixed decor — involving fine furniture and carpets, that was novel (and proved immensely influential), aimed at presenting an atmosphere comparable to that of a great country house: comfortable, relaxed, but well lit and calculated to permit the visitor's maximum enjoyment of fine painting. Laughter is not often heard in great museums — and the Fitzwilliam is one of the greatest of small museums — but I have heard it several times from in front of Hogarth's satire on French erotic pastoral convention ('Before' and 'After').

London, Oxford and Cambridge have perhaps the most important University museums in England, but a number of other universities are well equipped with them. Manchester has the Whitworth — celebrated especially for watercolours, textiles and prints (not least wallpapers), but including a notable selection of

Uccello: 'A Hunt in the Forest' (*Ashmolean Museum*)

British post-war painting, and, in the portrait of Payne Knight, one of Lawrence's most astonishing tours-de-force of portraiture. Birmingham has the Barber Institute of Fine Arts, combining (as the Courtauld will do at Somerset House) picture gallery and history of art department — with a concert hall as well. Its founder, Lady Barber in 1932, stipulated that 'works of exceptional and outstanding merit' should be acquired, and the paintings, from the thirteenth to the twentieth century, respond very laudably to that high ideal. The Institute is liberally endowed, although the escalation of prices is now somewhat crippling, and a veto on accepting anything as a gift has meant that a severer criterion of quality has inevitably kept out indifferent or borderline acquisitions. East Anglia, near Norwich, has the very idiosyncratic and personal collection given by Sir Robert and Lady Sainsbury, and housed in an early high-tech building (Norman Foster; Sainsbury Centre for the Visual Arts, 1977) which attracted astonished but generally admiring comment when it was opened. The collection is very mixed, the Sainsbury eye responding no less to some medieval carving than to Henry Moore. For painting, especially notable are the Modiglianis, and even more so the Francis Bacons, which include his portraits of the founders.

Financial problems in the 1980s have beset some University museums more grievously than others. University budgets have to focus on the universities' prime duties of teaching and research, and bids for support from limited funds from galleries for the formidably escalating running costs are liable to meet with limited success. Most benefactors, happy to give art objects, even buildings, find the subsidising of running costs lacks glamour and 'appeal-appeal'. Hence the visitor needs to check opening times very carefully before visiting, and to ascertain in advance whether those items he especially wants to see are available. On arrival, he may well find that there is an entrance charge, and certainly a 'begging-bowl' asking for support.

Paying an entrance charge will not surprise probably the majority of visitors from abroad — one pays to get into almost all Continental museums, and many in America. No one will be surprised either by the ubiquitous begging bowls, though many find the voluntary-but-morally-mandatory entrance charge, as practised with such ruthlessness at the Metropolitan in New York, repugnant. It is so far practised in Britain less compellingly (and less expensively) than in New York, but nevertheless it does brand the visitor as either a first-class citizen of generosity and prosperity, or a second-class reject, unable to pay his way, or even a bilker. A special class is that of the enraged conscientious objector muttering that he has already paid in his taxes. A state of moral indignation keeping guilt at bay is no frame of mind in which to extract from great works of art the best that they can offer.

Obviously, if it is a stark confrontation by budget — to charge admission or to close — the

gallery will charge. The only other solution — though do not speak this out aloud — is to sell. For small institutions an entrance charge to be cost-effective could be so high as to prove ineffective as too few visitors would come. At Oxford and Cambridge, for example, the Ashmolean and the Fitzwilliam must represent billions of pounds. At present market prices, they are almost the most valuable assets the universities have, and quite a proportion of their function is not academic: they give pleasure to the general public and to tourists. Academic administrators would not be human if the thought of sale did not cross their minds.

Manchester University sold from its famous Rylands library in 1988 early printed books claimed to be duplicates or in some way superfluous. Many bibliophiles disagreed furiously. Manchester was also confronted by the problems of Tabley House and its collection of first-rate British painting, including Lely, Reynolds, Lawrence and Turner, formed by Sir John Leicester (1762–1827) and owned by the University. (This at the moment is not open to the public.) Their difficulties have now been resolved by the lease of the Grade I listed building to a consortium for adaptation as nursing home and sheltered housing, but creating a non-profit museum trust to guarantee the continuation of the gallery floor in the house to manage the collection. This is a (relatively) happy outcome.

Further rumours in 1988 suggested that a satellite of London University at Egham in Surrey — the Royal Holloway and new Bedford College — might have to sell one of the most remarkable surviving nineteenth-century collections, bequeathed by Thomas Holloway in 1883 (also not open to the public). It includes work by Turner, Constable, Gainsborough and Victorian academicians — such as Frith's 'Railway Station', and famous early social realist paintings by Fildes. I hope that problem may have been resolved favourably by the time this book appears. Meanwhile, the watchword is, as ever but how often forgotten — eternal vigilance.

THE COUNTRY HOUSES

London itself has no longer any great domestic mansions inhabited as such; survivors serve as offices or, indeed, as museums. Many have been demolished; fragments may have been preserved in the Victoria and Albert Museum, or more spectacularly in the Metropolitan Museum in New York (where you can see the great staircase from Chesterfield House in Mayfair), or in the period rooms at Philadelphia, Boston and elsewhere in the States. The Percys, Dukes of Northumberland, have, for instance, long gone from Northumberland House at Charing Cross, and while they have retained their Adam splendour at Syon House at Isleworth, and furnished it well with paintings, the finest of the Northumberland pictures are in the family's northern stronghold at Alnwick Castle.

The process of the transfer of important collections from family London houses to country ones has a long history. In 1766 *The English Connoisseur* could still note that while at Chatsworth the paintings were 'few in number and indifferent', the family's collection at Devonshire House in Mayfair was surpassed by 'very few others either at home or abroad'. It is however Chatsworth that now holds that world-renowned collection; the only surviving witness to Devonshire House on Piccadilly is the handsome iron gates the other side of the road, that open if they ever are opened only on to Green Park. Indeed by 1766 Thomas Coke, Earl of Leicester, had already removed his collections from London to Holkham in Norfolk, and Paul Methuen was building the gallery in his house at Corsham in Wiltshire whither he transferred his pictures from London, the Methuen old masters. Before the end of the century, it was a cause for complaint for art-lovers coming from abroad that there was little in the way of art to be seen in London.

The changes in the national economic and social structure, aggravated especially by two world wars, have now in turn taken a heavy toll of those great, and not-so-great, country houses, and their collections of art. A famous exhibition at the Victoria and Albert Museum in 1974, the

reverberations of which were almost akin to those of a requiem mass minus the hope of resurrection, was titled *The Destruction of the Country House*, recording 1,200 houses already lost. Limited salvage operations had been possible since the late 1930s, when the National Trust managed to extend its remit to include taking on responsibility for houses and their contents, if deemed of high enough importance to be accepted by the Treasury in lieu of death duties, and made over to the Trust. Despite the existence of the National Land Fund, guided through Parliament by the Chancellor of the Exchequer, Hugh Dalton, in 1946 specifically to create a 'war memorial to our dead and the use of the living for ever', set up with a capital of £50 million, and later declared by him to have included 'the preservation of great historical houses' amongst its targets, the Treasury always refused to release a cash endowment towards costs of maintenance of any property made over to the National Trust. This limited the number of houses the Trust was able to accept to only those that would come with a realistic endowment.

Public dismay however helped promote legislation in 1975, allowing inheritors of houses of national importance exemption from Capital Transfer Tax (previously 'Death Duties'), subject to various conditions, one of which was that any exempt house be opened to the public for a minimum of sixty days a year. It also became possible for owners to establish private charitable trusts — including outstanding houses such as Chatsworth and Burghley. Then, in 1979, the Land Fund was prised from the grip of the Treasury, and used to capitalise a new 'National Heritage Memorial Fund'. The initial capitalisation was £12.4 million, and is supplemented by grants from the Treasury. However, according to some estimates, £50 million in 1946, properly managed, should have grown to £80 billion by 1988. No very convincing explanation of the discrepancy has been offered.

The National Heritage Memorial Trustees achieved nevertheless in their first decade substantial contributions to the acquisition by national bodies, including the National Trust (though that is not financed by the Treasury),

both of major country houses and their collections and of individual major works of art including paintings. The Trustees' discrimination in the allocation of their relatively modest income has been generally found delicately judicious, though inevitably within a limit that embraces subjects from bats to belfries, headlands to industrial archaeology, they may provoke some controversy. They have borne in mind that their aim is indeed to help establish a worthy, live War Memorial. That it is a memorial for the dead of two world wars can be too easily forgotten. It is perhaps not uncharacteristic of the machinery of bureaucracy that at one stage in the drafting of the enabling parliamentary bill for the Fund, the word 'Memorial' disappeared: a sharp call to order in *The Times* from Field Marshal Sir Gerald Templer (who devoted a determination and stamina to the funding of the National Army Museum comparable to that with which he had confronted terrorism in the Malayan peninsula) got it restored. Ironically, it is also in the same period that some national museums found themselves forced to impose entrance charges. I do not think the Field Marshal would have approved. The Army Museum is (touch wood) still free, but that the Imperial War Museum should charge seems an act of gross impiety, for it is quintessentially a war memorial.

A sensible procedure for the itinerant art-lover who can afford both the time and money, is to make carefully pre-planned forays into the various parts of the country, often combining in any one trip visits to the local museums of the area with visits to open country houses nearby. This does need careful scheduling, and is liable to reduce the campaigning season fairly drastically. All country houses that open (apart from some taken over by local authorities) do charge admission fees. If you are in search especially of a particular object or category of objects, it is always best to ring beforehand to discover if the desired object is available or can be made available — not away on loan or '*in restauro*', or simply not, for the time being, locatable. Simultaneously, opening times should be checked — and also, very much so, whether the visitor has freedom to wander or must submit to a guided

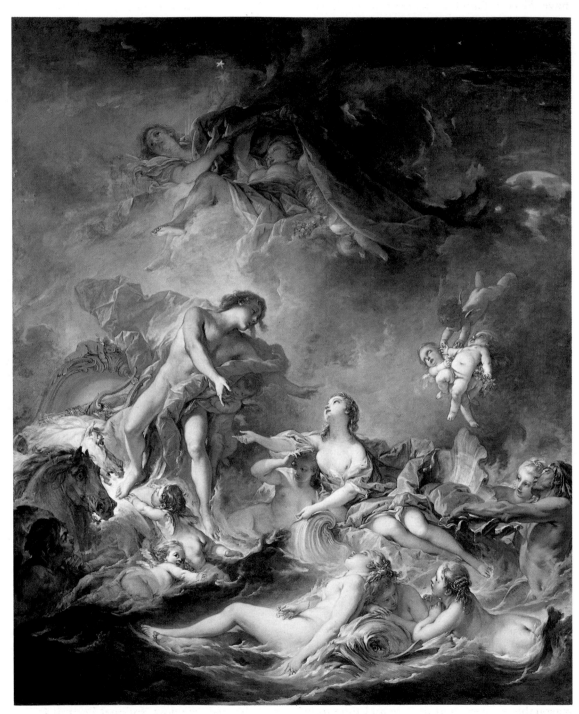

Boucher: 'The Setting of the Sun' (*Wallace Collection*)

tour. If writing, especially to country houses, I have always found it prudent to enclosed a stamped and addressed envelope.

Inevitably, there will be frustrations. Most houses open only the ground floor rooms, but if you are fortunate enough to have stayed as guest in a few houses of this kind, you will be only too aware that the upper floors may contain, hidden away in privacy, most rewarding paintings — not always major ones, but charming and attractive, even if as touching evidences of local artistic gaucherie — tucked away in the bedrooms, possibly in the attics. Guided tours are particularly frustrating when they allow only a glimpse of a room from its doorway, or if they close off from the group an enticing corridor, dismissed perhaps by the guide with a wave of the hand as 'a few Dutch paintings and the odd family portrait'. It is neither polite nor politic, if in a guided tour, to attempt to 'lose' it and stray at your own free will unhampered by being told not only where to go but what to look at.

Guides have a rough time, ever conscious as they must be of the needs of security and conservation ('please do not touch!'). They have done this round many many times, and if of robust imagination are likely to have 'improved' family anecdotes or traditions beyond confine of historical fact. However, if your guide is a member of the family and you have special knowledge of something on show, he or she may welcome it especially if you phrase your offering as a polite question.

When the family is still living in the house, their feelings about the invasion of it may well be tender — it all seems to be theirs, but often it is not. Under current legislation tax exemption can be obtained if your treasures are on view to the public for 'sixty days'. However this mandatory opening does not specify how much of the house must be open. Also if the paintings include inherited items exempted under earlier legislation for exemption from death duties as 'objects of national importance', the owners are under an obligation to give access to such objects for reasonable requests and at date and time to be agreed as mutually convenient, which may well present problems for the owners. Then tactful enquiries are needed.

Some of the most famous items, often published and exhibited in loan exhibitions, may not be on the 'public route'. Thus, generous though the available display at Chatsworth is, that celebrated and (for me) most evocative of all Poussin's paintings 'Et in Arcadia Ego', is not on the main route, and neither apparently are the remarkable additions to the Cavendish family portraiture commissioned by the present Duke from Lucian Freud. At Hatfield, one of the two very fine early English portraits of a celebrated Elizabethan blue-stocking, Lady Mildred Burghley, is not shown, nor is the prettiest masterpiece by J.M. Wright of two Cecil children. (But do not miss at Hatfield, on the stairs, a unique document in the history of English portraiture, the hasty painting of an innocuous member of the family daubed over a portrait of the Duke of Monmouth, at a time when an image of Monmouth after his disastrous rebellion was not desirable for display in a loyal household.)

At Althorp, there is very rigorous guiding, and too many of the famous paintings are not shown. Nigel Viney sighted never a Reynolds nor a Gainsborough nor a Stubbs on his recent visit, though masterpieces by all three are recorded there. While the 'connoisseurs' day' once a week does give access to the splendid long gallery with its famous Lelys and van Dycks, it does not otherwise enlarge the visit very much. Althorp has also been 'de-accessioning' some paintings through the salerooms. Others too have been traded in for fiscal reasons or allocated to museums, leaving sad gaps in this historically very remarkable ensemble.

A happier procedure has now managed to win Treasury approval, by which some paintings accepted in lieu of tax can be assigned to museums but then put out on indefinite loan to the houses whence they came. Thus the two remarkable Mytens whole-lengths, of the Earl and Countess of Arundel and Surrey, depicted as if seated in the galleries at Arundel House in which the legendary Arundel collection was once housed, are now National Portrait Gallery responsibility, but shown back amongst the Howard family portraits at Arundel Castle. So too van Dyck's superb 'Betrayal of Christ'

(Bristol Museum and Art Gallery) is back amongst Paul Methuen's pictures at Corsham.

Country houses have other frustrations for those seeking out paintings — so many are closed for at least two months and generally more in the winter; others are often open for only two or three days a week, and many only in the afternoons. For the most profitable use of time available, planning can be very complex. 'Country house crawling' remains though a major pleasure offered by the English summers, best in the course of bowling gently through a sunlit countryside, but if not, it is dry inside the houses.

The English country house has been claimed as the major contribution of the English to the arts. It offers an ensemble — setting, architecture, interior decor, furniture. It is the ensemble in fact that attracts the majority of visitors, and paintings, some may feel, are not always given

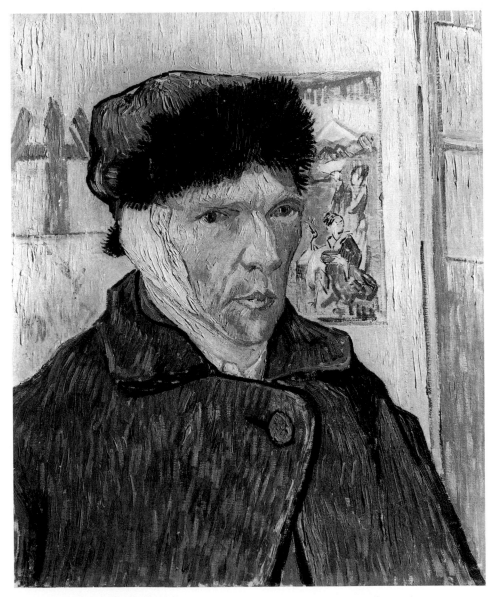

van Gogh: 'Self-portrait with Bandaged Ear' (*Courtauld Institute*)

the emphasis that they deserve. The connoisseur may not be able to get close enough to see many paintings properly and to avoid reflections. The hanging, from his point of view, may not be helpful. If the day is dark, the lighting may well be inadequate. Take a torch but it should not be used furtively. Use it openly, or the guide may well get agitated. The visitor should not photograph (especially with a flash) without ascertaining beforehand that it is allowed. Postcards, photographs, and slides are sometimes available, though quantity and quality are very variable; handlists and guide books, even catalogues likewise. Many houses now run a tea-room, even a (sometimes) licensed lunch-room, and food is often plain but good (though once or twice I have felt in the past that I had stumbled on the last home of Spam). On the other hand, with a little research and advice beforehand, 'country house crawling' can be extremely satisfyingly amalgamated with a basic 'pub-crawl' on the 'ploughman's lunch' principle of bread, cheese and beer. And there is no doubt that whatever frustrations may occur, if you are in search of paintings, the pleasure of discovering them in domestic settings has a very special and satisfying flavour of its own.

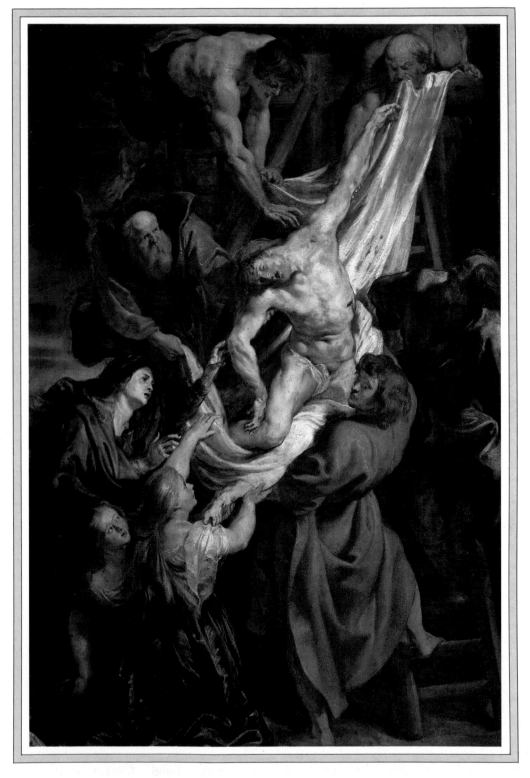

Rubens: 'The Descent from the Cross' (*Courtauld Institute*)

Gazetteer

ABBOT HALL ART GALLERY

MAP A

Kendal, Cumbria
Tel Kendal (0539) 22464

Abbot Hall, Kendal is an unqualified delight. In the house, originally designed by Carr of York, the ground floor retains its eighteenth-century elegance, with a number of appropriate pictures hanging in its well furnished rooms. These include portraits by Lawrence, Ramsay, Reynolds and, most strikingly, by Romney, who worked in the north of England in his early years. Among his works here is an unusual portrait group of 'Four Friends', which includes a self-portrait, and his masterly portrait group of 'The Gower Family'. Painted in 1776—77, after his sojourn in Italy, this remarkable picture uses the commonplace classical idiom of the eighteenth century to new effect, enhancing the charm and grace of the four children and their stepsister. There are also landscapes of the Lake District here, by such artists as Constable, Anthony Devis, de Loutherbourg and Ibbetson.

The upper floor of Abbot Hall has been transformed into well-lit galleries, where temporary exhibitions are held and where the twentieth-century collection is shown. This includes work by Schwitters, Redpath, Ben Nicholson, Keith Vaughan and many more.

ADLINGTON HALL

HHA MAP C

Macclesfield, Cheshire
5m N of Macclesfield on Stockport road (A523)
Tel Macclesfield (0625) 829206

Adlington Hall, a bewildering mixture of black-and-white half-timbering and Georgian elegance, has a fine collection of Legh family pictures, with some large frescoes of unknown date in the Great Hall. There are portraits by Souch, Johnson, van Dyck, Lely, Kneller, van Reysschoot, Opie, Zoffany and Raeburn. There are three admirable portraits by Hudson of Charles Legh (who was responsible for the Georgian additions to the building), of his wife and of his son; Hudson was at the top of his form with these pictures, work which his pupil Reynolds might well have envied.

ALNWICK CASTLE

HHA MAP B

Alnwick, Northumberland
Tel Alnwick (0665) 602207

The palatial state rooms (the work of the Italian architects, Luigi Canina and Giovanni Montiroli) at the Duke of Northumberland's

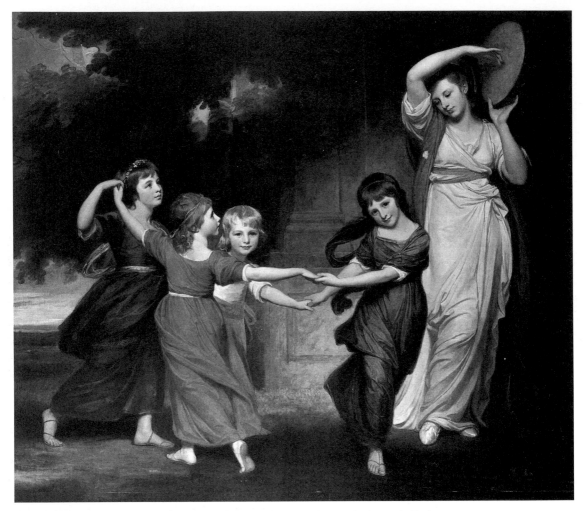

Romney: 'The Gower Family' (*Abbot Hall Art Gallery*)

Alnwick Castle are hung with old masters and with Percy family portraits. One of the best known of the former group is Titian's 'Bishop Armagnac and his Secretary'; there is Tintoretto's 'Ecce Homo'; there is an intense and powerful 'Crucifixion' by Reni, one of this artist's masterpieces; and there is the 'Lady with a Lute' by Palma Vecchio. There is in addition work by, or ascribed to, Garofalo, Lotto, Badalocchio, Feti, Sebastiano del Piombo, Annibale Carracci, Orizonte, Velazquez and Andrea del Sarto — this last a self-portrait. There is a splendid series of Canaletto views of Windsor Castle, Northumberland House, Syon House and Alnwick Castle; the busy view of Northumberland House is one of the finest of the

Venetian's English period. Now demolished, it was the town house of the family, the site marked by Northumberland Avenue. The family's country retreat of Syon House is a quiet haven within London's western sprawl.

This very impressive collection is outnumbered, but hardly outclassed, by the portraits, which include two superb van Dycks — of Queen Henrietta Maria and of the 10th Earl of Northumberland. Other portraits include work by Dobson, Lely, van Somer, van Loo, Cosway, Batoni, Hoppner, Reynolds (most strikingly with his 'Lady Beverley'), Lawrence, Sir Francis Grant (with an admirable picture of the 4th Duchess), Poynter, who is not often to be seen in this context, and de László.

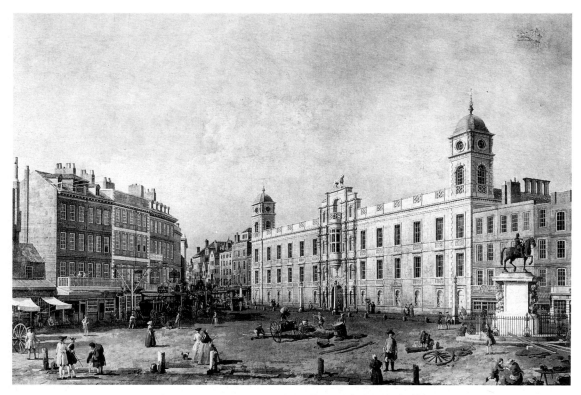

Canaletto: 'Northumberland House' (*Alnwick Castle*)

Landseer's 'The Challenge' is a memorably impressive picture, where a stag is seen bellowing his challenge in the still moonlight, with his rival swimming across the loch beneath the snow-covered highland peaks.

ALTHORP

GT　　　　　　　　　　　　　　　　MAP F

Northampton
6m NW of Northampton on Rugby road (A428)
Tel Northampton (0604) 770209

Althorp has been the main country house of the Spencer family since the Civil War. The family have been successively Barons Spencer, Earls of Sunderland and Earls Spencer, the house being built by the 2nd Earl of Sunderland in the late seventeenth century.

It has to be said, today, that the visitor is liable to be disappointed. Generally, only a handful of rooms are open to the public. Some of these rooms, moreover, are restricted, not by ropes, but by wicket-gates in the doorways, which in effect means that the pictures in these rooms are barely visible, and can only be glimpsed obliquely, or in a mirror. None of the superb pictures by Reynolds, Gainsborough or Stubbs can be seen. The visitor is shown the huge and extraordinary canvases by Wootton in the entrance hall — hunting and sporting scenes which are as much curiosities as works of art — a number of family portraits and some interesting self-portraits.

However, there is a vital difference once a week on 'connoisseurs' days', when the visitor is taken, by the back stairs, to see the famous picture gallery, certainly one of the most extraordinary rooms to be seen in England. Here are hanging the famous collection of portraits of the beauties of Charles II's court, commissioned from Lely, by Lord Sunderland, for this room, and all in their original 'Sunderland' frames. It is an astonishing experience to walk down the

43

Landseer: 'The Challenge' (*Alnwick Castle*)

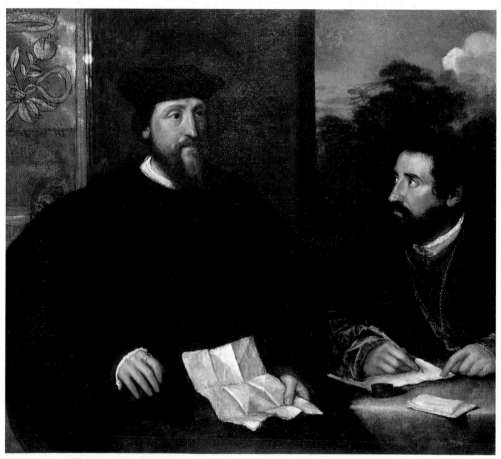

Titian: 'The Bishop of Armagnac and His Secretary' (*Alnwick Castle*)

full length of this beautiful room, passing in review, like an inspecting general officer, the rows of ladies on the wall, glowing, sulky and luscious. One can be forgiven the feeling that they are just a little overpowering.

The Long Room draws the visitor to the far end, where there is a superb climax in the form of van Dyck's famous double portrait of the Earls of Bristol and of Bedford. This picture succeeds effortlessly in upstaging all that has previously been seen; here is true magnificence, cultured superiority, style and swagger.

AMERICAN MUSEUM

MAP I

Claverton Manor, Bath, Avon
4m SE of Bath on Warminster road (A36)
Tel Bath (0225) 60503

The American Museum was founded in 1961, primarily to display American furniture in appropriate period settings. Among the pictures that hang here is a portrait by Earl, one of only two recorded pictures by this talented artist outside America. It is strange that there should be so few in England, as he is known to have worked here from 1778 to 1785. Claverton Manor, formerly the home of the Skrine family, is also notable as the scene of the twenty-two-year-old Winston Churchill's first political speech in 1897.

ANGLESEY ABBEY

NT MAP F

Cambridge
In village of Lode, 6m NE of Cambridge on B1102
Tel Cambridge (0223) 811200

Anglesey Abbey houses the Fairhaven Collection, formed by the 1st Lord Fairhaven, who bought and altered the house to display his large number of works of art, including some fine pictures. The original monastic buildings were much restored and altered when the house was

acquired in 1926; thirty years later a two-storied picture gallery was added.

Lord Fairhaven was a determined collector. His pictures include many that most people would find richly rewarding, but also some that will tend to seem somewhat strange, even quirky. For example, he had a passion for Windsor, and ended his life with an immense collection of landscapes of Windsor — over 100 paintings, 150 water-colours and drawings, not to mention 500 prints. Not all of these, of course, are on display; but the romantic outline of Windsor Castle can be seen in every light, at every season and from every direction in landscapes by Richard Wilson, Sandby, Marlow, John Varley, Cox, F. W. Watts, Goodwin and many others. Likewise Lord Fairhaven cherished unusually small landscape sketches, and there are many of these at Anglesey, the most entrancing being those by Constable, Wilkie and George Morland.

Although brought up in America, Lord Fairhaven was equally involved in royal portraits. He owned an unusual Constable, of George IV boarding the royal barge preparatory to opening Waterloo Bridge in 1817. He was also very fond of the work of Etty, and possessed twenty pictures by him. His only Gainsborough is a most unusual seascape. There is nothing in the least unusual, however, about the masterful Normandy coastal scene by Bonington.

The ground floor of the gallery contains the choicest of Anglesey's pictures. There are works by Oudry and de Fontenay, and a fine Cuyp: 'St Philip Baptising the Eunuch'. Above all there are two large, magnificent and famous landscapes by Claude — 'The Landing of Aeneas' and 'The Father of Psyche sacrificing at the Temple of Apollo', painted in 1663 and 1675. The paintings found their way to England in 1798, when the artist was, as earlier in the eighteenth century, extremely popular in this country; these noble works (known as the 'Altieri Claudes') are among the finest he ever executed. They stand out even among the treasures of the Fairhaven collection, which reflects the taste of an extremely wealthy man who followed no fashion and was always able to indulge his highly developed, if sometimes idiosyncratic, sense of style.

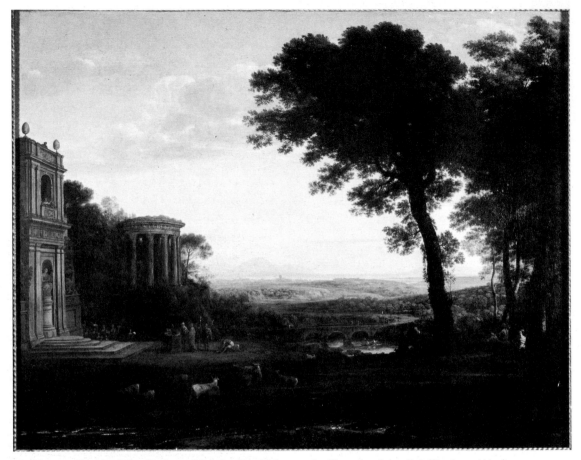

Claude: 'The Father of Psyche Sacrificing at the Temple of Apollo' (*Anglesey Abbey*)

ANTONY HOUSE

NT MAP H

Cornwall, near Plymouth
2m NW of Torpoint off A374
Tel Plymouth (0752) 812191

Dominating the entrance hall at Antony House is a portrait of King Charles I. Unlike the vast majority of royal portraits in country houses, this does not mark a royal visit, nor signify loyalty to the crown or gratitude to a royal patron. The picture was painted during the King's trial in 1648, at which one of the Carew family was a judge, and no doubt signifies his approval of the event and of its outcome. It is the work of the little-known Edward Bower who made several repetitions of it. Certainly, the impact of the momentous trial inspired Bower to produce a poignant picture of great emotional intensity.

The family portraits in this admirably graceful and comfortable early eighteenth-century home are dominated by the artists of West Country origin — Hudson, Reynolds, Northcote and Beach. Others are by Dahl, Kneller, John Wyck, Wootton, Beale, Benjamin Wilson, and Stuart, with twentieth-century contributions, notably by Birley.

APSLEY HOUSE

MAP K

(The Wellington Museum)
149 Piccadilly, London
Tel (01) 499 5672

Apsley House was built by Robert Adam, and is named after its first owner, Baron Apsley. It was later bought by the 1st Duke of Wellington, who both improved and extended it.

One of his additions was the Waterloo Gallery, a beautiful room overlooking Hyde Park. Although he held annual commemorative banquets here, there is nothing in the room that is in any way connected with the battle; this is not so surprising, as Wellington took the view that 'nothing, except a battle lost, can be half so melancholy as a battle won'. It does however, contain many of Wellington's pictures, which it was in part designed to display.

Many of these pictures came into his possession in an unusual way. After the British victory at the Battle of Vittoria in 1813, the puppet king of Spain, Napoleon's brother Joseph Bonaparte, was compelled to abandon his carriage and baggage-train in escaping from the battlefield. In this, along with his other booty, were found more than two hundred pictures looted from the Spanish royal collection, rolled up without their frames. When, in due course, the pictures had been identified, Wellington scrupulously ordered that they should be returned to the now-restored Bourbon King of Spain, Ferdinand VII; the King, however, asked Wellington to keep them as a gift, for freeing Spain from Napoleon. It is these pictures that give Apsley House its special quality, as they also do, though to a lesser extent, the Duke's country home at Stratfield Saye. It is a notable collection.

The pictures in the Waterloo Gallery are triple-banked and include Correggio's 'Agony in the Garden'. This was the Duke's favourite picture, which he used to dust personally with a silk handkerchief. There are also works by Cesari, Reni, Rubens, Sassoferrato, Guercino, Salvator Rosa, van Dyck and Mengs.

Spanish pictures are much in evidence, hung today as they were in the 1st Duke's time. Goya, Ribera and Murillo are represented, as is Velazquez — his early 'Water-seller of Seville' stands out, a profoundly serene and balanced picture. The Goya life-size equestrian portrait of Wellington is a muddled, unsatisfactory and ghostly object; it was indeed painted by Goya, but it almost certainly originally represented Joseph Bonaparte and was altered to Wellington after Joseph's flight!

Both in this splendid room and elsewhere in the house there is a large and fine collection of

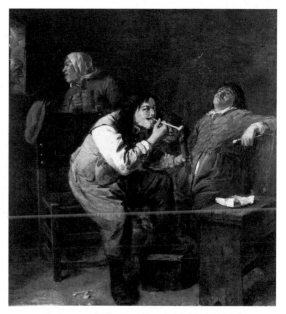

Brouwer: 'The Smokers' (*Apsley House*)

Dutch and Flemish pictures; many artists are represented, notably Storck, Teniers, Wouwerman, de Hooch, Backhuysen, Steen, Adriaen van Ostade, van der Heyden, Jan Bruegel, van der Neer and van der Meulen. These pictures live happily with two larger works from the 1st Duke's own time: Wilkie's 'Chelsea Pensioners Reading the Waterloo Despatch' and Burnet's 'Greenwich Pensioners Commemorating Trafalgar'.

There are portraits at Apsley House, of course. Those of Wellington himself are dominated by the head-and-shoulders by Lawrence, a picture

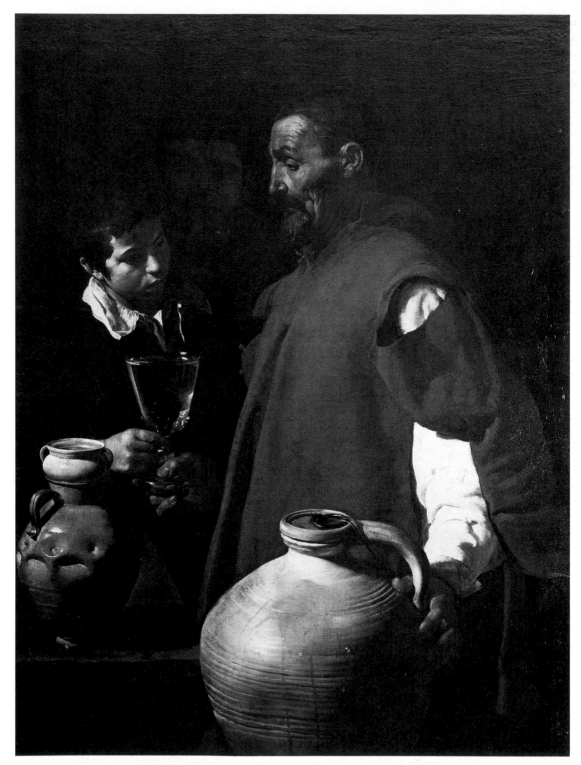

Velazquez: 'The Water-seller of Seville' (*Apsley House*)

which reflects the subject's practical common-sense and courage. There is a number of royal portraits, including Wilkie's splendid 'William IV', and his hilarious 'George IV' in highland dress; there are portraits of Wellington's comrades-in-arms including work by Hoppner, Pieneman, Lawrence and Dawe. There are a few battle-scenes, but the pervading impression which the visitor will take away from this fascinating collection will be of the treasures from Spain, so handsomely displayed.

ARBURY HALL

HHA MAP E

Nuneaton, Warwicks
2m SW of Nuneaton, off B4102
Tel Nuneaton (0203) 382804

Arbury Hall, a fine example of 'Strawberry Hill' gothic, is the home of the Newdigate family. There are many notable portraits here from Elizabethan days, including one of Queen Elizabeth ascribed to Bettes. There is also one of the famous beauty Mary Fitton, connected to the Newdigates by marriage, and sometimes identified as the 'Dark Lady' of Shakespeare's sonnets.

From later times there are admirable examples of Lely's work, and pictures by Kneller, Dahl, Knapton, Hoare and Lawrence. There are solitary examples of the work of Stuart, and of Vigée-Lebrun. Sir Roger Newdigate was painted in stately formality by Romney, who seems to have been more successful with his twin portrait of his second wife; he was also painted by Hoare, and most strikingly, by Arthur Devis in 1756/8.

This portrait is a splendid example of Devis's quaint charm. The subject is self-consciously seated in his new gothic library, leaning awkwardly on a desk (which is still to be seen in the library) with a plan of the house in his hand. The room is depicted with careful, if muted, precision, but a strange feeling of emptiness is conveyed, as if it were in a theatre. Elsewhere in the house, Devis also altered some older family portraits into full-lengths, so that they could be

fitted into the exuberant decoration of this enchanting house.

Arthur Devis: 'Sir Roger Newdigate' (*Arbury Hall*)

ARLINGTON COURT

NT MAP H

Barnstaple, Devon
8m NE of Barnstaple on Lynton road (A39)
Tel Shirwell (027 182) 296

Arlington Court, for long the home of the Chichester family, is a charming and secluded place to visit. The main block is Greek Revival in style, of 1820, with a compatible wing added in 1865. Sir Francis Chichester, the singlehanded circumnavigator, was not the only member of this family to be fascinated by the sea, and this is reflected in the pictures in the house — there are as many pictures of vessels of every kind as there are family portraits; the most notable picture, however, is a complex and mysterious watercolour by Blake, discovered in 1949 when the National Trust took over the house: 'The Circle of the Life of Man'.

ARUNDEL CASTLE

MAP J

Arundel, W. Sussex
Tel Arundel (0903) 883136

Arundel Castle belongs to the Duke of Norfolk, hereditary Earl Marshal, head of a leading Catholic family, and Britain's premier Duke. Within the large Victorian bulk of the Castle there is an extensive collection of Fitzalan-Howard family portraits, extending from Tudor times until the present day. Not all of these pictures are easy to see well, especially those high up in the immense baron's hall, or those in the semi-gloom of the tunnel-like picture gallery; but there is a good version of Holbein's well-known and much-copied portrait of the ambitious and tough 3rd Duke of Norfolk.

Mytens's portraits of the 14th Earl of Arundel and Surrey and of his wife (both on loan from the National Portrait Gallery) are fascinating. Known as the 'Collector Earl', he was the first great English collector: he travelled in his youth and was a patron of Rubens, van Dyck and many other artists. His pictures were assembled in London, at Arundel House, where Inigo Jones designed the sculpture and picture galleries which can be seen in the backgrounds of these portraits. They were painted in about 1618, and they have a style and grace about them which is quite different from earlier work, and which partly anticipates the work of van Dyck, who arrived in England fourteen years later. The portraits can be directly compared with a version of van Dyck's double portrait of the same couple, which emphasises the Earl's other interests of history and of exploration.

Many well-known names occur among the artists who painted the long series of family portraits. Lely's portraits of the 6th Duke and of his Duchess are outstanding, as are Gainsborough's of both the 11th Duke and the 12th Duke, and Lawrence's of the wife of the 13th Duke and of her sister. Scarcely less accomplished are Pickersgill's portrait of the 12th Duke in maturity and Vanderbank's of the 9th Duke. Fowler's 'Queen Victoria' should be noted, as should Millais's portrait of Cardinal Newman, a family friend; so too should the twentieth-century contributions of de László and Birley.

ASCOTT

NT

MAP F

Wing, Bucks
Outside Wing on Leighton Buzzard road (A418)
Tel Aylesbury (0296) 688242

Though open only for a short season, Ascott is supremely well worth visiting; for the ordinary visitor, there is hardly a more rewarding picture collection in the country to see and to enjoy.

Ascott is a Rothschild house, one of several dwellings built in the Vale of Aylesbury by members of this family in the second half of the nineteenth century — Waddesdon Manor is another that is open to the public. The two houses are sharply contrasted in appearance. Where Waddesdon is self-consciously grand and imposing, Ascott is much more self-effacing, originally built as a hunting-lodge, but standing in a fine position with wonderful views.

This is still a family home. The half-dozen ground-floor rooms which the public see are relatively modest in size; they are comfortable and domestic, and it is not too much to say that each one has at least one masterpiece hanging on its walls. Set in these tactfully opulent settings, with their Persian carpets, their fine eighteenth-century furniture and their superb porcelain, these splendid pictures seem different from similar pictures elsewhere. It is not only that they are well hung, well lit and there are no ropes or other obstructions; it is that, in the almost cosy atmosphere of Ascott, anybody is able to indulge the fantasy of fitting these fine paintings onto the walls of their own homes.

There is a stunning group of Dutch seventeenth-century pictures. Many masters are represented here — Adriaen van Ostade, Isaac van Ostade, Steen, van der Heyden, Wynants, Berchem, Wouwerman, with Cuyp's 'Dordrecht on the Maas' pre-eminent among them. This

Hobbema: 'Cottages in a Wood' (*Ascott*)

picture once suffered the gross indignity of being cut in half and sold as two pictures. It is now happily and splendidly united, peaceful and powerful, rich with feeling and pride, elegantly poised. Maes's 'The Milk Girl', Ludolf de Jonghe's 'A Lady Receiving a Letter' and Hobbema's 'Cottages in a Wood' are others that seize the attention.

There is a fine group of English paintings of the eighteenth century. Reynolds, Hogarth, Romney and Hoppner are well represented by portraits; but nothing here is finer than the late Gainsborough, 'Lady Mary Bruce, Duchess of Richmond', whose striking bright red hair contrasts so well and so audaciously with the pale blue satin of her dress.

A group of sporting pictures of the nineteenth century is dominated by Francis Grant's 'Four Brothers of the Rothschild Family Following Hounds'. It is from the 1850s and set in the fine hunting country of the Vale of Aylesbury. However, George Stubbs's 'Five Mares' is perhaps the best known of all Ascott's pictures. The splendidly observed and portrayed creatures stand under a tree by a pool, graceful, strong, serene and composed.

ASHDOWN HOUSE

NT MAP I

Lambourn, Oxon
3½ m NW of Lambourn on B4000

Ashdown House, high up and secluded on the Berkshire Downs, is one of the strangest and one

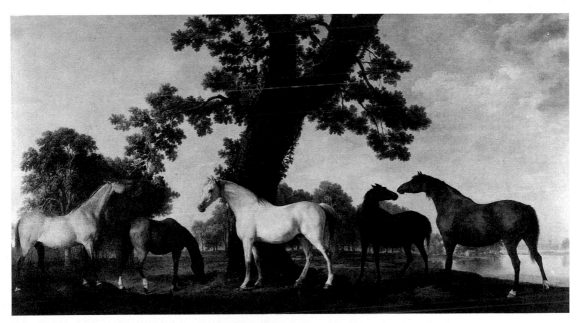

Stubbs: 'Five Mares' (*Ascott*)

of the most romantic houses in England. It was built, early in the 1660s, supposedly for the 'Winter Queen' of Bohemia, Charles I's unfortunate sister Elizabeth, by her lifelong admirer, devoted friend and supporter, the 1st Earl of Craven.

There are few contents in this mysterious, beautiful and ghostly white chalk mansion, but there is an interesting conversation piece by Dobson, along with Elizabeth of Bohemia's family portraits, left to Lord Craven on her death in 1662. These include a number of her thirteen children, including her youngest daughter Sophia, from whom the Hanoverian dynasty descended. These portraits were executed by Miereveld and by Honthorst during the Winter Queen's long, unhappy and penurious exile in Holland.

ASHMOLEAN MUSEUM

MAP F

Beaumont Street, Oxford
Tel Oxford (0865) 278000

The Ashmolean Museum is not only the oldest museum in Oxford, but the oldest public museum in England, having first opened its doors in 1683, when its premises were in Broad Street. Today it is housed in a handsome neo-Grecian building, designed by C. R. Cockerell and completed in 1845. Its collections include antiquities of many kinds, coins, and Eastern Art. The Western Art collection embraces one of the great print rooms of the world, with scores of drawings, among which work by Rembrandt, Michelangelo, Dürer and Raphael is to be found.

The museum takes its name from its founder, Elias Ashmole (1617–92), a former undergraduate, a fellow of the Royal Society, who had been given the collection of 'curiosities' built up by the Tradescants, father and son (John the Elder, ?1570–1637, and John the Younger, 1608–62). The Tradescants were gardeners, first to the Cecil family at Hatfield House, and subsequently to the royal family. Both had travelled widely on plant-collecting expeditions, in

Europe, North Africa, Russia and in America. From these travels they had brought back, not only plants, but 'rareties', many of which are still in the museum. Both these remarkable pioneers are commemorated in the museum, with a set of unusually informal portraits (perhaps by Thomas de Critz), while Ashmole has a fine, though much more pompous, John Riley portrait, in a magnificent frame carved by Grinling Gibbons.

The Ashmolean is notable for its large and high-quality collection of European and British painting. The early Italian work includes an early fourteenth-century 'Virgin and Child' which some have ascribed to Giotto, traditionally the 'founder' of modern painting, but which may have been painted by one of his collaborators. The most celebrated of the museum's early Italian work is Uccello's 'Hunt in the Forest', a masterpiece of the artist's late style, in which his interest in perspective is well demonstrated; the trees in the thick wood were trimmed to allow the mounted hunters free passage, and their excitement, matched by that of their attendants and their hounds, is dramatically conveyed.

A wooded background plays a large part, too, in Piero di Cosimo's 'The Forest Fire', a painting which is thought to be part of a series illustrating the history of primordial man. The animals in flight from the fire are detailed with precision and range from domestic beasts and birds to mythological creatures. Other work especially notable among the early Italian pictures includes paintings by Bicci di Lorenzo, Ghirlandaio, Bellini, Giorgione, Bronzino and Allori; but the visitor's attention may well be caught by an 'Annunciation' dating from about 1430, by an unknown artist; this is a very well preserved and striking example of the International Gothic style, with the Virgin sitting peacefully reading in a bright blue pavilion.

The Ashmolean's assembly of seventeenth-century pictures is wide-ranging. The Dutch and Flemish pictures include work by many artists much admired in Britain, such as Jacob van Ruisdael, Salomon van Ruysdael (with several examples, including 'A Village Feast', a genre work acquired in 1988), a highly charac-

teristic de Koninck, 'View over Flat Country', a van Goyen, several small works by Rubens and van Dyck, including a fine, separately displayed collection of flower and still-life paintings by such artists as Jan van Kessel the Elder, van Steenwijck, Fyt, Ruysch and David de Heem, the last with a splendid 'Still-life with Fruit', outstanding even in this company, without any apparent allegorical references, but with simple and sensual delight in the fruits of the summer: a mouth-watering picture, reminiscently enjoyed, one can imagine, in the long harsh Dutch winter seasons.

de Heem: 'Still-life with Fruit' (*Ashmolean Museum*)

Van Dyck's only large painting here, probably painted in Antwerp about 1630, is 'The Deposition', showing Christ lowered from the cross. The picture concentrates on the appalling physical destruction of the crucifixion with an unrelenting intensity, which may well surprise visitors who have hitherto known this artist from his glittering portraits.

Both Nicolas Poussin and Claude are represented by masterpieces. The former's 'The Exposition of Moses' translates the tragic mo-

ment of the baby's abandonment in its basket to a landscape filled with monuments of classical antiquity. Claude's painting was the last he painted, and may, indeed, be unfinished: 'Landscape, with Ascanius Shooting the Stag of Sylvia' has, as so often, a classical theme (taken, in this case, from Virgil's *Aeneid*) and it is a classical landscape of idyllic grace.

Chardin is represented by a still-life in which the simple elements, magnificently grouped, seem to have been charged with great, but peaceful, power. Likewise, Watteau is represented by a single characteristic work — 'Le Repos Gracieux'. Gainsborough, Ramsay and Reynolds are among the British eighteenth-century artists represented, as is Richard Wilson, with a landscape, and Wright of Derby, with a Wilson-like landscape. Italy is strongly represented, with contributions from Canaletto, Guardi, G. B. Tiepolo, Panini and Mengs, while Batoni's portrait of 'David Garrick' painted when the great actor-manager was in Rome in 1764/5 shows this artist in sparkling form.

Constable is represented by a brilliant study, 'Watermeadows near Salisbury'; Corot by an equally fresh 'Landscape: le Petit Chaville, Ville d'Avray', painted about 1824. Many French nineteenth-century artists have work in the Ashmolean, including Boudin, Daubigny, Courbet, Manet, Cézanne and Renoir. There is a fine group of pictures by Camille Pissarro, presented by the Pissarro family. Of these, perhaps the outstanding work is his 'Le Jardin des Tuileries, temps de pluie', painted in 1899, when the artist was suffering from eye-trouble, and generally in poor health. It is an exquisite impression of the Tuileries gardens on a dull, wet autumn day, an urban vista seen from above, often painted by this master in his later years. Van Gogh's 'Restaurant de la Sirène, Asnières' was painted during his two years in Paris, probably in 1887, and demonstrates his new-found command of the exhilaration of colour, which was to be so wholly fulfilled when he moved to the south the following year. Picasso is represented here by an even earlier work, 'Blue Roofs'. Painted in 1901 when the artist was 19 and on his first visit to Paris, it is filled with the excitement of a young artist in the great city.

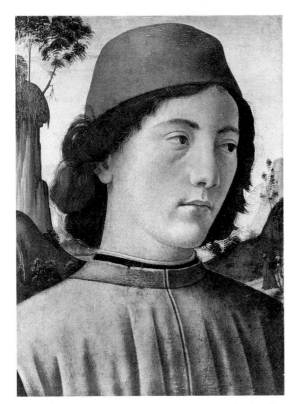

Ghirlandaio: 'Head of a Young Man' (*Ashmolean Museum*)

There is an unusual group of paintings by Samuel Palmer (as well as drawings). Many other nineteenth-century British artists' works are to be seen, notably a strong group of Pre-Raphaelite work, among which Millais's 'The Return of the Dove to the Ark' and Arthur Hughes's 'Home from the Sea' are outstanding. Twentieth-century work includes pictures by Sickert, Steer, Augustus John, William Nicholson, John Nash and Stanley Spencer.

ASTLEY CHEETHAM ART GALLERY

MAP C

**Trinity Street, Stalybridge, Greater Manchester
Tel Manchester (061) 338 2708**

The Astley Cheetham Art Gallery, named after its turn-of-the-century founder, has some fine early Italian paintings, such as a 'Portrait of a Young Man' by Allori. There are still more from the nineteenth century, by Cox, Linnell, Bonington (especially his brilliant 'New Rouen'), G. F. Watts, Burne-Jones and others. The twentieth-century works include a few paintings by such as Duncan Grant and Gertler, and many more by the local artist (and pupil of Sickert) Harry Rutherford.

ASTON HALL

MAP E

**Trinity Road, Aston, W. Midlands
Tel Birmingham (021) 327 0062**

Aston Hall is a large Jacobean house which has belonged to Birmingham Corporation since 1864 and is today an annexe to the City Museum and Art Gallery. Among its fine and appropriate contents is much that once belonged to the Holte family who built the house and lived here for 200 years; there are family portraits by Romney and Gainsborough and a portrait group by Soldi. Sadly the house itself, situated as it is near Aston Villa's famous football ground and only a couple of miles from the city centre, now looks incongruous, with something of the forlorn air of a beached and abandoned ocean liner.

ATKINSON ART GALLERY

MAP C

**Lord Street, Southport, Merseyside
Tel Southport (0704) 33133**

Southport's Atkinson Art Gallery, centrally situated above the town's main library, contains mostly British art from the nineteenth and twentieth centuries. It is a large collection, including many Victorian anecdotal paintings, with works from such artists as Cox, Cameron, Shayer, G. F. Watts and Ford Madox Brown. From a later time are Steer, Sickert, Brangwyn, Orpen, Laura Knight, Augustus John, Kelly and Bratby.

ATTINGHAM PARK

NT MAP E

**Shrewsbury, Shropshire
4m SE of Shrewsbury on Telford road (A5)
Tel Shrewsbury (0743) 77 203**

Attingham Park was the home of the Hill, later Noel-Hill, family. It was designed in 1782 by the little-known George Stewart, and altered in 1805 by John Nash. One of this family, the 3rd Lord Berwick, spent twenty-five years in Italy as a diplomat, partly in Naples as Ambassador to the Kingdom of the Two Sicilies, where he built up much of the collection now to be seen at Attingham. However, the Gérard portrait of Caroline Murat, Napoleon's sister who was once Queen of Naples, was bought by his descendant the 8th Lord.

Both the 3rd Lord and his brother the 2nd Lord, who was painted in Rome by Kauffmann in 1793, bought many landscapes by Philipp Hackert and by his brother Carl, German artists who lived and worked in Naples. Pictures such as Jacob Philipp Hackert's 'View of Pompeii' were popular as souvenirs of the Grand Tour, although not all travellers ventured as far south as Naples. This picture records the recently excavated Pompeii in great detail and conveys something of the excitement of such discoveries of the eighteenth century.

Portraits include work by Lawrence, Cotes, Hudson, Northcote, Hayter, Cosway, Vanderbank, Kelly and, unusually, Sickert, whose 'Lady in Blue' was described by its subject (the 8th Lady Berwick) with the words 'Nobody could call it a portrait, it is a fantasia in a characteristic subdued colour scheme'.

Other pictures at Attingham mostly hang on the blood-red walls of John Nash's handsome picture gallery of 1805/7, an early example of the use of cast-iron ribs to support the top windows. There is more of the Hackerts' work here, and several canvases by Orizonte, as well as work by Pynacker, Desportes, Schalken (a portrait of William III by candlelight), Brescianino, Kneller, van Loo, Salvator Rosa and Westall.

AUCKLAND CASTLE

HHA MAP B

**Bishop Auckland, Durham
Tel Bishop Auckland (0388) 602576**

Auckland Castle, once the country house, and still the home, of the Bishops of Durham, has a collection of portraits of successive bishops. Two of these are by Lawrence, and others are by Richmond, Riviere and Beechey. In addition there is a series, bought by an eighteenth-century bishop, of twelve religious pictures by Zurbaran, representing Jacob and his sons. This is a most impressive group, and the largest collection of Zurbaran's work outside Spain.

AUDLEY END

EH MAP F

Saffron Walden, Essex
1m W of Saffron Walden, off B1383
Tel Saffron Walden (0799) 22399

Audley End is a confusing place. It seems, at first glance, to be a Jacobean building — and indeed when twice its present size, it served as a palace for Charles II. Inside, however, it has been greatly altered and restored over the years, and is, in fact, mainly the creation of the late eighteenth century. Many of the rooms open to the public are somewhat gaunt and empty.

Whole collections of pictures came to Audley End through marriage, so that there is a very large number here. Sadly, not all of them are easy to see, nor easy to identify when seen. It is all too easy for the ordinary visitor to feel bewildered.

There is naturally a large number of portraits, with examples of the work of Eworth, van der Vaart, de Critz, Dahl, Wissing, and Honthorst. The Lelys include a double portrait of the artist and Hugh May. Dobson is here, as are Kneller, J. M. Wright, Reynolds, Seeman, Jervas, Rebecca, Benjamin West, Zoffany, Beechey, Ramsay and Lawrence.

There are some striking Venetian scenes by Canaletto, and a large number of Dutch pictures. 'View of the Coast at Egmond an See' is a fine and characteristic example of the work of Jan van Goyen, always a popular artist among English collectors, and to be seen in many country houses. Here the many closely-observed figures — church, beach, boats and sea — combine, under the beautiful sky, in a harmonious and masterly composition.

BADDESLEY CLINTON

NT MAP E

Solihull, Warwicks
5m SE of Solihull on Warwick road (A41)
Tel Lapworth (056 43) 3294

Many, in fact most, of the Ferrers family portraits at Baddesley Clinton are the work of a talented amateur, Rebecca Dulcibella Orpen, who married into the family in 1867 and lived in the house until her death in 1923.

BAMBURGH CASTLE

HHA; GT MAP B

Bamburgh, Northumberland
6m E of Belford, on B1342; Belford is 16m N of
Alnwick on Berwick-on-Tweed road (A1)
Tel Bamburgh (066 84) 208

Bamburgh is a Norman Castle on the coast which was bought and restored by the 1st Lord Armstrong, who also built Cragside. The picture collection includes work by Richard Wilson and Carmichael, and a number of royal portraits from the collection of the Duke of Cambridge.

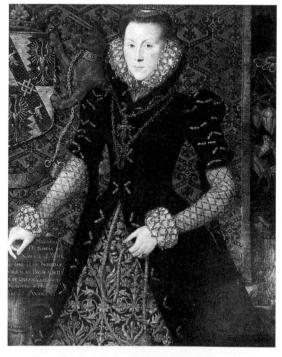

Eworth: 'Duchess of Norfolk' (*Audley End*)

There are other portraits by John Riley and by Kneller, and some portraits of the Armstrong family, including one by Annigoni.

BANKFIELD HOUSE

MAP C

Boothtown Road, Halifax, W. Yorks
Tel Halifax (0422) 54823

Bankfield House, an Italianate Victorian villa on a large scale, includes a collection of British twentieth-century paintings. These start, as it were, with Goodwin's large 'Amalfi' of 1900, and go on to include work by Fry, Sickert, Matthew Smith (who was born locally) with 'The Young Actress' of 1943. John Nash is also here, and so is Piper, with a large oil painting of 1961, 'Halifax'.

THE BANQUETING HOUSE

EH MAP K

Whitehall, London
Tel (01) 930 4179

The Banqueting House, the only visible surviving part of the old Whitehall Palace, and one of the first buildings in England in the Classical style, was built by Inigo Jones for James I in 1622. The great ceiling of this large, unfurnished room (a double cube 55′×55′×110′) is decorated with giant canvases by Rubens, commissioned by Charles I. It is the only surviving Rubens ceiling; it is also one of his finest works, rich in sumptuous colour, in imagination and energy. Installed in 1635, it celebrates James I's triumphal accession to the thrones of Scotland and of England; it is a political statement, emphasising Charles I's belief in the Divine Right of Kings.

Rubens worked with immense panache, and on a giant scale, on the panels which make up

this famous work; the vigorous, swirling baroque painting contrasts sharply with the classical lines of Jones's building.

It is supremely ironic that Charles I, the greatest collector and patron of the arts ever to sit on the English throne, walked through this room on his way to his execution in 1649, on a scaffold outside the building. One is bound to wonder if his impeccable demeanour on that cold January day allowed him to glance upwards as he passed through.

BARBARA HEPWORTH MUSEUM

MAP II

Barnoon Hill, St Ives, Cornwall
Tel Penzance (0736) 796226

This museum is devoted entirely to the work of Barbara Hepworth (and administered by the Tate Gallery). There are some paintings amongst the sculpture and memorabilia.

BARBER INSTITUTE OF FINE ARTS

MAP E

In University of Birmingham campus, Edgbaston,
W. Midlands
Tel Birmingham (021) 472 0962

Birmingham's Barber Institute of Fine Arts, founded in 1932, is, with its pictures, comparable in importance to the Ashmolean at Oxford, and Cambridge's Fitzwilliam. Though by no means enormous, it is a very fine collection of paintings indeed, filled with stunningly beautiful treasures from the thirteenth to the twentieth century. The purpose-built gallery was designed by Robert Atkinson, an expert in cinema design.

There is a magnificent group of Italian work. Outstanding here are Ugolino di Nerio's 'St Francis of Assisi', Martini's 'St John the

Evangelist', Bellini's 'St Jerome in the Wilderness' and a Cima 'Crucifixion' — a memorable composition with mourners on one side contrasted with a theatrical crowd of onlookers on the other (the Presentation to the People and the Agony in the Garden seen beyond.) There is a Bassano 'Adoration', a Veronese 'Visitation', Pellegrini's 'Judith and her Maidservant with the Head of Holofernes', a Tintoretto portrait, and work by Canaletto and Guardi. There is a joint work by Sebastiano and Marco Ricci — 'Allegorical Tomb of the 1st Duke of Devonshire'. Work by Cavallino, Dossi, Feti, Mateo, Signorelli and Solimena is also to be found.

The Low Countries are powerfully represented, starting with an important work by Mabuse. There is a great Rubens, 'Landscape at Malines', an unusual Hals portrait, and a famous 'Old Woman' by Rembrandt, with work by Cuyp, Steen, Flinck, Teniers ('The Bleaching Ground'), van Dyck ('Ecce Homo'), de Gelder,

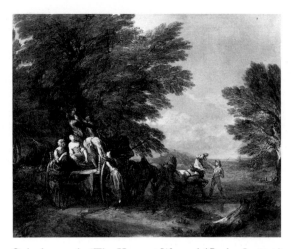

Gainsborough: 'The Harvest Wagon' (*Barber Institute*)

van Goyen, van de Cappelle, Maes and many more.

There is a Claude landscape, and work by Aubry, de Champaigne, Watteau, Ingres, Lancret, Vigée-Lebrun and Robert; there are Romney, Reynolds and Gainsborough portraits, with Gainsborough's masterly and richly coloured landscape 'The Harvest Wagon'. Richard Wilson, Turner, Crome and Lawrence are all to be seen here, and there is a fine Murillo — 'The Marriage Feast at Cana'.

From the nineteenth century there are pictures by artists not often seen in England — Delacroix, de Chavannes and Redon, for example. More familiar, perhaps, are such artists as Vuillard, Bonnard, Degas (with 'Jockeys before the Race'), Renoir, Corot, Courbet, Monet, Boudin, Manet, van Gogh and Whistler. There are two fine, and contrasting Gauguin pictures — 'Pont-Aven' and 'Bathers at Tahiti'.

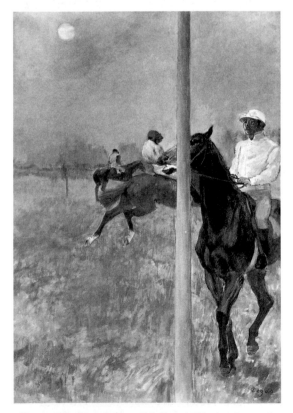

Degas: 'Jockeys before the Race' (*Barber Institute*)

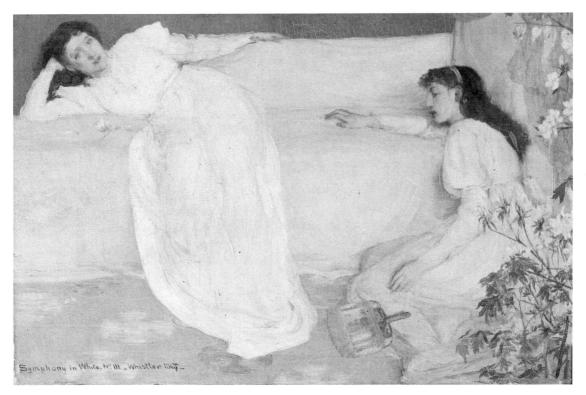

Whistler: 'Symphony in White' (*Barber Institute*)

BASILDON PARK

NT MAP J

Pangbourne, Berks
1m NW of Pangbourne on Streatley road (A329)
Tel Pangbourne (073 57) 3040

Basildon Park, built around 1780 to designs by
Carr of York, was near to demolition when
rescued in 1952 by Lord and Lady Iliffe, who
then spent twenty-five years restoring and re-
furbishing the house before giving it to the
National Trust.

There is a striking group of paintings of 'God
the Father' and seven of the Apostles, which
shows Batoni in an unfamiliar light, although he
himself wished to be remembered for such re-
ligious painting rather than his bread-and-butter
portraits of English milords visiting Rome
on the Grand Tour. Other Italian pictures at
Basildon, such as might have been bought on

just such a Tour, are three overdoors by Pittoni,
'Rebecca at the Well' by Galeotti and landscapes
by Orizonte.

Lord Iliffe is memorably commemorated in a
modest-sized portrait by his friend Sutherland;
this is a delight, at once penetrating, affectionate
and painted with a graceful lightness of touch.

BEAULIEU

HHA MAP I

Lyndhurst, Hants
In village of Beaulieu, 7m SE of Lyndhurst on
B3056
Tel Beaulieu (0590) 612345

There are plenty of activities of all kinds to
entertain visitors to Beaulieu, including the
famous Motor Museum. A handful of rooms in
the Palace House are shown to visitors, with
some family portraits of the Montagu family, by

Kneller, Jervas, Hudson, Wissing and Dahl, among others. Some of the pictures at Beaulieu were acquired on the prolonged Grand Tour of John Lord Brudenell, whose portrait by the Roman artist Mengs is to be seen in the collection. Joli's view of the Palazzo Reale in Naples was one of these, part of a series of pictures of those places Lord Brudenell visited during his extensive journeyings. A large view of Vesuvius by moonlight by Bonavia was commissioned similarly.

BEECROFT ART GALLERY

MAP J

Station Road, Westcliff-on-Sea, Essex
Tel Southend-on-Sea (0702) 347418

Comfortably housed in two former seaside houses, the Beecroft Art Gallery has a large collection of works of local interest. A smaller wide-ranging collection of paintings include a Constable landscape.

BELTON HOUSE

NT MAP F

Grantham, Lincs
3m N of Grantham on Lincoln road (A607)
Tel Grantham (0476) 66116

Belton House is very much as one imagines a perfect English country house should be — a neat, symmetrical, honey-coloured stone mansion in a fine park, at once domestic and warm, palatial and grand. It was built in the 1680s and altered 90 years later by James Wyatt.

As in many other houses, the family portraits dominate the picture collection: Soest, Romney, Reynolds, Kneller, Closterman, Riley, Jervas, Seeman, Hudson and Cotes are all represented. There are several Hoppners, notably a double

portrait of the 1st Lord Brownlow's two elder sons. There are later portraits also, among which Leighton and G. F. Watts are well represented. Mercier's family group includes Belton House in the background and the artist himself at work in the foreground. In the picture are Viscount Tyrconnel, Miss Dayrell on a swing, Lady Tyrconnel, William Brownlow, and Savile Cust pulling on a rope attached to the swing. Mercier introduced this kind of picture to England — portraiture combined with Watteau-esque outdoor activity.

There are many old masters in the house. The most unusual pictures here, however, and perhaps the greatest, are the huge canvases by Hondecoeter of idyllic garden scenes. The room they dominate was altered to accommodate them in 1879. Hondecoeter's gardens, though formal, have plenty of life in them, domestic fowl, dead game birds — birds were his favourite subject — dogs, and page-boys carrying dishes for an alfresco collation.

BELVOIR CASTLE

HHA MAP F

Leics, near Grantham
7m W of Grantham
Tel Grantham (0476) 870262

Belvoir Castle, prominent on its hill overlooking the Vale of Belvoir, was rebuilt after a disastrous fire in 1816, and now appears like a smaller version of Windsor Castle.

Many of the Manners family's collection of pictures were lost in the fire; even so, most of the rooms the visitor sees are hung with family portraits. The 1st and 2nd Dukes of Rutland were admirably painted by Closterman. Reynolds painted a sumptuous portrait of the 4th Duke, a striking posthumous portrait of his brother Lord Robert Manners, and a relaxed likeness of the famous Marquis of Granby, after whom innumerable inns were named all over England, allegedly by ex-service innkeepers loyally commemorating their former general. Other portraits likely to catch the eye are works by

Hondecoeter: 'Swan Shown in Landscape Garden' (*Belton House*)

Jervas, Hoppner, Shannon and Laura Knight.

There is a handsome top-lit picture gallery at Belvoir. It contains a wide-ranging collection, dominated by an excellent version of Holbein's vigorous portrait of an aggressively-posed Henry VIII. There is also a series of five pictures of The Sacraments, by Nicolas Poussin, including a powerful 'Last Supper' Reynolds had been involved in the purchase of these magnificent works in an advisory capacity and later protested to the Duke of Rutland of the day about their

Steen: 'Grace before Meat' (*Belvoir Castle*)

removal to Belvoir Castle from London, where he thought they should remain, so that more people could see them. Dutch pictures include work by Steen, Teniers and Willem van de Velde the Younger. There are also three Gainsborough landscapes, with 'The Wood-cutter's Return' prominent among them.

The Chapel at Belvoir has another 'Last Supper', by Gaspard Poussin, and a 'Holy Family' by Murillo, a warm, tender and quietly moving picture, characteristic of Murillo at his best.

BENINGBROUGH HALL

NT MAP D

York
8m NW of York off Sowerby road (A19)
Tel York (0904) 470666

Once the home of the Bourchier family, Beningbrough Hall now belongs to the National Trust. Like Montacute in the South-West, Beningbrough has become an outpost of the National Portrait Gallery, which has provided over 100 portraits here, covering the period 1688—1760, suitable for a house which was completed in 1716.

There are very few Bourchier family portraits. The pictures are of royal personages and other notable men and women. Kneller is especially well represented, with a number of royal portraits and eighteen of his portraits of the Kit-cat Club, whose members were mostly leading members of the Whigs.

Highmore is represented by a startling portrait, in Turkish costume, of the 4th Earl of Sandwich, the inventor of sandwiches; there is work by Mercier, Jervas, Knapton, Dahl, Batoni, Hudson, Reynolds, Seeman, Gainsborough and many more.

BERKELEY CASTLE

HHA MAP I

Bristol
15m NE of Bristol, off Gloucester road (A38)
Tel Berkeley (0453) 810332

The romantic medieval Berkeley Castle has, over the centuries, been adapted as a family home. As with the majority of country houses, there are many portraits, both royal and family, and here there are good examples of both categories.

Royal portraits include work by Johnson, van Somer, Ashfield, Lely and Kneller. The family portraits start with work by Gheeraerts, and

include further Lely and Kneller portraits, with pictures by Beale, Humphry, Batoni, Reynolds, Hoppner, Orpen and Raoul Millais. A naval Berkeley was charmingly portrayed as a timid midshipman by Cotes, and as an anything-but-timid admiral by Gainsborough. The Berkeleys have always been keen followers of the hunt, and their later portraits tend to merge with sporting pictures, which include a superb 'Groom and Horses' by Stubbs.

There are some splendid sea pictures by Willem van de Velde the Elder amongst a notable group of seventeenth-century work from the Low Countries, including pictures by Salomon van Ruysdael, Wouwerman, Brouwer and Cuyp. There are views by Danckerts of Whitehall Palace and of St James's Palace, and matching pictures of the Tuileries and Fontainebleau by Knyff.

BERRINGTON HALL

NT MAP E

Leominster, Hereford and Worcester
3m N of Leominster on Ludlow road (A49)
Tel Leominster (0568) 5721

Berrington Hall was built in the 1780s to designs by Henry Holland, son-in-law of 'Capability' Brown, who himself laid out the park. Some of the decorative work is attributed to Rebecca. The picture collection is notable for four large battle pictures by the marine artist Luny, two of them originals, two copies by Paton. They commemorate the naval victories of Admiral Lord Rodney, whose descendants lived here; two are of incidents in the Battle of the Saints of 1782, one of the Battle of Martinique and one of the Moonlight Battle, both of which occurred in 1780. There are also works to be seen by Ramsay, van Goyen, Linnell and others.

BERWICK MUSEUM AND ART GALLERY

EH MAP B

The Barracks, Ravensdowne, Berwick-on-Tweed,
Northumberland
Tel Berwick-on-Tweed (0289) 330933

The great collector Sir William Burrell lived near Berwick-on-Tweed in his later years, and gave a tenth of his collection to the town (the rest, of course, forming the Burrell Collection in Glasgow). Included in this munificent gift were a number of French nineteenth-century paintings. These are handsomely displayed, and wonderfully labelled, in this museum, and include work by Fantin-Latour, Géricault (notably 'Wounded Cavalry Officer'), Michel, and many others, including those forerunners of Impressionism, Boudin and Daubigny.

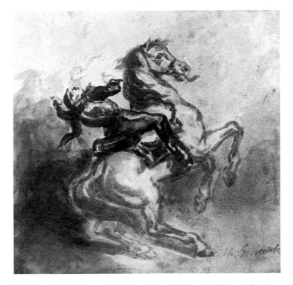

Géricault: 'Wounded Cavalry Officer' (*Berwick-upon-Tweed Museum*)

63

BEVERLEY ART GALLERY AND MUSEUM

MAP D

Champney Road, Beverley, Humberside
Tel Hull (0482) 882255

The Beverley Art Gallery is devoted to a comprehensive collection of the work of the local artist Frederick Elwell (1870–1958), who specialised in scenes from country life.

BIRMINGHAM CITY MUSEUM AND ART GALLERY

MAP E

Chamberlain Square, Birmingham
Tel Birmingham (021) 235 2834

Standing proudly and confidently slap in the centre of Birmingham, the City Museum and Art Gallery is an impressive example of late nineteenth-century architecture, powerfully exuding civic pride and Victorian energy.

The picture collection in this large building is one of the best in the country: a representative collection of European art, with an especially famous group of Pre-Raphaelite paintings and less emphasis than might be expected on Victorian narrative pictures. The galleries are splendidly comfortable, well worthy of the fine work displayed in them.

One of the early treasures is a panel by Martini: 'Saint Holding a Book'. There is Cima's 'Dead Christ', a tiny jewel-like panel by Christus of 'The Man of Sorrows' (Christ displaying his wounds), and the 'Cornbury Park Altar-piece' by Bellini, which includes a portrait of a donor as well as the Madonna and Child with Saint Peter and Saint Paul. There is an altar-piece by Isenbrandt, with a finely detailed 'Adoration' on the central panel, and a 'Nativity' and a 'Presentation in the Temple' on the two wings. It is

instructive to compare this with the slightly earlier 'Nativity' by Memlinc, with its equally telling and even more precise detail and background.

There is a wide range of European painting of the seventeenth century. Rubens is represented by a small sketch for the central figure of James I for the Banqueting House ceiling, and there is also work by van Goyen, Ruisdael and Willem van de Velde the Younger. A Dobson portrait is matched by Lely's signed portrait of Oliver Cromwell. There is 'Susanna and the Elders' by Lely, and work by Giordano, Dolci, Pietro da Cortona, Crespi, Reni, Claude, Pellegrini, Strozzi, Murillo, Guercino, and Orazio Gentileschi with his majestic 'Rest on the Flight to Egypt'.

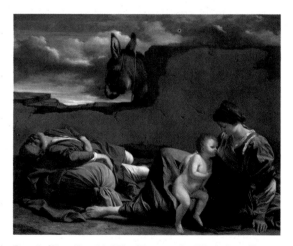

Orazio Gentileschi: 'The Rest on the Flight into Egypt'
(*Birmingham City Art Gallery*)

British work dominates the eighteenth-century pictures at Birmingham. Gainsborough, Reynolds, Ramsay, and Lambert are well represented. Paintings by Hogarth include 'The Distressed Poet'. There is a large and splendid landscape of Okehampton Castle by Richard Wilson, and there are examples of the work of Zoffany, Batoni, Ibbetson and de Loutherbourg, the last rather surprisingly with two religious works. Guardi has a Venetian scene here, while Canaletto is represented by two of the views of Warwick Castle that he painted in the late 1740s. There is a Shakespearean scene by Fuseli, an

example of Boucher's work, and a rare chance to see a painting by Subleyras — 'The Blessed John of Avila'.

From the nineteenth and twentieth centuries there is work by Cox, Leader (whose 'February Fill Dyke' is one of his best landscapes), Clausen, Sisley, Sickert (including an unusual 'Dieppe Races'), Vuillard, Camille Pissarro, Renoir (with a view of St Tropez), Stanley Spencer, Sutherland, Piper, Gilman, Gore, Paul Nash, Francis Bacon and many others. Kokoschka has a self-portrait here, while Matthew Smith is unusually represented by a landscape, albeit using many of the red tones the onlooker is accustomed to in his nudes and his still-lifes. Degas's 'Roman Beggar Woman', painted as early as 1857, is another unusual picture, powerful and intense.

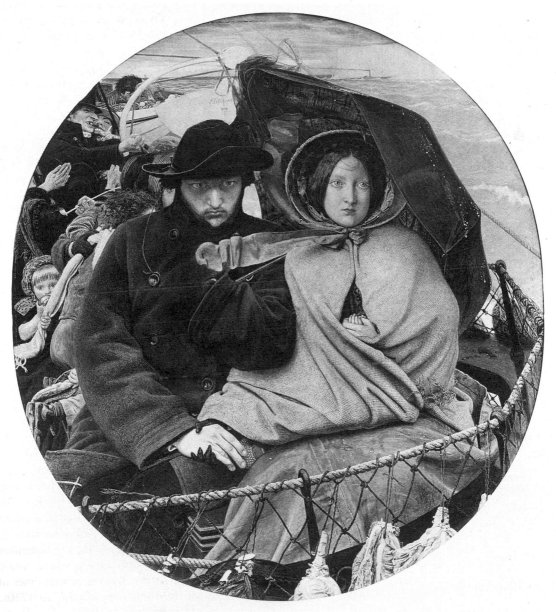

Ford Madox Brown: 'The Last of England' (*Birmingham City Art Gallery*)

The Pre-Raphaelite work is grouped together, in a large gallery which concentrates on the work of the Brotherhood. This is perhaps the finest assembly of their work.

The best known of all the pictures here, however, is by one who was never a committed member of the Brotherhood, although closely connected: Ford Madox Brown. The picture is 'The Last of England'. The visitor's first thought on seeing this masterpiece, so often seen in reproduction, may well be surprise at its modest size; yet its intense and dramatic feeling distils all the hopes and fears and sorrows of emigration — an experience that touched lives of so many families in the early 1850s, when it was painted. Equally well known, and as surprisingly modest in size, is John Millais's 'The Blind Girl', where the brilliantly painted landscape and rainbow help to prevent the picture from toppling over the edge of the slippery slope towards that slushy sentimentality to which Millais sometimes succumbed in later life.

Rossetti's 'Beata Beatrice' is a posthumous portrait of his wife, Elizabeth. Holman Hunt is represented by his 'The Finding of the Saviour in the Temple', and by his portrait of Rossetti. Gathered here, also, is work by Dyce, Leighton, Forbes, Alma-Tadema, Frith and the less well known Sandys and Hughes.

BLACKBURN MUSEUM AND ART GALLERY

MAP C

Museum Street, Blackburn, Lancs
Tel Blackburn (0254) 667130

Blackburn's collection of pictures is spread through the town's museum. It consists of British work from the nineteenth century, for the most part, in which Leighton, Linnell, Stone, and many others are represented. It has also, perhaps unexpectedly, a fine collection of Japanese prints, which can be consulted on prior application.

BLENHEIM PALACE

HHA MAP E

Woodstock, Oxon
In Woodstock, 8m NW of Oxford on Stratford Road (A34)
Tel Woodstock (0993) 811325

Nowhere in England is more palatial than Blenheim Palace. Such is the scale of the place that the visitor approaching this majestic building is at first inclined to feel like a midget. The hugely tall entrance hall, decorated with a Thornhill ceiling, does nothing to dissipate this feeling, but the rooms through which the visitor is conducted are reassuring. They are more modest in scale, while equally magnificent.

Although there are a couple of fine van Dycks, almost all the pictures date from the time of the 1st Duke of Marlborough, for whom Blenheim was built in gratitude for his many victories. Several contemporary artists painted him: Kneller, more than once, Seeman, and Closterman.

In the Red Drawing Room, the visitor can have the unique experience of comparing Reynolds's huge portrait group of the 4th Duke and his family with Sargent's similarly sized, though narrower, group of the 9th Duke and his, smaller, family. This remarkable picture was commissioned to hang where it does, in direct competition, as it were, with the Reynolds across the room. Though many experts praise the Reynolds as a masterpiece of composition, some visitors may feel that, in this instance, Sargent upstages Reynolds, adopting the grand manner of van Dyck with exhilarating skill.

Dolci's 'Adoration of the Magi' is an early work, painted with great attention to detail in the elaborate and colourful costumes — so much so that it was once thought that the picture must be painted on copper, rather than canvas, as is in fact the case. Dolci was a favourite artist of English collectors from the Restoration onwards. Unlike many of the treasures at Blenheim, this 'Adoration' was not given to the 1st Duke, and it is not known exactly when it came into the Marlborough family's collection which was sadly diluted — as far as old masters

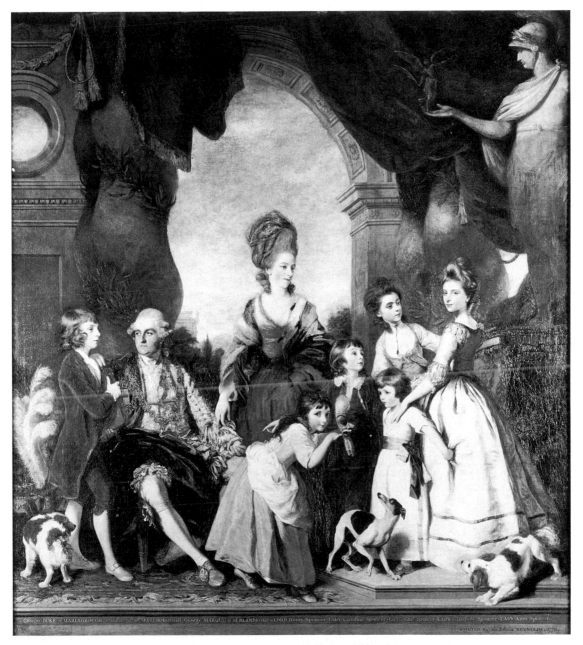

George DUKE of MARLBOROUGH. Caroline 4th of MARLBOROUGH. George MARQUESS of BLANDFORD. LORD Henry Spencer. LADY Caroline Spencer. LADY Eliz: Spencer. LADY Charlotte Spencer. LADY Anne Spencer.

PAINTED By Sir Joshua REYNOLDS. 1778.

Reynolds: 'The Marlborough Family' (*Blenheim Palace*)

are concerned — at a famous sale, especially of a rich representation of Rubens, in the late nineteenth century.

BLICKLING HALL

NT MAP G

Aylsham, Norfolk
1½m NW of Aylsham, on Fakenham road (B1354)
Tel Aylsham (0263) 733084

Blickling is a superb Jacobean mansion, built of warm red brick, handsome and welcoming. Surrounded by its splendid garden and parkland, it is a beguiling place to visit.

Although Blickling's pictures are few in number, and plainly not among its greatest glories, there are some very worthwhile portraits to be seen here. One of the most striking is that of the builder of the house, Sir Henry Hobart, whom Mytens portrays as the shrewd lawyer which indeed he was. There are a couple of fine Gainsboroughs, a Reynolds and a Kneller among a very high proportion of unattributed portraits. Wootton and Jervas collaborated on a portrait of George II with the lamentable result that the unfortunate king looks as though he is riding a merry-go-round horse. His mistress, Lady Suffolk, did much better, in a spritely portrait now thought to be by Gibson.

Other artists represented at Blickling include Prinsep and Cotman. There is also an outstanding Canaletto view of Chelsea from south of the Thames.

BOLTON MUSEUM AND ART GALLERY

MAP C

Le Mans Crescent, Bolton, Greater Manchester
Tel Bolton (0204) 22311

The lively Bolton Art Gallery, in the strangely-named Le Mans Crescent behind the massive Town Hall, houses a small group of seventeenth-century old masters, which includes Giordano's 'Death of Seneca'. There is a much larger assembly of twentieth-century British art, in which may be found work by Duncan Grant, Bell, William Roberts, Hitchens, Wadsworth, Augustus John, Sickert, Lamb, Laura Knight, and Burra, with 'Bird Woman, Duennas' a complex work of the early 1930s.

BOUGHTON HOUSE

HHA MAP F

Kettering, Northants
3m N of Kettering on Stamford road (A43)
Tel Kettering (0536) 515731

The richness of the picture collection at Boughton House might well be thought of as overwhelming, even overpowering, if it were not for the tremendous charm of this peaceful rural retreat of the Dukes of Buccleuch — a compelling mixture of monastic buildings with a classical, French-style frontage dating from the 1690s.

Among the large number of pictures to be seen, the visitor will not fail to notice especially Murillo's 'St John the Baptist', a splendid Hondecoeter cockerel, portraits of the 1st Duke by Dahl and by Closterman, an astonishing and compelling 'Adoration' by El Greco, and 'Harvest Scene' by Teniers. Annibale Carracci's 'Young Man in a Plumed Hat' is an admirable example of the work of an artist much admired by collectors, especially in the eighteenth century. It is not known when it came into the collection, and has only recently been ascribed to this artist, having previously been thought to be the work of Passarotti, or Caravaggio, or Zuccaro.

Monnoyer created two dozen overdoors and overmantel flower paintings for Montagu House in London; these were brought to Boughton House when the former was acquired for the newly-created British Museum in 1747. They are the largest single assembly of Monnoyer's work, which has a noticeably greater freedom and exuberance than Dutch flower paintings

from earlier years of the seventeenth century. These date from the 1690s. There are a number of works from the Low Countries from the seventeenth century, and there is a very fine Samuel Scott view of 'The Thames by Montagu House'.

There are Honthorst portraits of Frederick of Bohemia and of his Queen, and family portraits of high quality. The portrait of the 3rd Earl of Southampton (the grandfather of the 1st Duke's

de Critz: '3rd Earl of Southampton'
(*Boughton House*)

wife) is attributed to John de Critz. It is known to have been painted in 1603, and includes, somewhat haphazardly, a small picture of the Tower of London, from which the Earl had just been released; it also includes a favourite, but angry-looking cat. The portrait of Elizabeth Vernon, the Countess of Southampton, was painted by an unknown artist a little earlier. It has the unique fascination of showing a great Elizabethan lady at her toilet. Her ermine-lined crimson Countess's State robe lies on some embroidered cushions; she wields an ivory comb

on her long hair; her jewel-box stands open on a table, with all its contents carefully set out around it; her ruff is pinned to a curtain; her elaborate clothes are detailed with great precision — an embroidered jacket with a zig-zag hemline, lace cuffs and collar and a patterned skirt with a protective gauze overskirt. Close to her slippers, her small pet dog squats on another cushion.

John, Lord Brudenell, in the course of an extensive and painstaking Grand Tour had the unusual distinction of having been painted by both Batoni and Mengs, the resident Roman artists in the late 1750s, who specialised in portraits of itinerant milords. Both artists were stimulated by the direct rivalry. Batoni's portrait is anything but a routine effort; the sitter's clothes and features are painted with immense skill; the mandolin under the arm, and the manuscript music (actually of a Corelli sonata) skilfully hint at the interests of this studious young man. The clear and vibrant colours of the Mengs portrait (to be seen at Beaulieu, the possession of another branch of the Montagu family) suggest a heightened, and by no means unsuccessful attempt to outdo Batoni on this occasion.

Nobody is likely to forget the astonishing spectacle of more than forty van Dyck grisaille sketches in one room; they are studies for his famous series of etchings of contemporaries (published as 'The Iconography' in 1641). It has to be added that the room is the only one at Boughton House where the pictures cannot be seen clearly.

THE BOWES MUSEUM

MAP B

Barnard Castle, Durham
Tel Teesdale (0833) 37139

The unwary visitor will certainly be surprised by the first sight of the Bowes Museum, a very large Victorian mock-Renaissance chateau, which seems to have strayed from the Loire Valley to dominate the town of Barnard Castle.

Goya: 'Don Juan Antonio Melendez Valdes'
(*The Bowes Museum*)

It houses the collection of John and Josephine Bowes, and has aptly been nicknamed 'the Wallace Collection of the north'.

Amid the many treasures in this amazing place there is a very large collection of pictures, which is also a surprise in that it includes hardly any British work. In style and in scale it is set apart from any other collection in the country. The pictures are concentrated in three immense galleries on the top floor. These house, respectively, Spanish pictures; Italian pictures; and pictures from the Low Countries and from France.

The collection from Spain is most unusual. There is a notable El Greco, 'The Tears of St Peter'; and there is work by Carreño (unique in Britain), Antolínez, a remarkable still-life by de Ledesma, a Goya portrait and a study of a prison interior, among much more. Two large Canaletto views of Venice are very apparent in the Italian room, and there is work by Cavallino, Salviati, Giordano, Franciabigio, Pellegrini, Solimena, Trevisani, Foschi (a wonderful snowy

landscape), Bonito, and a splendid sketch by Giovanni Battista Tiepolo for a ceiling painting — 'The Harnessing of the Horses of the Sun'. Two other works stand out: 'A Miracle of the Holy Sacrament' by Sassetta, and 'The Crowning with Thorns of St John' by Camilo.

The Low Countries group of seventeenth-century pictures includes work by Snyders, de Vlieger ('Dutch Man-of-war at Anchor'), Willaerts, Maerten van Heemskerck, van der Muelen, Bor, Avercamp, Ruysdael, van Uden, and Maes, with a forceful portrait of a burgomaster. Teniers is represented by an unusual 'Music Party'.

French work is very much in evidence, and very much in tune with the general contents of the Bowes Museum. There are charming sea-pictures by Durand-Brager, and work by de Champaigne, Largillière, Oudry, Vernet, Boucher, van Loo, Gérard, Danloux, Granet, Robert, Courbet, Fantin-Latour and three delightful pictures by Boudin.

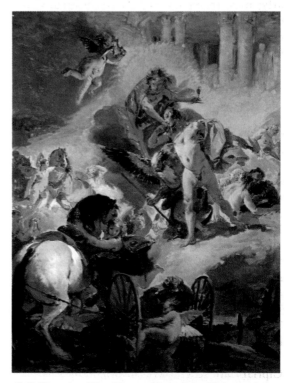

G.B.Tiepolo: 'The Harnessing of the Horses of the Sun' (*The Bowes Museum*)

All these pictures are splendidly displayed; the labelling at the Bowes Museum is exemplary, as there are brief, informative and entertaining notes, which do much to add to the pleasures of a visit to this extraordinary place.

BOWOOD HOUSE

HHA MAP I

Calne, Wilts
2½m W of Calne, on Chippenham road (A4)
Tel Calne (0249) 812102

The 'big house' at Bowood was demolished in 1955, but the fine Lansdowne collection of pictures is housed in the remodelled 'Little House', in the chapel, and in the orangery, which has been splendidly adapted as a picture gallery. Unlike many private collections, the Lansdowne collection has an admirable catalogue, informative, entertaining and scholarly; it is, moreover, splendidly printed. However, not all the pictures listed are invariably on display, as special exhibitions on Bowood and the Lansdownes (well worth seeing in themselves) necessitate a rearrangement of the collection.

The collection, which mainly reflects the taste of the 3rd Marquess of Lansdowne (1780–1863), embraces works by sixteenth-century Italian artists, Dutch seventeenth-century paintings, English portraits and interesting subject paintings by British artists of the nineteenth century (not to mention an extensive collection of watercolours and drawings, notably those of Bonington).

The chapel has a studio version of a Titian 'Holy Family', and a copy of a Murillo 'Virgin and Child'. Above the altar is a late-fifteenth-century Italian panel, a 'Madonna and Child'. There is a 'Rest on the Flight to Egypt' by Tiarini and 'Spanish Monks' by Wilkie, commissioned in 1833.

In the orangery, six decorative panels by Cipriani are to be seen, all originally made for Lansdowne House in London and dealing with mythological subjects. There are also six

Stanfield views of the Mediterranean coastline — part of a series of ten originally commissioned by the 3rd Marquess, many of which were sold later and are now being re-assembled by the present owner of Bowood. There is also work here by Eastlake, Callcott and Witherington.

The group of Reynolds portraits indicates the same patron's appreciation of this artist, for only one of the group has any family link with the Lansdownes. Gainsborough is represented by a delightful 'Landscape with Cattle Returning Home': here the rustic details contrast with the romantic background, possibly because the picture originally belonged to a friend of Gainsborough, the musician Carl Abel, and the background may perhaps suggest the latter's native Bohemia.

Other pictures at Bowood include state portraits of George III and Queen Charlotte from Ramsay's studio, and work by Serres, Fabre, Terborch, van Mieris, Leighton and Birley.

BRAMALL HALL

MAP C

Bramhall, Stockport, Cheshire
4m S of Stockport, off A5102
Tel Manchester (061) 485 3708

The half-timbered Bramall Hall has some Davenport family portraits and some wall-paintings in the ballroom, dating from around 1600 and made in imitation of tapestries.

BRAMHAM PARK

HHA; GT MAP D

Wetherby, W. Yorks
5m S of Wetherby on A1
Tel Wetherby (0937) 844265

At Bramham Park, there is a large number of sporting pictures. These include work

by Sartorius, Ferneley, James Ward and Henderson. 'Lord Rivers Coursing' by the Swiss artist Agasse, painted in 1815, depicts the then owner of Stratfield Saye engaged in coursing, a sport for which he bred greyhounds. Lord Rivers, probably pictured at Newmarket, where he also owned a horse, and where coursing meetings were held, was Agasse's first important English patron. Lane Fox family portraits include work by Kneller, Vanderbank, West, Beechey, Hudson, Hoppner and Sir Francis Grant. There is also a group of cabinet pictures, which includes work by Vogelsang, Wootton, Jordaens, Pourbus, Calvert and Orizonte.

BRANTWOOD

MAP A

Coniston, Cumbria
2½m SE of Coniston
Tel Coniston (0966) 41396

John Ruskin is the only man to be commemorated in no less than three galleries. They are at Bembridge, at Sheffield and here at Brantwood, his home for the last thirty years of his life. Brantwood is preserved with many mementoes of him and of his work, including many watercolours both by him and by his friends.

BREAMORE HOUSE

HHA; GT MAP I

Fordingbridge, Hants
3m N of Fordingbridge on Salisbury road (A338)
Tel Downton (0725) 22270

The Elizabethan Breamore House has many attractions for the visitor, but they cannot be viewed at leisure. The visitors are guided round — in rather large parties.

The family portraits of the Hulse family, who still live here, include paintings by Simon Verelst, Riley, Dahl, Knapton and Hudson, with

a fine group of Cotes pastels. Royal portraits include a flattering 'Prince Regent' by Beach, and an admirable Kneller of George I.

There are Dutch and Flemish pictures, including work by Fyt, Pieter Neefs the Elder and Lievens. But the most memorable pictures of Breamore are two very different paintings. One is a large scene of feasting and dancing outside an inn, by Teniers, entitled 'The Coming of the Storm', in which his own wife and house appear. The other is 'The Boy with a Bat', by an unknown artist, which records cricket as an important eighteenth-century upper-class pre-occupation. The boy is Walter Hawkesworth Fowkes. The bat is a vast curved implement, common enough at the time. The stumps he is carrying predate our rounded set of three; they are two in number and flat, with deep notches for bails. The background is the ruined Newark Castle, with its adjacent seven-arched bridge; the ground on which Fowkes is standing is still used for cricket today.

BRIGHTON MUSEUM AND ART GALLERY

MAP J

Church Street, Brighton, E. Sussex
Tel Brighton (0273) 603005

Brighton Museum and Art Gallery is centrally situated almost next-door to the Royal Pavilion, which itself, though superbly decorated, has only a small handful of pictures. The Art Gallery has a large and notable picture collection.

The Dutch and Flemish pictures are dominated by Lievens's unforgettable 'The Raising of Lazarus', but also include work by de Gelder and Maes. Other artists represented here include Kauffmann, Zoffany, Joseph Wright of Derby, George Morland, Linnell, Wheatley, Carlone, Sebastiano Ricci, Giordano, Romney, Zuccarelli, Opie and Lawrence (with a version of his superbly sumptuous state portrait 'King George IV in Coronation Robes').

Notable Victorian paintings include 'A View

of Gwalior' by Lear and work by Alma-Tadema, Brett, Fildes and Poynter. The twentieth-century collection includes work by Brangwyn, Philpot, Wood, Matthew Smith, Laura Knight, Spear, Nevinson, Duncan Grant, Ginner, Hitchens, Gertler and Bell.

BRISTOL CITY MUSEUM AND ART GALLERY

MAP I

**Queen's Road, Bristol
Tel Bristol (0272) 299771**

Bristol City Art Gallery has an extensive collection of paintings of high quality. Space is given to local artists, in particular to the important Danby and Müller and the charmingly idiosyncratic Sharples. Lawrence was born in Bristol, and there are some good examples of his work.

Bellini: 'The Descent of Our Lord into Limbo'
(*Bristol City Art Gallery*)

Crespi: 'The Flight into Egypt' (*Bristol City Art Gallery*)

There is also an impressive collection of European art from the fifteenth century. Notable are Bellini's 'The Descent of Our Lord into Limbo', Cranach's portrait of Martin Luther, and seventeenth-century works by Claesz, Battista, Crespi (a rare appearance in Britain), Trevisani, Solimena, Jordaens, Berchem ('The Angel Appearing to the Shepherds'), Domenichino, Marieschi (his only signed work in Britain) and Pietro da Cortona. The gallery has a fine group of nineteenth-century French works — Gros, Delacroix, Couture, Sisley, Courbet, and Moreau are represented, as are Vuillard and Redon from the early years of the twentieth century. Hogarth, Hudson, Morland and Opie, from the eighteenth century, are matched by such artists as Tissot and Watts from the nineteenth. Modern British works include fine examples by Ben Nicholson, Wadsworth, Matthew Smith, Lanyon, William Scott and Sutherland.

73

BROADLANDS

HHA MAP I

Romsey, Hants
Outside Romsey on Bournemouth road (A31)
Tel Romsey (0794) 516878

Once the home of the Palmerston family, and subsequently of Earl Mountbatten of Burma, Broadlands is a handsome house standing serenely on the banks of the River Test. The visitor here is treated with style. The pictures are not numerous but they are high in quality, and very well worth coming to see.

The late Lord Mountbatten's passionate interest in his family history is reflected on the walls of his home. Portraits of many of his Hessian ancestors are to be found, the most striking being those by Vigée-Lebrun; there is a von Angeli portrait of his great-grandmother, Queen Victoria; and there are several portraits of his wife's family, with striking contributions from de László. In addition, these are three van Dyck portraits here of Charles I, Henrietta Maria, and Madame Vinck.

'An Iron Forge' by Wright of Derby is a surprising picture to encounter in this Palladian mansion. A spectacular masterpiece, it demonstrates Wright's use of unusual and dramatic sources of light, and his interest in the first stirrings of the Industrial Revolution; the latter no doubt came in part from the fact that many of his patrons were men of commerce, rather than landed gentry. The picture was bought by the 2nd Viscount Palmerston, a discerning collector who was father of the more famous 3rd Viscount, the renowned Foreign Secretary and Prime Minister.

BROUGHTON CASTLE

HHA MAP E

Banbury, Oxon
2m SW of Banbury, on Shipston-on-Stour road
(B4035)
Tel Banbury (0295) 62624

Although Broughton Castle is surrounded by a moat, it is scarcely a castle in appearance. It is, in fact, a very pleasing medieval and Tudor manor house. The home of the Fiennes family for more than 600 years, it is marvellously well preserved.

There are a number of family portraits. Lely's portrait of Mrs Nathaniel Fiennes is outstanding, a delightfully relaxed and charming work — the sitter was the mother of Celia Fiennes, the indefatigable writer of the journals of her extensive and energetic travels throughout England. There are portraits here by Reynolds, Adam de Colone, Wells and Haydon. There is also a modest collection of other pictures, including works by van Schooten, Lambert, Sartorius, Orme and Peeters.

BUCKLAND ABBEY

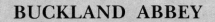

NT MAP H

Yelverton, Devon
2m W of Yelverton
Tel Yelverton (082 285) 3607

Buckland Abbey displays a number of pictures. Some of these are connected with Sir Francis Drake, whose house this was. They include a portrait of Drake ascribed to Gheeraerts, and a portrait of Queen Elizabeth I. There are many pictures of nautical interest, including a number of portraits of admirals and other distinguished sailors by Northcote.

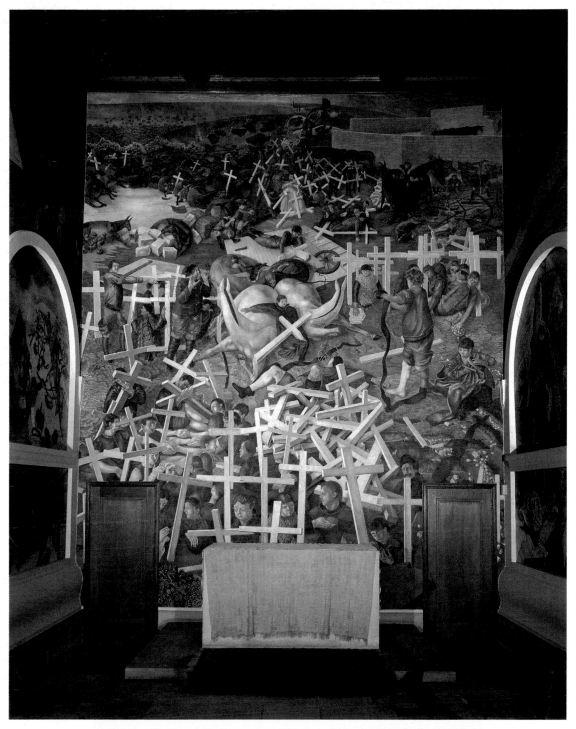

Stanley Spencer: 'Resurrection' (*Sandham Memorial Chapel, Burghclere*)

BURGHCLERE

NT MAP I

Sandham Memorial Chapel
Burghclere in Hants, near Newbury
4m S of Newbury on Winchester road (A34)
Tel Burghclere (063 527) 394 or 292

This peaceful private memorial chapel must be one of the most unusual places in England. Three of its walls were decorated, over several years in the 1920s, by Stanley Spencer. Into these huge canvases, Spencer poured his experiences as a private soldier in World War I, especially as a hospital orderly in Salonika.

In truly Spencerian style, the everyday experiences of the soldier's life are recorded with precision and good humour. One wall is taken up with Spencer's view of the Resurrection, a theme that haunted him all his life: here the dead soldiers are shown emerging from their wartime graves, re-establishing friendships, re-possessing their pet animals and 'handing-in' to the Quartermaster's stores the white crosses that had marked their graves, and which they no longer need. Spencer's compelling visions, with his careful artistry, are extraordinarily vivid and touchingly intense. It is a unique place, wonderful and moving.

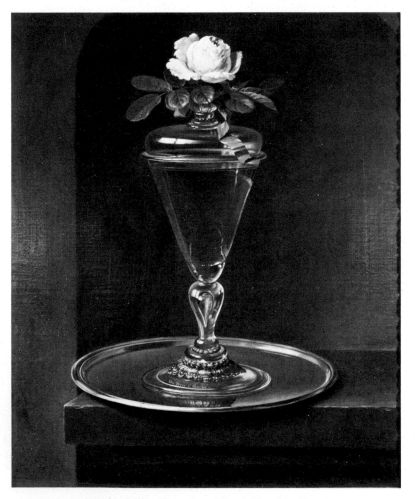

van der Mijn: 'Rose in a Glass' (*Burghley House*)

BURGHLEY HOUSE

HHA; GT MAP F

Northants, near Stamford
1m S of Stamford, off A1
Tel Stamford (0780) 52451

Burghley House advertises itself as the largest and grandest Elizabethan house in the country. It is a vast mansion, almost vulgar in its exuberant display, and much visited. There is a huge collection of pictures, many of which are all too easy to miss as the visitor is whirled, in less than an hour, through eighteen rooms in which over 500 pictures are hung, all carefully labelled and numbered. It is not hard to feel oppressed by the immense wealth of the contents of this house.

Many of the ceilings and walls were decorated by Verrio, and Verrio's portrait by Kneller, together with the artist's self-portrait, are among the large series of portraits of members of the 'Order of Little Bedlam', a gentlemen's drinking club which was instituted at Burghley by the 5th Earl of Exeter.

Scarcellino's small devotional panel, 'The Madonna and Child with the Infant Saint John', has a striking freshness and urgency; likewise Orazio Gentileschi's 'Madonna and Child in a Landscape' and Veronese's altar-piece in the domestic chapel.

Among the Dutch pictures, there is a startling 'Rose in a Glass' by van der Mijn, an artist who was employed early in the eighteenth century to clean and restore the collection. 'Rent Day' by Pieter Bruegel the Younger also stands out.

Other notable portraits that strike the visitor are of Henry VIII attributed to Joos van Cleve, and the 1st Earl of Exeter by Johnson.

BURTON AGNES HALL

MAP D

Bridlington, Humberside
6m SW of Bridlington on Driffield road (A166)
Tel Bridlington (0262) 89324

A visit to Burton Agnes Hall, glowing and elegant in the beautiful Yorkshire wolds countryside, is, for the picture-lover, an astonishing and exhilarating experience.

Built by Robert Smythson, the best-known Elizabethan architect, the house is both beautiful and fascinating and would be worth a visit on its own account. The Boynton family portraits and its other 'country house' pictures are also of high quality and much interest. Yet what is unique here is the large, varied and stimulating collection of nineteenth- and twentieth-century pictures, all assembled since the Second World War, and unrivalled among English country houses for its class, its extent and the excitement it generates.

Family portraits include the triple 'Misses Griffith' by Gheeraerts, as well as pictures by Cotes, Riley, Mercier, Reinagle, and Kneller. There is one of Walker's portraits of Cromwell. Three landscapes by Marlow, commissioned in the 1760s, all record buildings with which the Boynton family had connections, and admirably evoke the beautiful countryside around Burton Agnes Hall; he also painted some overdoors and a view of Warwick Castle. There is a Gainsborough landscape, a 'Fishing Party' by Mercier, and pictures by Hondecoeter, Richard Wilson, Willaerts, Cosway and Gilpin.

The Impressionist, Post-Impressionist and Realist pictures go wonderfully well with the panelling in the Elizabethan long gallery. An astounding array is here, with contributions from Corot, Courbet, Boudin, Renoir (including a delightful 'Portrait of a Woman'), Cézanne, with a still-life, Utrillo, Derain, Gauguin, Matisse, Vlaminck, Manet, Camille Pissarro (a charming 'Woman Shelling Peas'), Segonzac, Duncan Grant, Sickert, Innes and many others.

77

BURTON ART GALLERY

MAP H

**Kingsley Road, Bideford, Devon
Tel Bideford (023 72) 76713**

Opened in 1951, the Burton Art Gallery holds a number of collections, including pictures by local artists as well as work by Reynolds, Opie, Shayer and Clausen.

BURTON CONSTABLE HALL

HHA MAP D

**Hull
7½m NE of Hull, off Bridlington road (A165)
Tel Hornsea (0964) 562400**

There are family and royal portraits at Burton Constable. Owing to ropes and other obstacles they are not all easy to see; and, if seen, they are difficult to identify. There are pictures attributed to Gheeraerts and Kneller, and there are some nineteenth-century portraits by Dubufe and pictures by Casali. However, picture lovers may well be more interested in the working 'camera obscura', similar to the one Canaletto used to secure complete accuracy in his topographical views.

BURY ART GALLERY AND MUSEUM

MAP C

**Moss Street, Bury, Greater Manchester
Tel Manchester (061) 705 5097**

Bury Art Gallery's collection consists, almost entirely, of a handsome assembly of nineteenth-century British landscape and subject paintings. Turner ('Calais Sands, Low Water') and Constable are well represented, as are Palmer, Linnell and Cox. Landseer's contribution is the very unsentimental 'A Random Shot', originally commissioned by the Prince Consort but rejected on the grounds that it was too gruesome and unpleasant, a judgment with which many will concur. In contrast, there is the idyllic 'Spring Morning, Haverstock Hill' by Clausen.

BUSCOT PARK

NT MAP I

**Faringdon, Oxon
3m NW of Faringdon on Lechlade road (A417)
Tel Faringdon (0367) 20786**

Buscot Park houses the Faringdon Collection, created by the business entrepreneur who became the 1st Lord Faringdon in 1916, and by his successors. It is a wide-ranging collection, and finely displayed in this elegant house.

Most unusually in a country house, family portraits are notable by their absence, though there are some examples of portraiture by Reynolds, Lawrence, Kauffmann and Mercier. There are also some subject pictures by Reynolds, and an outstanding landscape by Gainsborough. Other eighteenth-century work includes landscapes by Richard Wilson, Ibbetson and Lambert.

From the previous century come Murillo's 'Triumph of the Eucharist'; portraits by Jordaens, Salvator Rosa and Rubens; 'St Jerome' by Mola; and the most celebrated picture in the collection, Rembrandt's portrait of a young man, believed to be Clement de Jongh.

There is an abundance of work by the Pre-Raphaelites and their contemporaries. Rossetti, Ford Madox Brown, John Millais, Watts, Leighton are here. So too are the four large canvases of Burne-Jones's 'The Legend of the Briar Rose', a very full exposition of the Pre-Raphaelite ideals; the artist also designed the frames for this remarkable series.

CAMBRIDGE COLLEGES

MAP F

Cambridge Colleges are open to the public only to a limited extent but their halls and chapels are usually accessible — at least at certain times.

There are always portraits in the halls: Corpus Christi (0223 338000) has work by Reynolds, Romney, Kneller and de László; Sidney Sussex (0223 338800) has a portrait of Cromwell at-tributed to the miniature painter Samuel Cooper; St John's (0223 338600) has a portrait of Wordsworth by Pickersgill; there are also par-ticularly interesting collections at Caius (0223 332400) and Trinity (0223 338400).

Corpus Christi's chapel has an altar-piece by Elisabetta Sirani; Clare (0223 333200) has an 'Annunciation' by Cipriani; Emmanuel (0223 334200) has a stylish rococo painting by Amigoni, 'The Return of the Prodigal Son'; Sidney Sussex chapel has a large early Italian rococo painting by Pittoni; that at Pembroke

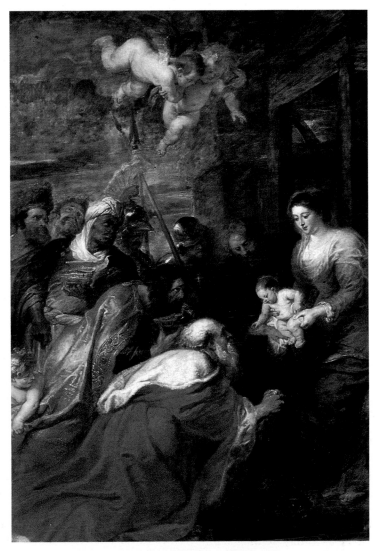

Rubens: 'The Adoration of the Magi' (*King's College, Cambridge*)

(0223 338100) is attributed to Barocci and once belonged to Reynolds, the chapel itself being Wren's first completed building and the earliest religious building in Britain to have been built in the classical style.

King's College (0223 350411) has a world-famous, cathedral-size chapel, with one of the three masterpieces of English late-Gothic fan vaulting. In 1962 the College was given Rubens's 'The Adoration of the Magi' by Alfred Alnatt, who had acquired the picture for £275,000. It now stands behind the altar, the east end having been altered and adapted to accommodate this masterpiece, in which Rubens combines vitality with poise, and strength with charm. The degree in which these qualities harmonise with the superb Renaissance screen, the finest glass in England and the soaring spirituality of the architecture, remains a subject for acidulous donnish debate.

CANNON HALL

MAP C

Cawthorne, Barnsley, S. Yorks
4m W of Barnsley on Oldham road (A635)
Tel Barnsley (0226) 290 270

Cannon Hall is a handsome mansion, designed by Carr of York, in a park a few miles west of Barnsley. Although some of its pictures are occasionally on display in the Cooper Gallery, Church Street, Barnsley, there is generally a fine display of pictures here. These include portraits by Lely, Wright, Highmore, Mercier and Constable; there is an Italian landscape by Wootton (an early exponent of the Italian style in England), an unusual 'Shipwreck' by George Morland, very different from the studies of rural life for which Morland is best known. There is a handsome assembly of seventeenth-century Dutch and Flemish pictures. The latter include 'Music Lesson' by Metsu, a fine van de Velde seascape, and work by Coques, Everdingen, van der Heyden, Pynacker and Jan Weenix.

CANONS ASHBY HOUSE

NT MAP F

Nr Banbury, Northants
10m NE of Banbury on Northampton road
(B4525)
Tel Blakesley (0327) 860044

Canons Ashby, the modest home of the Dryden family for over 400 years, has some wall-paintings and family portraits; of the latter, a version of Kneller's arresting likeness of the poet John Dryden stands out, as does Richardson's of another member of the family.

CAPESTHORNE HALL

HHA MAP C

Macclesfield, Cheshire
5m W of Macclesfield, on Manchester/London
road
(A34)
Tel Macclesfield (0625) 861221

Capesthorne Hall has many portraits of the Bromley-Davenport family, whose home this is. Sadly, ropes and wicket-gates in doorways make it difficult to see, or to identify, some of these. However, there are copies of royal and other portraits by van Dyck and Lely, as well as work by Riley, Knapton, Dahl (with an excellent portrait of Mr Speaker Bromley), Vanderbank, Richardson, Ramsay (with a portrait of J.J. Rousseau) and Birley. There are Venetian views by Richter, and an extraordinary supposed self-portrait by Salvator Rosa. Possibly the best picture here is a remarkable Spanish landscape attributed to Murillo. The most intriguing is Lowry's portrayal of Capesthorne, where he seemed to see the mansion's Victorian-Elizabethan towers as close relations of the factory chimneys that so often appear in his industrial townscapes.

CARLISLE MUSEUM AND ART GALLERY

MAP A

**Castle Street, Carlisle, Cumbria
Tel Carlisle (0228) 34781**

Carlisle Museum and Art Gallery has a small collection. In this, Romney and Raeburn are represented, together with a group of Pre-Raphaelite works and twentieth-century contributions from Stanley Spencer, Lewis, and Winifred Nicholson. There are also works by local artists, notably Bough.

CARTWRIGHT HALL

MAP C

**Lister Park, Bradford, W. Yorks
Tel Bradford (0274) 493313**

In Cartwright Hall, a purpose-built turn-of-the-century gallery, there is a small collection of European work, including paintings by Rosso, Reni and Paul Brill. There are portraits from the eighteenth century, and these are dominated by Reynolds's sumptuous 'Brown Boy' — which is in fact a portrait of Thomas Lister, whose family once owned the park in which Cartwright Hall stands.

There is a large collection of Victorian painting, including many narrative pictures, with work by Poynter, Grimshaw, Etty, Long, James Ward and many others; Ford Madox Brown is represented by 'Wycliffe'.

Later British work includes paintings by Sargent, Rothenstein (who was born in Bradford), Steer, Paul Nash, William Roberts, Gilman, Gore, and Stanley Spencer. Hockney, another Bradford-born artist, is handsomely represented.

CASTLE HOWARD

HHA MAP D

**York
15m NE of York, off Scarborough road (A64)
Tel Coneysthorpe (065 384) 333**

Everything at Castle Howard is on the grandest possible scale. Built slowly during the first forty years of the eighteenth century, it is Vanbrugh's, and Hawksmoor's, masterpiece. The Hall is on a breathtaking scale, and the Long Gallery seems to be longer than any other gallery in the country. The pictures do well to hold their own in these surroundings.

Family portraits of the Carlisle branch of the Howard family are much in evidence, starting with a version of Holbein's famous, and much-copied, portrait of Thomas Howard, the 3rd Duke of Norfolk. This is matched by the same artist's portrait of this Duke's sovereign, Henry VIII, who looks sly and overweight, but is still not without overpowering regal presence.

There are also portraits by Kneller, Hoppner, Opie, Lawrence, and many other artists. There is a copy of Scrots's portrait of Henry Howard, Earl of Surrey, and the local artist John Jackson's charming likeness of Lady Mary Howard, daughter of the 6th Earl of Carlisle. Gainsborough is represented by a portrait, and by his 'Girl with Pigs', for which Reynolds once paid 100 guineas.

There is a Reynolds full-length of 'Omai, the Gentle Savage', and a stately portrait of the 5th Earl of Carlisle, painted when the latter was twenty-one. He wears the robes of the Order of the Thistle, and the picture has a classical background appropriate to Castle Howard, where it has been since the Earl paid 150 guineas for it in 1775.

There is also a Rubens here from Reynolds's own collection, with work by Marco Ricci, Parmigianino, Veronese, Tintoretto, and many more, with Feti's 'Music Master' especially notable. Guercino's 'Erminia Finding the Wounded Tancred' is one of this artist's masterpieces. The urgency of the figures contrasts

Hockney: 'Le Plongeur' (*Cartwright Hall*)

sharply with the beauty and peace of the landscape.

There are Roman views, of the Colosseum and of the Forum, by Panini, together with four of his Roman *capricci*. Panini specialised in providing noblemen on the Grand Tour with such souvenirs of their visits. The *capricci* are views of various ruined buildings and statuary grouped harmoniously, but not as dictated by the actual topography — a concertina form of art which was doubtless more economical than separate views of each object. There are also some Zuccarelli landscapes and some delightful views of Castle Howard by the skilful Marlow.

CECIL HIGGINS ART GALLERY AND MUSEUM

MAP F

Castle Close, Bedford
Tel Bedford (0234) 211222

The Cecil Higgins Art Gallery and Museum was created after World War II. It is well-housed and conveniently situated in the middle of the town. The chief strength of the collection lies in its English water-colours, but there are also

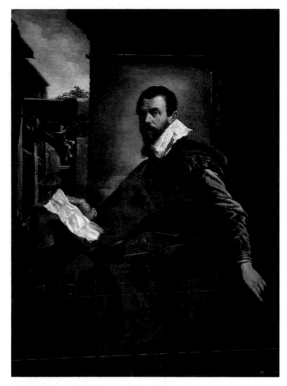

Feti: 'The Music Master' (*Castle Howard*)

some distinguished pictures here by J. M. W. Turner, Dadd, Ford Madox Brown and Stanley Spencer, the result of very enterprising and sensitive buying.

CHARLECOTE PARK

NT MAP E

Stratford-upon-Avon, Warwicks
5m NE of Stratford, off B4086
Tel Stratford-upon-Avon (0789) 840277

Charlecote Park is a fine example of Victorian architecture, set in an incomparable position on the banks of the River Avon. The pictures in this house, a most rewarding one to visit, are mainly family portraits, with some copies of well known royal portraits. The Lucy family, who have lived here since the thirteenth century, were never very wealthy, so that the portraits are usually modest. However, two of the family portraits are

the only positively documented works by Larkin. There are also a couple of Raeburns, and some by Gainsborough (one of which cost eight guineas in 1760).

CHARLESTON FARM HOUSE

MAP J

Lewes, E. Sussex
6m E of Lewes on Eastbourne road (A27)
Tel Ripe (032 183) 265

Charleston Farm House, the home of Clive and Vanessa Bell, and of Duncan Grant, from 1917 until Grant's death in 1978, is a delight for the visitor. This country outpost of 'Bloomsbury' was, from the start, enthusiastically decorated by the artists, by their friends and visitors, and by their families: walls, doors, fireplaces, bath panels and furniture have all been painted with great skill, style and wit. There are also notable pictures in every room of the house. (The so-called 'Bloomsbury Group', the friends and associates of Vanessa Bell and her sister Virginia Woolf, began to feature prominently in English life from about 1910).

The great majority of the pictures, naturally, are the work of Vanessa Bell and of Duncan Grant, many of them directly related to their lives at Charleston, and to their families. There are also paintings and drawings by friends such as Baynes, Le Bas, Bergen, Sickert, Etchells, Fry and many others.

Charleston is enriched by this assembly and by its studio-workshop atmosphere. It is a scintillating monument to a style and an achievement which is part of art history.

CHARTWELL

NT MAP J

Westerham, Kent
2m S of Westerham on Edenbridge road (B2026)
Tel Edenbridge (0732) 866368

Chartwell is preserved as the home of Winston Churchill. Among all his many accomplishments he was an amateur painter of enthusiasm and distinction. He benefited greatly from advice and instruction from artist friends, such as Sickert, Lavery, Orpen and William Nicholson, and a large number of his paintings — landscapes and still-lifes — are to be seen at Chartwell. In addition there is a gorgeous Monet, 'Pont de Londres', and portraits of the great man, notably that by Lavery of 1916, when Churchill was serving in the army in France.

CHATSWORTH

MAP C

Bakewell, Derbyshire
4m E of Bakewell
Tel Baslow (024 688) 2204

No house in England is more ducal in appearance than Chatsworth, the home of the Dukes of Devonshire. This stateliest of stately homes is exactly as it should be, serenely beautiful in its splendid setting. It is a late seventeenth-century classical building, largely designed by William Talman, much altered and added to over the years, the main additions being by Wyatville. If the interior might strike the visitor as over-ornate and heavy, the magnificent pictures will do more than compensate for any feelings of this kind. They are unsurpassed in a private home in England. Sadly, many of the more famous pictures (well known in reproduction) hang in the private apartments, and cannot be seen by visitors.

In the first place, at once noticeable in the North Entrance Hall, and overpoweringly so

Pietro da Cortona: 'The Call to St Peter' (*Chatsworth*)

in the Painted Hall beyond, there are many decorated ceilings, walls and staircases, most of them work by Laguerre, by Verrio and by Thornhill — an opportunity here to compare the skill and the relative merits of these three specialists, a Frenchman, an Italian, and their younger English rival. There is a much later contribution, also, in the shape of a ceiling painted by Hayter, although not at first intended as such.

The Dutch paintings at Chatsworth are not especially numerous, but the visitor's eye is likely to be caught by pictures by Jan Weenix, Jan Bruegel, Brouwer, van der Meulen, Teniers and Wouwerman. No visitor fails to be struck by van der Vaart's astonishing *trompe-l'oeil* of a violin and a bow hanging on a door, originally done for Devonshire House in London.

'Et in Arcadia Ego', regarded as Nicolas Poussin's masterpiece, unfortunately is not on public view, nor Murillo's simple and graceful 'Holy Family'. This artist's work became so popular in England that there came to be more of his pictures here than in his native Spain. 'The Presentation in the Temple' and 'The Flight into Egypt' by Sebastiano Ricci were on display when he came to London in 1713. Painted either for the 3rd Earl of Burlington or for his friend the 2nd Duke of Devonshire, they are very much in the style of Veronese — and there are indeed at Chatsworth two copies by Ricci of Veronese works.

There is much else to see and to admire. There is a portrait of a girl by de Vos, many

flower paintings by Monnoyer, two delightful landscapes by Fleury, and work by Gaspard Poussin, Giordano, Domenichino, Vouet, Patch, Maratta, Rosa, Boltraffio, Pietro da Cortona and Landseer.

Apart from admirable examples by Reynolds, there are few royal portraits to be seen here. The succession of family portraits is magnificent, and is one of the very few that maintains its high standard right up to the present day; many artists' work is included, the most notable contributions coming from Knapton, van Dyck, Sargent, Annigoni, Birley, Reynolds, Kneller, Jervas, de László, Millais, Watts, Hayter, Hudson, Lely, Wissing and Honthorst.

Knapton's portrait of the 3rd Earl of Burlington came to the family through his daughter Charlotte, who married the 4th Duke. Burlington is seen with a bust of Inigo Jones in the background and he is holding a copy of William Kent's 'Designs of Inigo Jones', marking his respect for the architect whom, with Palladio, he venerated. His enthusiasm for Palladian ideas made him highly influential in his time. Lambert's paintings of Burlington's Chiswick House are also at Chatsworth, with Pieter Rysbrack's view of the garden — both house and garden were thought to be revolutionary when they were created — but they are only occasionally on display.

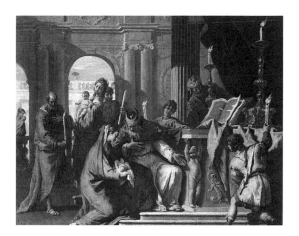

Sebastiano Ricci: 'The Presentation in the Temple' (*Chatsworth*)

For the visitor to Chatsworth, some of the very best pictures are kept to the last. Hals's 'Portrait of a Gentleman' is a scintillating masterpiece, rather less flamboyant than much of this artist's work, and seemingly more thoughtful and penetrating. Rembrandt's portrait of an old man (perhaps King Uzziah stricken with leprosy) is of a quality rarely seen in country houses. The feeling which this sublime picture generates makes the onlooker almost believe that Rembrandt had access to qualities denied to any other artist.

Plainly, Chatsworth is a large house, with a large and varied picture collection, even though many pictures have been handed over to national collections in lieu of tax, and many prints and drawings sold. Time is needed to take it all in, but it is time that is most richly rewarded.

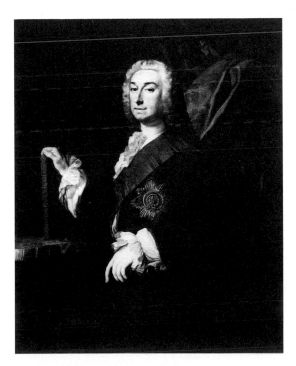

Knapton: '3rd Earl of Burlington' (*Chatsworth*)

CHELSEA ROYAL HOSPITAL

MAP K

Royal Hospital Road, London
Tel (01) 730 0161

Chelsea Royal Hospital, the home of the well-known Chelsea Pensioners, is a handsome group of buildings, designed by Christopher Wren. Its chapel has a dramatic 'Resurrection' painted in the apse by Sebastiano Ricci; this is his major work in England and his light touch and decorative feeling show to great advantage, particularly to those familiar with the more ponderous works of his predecessors such as Verrio. The hall is dominated by a huge wall-painting of 'The Triumph of Charles II', in which the mounted monarch is shown trampling on serpents and surrounded by marine deities. This work was started by Verrio in 1687, but was completed (and signed) by Cooke three years later. Also in the hall are Closterman's portrait of the 1st Duke of Marlborough and a series of state portraits of monarchs from Charles II (the founder of the Hospital) to Queen Victoria. In the Hospital's museum are more pictures, notably Haydon's 'Wellington Describing the Field of Waterloo to George IV'.

CHELTENHAM ART GALLERY AND MUSEUM

MAP E

Clarence Street, Cheltenham, Glos
Tel Cheltenham (0242) 37431

Notable above all for its superb collection from the Arts and Crafts period, Cheltenham Art Gallery, a cheerful and lively place, also has a large picture collection. This includes a group of Dutch paintings, with work by Metsu and a member of the de Heem family as well as British art covering three centuries.

CHICHELEY HALL

HHA

MAP F

Newport Pagnell, Bucks
2m NE of Newport Pagnell on Bedford road
(A422)
Tel North Crawley (023 065) 252

Chicheley Hall is a cheerful red-brick early Georgian house. Its surprisingly grand entrance hall has a ceiling painting by Kent. There are family portraits, including two by Hudson. The house once belonged to the 2nd Earl Beatty, son of the First World War admiral, who had collected a number of naval pictures, by Serres, Swaine and others, as well as a version of Abbott's famous portrait of Nelson. There are de László portraits of the 2nd Earl and his wife.

CHIDDINGSTONE CASTLE

HHA

MAP J

Edenbridge, Kent
In Chiddingstone, 4m E of Edenbridge
Tel Penshurst (0892) 870347

Lonely, strange, and rather neglected in appearance, Chiddingstone Castle is filled with a disparate collection, which includes a remarkable number of portraits and other relics of the royal house of Stuart, from Mary Queen of Scots to Henry, Cardinal of York. These include portraits by, or ascribed to, Johnson, Riley, J. M. Wright, Largillière, van Loo, Honthorst and Batoni, as well as a nude by Lely, identified as Nell Gwyn, though some think the face resembles more that of Barbara Villiers, Duchess of Cleveland, a rival mistress of Charles II.

CHISWICK HOUSE

EH MAP K

Burlington Lane, Chiswick, London
Tel (01) 995 0508

Lord Burlington's Palladian 'villa' in his park at
Chiswick, probably the most influential building
ever erected in England, has been carefully
restored to its original state, with its William
Kent interiors in fine condition. It also contains

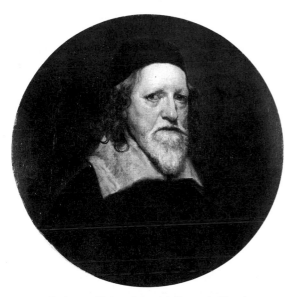

Dobson: 'Inigo Jones' (*Chiswick House*)

some of the pictures which were hung here when
the villa was completed in 1729. Some of the
pictures, including those by Kent himself, are
incorporated in the scheme of decoration in the
form of panels and overmantels, as are those of
Sebastiano Ricci. Pictures by Kneller, Reni and
Dobson (an original portrait of Inigo Jones) add
to the fascinating atmosphere of this famous
place.

CHRISTCHURCH MANSION AND WOLSEY ART GALLERY

MAP G

Christchurch Park, Ipswich, Suffolk
Tel Ipswich (0473) 213761

Christchurch Mansion is a Tudor house in a
parkland setting near the centre of Ipswich; to
this house the Wolsey Art Gallery has been
added. The extensive art collection is finely dis-
played in this environment; the atmosphere is
lively and inspiriting.

There is emphasis on work by local artists,
and this includes splendid small collections of
both Gainsborough's and Constable's works.
The former is represented by both portraits and
landscapes, notably 'A Country Cart Crossing a
Ford' and 'A View near the Coast'. There is an
unusual religious picture by Constable, and a
number of his local landscapes. These include
two of the supremely happy pictures of his early
days — of his father's flower garden and his
kitchen garden.

There is a fine assembly of Tudor and Stuart
portraits, including an admirable Mytens of
John Cotton. The twentieth century is also
well represented. If this part of the collection
is dominated by Steer, most clearly by his
'Knucklebones, Walberswick', there is a
distinguished assembly of other British art, in-
cluding works by Weight, Munnings, Gilman,
Gore, Sickert, Bevan, Ginner and Lucien
Pissarro.

CLANDON PARK

NT MAP J

Guildford, Surrey
3m E of Guildford on A247
Tel Guildford (0483) 222482

Clandon Park, the home of the Onslow family
for 300 years, dates from the 1730s. Designed by

Steer: 'Knucklebones, Walberswick' (*Christchurch Mansion and Wolsey Art Gallery*)

CORSHAM COURT

HHA MAP I

Corsham, Wilts
In Corsham, 4m W of Chippenham on Bath road (A4)
Tel Corsham (0249) 712214

Still the home of the Methuen family, Corsham Court contains one of the most noted and remarkable private picture collections in the land. This is displayed in the state rooms, which were built specifically for the purpose of housing these pictures, and completed in 1772. Designed by 'Capability' Brown, these rooms are splendidly suited to their purpose, especially the magnificent and supremely comfortable picture gallery, one of the great rooms of England. Nowhere are pictures better displayed than at this entrancing place, which also has an exceptionally well-written, informative and well-produced guide book.

Among the many fine pictures are such treasures as Reni's portrait of Pope Gregory XV, two coastal scenes by Salvator Rosa, a portrait group of three Gaddi children by Anguisciola, 'Christ in the House of Simon the Pharisee' by Dolci, an 'Annunciation' from the studio of Fra Filippo Lippi, and another by Granacci. There is also 'The Infant Christ as Salvator Mundi' by Guercino, and 'Christ and the Woman Taken in Adultery' by Assereto. Pietro da Cortona's 'Tancred and Erminia', a spirited treatment of a not unusual seventeenth-century subject, is as remarkable for its grace and skill as it is for its magnificent rococo frame.

No single artist has been more consistently fashionable in England than van Dyck, from the moment of his arrival and brief sojourn of nine years in this country. His portraits were enormously admired in the next century, not least by Reynolds and by Gainsborough. It is therefore surprising that few of van Dyck's major works were bought in the days when English collecting was at its height. Van Dyck's 'The Betrayal of Christ' is one of the finest acquired, bought by Sir Paul Methuen for £100 in 1747.

a Venetian architect, Giacomo Leoni, it is a large red-brick house with an entrance hall of huge proportions, and houses the family picture collection.

This is notable for a number of pictures by Barlow. There are large pictures of birds and fishes, a 'farmyard-scape', a fine panoramic group-portrait of a pack of hounds and a picture of a farm labourer — a very early portrait of a working man. There are sporting pictures by John Ferneley and an outsize picture of a horse and a jockey by Wootton. There is an excellent bird's-eye view of the estate by Knyff.

The family portraits of the family, which was much involved in politics and provided no less than three Speakers of the House of Commons, include a House of Commons group painted jointly by Thornhill and his son-in-law Hogarth, as well as several works by Kneller (including a particularly powerful, though scarcely finished, portrait of Denzil Onslow), by J. M. Wright, Hysing and, in the twentieth century, de László.

The great artist painted several versions of this subject. The Corsham picture, painted in 1632, not long before he came to England, is a wonderfully balanced and tremendously dramatic picture. There is no finer van Dyck religious painting in the country.

Family portraits at Corsham Court include a charming Reynolds of two children, with other contributions from Romney, and from de László, who painted the 4th Lord Methuen (himself to be elected an RA in later years) as an officer in the First World War.

COUGHTON COURT

NT MAP E

**Alcester, Warwicks
2m N of Alcester on Birmingham road (A435)
Tel Alcester (0789) 762435**

That the Throckmortons of Coughton Court were a Catholic family led to what Sir Oliver Millar has described as 'perhaps the most beautiful portraits of English men and women compelled to live abroad'. These are those of the family painted in Paris in 1729 by Largillière. The artist's portrait of the 4th Baronet, Sir Robert Throckmorton, is in a contemporary French carved gilt frame which perfectly enhances the rococo brilliance of the portrait.

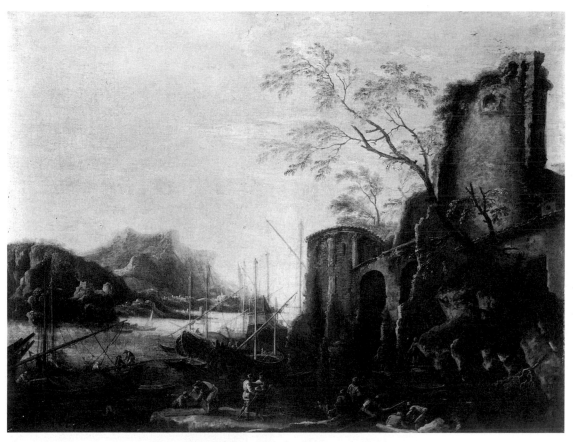

Rosa: 'Coastal Scene by the Phlegraean Fields, with figures in foreground' (*Corsham Court*)

This may well be, as has been suggested, the last portrait to be painted of a man wearing armour, for Sir Robert wears a shining breastplate. This flamboyant picture contrasts tellingly with Largillière's other remaining portrait at Coughton Court, that of Sir Robert's aunt, Anne Throckmorton, Abbess of an Augustinian convent. The latter picture is subdued in tone, but as delicate and as skilfully painted as its counterpart.

COURTAULD INSTITUTE GALLERIES

MAP K

Woburn Square, London
Tel (01) 580 1015

For thirty years discerning art-lovers have enjoyed the peaceful and comfortable galleries of the Courtauld in their home on the top floor of the Institute in the heart of Bloomsbury, designed by Charles Holden. It is intended that this stunning collection will move at the end of 1989, to the elegant rooms of Somerset House where it will be possible for more of the pictures to be on permanent display: only part of the whole can be shown at Woburn Square.

The Courtauld Institute, part of the University of London, has built up its collection largely through bequests; these have come from, amongst others, Lord Lee of Fareham, from Roger Fry, from Mark Gambier-Parry, from Count Seilern and, of course, from the first benefactor, Samuel Courtauld, the industrialist after whom the Institute is named, and whose gifts started in 1931. For lack of space the Roger Fry bequest (with its collection of paintings from the Bloomsbury group) and the early Italian masterpieces of the Gambier-Parry collection, will not be on display until the Courtauld moves to Somerset House.

Count Antoine Seilern's bequest, known as The Princes Gate Collection, spans 600 years of painting, and is especially notable for work by Rubens and G.B. Tiepolo. It can be said to start

with a triptych by Daddi, which demonstrates this remarkable artist's achievement in moving on from the style of his master, Giotto. There is an early masterpiece from the Low Countries: this is probably the earliest surviving work of the Master of Flémalle, a triptych of about 1415 still miraculously in its original frame — the panels are of 'Entombment', 'Two Thieves with the Empty Cross and a Donor' and 'Resurrection'.

There is work by Massys (notably 'Madonna and Child'), by Palma Vecchio ('Venus in a Landscape'), Tintoretto, Parmigianino, Aertsen, Zoppo ('St Sebastian with Saints') and Pieter Bruegel the Elder, with 'Landscape with the Flight to Egypt'.

There are more than thirty paintings by Rubens in the Princes Gate Collection, of many types. There are portraits, of Charles V, of the explorer Cortez, of Jan van Montfort, and a group portrait of Jan Bruegel with his family. There are many religious pictures and sketches, and in the case of 'Conversion of St Paul' there are both a preliminary sketch and the finished

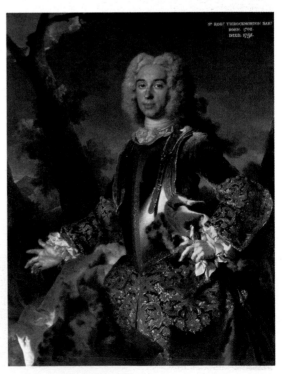

Largillière: 'Sir Robert Throckmorton' (*Coughton Court*)

work. There are designs for tapestries, there are such pictures as 'Death of Hippolytus', and there are several landscapes, notably a 'Moonlit Landscape', a magnificent late work which was later to be owned by Reynolds, and greatly admired by Gainsborough and by Constable. It is possible here, more than anywhere else in England, to get an overall impression of Rubens as an artist: a superb and masterly painter, with tremendous powers of expression and of organisation, able to handle large and complex subjects with effortless and dramatic grace and balance; this is nowhere better exemplified than by the 'Descent from the Cross', a brilliant study for the famous altar-piece in Antwerp.

Teniers is represented by a dozen or more of the small copies he did of pictures from the Archduke Leopold Wilhelm's collection, of which he was the curator; there is also the 'Interior of a Picture Gallery' left unfinished by Francken at his death and completed by Teniers. There is a small Claude landscape, several works by van Dyck, Feti's 'Parable of the Sower' and work by Lotto.

Giovanni Battista Tiepolo is strongly represented, with a dozen paintings, all preparatory work for ceiling decorations or for altarpieces. There is also work by Barbault, Crespi, Guardi, Mura, Pittoni and Sebastiano Ricci.

The Princes Gate Collection extends into the nineteenth and twentieth centuries, with work by Cézanne, Degas, Camille Pissarro, Renoir, Manet, Morisot and Kokoschka, of whom Seilern was an active patron, but these are included among the staggering display of Impressionist and Post-Impressionist pictures,

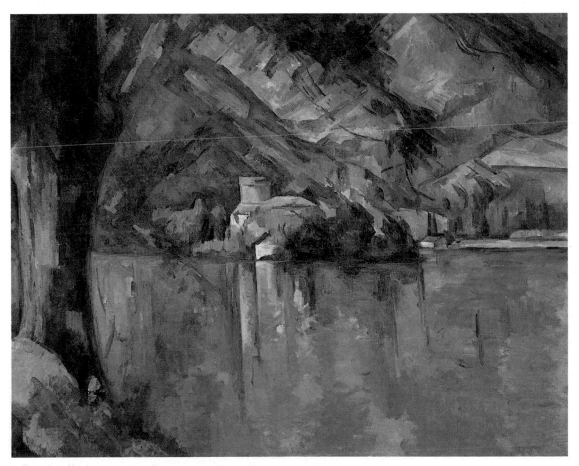

Cézanne: 'Le Lac d'Annecy' (*Courtauld Institute*)

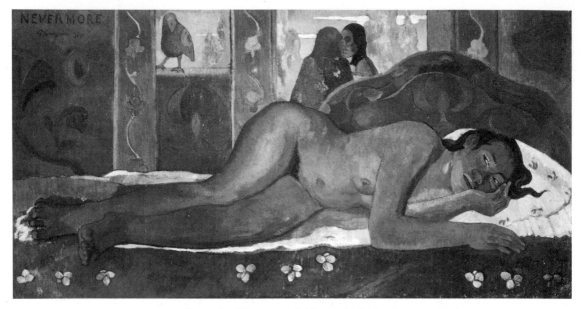

Gauguin: 'Nevermore' (*Courtauld Institute*)

given to the Courtauld by Samuel Courtauld himself. It is by no means a large collection, but it is enormously attractive. It is hard to imagine anybody who cannot at once relate to these masterpieces, many of them familiar from reproductions, but infinitely more appealing and effective when seen in this most handsome of collections.

Impressionism, the most important artistic movement of the nineteenth century, was originally a derisive nickname, taken from a picture by Monet ('Impression, Sunrise') seen at an exhibition in 1874 of like-minded artists whose aim was to achieve greater naturalism by exact analysis of tone and colour and by seeking to show the play of light on the surface of objects. Post-Impressionism is a vaguer term, signifying a reaction from Impressionism towards a more formal conception and a renewed stress on the importance of the subject.

Boudin's 'Beach at Trouville' is one of these, as is van Gogh's 'Self-portrait with Bandaged Ear', a fiercely poignant self-portrait of a desperate man, deeply troubled; the picture contrasts in every possible way with the happiest of his landscapes, painted in the same year — 'Peach Blossom in the Crau'. Cézanne is represented by his 'Lac d'Annecy', a splendid

still-life with pears, 'The Card-Players' (one of half-a-dozen versions of this subject) and 'La Montagne Sainte Victoire', also a subject that Cézanne painted on many occasions.

There are works by Sisley, Utrillo, Vuillard, Bonnard, Daumier, Degas, Modigliani, Monet, Camille Pissarro ('Lordship Lane Station'). Seurat's 'Young Woman at a Powder-table' shows a rare glimpse of this artist's private life, for this is a portrait of his mistress. 'Douanier' Rousseau's 'Customs House' shows one of his former places of work, while Toulouse-Lautrec's 'Jane Avril in the Entrance of the Moulin Rouge' combines one of his favourite places with one of his favourite models. Renoir's 'Ambroise Vollard' portrays the great Parisian art-dealer who was friend to many of the Impressionists. 'La Loge' is one of Renoir's best-known pictures; he never portrayed a beautiful girl with more skill and more delight than he showed with this excited and glowing young woman in her box at the theatre and her self-effacing escort.

There are three Gauguin pictures here. There is 'Haymaking' from the artist's time at Pont-Aven, and there are two from his days in Tahiti. These are 'Te Rerioa' ('Day-dreaming'), a mysterious work in which everything has a dreamlike quality, and 'Nevermore', a more familiar

picture, powerful and enigmatic, in rather sombre colours, and seeking, in the artist's own words, to express 'long-lost barbaric luxury'.

The Courtauld collection is rounded off by two of the most famous images of the nineteenth century. The first is Manet's sketch for 'Déjeuner sur l'Herbe' — the finished version, having caused a huge sensation when it was painted in 1862/3, is now in the Musée D'Orsay. The second he painted nearly twenty years later — 'A Bar at the Folies-Bergère'. This is a marvellous composition, skilfully divided by the bar and the mirror on the wall behind. The array of bottles and fruit on the bar are painted with precision, while the crowded room seen in the mirror is treated in a more Impressionist manner, as is the customer (perhaps a self-portrait) also reflected with the barmaid's back-view. The central figure of the barmaid, clad in Manet's favourite black, is at once engagingly charming, and mysteriously thoughtful, with her hour-glass figure and her simple hair-style. What is this delightful creature considering? Is she contemplating the follies of the human race? Is she thinking about a lover? Or is she merely embarrassed by a remark made by the just discernible customer?

CRAGSIDE

NT MAP B

Rothbury, Northumberland
½m E of Rothbury on Alnwick road (B6341)
Tel Rothbury (0669) 20333

Cragside, an amazing house designed by Norman Shaw, was built in the 1870s for the 1st Lord Armstrong. It no longer contains his original picture collection. There is, however, his portrait by Watts, much work by the local artist Emmerson (a protégé of Armstrong's), and work of the Pre-Raphaelite school by de Morgan, Spencer-Stanhope and others.

CROFT CASTLE

NT MAP E

Leominster, Hereford and Worcester
5m NW of Leominster, on B4362
Tel Leominster (056 885) 246

In the main, there are family portraits at Croft Castle, home of the Croft family since Norman times, and inevitably fortified, set as it is in the disturbed Welsh border country. Abbott, Gainsborough and Lawrence are here, as is Henry Robert Morland (father of George) with a striking portrait of the actress Peg Woffington.

CROMWELL MUSEUM

MAP F

Grammar School Walk, Huntingdon, Cambs
Tel Huntingdon (0480) 52861

The Cromwell Museum commemorates the history of the English Civil War at the great man's birthplace, in the former Grammar School (which he attended in his time). There are portraits, especially of the Lord Protector's family, including one of the many versions of Robert Walker's 'Oliver Cromwell' — in this one, Walker supplies Cromwell with a body borrowed from van Dyck's painting of the Royalist standard bearer, Sir Edmund Verney, who was killed at the Battle of Edgehill and whose (real) body was never recovered.

DALEMAIN

HHA; GT MAP A

Penrith, Cumbria
3m SW of Penrith on Ullswater road (A592)
Tel Pooley Bridge (085 36) 450

Dalemain is built around a pele tower, with early Georgian façades of pearly-pink stone. In

this delightful house, there is a large Venetian scene by Marieschi, and Hasell family portraits, including a couple of van Dycks, a Kneller, enchanting contributions from Arthur Devis and from Zoffany, and a sternly authoritative Sir Francis Grant of the Victorian Edward Hasell. It is a perfect small collection, shown with style in equally perfect surroundings.

DARLINGTON ART GALLERY

MAP B

Crown Street, Darlington
Tel Darlington (0325) 462034

The floridly-decorated Darlington Art Gallery has a fair-sized collection which includes work by Gore, Brangwyn and Sutherland.

DEENE PARK

HHA
MAP F

Corby, Northants
6m NE of Corby, on Kettering/Stamford road
(A43)
Tel Bulwick (078 085) 278 or 361

Deene Park, a Tudor and Georgian mansion which is the home of the Brudenell family, has many family portraits, including some of high quality and much interest. These are Larkin's full-length of Lady Elgin, and J. M. Wright's 1658 portrait of the 1st Earl of Cardigan, when the latter was aged eighty and much harrowed by imprisonment during the Civil War. Reynolds's stately portrait of Lady Mary Montagu has the white-faced, almost ghostly aspect of some of his pictures. There is an unusual and interesting set of twelve Jacobean portraits of women and children, the sitters all as unknown as the artist.

Sant's group of the Royal Family listening to the 7th Earl of Cardigan's account of the charge of the Light Brigade (which he had led) allegedly once included Queen Victoria, until she had herself painted out when she became aware of the Earl's scandalous private life.

Ferneley paid several visits to Deene Park between 1822 and 1844 to paint groups of hunters. Their reappearance over the years can be studied, as can the development of his style and his skill as an animal portraitist.

DERBY MUSEUM AND ART GALLERY

MAP E

The Strand, Derby
Tel Derby (0332) 31111

The Derby Art Gallery is dominated by the work of Joseph Wright, always known as Wright of Derby. Although not all are always on display, the gallery owns twenty-eight canvases from every period of his life, embracing all the aspects of the work of one of the first artists to respond to the stirrings of the Industrial Revolution in the late eighteenth century.

There is a self-portrait, a youthful study in van Dyckean costume. There are portraits, notably of Erasmus Darwin and of Jedediah Strutt, and portrait groups, the most striking being 'The Reverend Ewes Coke and His Family'. There are scenes from Shakespeare, and enig-

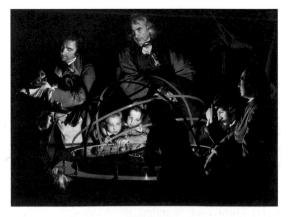

Wright of Derby: 'A Philosopher Lecturing on the Orrery' (*Derby City Art Gallery*)

matic works, such as 'The Indian Widow' and 'Miravan Breaking Open the Tomb of his Ancestors'. There are, above all, works that show his daring and dramatic use of a concealed source of light, such as 'A Philosopher Lecturing on the Orrery', and 'The Blacksmith's Shop', both dealing with subjects rarely used before as subjects by artists.

DOCTOR JOHNSON'S HOUSE

MAP K

17 Gough Square, London
Tel (01) 353 3745

This handsome Queen Anne house, reached by a narrow alleyway from Fleet Street, stands marooned amongst tall office-blocks. It contains many mementoes of Samuel Johnson, who lived here for nine years: his famous Dictionary was compiled in the attic workroom. There are some portraits here, notably a self-portrait of Reynolds, and some other pictures, such as Frith's 'Doctor Johnson and Mrs Siddons'.

DODDINGTON HALL

HHA MAP D

Lincoln
5m W of Lincoln, on B1190
Tel Lincoln (0522) 694308

Doddington Hall, in all probability a creation of the Elizabethan architect Robert Smythson, is unchanged outside, although remodelled inside in the 1760s. Serene in the Lincolnshire countryside, it has a portrait collection of quality, mainly of members of the Hussey and Delaval families. There is also a small number of royal portraits.

The family's likenesses include works by Lely, Dahl and Kneller; by Reynolds, with a resplendent double-portrait in Coronation robes, as well as a full-length; by Lawrence, with

an appealing 'Sarah Gunman'; and lastly by Sargent, with a dashing and bold 'Ena Mathias'. Lely is also represented with a classical picture.

The whole ensemble, in this beautiful house with its elegant Long Gallery, makes this a most rewarding place to visit.

DORNEY COURT

MAP J

Bucks, near Windsor
2m NW of Windsor, on B3026
Tel Burnham (062 86) 4638

Dorney Court, a charming and modest red-brick, half-timbered manor house, has a number of portraits of the Palmer family, who have lived here since 1600, including pictures by Johnson, Lely and Kneller.

DUDMASTON

NT MAP E

Bridgnorth, Shropshire
5m SE of Bridgnorth on Kidderminster road
(A442)
Tel Quatt (0746) 780866

Dudmaston is a late seventeenth-century house with much to interest the visitor. The pictures are unexpected and unusual.

There are portraits of the Wolryche and Whitmore families who lived here for 850 years; generally, the artists are unknown, presumably local men. There is a small group of early eighteenth-century portraits of servants on the estate. There is work by Bosboom, van der Venne and Savery. There is a notable collection of Dutch flower paintings, originally gathered together by Francis Darby of Coalbrookdale: this includes work by van Os, van Huysum and van Brassel.

There is much twentieth-century work, including pictures by Alan Davie, Ben

Nicholson, Delaunay, Venard and Dubuffet, and there are modern Spanish pictures by Tàpies and Munoz. There are topographical watercolours, and an important collection of botanical art, including work by John Nash and Grierson.

DULWICH PICTURE GALLERY

MAP K

College Road, Dulwich, London
Tel (01) 693 5254

Belonging to a well-known school, in a building designed by Sir John Soane, the Dulwich art collection was the first in England (and one of the first in Europe) to be opened to the public. This occured in 1814, ten years before the National Gallery opened its doors.

The genesis of the Dulwich picture collection lay in the foundation of the college by the successful actor-manager Edward Alleyn; when he died, in 1626, he left his modest collection of thirty-nine pictures to his college; these were mostly portraits of mediocre quality but great historical interest. Further bequests followed, notably that from Cartwright in the 1680s, including important theatrical and literary portraits — for example what may well be a self-portrait of the actor Richard Burbage.

The collection was turned into one of major importance by the bequest of Sir Peter Bourgeois RA in 1811; this was made up of an endowment and nearly four hundred pictures assembled over the years by himself and by his friend the art-dealer Noel Desenfans. Many of them had been acquired amid upheavals following the French Revolution and during the Napoleonic Wars, in an attempt to start a national collection in Warsaw, which had to be aborted when the King of Poland, who had commissioned Desenfans, was forced to abdicate.

Dulwich is especially rich in seventeenth-century work, much of it of superb quality, and in British work of the eighteenth century. It is a stunning assembly, handsomely housed in the simple and elegant top-lit galleries which Soane

devised; most unusually, it includes a discreet mausoleum for the bodies of the founders. Though blitzed in the Second World War, it was rebuilt to Soane's surviving plans.

Work from the Low Countries of the seventeenth century is prominent at Dulwich. There are half-a-dozen Cuyp landscapes, with 'A Road Near a River' being especially attractive; there is a similar group, albeit of more varied subjects, by Teniers, with 'A Winter Scene' possibly the most notable. Amongst many others, there are works by de Gelder (a very popular 'Jacob's Dream'), Dou (whose 'Lady Playing a Clavichord' may have influenced Vermeer's picture of a similar subject in the National Gallery), Jan Weenix, the younger Willem van de Velde, Adriaen van Ostade, van Huysum (with a number of flower pictures), several by Berchem, Backhuysen (whose 'Boats in a Storm' may have been an influence on Turner), van Calraet, Brouwer, Pynacker, Hoet, Neefs, Hobbema ('Landscape with a Watermill'), van Ruisdael, Wynants and many by Wouwerman.

There are several pictures by Rubens: some admirable Saints; the imposing 'Venus, Mars and Cupid'; a rather playful portrait of, it is believed, 'Catherine Manners, the Duchess of Buckingham'; and, perhaps above all, 'Hagar in the Desert'.

Van Dyck is likewise represented by a variety of pictures. There is a magisterial portrait of 'Emmanuel Philibert of Savoy, Prince of Oneglia', the Viceroy of Sicily, a portrait of a young Englishman thought to be the Earl of Bristol, and a painful death-bed portrait of Venetia Stanley, the wife of Sir Kenelm Digby. Van Dyck's 'Samson and Delilah' and his 'Madonna and Child' reflect his training in Rubens's studio: they are graceful and assured pictures.

Rembrandt is to be seen at Dulwich, with two fine pictures. There is a deeply-felt and somewhat harrowing portrait of a young man, which may be the artist's son Titus; and there is a simple and charming 'Girl Leaning on a Window Sill', an affectionate, masterly and happy picture. This subject was to be frequently used in later years, notably by Reynolds in his similar picture at Kenwood.

Murillo: 'The Flower Girl' (*Dulwich Picture Gallery*)

Also from the seventeenth century, there are pictures by Murillo: 'Two Peasant Boys and a Negro Boy', his famous 'Flower Girl' and a 'Madonna' — all of them charming and without the saccharine quality that sometimes afflicted his work. There is work by Pietro da Cortona, Reni, Lebrun, del Mazo, Guercino, Dolci, and Claude, with 'Jacob with Laban and His Daughters'; Nicolas Poussin is represented by half-a-dozen pictures including his 'Nurture of Jupiter' and his 'Triumph of David'.

Lely has portraits here; in addition there is his 'Young Man as a Shepherd', which was once the prized possession of Horace Walpole, and his 'Sleeping Nymphs', the most elaborate of his paintings of figures in a landscape, which he would no doubt have preferred to paint were it not for the need to earn a living by painting portraits. There is a strange Kneller of 'Edward and Lady Mary Howard', where the children, in their classical garments, are accompanied by an incongruous King Charles spaniel puppy. Other seventeenth-century British portrait painters represented include Mary Beale, Johnson, Greenhill and John Riley, whose work here includes a startlingly frank portrait of the unpleasant Will Chiffinch, page and pimp to Charles II.

Moving on to the next century, there is a number of brilliant sketches by G. B. Tiepolo, and work by Rigaud, Watteau, Sebastiano Ricci, Soldi, Vernet and Zuccarelli, with two high-quality Canalettos, one of a Venetian subject and the other of 'Old Walton Bridge'.

Most well-known eighteenth-century British artists have work at Dulwich: Dahl, Jervas, Knapton, Vanderbank, Hudson, Romney and Hogarth are all represented by portraits; Hogarth also has an enchanting 'Fishing Party'. De Loutherbourg and Richard Wilson (with 'Tivoli') are both represented by landscapes, whereas Gainsborough is seen here only with portraits, including one of de Loutherbourg, who had taught Sir Peter Bourgeois. There is a group of portraits of the Linley family, whom Gainsborough knew well during his years in Bath, the most striking being the double portrait of two Linley daughters, painted shortly before one of them eloped with the playwright

Sheridan. Gainsborough's portrait of 'An Unknown Couple in a Landscape', from an earlier date, has the delicious freshness associated with his portraits of this kind: the young couple, in their best clothes, loll elegantly against the wooden fence around their cornfield, fitting effortlessly into the landscape, utterly English and absolutely delightful.

Reynolds's contribution is rather smaller. It includes a version of his bespectacled self-portrait, and a copy for Desenfans (and probably mostly painted by himself) of his 'Mrs Siddons as the Tragic Muse'.

Reni: 'St John the Baptist in the Wilderness'
(*Dulwich Picture Gallery*)

There are some Lawrence portraits, including one of William Linley, the member of the family who gave the Linley Gainsboroughs to Dulwich. There is a Bourgeois self-portrait, with portraits of him and of Desenfans by Northcote. The most up-to-date picture to be seen is Denning's 1823 portrait of the future Queen Victoria at the age

of four, astoundingly self-possessed, over-dressed and regal even as an infant. Denning was curator at Dulwich from 1821 to 1864.

DUNHAM MASSEY

NT MAP C

**Altrincham, Cheshire
3m SW of Altrincham off A56
Tel Manchester (061) 941 1026**

Dunham Massey is an eighteenth-century mansion of great charm, once the home of the Grey family, Earls of Stamford. There is plenty here to entertain visitors, and many of the best portrait painters are represented on its walls: Johnson, Lely, Kneller, Romney, Wright of Derby, Cotes, Dahl, Reynolds and Mengs.

The 5th Earl of Stamford is to be seen in two pictures, both painted in Florence by Patch when the Earl was on the Grand Tour as a young man. Patch had settled in Florence and catered to the coarser taste of some of those on the Grand Tour with a series of caricature conversation-pieces in which the various sitters can be identified. In one of those at Dunham Massey, the setting is a fashionable meeting place on the Arno, kept by Charles Hadfield, who is depicted punch-bowl in hand. Paintings of Bacchus and Silenus on the walls suggest the spirit in which such parties were conducted.

DYRHAM PARK

NT MAP I

**Bath, Avon
8m N of Bath on Stroud road (A46)
Tel Abson (027 582) 2501**

Built for William III's Secretary of State William Blathwayt, Dyrham Park and its contents are a remarkable survival of Dutch William-and-Mary taste. The house, modestly grand, or grandly modest, with a great view from the lower slopes of the Cotswolds over the Severn Valley, provides a delightful experience.

It contains notable Dutch and Flemish pictures from the collection of Thomas Povey, Blathwayt's uncle and a friend of Samuel Pepys. Van Minderhout, Hondecoeter, Snyders, and van Hoogstraeten are represented. Casali provided some ceiling paintings. There is also a good Murillo, 'Peasant Boy and Old Woman' (also, for good measure, a copy of it by Gainsborough).

The most striking of the Dutch paintings is the big perspective view down a corridor, signed and dated by Hoogstraeten, 1662, painted either after the artist's arrival in England that year, or earlier, in Holland. The interior depicted is entirely Dutch in character. Before it came to Dyrham, it was seen, in 1663, by Pepys in Povey's house in Lincoln's Inn Fields in London, artfully placed behind a cupboard door: 'But above all things, I do most admire his piece of perspective especially, he (i.e. Thomas Povey) opening the closet door and there I saw that there is nothing but only a plain picture hung upon the wall'. Subject matter and view are very much in the manner of de Hooch (master of the escape route): an illusionistic view out of reality into another reality — across a chequered floor, through a hall and then another room, with the unheard conversation of a couple half-glimpsed, away through an open door to an empty chair by a fireplace in a second room beyond. The way is guarded by an alert, slightly wary, little dog. A broom is leaning against the doorpost. A bird sits in a cage hung high above them; the cage door is open. It has a fascination of silence and slow time, almost Proustian. Another painting by the same artist, a view of a courtyard, with a figure seated reading on steps in front of a giant colonnade, has something of the same elusive mystery.

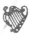

van Hoogstraeten: 'View down a Corridor' (*Dyrham Park*)

EASTNOR CASTLE

MAP E

Ledbury, Hereford and Worcester
2m E of Ledbury on Tewkesbury road (A438)
Tel Ledbury (0531) 2305

The castle, started in 1812 for the 1st Earl Somers, is battlemented and turreted in the formidably Romantic nineteenth-century version of gothic. Its interiors are impressive if not cosy.

The collection of paintings has been much diluted over the years, under the impact of death duties. John, Lord Somers (1651–1716), a famous Lord Chancellor, was an early British patron of the arts and of literature. Many, if not all, of his paintings came to the Cocks family, and so to Eastnor (where there are three portraits of him, one by Lely, two by Kneller), via the marriage of his sister and heiress to Charles Cocks. Paintings ascribed to Bassano and Tintoretto probably came from him, as did the spectacular vision of the Sicilian philosopher and mystagogue, Empedocles, leaping into the crater of Etna (to prove his divinity, subsequently confirmed, according to legend, by the volcano ejecting his sandal transmuted into bronze). This is a fine example, about 1660, of the work of Salvator Rosa, the Neapolitan-born painter who came to be, in the eyes of British connoisseurs and literati of that century, one of the near-divine trinity of artists whose landscapes constituted the ideal of the Picturesque: Claude, Poussin, and Rosa. Edmund Burke had defined the Picturesque in terms of opposite poles: the 'beautiful' and the 'sublime'. Claude came to be identified above all with the beautiful, Rosa with the sublime. Thus Horace Walpole, travelling through the Alps, could enthuse about 'precipices, mountains, torrents, wolves, ramblings, Salvator Rosa . . .'

The family portraits at Eastnor include an excellent selection of Romney's work, especially a romantic full-length of the 1st Earl Somers, standing pensive in a landscape, a lock of his drowned brother's hair in his hand. In the nine-teenth century, Watts was a close friend of the family. Virginia, Countess Somers, was one of the famous Pattle sisters and Watts's full-length portrait of her, of 1849, is one of his masterpieces, if somewhat uncharacteristic in the simplicity of its almost van Dyckian elegance. There is also a version of Watts's head and shoulders of Tennyson rather more freely handled than that in the National Portrait Gallery, less hieratic than the London one, but nevertheless presenting the laureate poet very much as a seer and prophet. Five frescoes by Watts, of 'The Elements', formerly in the Somers house in London, in Carlton House Terrace (later inhabited by Ribbentrop as German Ambassador), were re-sited at Eastnor in 1976.

ECCLESHALL CASTLE

HHA MAP E

Eccleshall, Staffs
½m N of Eccleshall, on Newcastle road (A519)
Tel Eccleshall (0785) 850250

For centuries the residence of Bishops of Lichfield, strongly fortified, Eccleshall Castle is now a handsome late seventeenth-century house rather than anything resembling a castle. It has a small but wide-ranging collection. There are works here by Miereveld, J. M. Wright, Beechey, Grimshaw (with two powerful moonlit landscapes) and members of the Herring family. There is also a number of nineteenth-century seascapes, several by the Yorkshire artist Henry Redmore.

THE ELIZABETHAN HOUSE MUSEUM

MAP G

4 South Quay, Great Yarmouth, Norfolk
Tel Great Yarmouth (0493) 855746

The pictures on display at The Elizabethan House Museum include 'The Dutch Fair' by

101

George Vincent and other works of the Norwich school — an informal grouping of families, pupils and friends around its two great masters, Cotman and Crome.

ELTON HALL

GT MAP F

Peterborough, Cambs
5m W of Peterborough, on Oundle road (A605)
Tel Elton (08324) 310

Elton Hall, a house of much charm, is not very widely known; it has an unusually fine, and wide-ranging, picture collection. Family portraits of the Proby family, who have lived at Elton for 300 years, include a fine series by Reynolds, a family friend; there is also Reynolds's portrait of the actress Kitty Fisher, and his 'Snake in the Grass'. There is a wonderful Constable landscape, 'Dedham Vale', matched with a landscape by Gainsborough, who is also represented by some family portraits. Luini's 'Boy with a Puzzle' is striking, as is a Hobbema landscape, Genga's 'Madonna della Misericorda', Dou's supposed self-portrait as a flute-player, and a Gaspard Poussin landscape. Many pictures were bought in Victorian and Edwardian times, among them Millais's 'The Minuet' and O'Neil's 'Eastward Ho!' This picture caught the imagination of the public at the Academy exhibition of 1858, depicting as it did dramatically the departure of troops from Britain to quell the Indian Mutiny, which had broken out the previous year. There is also Alma-Tadema's 'A Dedication to Bacchus', a fine example of the preoccupation of some artists with scenes from the ancient world.

EUSTON HALL

HHA MAP G

Thetford, Suffolk
3m S of Thetford on Stowmarket road (A1088)
Tel Thetford (0842) 66366

Euston Hall is the home of the Dukes of Grafton. The 1st Duke was Henry Fitzroy, one of Charles II's bastard sons, so it is not at all surprising to find here a magnificent collection of Stuart family portraits.

The house was built in 1670 by Lord Arlington, a member of the 'Cabal', whose daughter married Henry Fitzroy and thus became the 1st Duchess. 'A View of Euston Hall' by an unknown artist of the early eighteenth century is an early example of a kind of topographical picture that was to become — indeed still is — highly popular. The house is accurately depicted in the middle distance, while the foreground is partly occupied by something apposite, often, as in this case, a hunting party.

There are versions of van Dyck's Charles I, his Queen, and his children. The Lelys include a sumptuous state portrait of Charles II, with likenesses of Lord Arlington, of Barbara Villiers, Lady Castlemaine (Henry Fitzroy's mother, and later Duchess of Cleveland), and of Prince

O'Neil: 'Eastward Ho!' (*Elton Hall*)

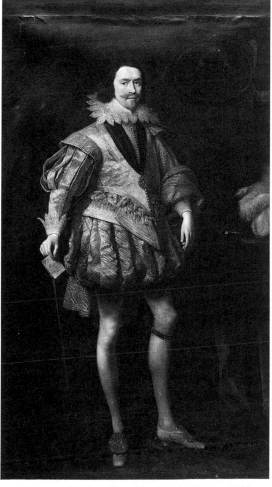

Mytens: 'Duke of Buckingham' (*Euston Hall*)

Rupert. There is a portrait by de Champaigne of Charles II in exile, and by Mignard of his sister 'Minette', Duchess of Orleans.

Later portraits include a Batoni of the 3rd Duke in the uniform of the Suffolk Militia. It was this Duke who also commissioned a fine Stubbs 'Mares and Foals', showing horses bred by the Duke in the grounds of Euston.

FAIRFAX HOUSE

HHA MAP D

**Castlegate, York
Tel York (0904) 55543**

The beautifully restored and furnished mid-eighteenth-century Fairfax House has been provided with appropriate pictures. These include a number of pictures by Etty, and some Dutch pictures, among which there are paintings by Storck and a fine example of the work of Willem van de Velde the Elder.

FALMOUTH ART GALLERY

MAP H

**The Moor, Falmouth, Cornwall
Tel Falmouth (0326) 313863**

Falmouth Art Gallery is not large and has frequent temporary exhibitions; consequently the permanent collection is not often on view. The visitor therefore has to depend on good fortune for the opportunity of seeing studies by Burne-Jones for 'The Lady of Shalott', 'The Bouquet' by Waterhouse and other pictures here.

FELBRIGG HALL

NT MAP G

**Cromer, Norfolk
2m SW of Cromer on Holt road (A148)
Tel West Runton (026 375) 444**

It is hard, if not impossible, to think of a more agreeable house to visit than Felbrigg Hall. This handsome, but by no means enormous, house, built in an enchanting mixture of styles and materials, stands, remote but welcoming, in the gently rolling fields and woods of northern Norfolk. It is an especial delight to be able to

103

enjoy the pictures at Felbrigg in a gracious and uncrowded atmosphere; for, while deservedly popular, it is somewhat removed from the mainstream of tourism.

Although the house is of relatively modest size, the collection of pictures is both remarkable and extensive. It comprises family portraits of the Windham family, who lived here for over 400 years, and the pictures were assembled on a prolonged Grand Tour taken by one of its members around 1740. Lack of funds inhibited further purchases of pictures, or building, so that what the visitor sees at Felbrigg is the home of a cultivated country squire of the mid-eighteenth century — restrained, elegant, utterly delightful.

The family portraits take second place in this house. Kneller, Beale and others are represented, but they are very much what one might expect to find in similar houses, with nothing very extraordinary about them. However, there is a fine, mature Reynolds, which is a striking, thoughtful and compelling example of his work.

The 'Grand Tour' pictures are hung in the rooms which were remodelled in the 1750s especially to house them. The William Windham who made the tour had two outstanding passions. First, he loved Dutch sea-pictures, and there are some fine examples here — by van de Velde, by de Vlieger, by Backhuysen and by many others. There are also two large Samuel Scott views of the Thames, a harbour scene by

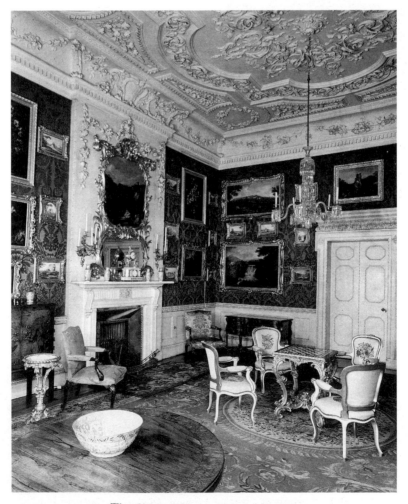

The Cabinet Room (*Felbrigg Hall*)

Vernet, a classical scene by van Herp, 'Girl with Roses' by Mercier, and two landscapes by Zuccarelli.

William Windham's second passion was for the works of Busiri. He bought no less than twenty-six gouaches of this artist, of classical antiquities and landscapes in the Campagna. Hung in the room designed for them, carefully interspersed with Dutch pictures and with seven larger Busiri oil landscapes, the effect is vastly compelling. Outstanding among the Dutch pictures here are 'View on the Meuse' by van Valckenborch and 'Fishermen on a Beach' by van der Poel, while there are also flower pictures by van Vogelaer and two Poussin-like landscapes by Jan Glauber. This room exemplifies perfectly the intimate room, or cabinet, much in vogue in the late seventeenth and eighteenth century, with the cabinet pictures which were hung in it usually of genre subjects, and normally small in size, from the minor Dutch masters especially.

It is ironic that two charming oil panels by Storck, which in a sense combine William Windham's two passions, were in fact bought later by a relative. Dutch seascapes and Italian views are combined in these — 'An Italian Seaport with a Fountain of Neptune' and 'An Italian Seaport with the Ruins of a Classical Temple'.

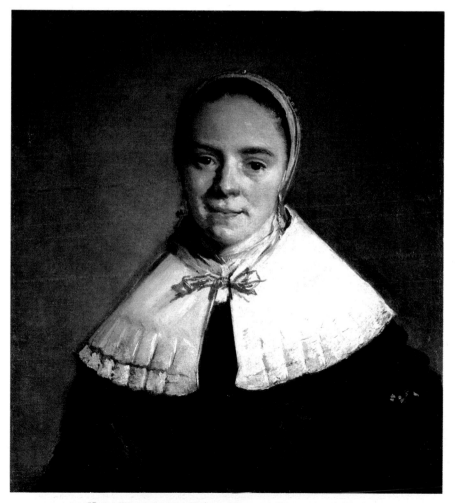

Hals: 'Portrait of a Young Woman' (*Ferens Art Gallery*)

FENTON HOUSE

NT MAP K

Hampstead Grove, London
Tel (01) 435 3471

The collections displayed in this handsome house of the 1680s are primarily of early musical instruments and of porcelain. There is in addition a loan collection of work by William Nicholson, comprising portraits, landscapes and some of his admirable still-lifes. There is a miscellany of other pictures, including a portrait by Lawrence of William IV as Duke of Clarence.

FERENS ART GALLERY

MAP D

Queen Victoria Square, Hull
Tel Hull (0482) 222750

Hull's lively Ferens Art Gallery is centrally sited and handsomely appointed. It holds an extensive collection of pictures — Netherlandish, old masters, British painting from the seventeenth century, nineteenth-century French pictures, and a large group of twentieth-century British painting.

Hals's 'Portrait of a Young Woman' is the outstanding picture of the first group, a remarkably sensitive and vivacious portrait. Other works in this group include pictures by Gheeraerts, van der Helst, Brekelenkam, Fabritius, van Goyen and Gysbrechts.

The impressive old masters include 'Annunciations' from both Maffei and Philippe de Champaigne, affording an interesting contrast in the styles and methods of these two contemporaries. Canaletto's picture here is 'View on the Grand Canal', while Guardi's for once is not a view but a tall narrow painting, part of the decoration of a Venetian palazzo, with a scene from a popular romance. British painting from the seventeenth and eighteenth centuries includes portraits by Dobson, John Riley, Hogarth, Arthur Devis and

Cotes, with landscapes by Constable, Richard Wilson, Ibbetson and Bonington. Nineteenth-century British art includes work by Callcott, Stanfield, Pettie, Butler, Leighton and Elwell, but this period is dominated here by the extensive collection of marine pictures, a large and (outside London) unrivalled display. Hull's own John Ward, Anderson, Redmore and Grimshaw are among the many artists represented, matching earlier masters also included in the Ferens collection, such as Willem van de Velde the Younger and Ludolf Backhuysen.

From the twentieth century, Steer's splendid 'Boulogne Sands' is here, as is Sickert's 'The Hotel Royal, Dieppe' and contributions from Gore, Gilman, Matthew Smith, Grant, Wadsworth, Bomberg and Lewis. There is also a group of portraits, in which work by Rutherston, Hamnett, Kelly and Augustus John is included. More modern work includes paintings by Davie, Bridget Riley, Hockney and Auerbach.

FIRLE PLACE

HHA MAP J

Lewes, E. Sussex
5m E of Lewes on Eastbourne road (A27)
Tel Glynde (079 159) 335

Firle Place is as beautiful as is its situation below the South Downs — a Tudor house remodelled in Georgian times. The pictures here are both numerous and impressively high in quality. Almost the first picture the visitor sees is a large and resplendent group portrait by van Dyck. This is an early work of great splendour which portrays John, Count of Nassau, and his family. One of the descendants of the young children in the picture was later to marry the 2nd Earl Cowper; the Cowper collection descended to the Desborough family, and, through the wife of the 6th Viscount Gage, it came in part to Firle Place.

The notable family portraits include a Gainsborough of the 2nd Viscount Gage, and a somewhat strange Reynolds of the Viscount's

brother-in-law, Lord Eardley, as an undergraduate. There is also a charming Arthur Devis portrait of the 2nd Viscount. There are further portraits by Reynolds, and contributions from Johnson, Richardson, Copley, Hoppner, Lawrence and Beach. There is a Watts portrait of C. W. Grenfell, and his descendant Lord Desborough is portrayed by Cope. The 7th Viscount Gage sat to his near neighbour and tenant, Duncan Grant.

There is a spirited portrait by Zoffany of the 3rd Earl Cowper, shielding himself from the sun with his tricorne hat. Zoffany had been sent to Florence to paint his celebrated picture, now in the Royal Collection, of 'The Tribuna of the Uffizi' — a group of English noblemen in Florence in the 1770s, together with many of the pictures and sculptures they admired and, in some cases, purchased. One of those depicted is Cowper. His portrait (and that of his wife) was painted during Zoffany's time in Florence. Cowper had prolonged his Grand Tour to the point of settling in Florence permanently, entertaining lavishly and collecting assiduously. Zoffany's picture conveys something of the quirkiness of this engaging figure.

Many of the pictures which he bought during his years in Florence are at Firle Place today. Dominant among these is the 'Holy Family' of Bartolommeo. There is work by Franciabigio, and by Puligo, another follower of del Sarto. There is a head of Christ by Correggio, and examples of the work of Rubens, Moroni, Tintoretto, Guardi, Marieschi, Zuccarelli, Panini and Salvator Rosa.

One of the masterpieces from the Desborough collection is 'Landscape with Windmills' by de Koninck, one of the most striking of panoramic

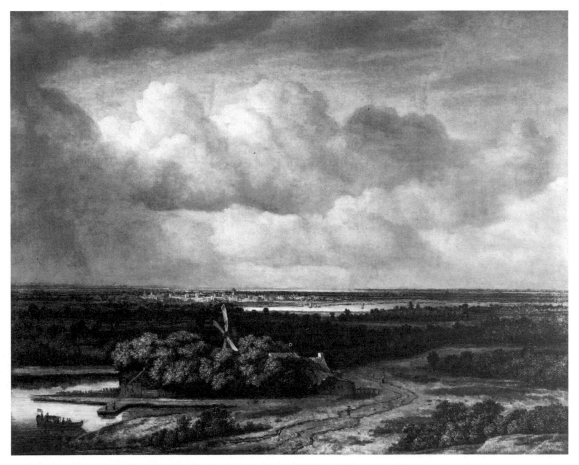

de Koninck: 'Landscape with Windmills' (*Firle Place*)

views, so much suited to the landscape of Holland, and so popular in England, especially in the eighteenth century, when this example, along with many others, first found its way to this country.

THE FITZWILLIAM MUSEUM

MAP F

Trumpington Street, Cambridge
Tel Cambridge (0223) 332900

A visit to Cambridge is always exhilarating; of all the many splendid things to see and to enjoy, none is more rewarding than the Fitzwilliam Museum, where a magnificent collection includes a fine assembly of pictures. The museum, thought by many to be the finest small museum in Europe, is housed in a centrally-sited, purpose-built and noble neo-classical building, designed by George Basevi in the 1830s, but finished under the supervision of C. R. Cockerell (the architect of the Ashmolean Museum in Oxford) after Basevi's death in 1845. There have been several subsequent additions.

The museum takes its name from its founder, the bachelor 7th Viscount Fitzwilliam (1745–1816), a rich and passionate collector of pictures, books, manuscripts and prints. A former undergraduate of Trinity Hall, Fitzwilliam left his collection to Cambridge University, with £100,000 for a building in which to house it. Fitzwilliam's portrait, by Wright of Derby, is in the museum. The pictures in his collection included magnificent paintings by Veronese, Palma Vecchio and Titian, many Dutch paintings and work by Canaletto and Bellotto. Numerous benefactions have followed this magnificent beginning, many of them stimulated by the famous Sir Sydney Cockerell, director from 1908 until 1937. Especially notable bequests came from Charles Fairfax Murray (d. 1919) and the 2nd Lord Fairhaven (d. 1973).

There is an exceptional number of early Italian paintings at the Fitzwilliam. These include three splendid panels by Martini, sophisti-cated and rich in colour, and thought to have been painted in the 1320s. There are two panels by Domenico Veneziano, delicate in colour, with careful and precise perspective and filled with charm. Another, a fine panel by Bernardino Pintoricchio, 'Virgin and Child with St John the Baptist', is also rich in colour and balanced with a delightful landscape background. There is later Italian work of great splendour, including Veronese's 'Hermes, Herse and Aglauros', a fine late example of the artist's work. It is an unusual subject, taken from Ovid's *Metamorphoses*, and demonstrates Veronese's characteristic love of sumptuous settings and rich materials; Palma Vecchio's 'Venus and Cupid' is one of his finest works, with a voluptuous Venus reclining in a landscape. This picture makes a fascinating contrast with Titian's 'Venus and Cupid with a Lute-player'. These three were all bought by Fitzwilliam from the dispersal of the famous Orleans Collection, and the Titian, with its casual and evident sensuality, makes a further contrast with the same painter's violent and disturbing 'Tarquin and Lucretia', painted, amazingly, when the artist was in his eighties.

Two rarely-seen artists are Joos van Cleve, with an admirable 'Virgin and Child', and Jacques Fouquier, whose 'Winter Scene' is the only example of his work in an English public collection. Likewise unique in Britain is Liss's 'A Bacchanalian Feast'. Rubens has several small oil studies of swift virtuosity in the Fitzwilliam, also a complex and spirited 'Death of Hippolytus', and 'Head of a Bearded Man', a vigorous study, taken from life, and kept in the studio as working stock-in-trade, for future inclusion in an appropriate place — in this case the head was used to represent Caspar in an Adoration. Van Dyck's 'Virgin and Child' is a rare example of one of his devotional pictures in an English public collection (though another admirable one is in the Ashmolean and they are to be seen occasionally in country houses, most strikingly at Corsham Court). This vastly appealing image dates from the three years he spent in Antwerp, after his return from Italy and before his departure for England. It clearly shows how he fused, with the utmost skill, the teaching of his master, Rubens, with all the influences of

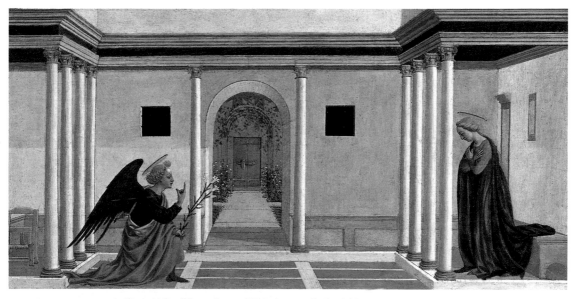

Domenico Veneziano: 'The Annunciation' (*Fitzwilliam Museum*)

the masterpieces he had seen during his time in Italy.

There is a large collection of Dutch and Flemish work from the seventeenth century. This includes a brilliant late 'Portrait of a Man' by Hals, an unusual oval-shaped 'Sunset after Rain' by Cuyp (much admired, and copied by Gainsborough), together with work by such artists as Jacob van Ruisdael (with four landscapes), van Goyen, van der Neer, Hobbema, Steen, Simon Verelst, Pynacker and many more. The little-known Berckheyde demonstrates in a pair of pictures his ability as a topographical town-artist, well before Canaletto and Bellotto perfected the art.

There is a large collection (bequeathed by the 2nd Lord Fairhaven), separately shown, of flower paintings, in which the work of van Huysum is prominent, with twelve pictures marking the months of the year; the work of Ruysch is also notable. These Dutch examples are joined by work from Melanie de Comolera, who held the unusual appointment of Flower Painter to Queen Adelaide and to Queen Victoria.

The English collection at the Fitzwilliam includes one of Eworth's finest portraits, long supposed to have been of Queen Mary I as a princess, but now accepted as of an unknown lady, though possibly named Mary. All well-known British artists of the eighteenth century are represented. Hogarth has some excellent pictures here, such as the small and fiercely satirical 'The Bench', as well as his near-pornographic, and very entertaining 'Before' and 'After' (a deliberate parody of the elegant erotica of French rococo painters). Gainsborough's 'Heneage Lloyd and His Sister' has all the almost naive charm of his early work, with the two figures, elegantly dressed, disposed in a landscape. Highmore's four illustrations for Richardson's *Pamela* are notable, as are Stubbs's two paintings, and Raeburn's superbly sensitive portrait of William Glendonwyn, lit with marvellously-painted golden light.

There are a number of Constable's pictures, including two portraits, and one of the pictures he painted in the Brighton area in the 1820s — 'Hove Beach'. Work by Bonington, de Wint, Müller and Cox is also noteworthy. Beaumont is represented; he was the collector who, in effect, started the National Gallery, and was himself a talented amateur artist.

Many English nineteenth-century artists have work at the Fitzwilliam. Well-known figures such as Landseer, Leighton, Millais, Etty, Ford Madox Brown and Holman Hunt are joined by less familiar artists such as Egg, Lear and

Elmore. Elmore's 'On the Brink' marks his transition from a history painter to a talented interpreter of contemporary life, often, as in this example, with strong moral undertones.

Among the twentieth-century British work, that of Augustus John is especially noticeable, particularly his portrait of Thomas Hardy, and examples of his work in France before the First World War, with his growing family much in evidence. His sister Gwen is also represented, as are Sickert, Gilman, Gore, Matthew Smith, Paul Nash, Steer (with one of his entrancing Walberswick studies), Bomberg and Stanley Spencer. A remarkable benefaction by Dr Alastair Hunter established an important nucleus of more internationally celebrated twentieth-century work, ranging from a Picasso cubist picture to characteristic work of the American post-war movements.

Probably the most popular group of paintings in the Fitzwilliam is the assembly of work from

Fantin-Latour: 'White Cup and Saucer' (*Fitzwilliam Museum*)

France. This is wide-ranging and includes examples from artists not often seen in this country, such as Bourdon, Lebrun, Vouet, Pater, Oudry, Lancret, as well as the better-known Nicolas Poussin and Claude, here represented by a small and glowing landscape painted about 1639 for Pope Urban VIII, and featuring the Pope's newly-built summer residence at Castel Gandolfo.

Later work from France also includes artists relatively unfamiliar in Britain, such as Couture,

Desportes, Delacroix, Picot, Bonvin and many more. Fantin-Latour is represented by two small but superb still-lifes of unforgettable simplicity and quiet power.

Corot and Courbet introduce the better-known French nineteenth-century artists, including many of the very finest, such as Cézanne, Manet, Sisley, Seurat, Camille Pissarro, Gauguin, van Gogh, Théodore Rousseau, Bonnard, Monet (with a delightful 'Le Printemps'); Degas — with a dashing study, 'Au Café' (almost as quick and immediate as his

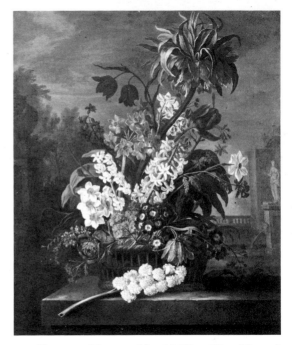

van Huysum: 'Flowers, March' (*Fitzwilliam Museum*)

drawings, of which the Fitzwilliam has a fine collection) — Derain, Matisse, Dufy and Picasso.

Perhaps, however, the visitor will carry away from this enchanting collection an especially happy memory of two absolute masterpieces by that very uneven painter, Renoir: the fine landscape 'Le Coup de Vent', which was probably exhibited at the first Impressionist exhibition of 1874, and the beautiful 'Place Clichy', once the property of the master-collector Samuel Courtauld, a wonderfully evoked vision of contemporary life.

FLETCHER MOSS MUSEUM AND ART GALLERY

MAP C

Stenner Lane, Didsbury, Greater Manchester
Tel Manchester (062) 445 1109

Most of the paintings at the Fletcher Moss Museum and Art Gallery, a branch of the Manchester City Art Gallery, are by artists from the north-west of England. The Preston-born Arthur Devis is represented by a double portrait. Sir Richard Arkwright, that pillar of the Industrial Revolution, is appropriately portrayed by Wright of Derby. There are also many pictures by Frederick Shields, Manchester's most prolific nineteenth-century artist.

FORTY HALL

MAP K

Forty Hill, Enfield, London
Tel (01) 363 8196

Forty Hall Museum, housed in a Jacobean house, is mainly devoted to eighteenth-century drawings and water-colours; but it also contains 'The Dell' by Constable.

GAINSBOROUGH'S HOUSE

MAP G

46 Gainsborough Street, Sudbury, Suffolk
Tel Sudbury (0787) 72958

Thomas Gainsborough was born in this modest town house in 1727, soon after the artist's father had added the fine brick façade. It now houses a collection of Gainsborough relics, including some pictures from the great artist's early days, when he was feeling his way and painting portraits of local worthies.

Gainsborough's nephew's 'Children in a Landscape' is to be seen, and a later, major, landscape of his own was a triumphant acquisition in 1987. Gainsborough's house is as evocative as it is interesting.

GAWSWORTH HALL

MAP C

Macclesfield, Cheshire
3m SW of Macclesfield on Congleton road (A536)
Tel North Rode (026 03) 456

The ancient black-and-white half-timbered Gawsworth Hall is now the home of the Richards family, after centuries of occupation by the Fittons, followed by the Stanhopes, Earls of Harrington. There are some portraits here of former occupants, including a fine example of Ramsay's work. There is also an unusual Jacobean portrait of Anne, Lady Fitton, where the stiffness and formality of the normal 'Jacobethan' portrait of the time has eased towards playfulness, character and style.

To suit the low-ceilinged rooms, the pictures at Gawsworth are of modest size; among them are works by Wilkie, Turner, Constable, George Morland, Reynolds and J. S. Cotman.

GAWTHORPE HALL

NT MAP C

Burnley, Lancs
3m NW of Burnley on Clitheroe road (A671)
Tel Padiham (0282) 78511

Gawthorpe Hall, a late Elizabethan house skilfully altered in the nineteenth century, has some Shuttleworth family portraits as well as a number of pictures, from the seventeenth century, loaned by the National Portrait Gallery, including work by Kneller, from J. M. Wright's studio and a version of Lely's 'Duchess of Cleveland'.

111

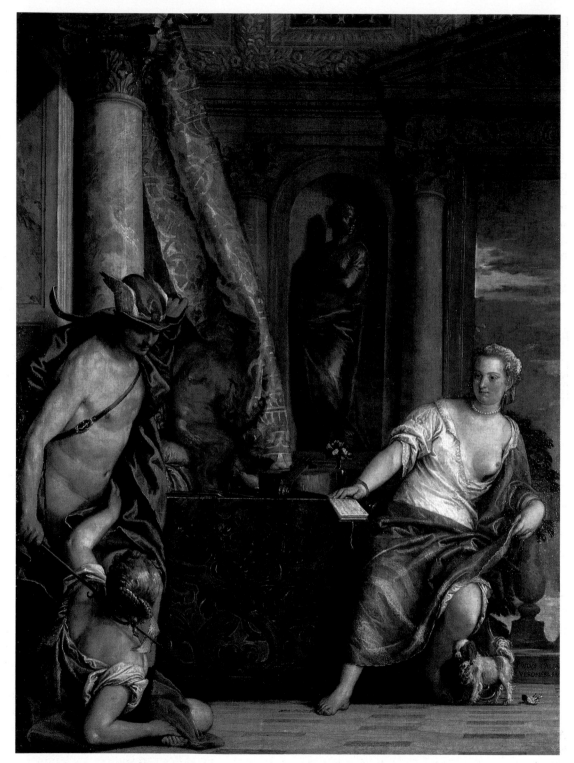

Veronese: 'Hermes, Herse and Aglauros' (*Fitzwilliam Museum*)

THE GEFFRYE MUSEUM

MAP K

**Kingsland Road, Shoreditch, London
Tel (01) 739 8368**

The Geffrye Museum, charmingly housed in a range of former eighteenth-century almshouses, contains a series of modest-sized domestic rooms, from Elizabethan to the 1930s, all carefully filled with contemporary furnishings. These include a number of apposite pictures, amongst which is a notable double portrait of George Moser and his wife by Tuscher, a self-and-family portrait by Beale, and a portrait of a gentleman by Batoni.

GLOUCESTER CITY MUSEUM AND ART GALLERY

MAP E

**Brunswick Road, Gloucester
Tel Gloucester (0452) 24131**

Gloucester Museum and Art Gallery has some eighteenth-century British paintings, including work by Richard Wilson and by Gainsborough. William Turner of Oxford is represented, as are Rothenstein and Steer.

GLYNDE PLACE

HHA

MAP J

**Lewes, E. Sussex
4m E of Lewes off Eastbourne road (A27)
Tel Glynde (079 159) 248**

A mile or so from the world-famous Glyndebourne Opera House is Glynde Place, an Elizabethan house with a complicated dynastic history. Passing by descent since at least the twelfth century; not always to male heirs, it has been owned successively by Waleys, Morleys, Trevors and Brands. It is now the home of Lord Hampden. The family portraits include work by Coques, Johnson, Lely, Kneller, Copley, Zoffany and Greuze. There is also a number of other pictures, mainly Dutch.

GODINGTON PARK

HHA; GT

MAP J

**Ashford, Kent
1½m W of Ashford, off Maidstone road (A20)
Tel Ashford (0233) 620773**

Godington Park is a handsome Dutch-gabled house, Jacobean in appearance, but including earlier work. There are portraits here by Johnson, Lely, Kneller, Raeburn (with two fine portraits of Scottish judges), Birley and Elwes. There is also a modest number of other pictures, with work by van Leen, Castiglione, Nasmyth and Wouwerman.

GODOLPHIN HOUSE

HHA

MAP H

**Helston, Cornwall
5m NW of Helston, between Townshend and
Godolphin Cross
Tel Penzance (0736) 762409**

In the picture collection at Godolphin House, in far western Cornwall, there is a portrait of one of the most famous horses in history, one of the founding fathers of English bloodstock. This is 'The Godolphin Arabian', painted by Wootton with a background of classical arches and an Italian-looking landscape.

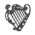

113

GOODWOOD HOUSE

HHA MAP J

Chichester, W. Sussex
3½m NE of Chichester, off Midhurst road (A286)
Tel Chichester (0243) 774107

The famous Goodwood House, home of the Dukes of Richmond, has many fine paintings within its flint walls. The best known are the van Dyck portraits, the first two pictures done by Canaletto after he arrived in England in 1746,

and the three splendid groups by Stubbs.

Royal and family portraits overlap here, as the 1st Duke was a bastard son of Charles II. Van Dyck's large group of Charles I with his Queen and his two elder children, seated in state with Westminster and the Thames in the background, is a fine example of the swagger and style which the artist could put into his most formal work. More intimate and charming is his picture of the five children of Charles I and an enormous dog; this is the actual picture which once hung in the breakfast room at Whitehall Palace — there must be scores of copies and versions, of varying degrees of proficiency, in

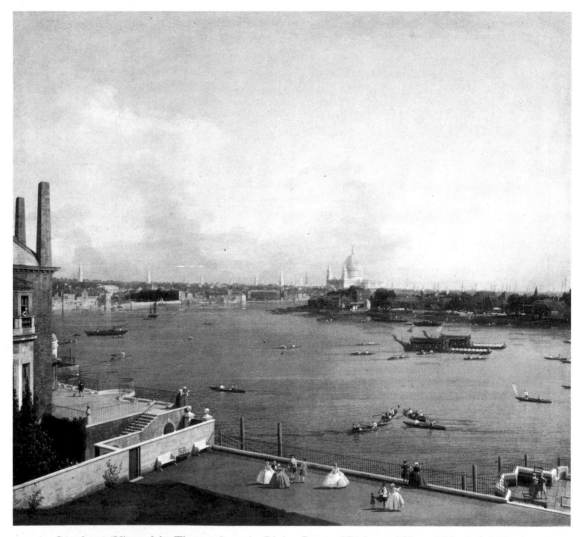

Canaletto: 'View of the Thames from the Dining Room of Richmond House' (*Goodwood House*)

country houses all over England.

Many other famous portraitists are to be found here: Lely (with, among others, a classical portrait of Frances Stewart, who modelled for Britannia on the coinage), Wissing, Gascars, Kneller, Pourbus, Reynolds, Romney, Rigaud, Sanders, van Loo, Vanderbank, Hudson, Hoppner, and Lawrence, with his magnificent full-length of the 5th Duchess.

The pair of Canalettos were commissioned by the 3rd Duke, and are familiar from innumerable reproductions. Both were done from upstairs windows in Richmond House, whose site is marked today by Richmond Terrace, one looking northwards across the former Privy Garden and up Whitehall; the other looks north-eastwards, over the house's riverside terrace, across the broad sweep of the then unembankmented Thames to the City and St Paul's, with the spires of Wren's churches evident at many points. Both these splendid compositions, so full of historic interest, and so exact, are painted with superlative skill and panache, and are generally considered to be the masterpieces of Canaletto's English period.

The three Stubbs pictures were painted early in his career, when he was staying at Goodwood. They show the 3rd Duke and his friends at country pursuits, attended by their liveried servants and superbly mounted. They are seen out with the Charlton hunt, watching racehorses training on the Downs above the house, and shooting, on foot, but with horses nearby. As in all Stubbs's work, the portraiture of the animals and of the servants is as careful as that of the masters and the patron.

GORHAMBURY HOUSE

HHA MAP F

St Albans, Herts
2m W of St Albans on A4147
Tel St Albans (0727) 54051

The peaceful and graceful Gorhambury, serene in its broad acres between St Albans and the M1, contains a prodigious portrait collection, assembled over the centuries by the Grimston and Bacon families, extraordinary in its extent and its scope.

It begins — or should begin — with one of the earliest English portraits. Dated 1446, it was painted when Edward Grimston, as ambassador to the Burgundian court, sat for Christus. The picture, however, is of such importance in the history of English portraiture that it is on permanent loan to the National Gallery, with a large photographic copy on display at Gorhambury.

From this startling beginning, the family portraits continue in an unbroken sequence to the present day, with many well-known names making their contribution to a large number of admirable pictures. A visit to Gorhambury provides a complete introduction in miniature to the history of the portrait in England.

In addition to the family portraits, although sometimes overlapping with it, there is, mainly in the great hall, a large assembly of pictures of persons of distinction of the seventeenth century, a 'Gallery of the Great' collected in that century by Sir Harbottle Grimston. There is a notable three-quarter-length portrait of Queen Elizabeth I ascribed to Nicholas Hilliard; this is quite different from the usual, formal icons seen elsewhere, with mask-like features, and one feels that it must record the Queen's actual appearance. There is a striking van Somer portrait of Sir Francis Bacon, Lord Chancellor, while the supremely talented Sir Nathaniel Bacon is represented by a large and elegant self-portrait (his only known full-length), with a small portrait of his wife and two large still-lifes.

Some of the best of the family portraits from the seventeenth century come from Riley and from Wissing. The latter produced an exceptionally fine picture in his portrait of Mary Grimston, painted around 1684 before her early death. Holding a pomegranate (possibly as a symbol of virginity), she off-handedly plucks a grape from a dish of fruit offered by a negro page-boy. In the crowded background lurks a mysterious palace. The eighteenth-century section is dominated by Reynolds's group portrait of four children of the 2nd Viscount Grimston, and there are admirable contributions from Ramsay, Batoni, Hoppner, Hudson and Cotes.

It cannot be said that the portraits from the Victorian era are very striking, but the collection ends with a flourish in the twentieth century, with fine pictures by Birley, de László and Spear's portrait of the 6th Earl of Verulam.

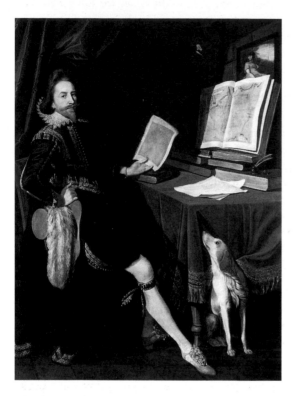

Sir Nathaniel Bacon: 'Self-portrait' (*Gorhambury*)

GRAY ART GALLERY

MAP B

Clarence Road, Hartlepool, Cleveland
Tel Hartlepool (0429) 66522

The Gray Art Gallery and Museum, housed in a Victorian villa in the 'New Town', has a collection that includes work by Maclise, Stanfield and Forbes.

GROSVENOR MUSEUM

MAP C

Grosvenor Street, Chester
Tel Chester (0244) 321616

The Grosvenor Museum's collection of pictures concentrates on Cheshire portraits and on local topographical views. There is work by Souch, J. M. Wright, van Somer, Opie and Finnie. The sporting artists Daniel and Henry Clowes, and Tasker are also represented.

GRUNDY ART GALLERY

MAP C

Queen Street, Blackpool, Lancs
Tel Blackpool (0253) 23977

In Blackpool, the Grundy Art Gallery has a collection of British art from the nineteenth and twentieth centuries. This includes pictures by such artists as Creswick, Linnell, von Herkomer and Leader. Augustus John is there (with a portrait of T. E. Lawrence). So too are Ravilious and Laura Knight, and Paul Nash with 'Sanctuary Wood', one of his finest First World War pictures.

GUILDHALL

MAP F

High Street, High Wycombe, Bucks
Tel High Wycombe (0494) 26306

In the Guildhall is a very large painting by J. H. Mortimer, originally in the parish church — 'St Paul Preaching to the Britons'. A pupil of Hudson, Mortimer won the Society of Arts prize in 1764 with this picture.

GUILDHALL

MAP G

Norwich
Tel Norwich (0606) 666071

There are portraits of mayors, aldermen and other city worthies in the Norwich Guildhall; There are others in the council chamber of the nearby 1930s city hall; and yet more, not far away, in St Andrew's Hall. All three places are open to the public if not otherwise in use. Most of the portraits are from the eighteenth century, including several by the elder J. T. Heins.

GUNBY HALL

NT MAP D

Burgh-le-Marsh, Lincs
7m W of Skegness on Horncastle road (A518)
Tel Scremby (075 485) 212

Built in 1700, Gunby Hall, the home of the Massingberd family, has portraits of this family, including two by Reynolds. These are of his friend Bennet Langton and his wife, who were connected by marriage with the Massingberds. Reynolds's portrait of his friend is far from the grand pictures by which he made his living; this is an affectionate, relaxed and penetrating study of a well-liked companion.

HAGLEY HALL

MAP E

Stourbridge, W. Midlands
12m SW of Birmingham on Kidderminster road
(A456)
Tel Hagley (0562) 882408

The Lyttelton family still live at Hagley Hall, a compact and elegant Palladian mansion built in the 1750s. The family's fine possessions, including the pictures, are very accessible to the visitor.

As in many other houses, ancestral portraits

predominate; but there is plenty more to be seen — Zuccarelli landscapes, 'The Dead Christ' by van Dyck, a Wootton landscape, a Bampfylde coastal scene, pictures and a ceiling by Cipriani and a famous Holbein-like 'The Misers' by van Rymerswaele.

Family portraits include examples by van Somer, Reynolds, Richard Wilson (normally a landscape painter), Ramsay and West. There is a combined portrait and battle-scene by Wootton, and an unusual Batoni, in that it portrays a mature Lyttelton ancestor, rather than a young man on the Grand Tour. Earlier work includes examples by Lely, Jervas and Riley.

HALL I' THE WOOD

MAP C

Green Way, Bolton, Greater Manchester
Tel Bolton (0204) 51159

The extravagantly half-timbered Elizabethan Hall i' the Wood, a branch of Bolton Art Gallery, is furnished with appropriate oak furniture, and the walls are hung with similarly appropriate pictures. Among them is a modestly important Elizabethan portrait, of the poet Sir Philip Sidney by John de Critz (once in Lord Chesterfield's collection of portraits of poets).

HAM HOUSE

MAP K

Richmond, Surrey
Tel (01) 940 1950

Ham House's baroque interior is, seemingly miraculously, preserved almost unaltered from the date it was created, in the high fashion of the 1670s, by the Duchess of Lauderdale, wife of one of Charles II's ministers.

There is a portrait of her at Ham House, painted by Lely in her youth, in the 1640s; an unusually beautiful picture, silvery and ro-

mantic. This contrasts strangely with his much later double portrait of the Lauderdales: they both had reputations for rapacity, which these unflattering but formidable likenesses do nothing to dispel. Other portraits, including works by Johnson, Vanderbank, Kneller and Constable (unusually with copies after Reynolds and Hoppner), are spread through the house, notably in the hall and in the gallery. The gallery is an especially fascinating room with the pictures in their original 'Sunderland' frames — among which a group of fine Lelys (including one of the Duchess) and J. M. Wright's portrait of the Cavalier Colonel John Russell stand out.

Throughout the house there are painted ceilings, and many pictures, often Dutch, inset as overmantels, overdoors and otherwise as an integral part of the scheme of decoration. Four splendid sea pictures by Willem van der Velde the Younger, for example, are inset as overdoors in, of all places, the Duchess's bedroom. Work by other notable artists at Ham House include pictures by Danckerts, Dou, Wynants, Bloemaert, Mercier, Vroom, van der Bergen and Thomas Wyck, who contributed several pictures, including 'The Alchemist' in the Duke's closet, a good example of a subject thought appropriate at the time for such intimate rooms.

There is an early copy of the lost Andrea del Sarto 'Pinti Madonna'. Works by interesting, if minor, painters of the occupants' period include a charming little group ascribed to Joan Carlisle (a very rare, female, precursor in the 1650s of the 'conversation piece', the small informal portrait group which was to become very popular in the eighteenth century); two paintings of birds (one dated 1673) by the first British sporting painter, Barlow; and canvases of high accomplishment by Ferguson, a Scotsman who worked mainly in Holland.

HAMPTON COURT PALACE

EH MAP J

East Molesey, Surrey
Tel (01) 977 8441

The Thames-side Hampton Court Palace is a glorious and compelling combination of the Tudor magnificence of Cardinal Wolsey's original palace, and the superb state rooms designed by Wren for William III, whose favourite residence this was. Wren's rooms are wonderfully adapted to the display of tapestries and pictures.

Queen Victoria, who greatly preferred Windsor, opened Hampton Court to the public in 1838, within eighteen months of coming to the throne; it had, like many country houses, been unofficially accessible before this time, but only to those who were able to tip the housekeeper or steward sufficiently.

Many other former — and current — royal houses are now accessible to the public:

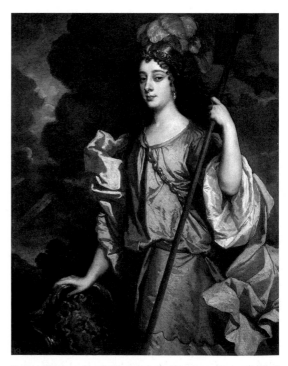

Lely: 'Countess of Cleveland' (*Hampton Court Palace*)

Greenwich, Kew, Kensington, Osborne, Sandringham and Windsor. There are, however, more rooms to be seen at Hampton Court than at any of the others; and there is more to be seen here — about five hundred examples — of the large and immensely rich royal picture collection.

The disastrous fire of March 1986 damaged both the Wren building and the picture collection, though only one painting was totally destroyed. It is hoped that the huge and painstaking task of restoring the damage will be completed by 1991, by which time all of the artistic treasures should be back in place. Until then, a few of those mentioned here may be temporarily in store or on show elsewhere.

The first interior which the visitor encounters is the King's staircase, its walls and ceiling decorated by Verrio with classical themes. Verrio, who worked at Hampton Court from 1700 until his death in 1707, was also responsible for the decoration in William III's bedroom, the King's dressing room, which has scenes concerning Mars and Venus, the Queen's dressing room, and William III's separate banqueting house, in the gardens overlooking the Thames. The Queen's bedroom has a notable ceiling ('Aurora Rising from the Waves') by Thornhill, who also decorated the chapel royal and the royal pew. Kent did some decorative work here, in the Cumberland suite and in George II's public dining room. Earlier unknown sixteenth-century artists had worked at the lavish decorations in Wolsey's closet, either for the Cardinal, or for Henry VIII, to whom he gave the palace in 1525, in a desperate and unsuccessful attempt to retain the King's favour.

Though restricted to those painted before the palace was completed, there are portraits here in abundance. There is work by Mabuse ('The Children of Christian II of Denmark'). Attributed to van Cleve is a portrait of Henry VIII which shows a very different person, and far more humane, from the image made familiar from Holbein's portraits. There is a small-scale copy by van Leemput of the Holbein wall-painting that was destroyed when Whitehall Palace was burnt down in 1698, a painting depicting Henry VII with his wife, Elizabeth of

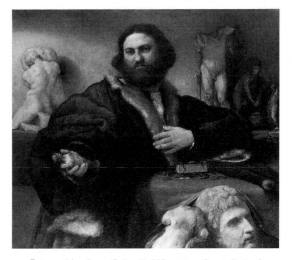

Lotto: 'Andrea Odoni' (*Hampton Court Palace*)

York, Henry VIII and Jane Seymour (who died at Hampton Court). Honthorst is here with a portrait of Elizabeth of Bohemia, as well as a huge allegorical canvas, 'Apollo and Diana', with Charles I and his Queen as Jupiter and Juno.

There are several Mytens portraits, including one of Charles I as Prince of Wales, and two of Charles I and Henrietta Maria; though these have a certain naive charm, they illustrate clearly why it was that van Dyck was so immediately successful on his appearance in England soon after they were painted.

Lely contributes a full-length of Anne Hyde, Duchess of York, the mother of both Queen Mary and Queen Anne. Lely's portrait of the latter is here as well, painted when she was a child, with a pet bird on a string. Lely also painted a number of 'Windsor Beauties', ladies of Charles II's court, which now hang here, in a very similar manner to those that hang in the Long Gallery at Althorp.

Kneller likewise produced a series of 'Hampton Court Beauties'. Today, as with the Lely group, one is struck not so much by the beauty of the sitters as by the extraordinary similarity of their features. Kneller also produced a gigantic equestrian portrait of William III, which was painted in 1701, the year before the King died as a result of a fall from his horse in the grounds of Hampton Court.

Bronzino: 'Woman in Green' (*Hampton Court Palace*)

In the profusion of old masters here, many of them of the highest quality, it is all too easy to miss some of the best, such as Massys's portrait of Erasmus; the 'Adoration' by the Master of the Van Groote Adoration; overdoors throughout the state rooms by Jacques Rousseau, Achtschellinck, Bogdany and Liberi; a number of pictures by Tintoretto, 'Esther and Ahasuerus', 'Head of an Old Man', 'Portrait of a Man', 'Nine Muses', 'A Venetian Senator' and 'A Knight of Malta'; Veronese's 'Adoration of the Magi' and his 'Marriage of St Catherine'; Lotto's 'Portrait of a Man', 'Andrea Odoni', and 'Portrait of a Man with a Trap'; Palma Vecchio's 'Virgin and Child and St Catherine and St John'; Bassano's 'Self-Portrait' and 'The Good Samaritan'; Franciabigio's 'Jacob Cennini'; Dossi's 'St William' and 'Virgin and Child with Saints Anne, Peter and Paul'; Raphael's youthful self-portrait; Correggio's 'Virgin and Child with Saints'; Bronzino's 'Portrait of a Woman in Green'; Holbein's portrait of the printer Frobenius and his 'Noli me Tangere'; Joos van Ghent's portrayal of Federico, the famous Duke of Urbino and his son listening to an oration; Parmigianino's 'Minerva' and 'Portrait of a Boy'; Andrea del Sarto's 'Holy Family'; Vouet's 'Diana', Orazio Gentileschi's 'Joseph and Potiphar's Wife'; Strozzi's 'Concert'; 'Christ in the House of Simon', a huge canvas by Sebastiano Ricci and his 'Continence of Scipio'; Pietro da Cortona's 'Augustus and the Sibyl'; Annibale Carracci's 'Il Silenzio'; de la Tour's 'St Jerome', the only example of this master's work in London, with only two others in England (at Leicester and at Stockton); Feti's 'Sacrifice of Elijah'; Giordano's 'Psyche Feasting' and 'Psyche Honoured'; Ribera's portrait of Duns Scotus; Joos van Cleve's 'Self-portrait', 'Portrait of the Artist's Wife' and 'Holy Family and Angels'.

From the Low Countries come Pieter Bruegel's 'Massacre of the Innocents', an event taking place in snow, as must have seemed appropriate to a northern artist; Bloemaert's 'Wedding of Cupid and Psyche'; Mor's 'Charles V'; works by Teniers, de Hooch, van Ruysdael and Molenaer (including 'Dutch Merrymaking').

The former lower orangery, approached through part of the splendid gardens, has been adapted as a special gallery for a single work. This is Mantegna's finest achievement — his nine large, square panels of 'The Triumph of Julius Caesar' painted for the ruling family of Mantua. This majestic masterpiece was Charles I's largest purchase, which luckily survived the sales of royal pictures held under the Commonwealth, perhaps because Hampton Court was kept for Cromwell's use. Together, the pictures present a worm's-eye view of the elements of a Roman triumph — an official procession through Rome by victorious generals, in this case Julius Caesar after the conquest of Gaul. There are soldiers, captives, booty, trumpeters, banners, elephants and, finally, Caesar himself, a gravely introspective figure rather than a triumphal general. It seems right that these pictures should have their own gallery where they can be studied and admired in a peaceful and elegant atmosphere. Painted near the end of the fifteenth century, they heralded a new age of artistic perception in the High Renaissance; now, mostly recently restored from the attrition of the centuries, they are still magnificently impressive.

Tintoretto: 'The Milky Way' (*Hampton Court Palace*)

HANBURY HALL

NT MAP E

Droitwich, Hereford and Worcester
3½m E of Droitwich, off B4090
Tel Hanbury (052 784) 214

The most remarkable works of art at Hanbury Hall are the elaborate painted walls and ceilings of the main staircase. Thomas Vernon built the house in 1701 and the paintings were an expensive afterthought. He did well to get the services of Thornhill (who had been working for a Herefordshire neighbour at Stoke Edith) who was later to be famous for his work at Greenwich, in St Paul's Cathedral, and elsewhere. The staircase ceiling shows classical gods and goddesses, curiously mixed with references to the political uproar surrounding the trial of Dr Sacheverell, which occurred in 1710. The walls of the staircase hall and the ceiling of the long room, have classical figures but no current politics. All these large areas are handled with great assurance by Thornhill.

Family portraits in the house include portraits of the builder and his wife, by Kneller; and there are canvases by many others, including Hondecoeter and Monnoyer.

HARDWICK HALL

NT MAP D

Chesterfield, Derbyshire
9½m SE of Chesterfield, off Mansfield road
(A617)
Tel Chesterfield (0246) 850430

Clearly to be seen from the M1, Hardwick Hall is a breathtaking sight, a towering architectural masterpiece, the Elizabethan equivalent of high-tech. This stupendous building, designed by Robert Smythson, was begun when its owner, the amazing Bess of Hardwick was already over seventy years old. After her death, her Cavendish heirs preferred to live at Chatsworth, which led

to the almost miraculous preservation of this house, virtually intact since the death of its formidable builder in 1608.

It also meant, it has to be said, that this was not the place where the cream of the Cavendish family picture collection was kept. Nevertheless, there are some fine portraits here, and an historically important set of likenesses from Bess of Hardwick's time, some of them identifiable in a contemporary inventory. The long gallery is one of the great spectacles of England. The portraits hang on top of the tapestries for which this immense room was 'made to measure' in an unforgettable and unique prodigality. The many portraits here, and throughout the house, include examples of the work of Bettes (Sir William Cavendish), Mytens, Kneller, Dahl, Closterman, J.M. Wright, Wissing and Thomas Barber of Nottingham. Portraits of Mary, Queen of Scots and of Thomas Hobbes also stand out, both by unknown artists. There is a remarkable portrait of Queen Elizabeth, probably the joint work of Hilliard and Lockey.

Equally compelling is the portrait of Bess herself, also attributed to Lockey. Although no doubt a flattering likeness, the onlooker can absorb from this picture a flavour of this resolute woman; ambitious, a collector and builder on a prodigious scale, and a tough lady who lived to be ninety, burying no less than four husbands, each one richer than the last. Her portrait, with its large quadruple necklace of enormous pearls, has probably hung in the long gallery from the day it was built.

HAREWOOD HOUSE

HHA MAP D

Leeds
8m N of Leeds on Harrogate road (A61)
Tel Leeds (0532) 886225

The Palladian exterior of Harewood House was designed by Carr of York; the interior was in the hands of Robert Adam, and the furniture by Thomas Chippendale. There are fine and very important pictures amongst the sumptuous

El Greco: 'Man, Woman and Monkey' (*Harewood House*)

Reynolds: 'Lady Worsley' (*Harewood House*)

decoration, including wall and ceiling paintings by Biagio Rebecca, by Angelica Kauffmann and her husband Antonio Zucchi, and by the Danish artist Nicholas Dall.

Other pictures fall into two groups — family portraits and old masters. The latter includes work by Titian, Veronese, Tintoretto and Ribera. There is a 'St Jerome' by Cima and a fascinating group by El Greco, where the faces are illuminated by a lighted fir-cone. Perhaps above all there is a superb Bellini 'Madonna and Child'.

The Lascelles family portraits include work by Cosway, Gainsborough, Hoppner, Romney, Lawrence, Beechey, Winterhalter, Lavery and William Nicholson; the Princess Royal, married to the 6th Earl of Harewood, was memorably painted by Birley and, in an equestrian portrait, by Munnings. The cream of the portraits at Harewood, however, are the two Reynolds full-lengths of two sisters — Lady Harrington and Lady Worsley, the latter in a stunning red costume.

HARRINGTON HALL

HHA MAP D

Spilsby, Lincs
4m N of Spilsby, off Louth road (A16)
Tel Spilsby (0709) 52281

Lying deep and peaceful in the Lincolnshire countryside, Harrington Hall has a modest picture collection; many of these are Maitland family portraits, including three admirable pictures by Sartorius.

HARRIS MUSEUM AND ART GALLERY

MAP C

**Market Square, Preston, Lancs
Tel Preston (0772) 58248**

The Harris Museum and Art Gallery is large and impressive, dominating Preston's central Market Square. The Art Gallery occupies the upper floor of this building. Its extensive collection of British art is mainly from the nineteenth and twentieth centuries, but it includes a group of pictures by the Preston-born Arthur Devis, as well as topographical paintings by his brother Anthony and portraits by his son, Arthur William. Amongst the former's pictures here are two striking family groups (the Vincents and the Bulls), a portrait of his wife, and two self-portraits — a rather bland likeness of 1737, and a much more deeply felt, almost Rembrandtesque, portrait of 1754.

There is a fine group of nineteenth-century seascapes; Linnell is well represented here, as is Leader, with a large and impressive 'Cambria's Coast'. Other pictures to be especially noted are by Cox, Clausen, Cotman, Leslie, Landseer, Etty and Frith, the latter with a charming and unusual 'The Opera Box'.

From the twentieth century, there are Fry, Stanley Spencer, Matthew Smith, Roberts, and Weight, amongst many more.

HARTLAND ABBEY

HHA MAP H

**Bideford, Devon
15m W of Bideford off Bude road (A39)
Tel Hartland (023 74) 559**

Almost hidden in the remote north-western corner of Devon, Hartland Abbey contains, for the most part, family portraits, notably from painters of West Country origin, including Reynolds, Northcote and Beechey.

HARTLEBURY CASTLE

MAP E

**Kidderminster, Hereford and Worcester
3m S of Kidderminster, off Worcester road (A449)
Tel Hartlebury (0299) 250410**

Hartlebury Castle, with its predecessors on the same site, has been the palace of the Bishops of Worcester for 750 years. In the state rooms there is a complete collection of portraits of successive bishops, including one who was to become Pope Clement VII. Gainsborough and Seeman are among the artists represented.

HATFIELD HOUSE

GT MAP F

**Hatfield, Herts
In Hatfield, opposite station
Tel Hatfield (07072) 62823**

The Cecil family have been servants of the state for many generations. Hatfield House has been the family's principal country home since the time it was built in Jacobean days by Robert Cecil, 1st Earl of Salisbury. The 2nd Earl of Salisbury was painted by Geldorp, standing in the grounds of the newly-built Hatfield House, which can be seen in the background.

Hatfield contains a very fine set of standard portraits of early kings and queens. There is a full-length of James I, another of Charles I by Mytens, and two portraits of Queen Elizabeth, under whom the family rose to fortune and to power. The Elizabethan portraits are called the 'Ermine' and the 'Rainbow' portraits, the latter attributed by some experts to the younger Marcus Gheeraerts. It certainly bears no relation to the monarch's actual appearance at the time it was painted, about the year 1600, but is based on the officially approved image: the 'Mask of Youth', made by the miniaturist Nicholas Hilliard in 1594. Such details as the rainbow which the Queen holds, somewhat in the manner

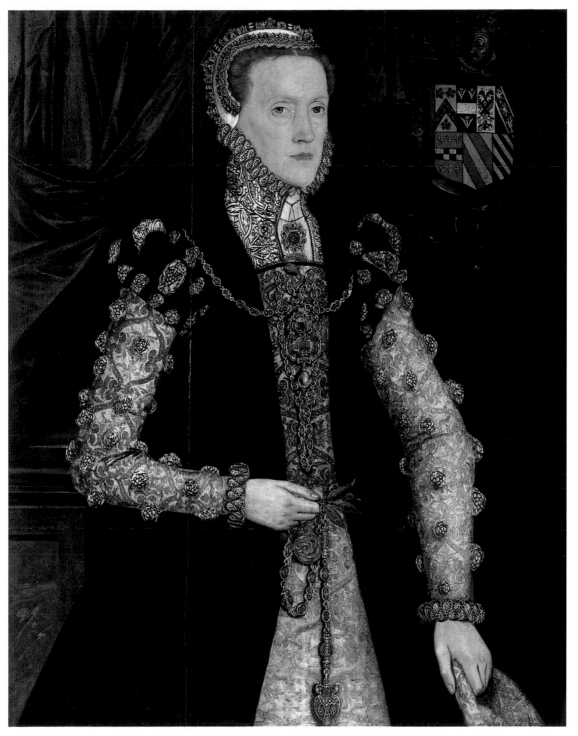

Eworth: 'Mildred, Lady Burghley' (*Hatfield House*)

of a steering-wheel, the embroidered eyes and ears on her golden cloak, the serpent on her sleeve and the spring flowers on her bodice all have, no doubt, symbolic meanings; about these there is debate, but no final conclusions. The other portrait of the Queen is attributed to Hilliard or Segar. It is of earlier date, of high quality and more austere, in very dignified black. Painted about 1585, it is known as the 'Ermine' portrait from the animal that appears in it (signifying chastity).

Portraits dominate the collection, but there are other pictures to be found, including a Rubens 'Man in a Black Hat' and landscapes by Cuyp and by Salomon van Ruysdael. A great rarity is a rendering of Elizabethan junketing at Bermondsey in about 1570 signed by Joris Hoefnagel.

There was a burst of splendour towards the end of the eighteenth century, when the wife of the 1st Marquess was magnificently painted by Reynolds, in a full-length with a landscape background. The Marquess himself sat for Romney and, at a later date, for Beechey. The latter also painted the portrait of George III with Hatfield House in the background, a present from the King to mark a royal visit in 1800. There are paintings too by Gérard and Lawrence from about this time, and Wilkie's full-length of the great Duke of Wellington. In the last century, the 3rd Marquess, three times prime minister and the last to hold that office as a member of the House of Lords, was portrayed in thoughtful style by Richmond, who also painted a Rubens-inspired picture of his wife and his eldest son.

The twentieth-century portraits at Hatfield House have a distinction that is rarely encountered elsewhere. Included among them is an impressive full-length by Philpot and an unfinished and characteristic portrait by Augustus John, stylish and dashing.

HATTON GALLERY

MAP E

Venns Lane, Hereford
Tel Hereford (0432) 267409

The Hatton Gallery is mainly devoted to the work of Brian Hatton, a self-taught artist who was born in 1887 and who died in Egypt during the First World War. In addition there are works by other artists such as Kneller, Cox and Steer, the last with a fine landscape, 'Stroud Valley'.

HAWORTH ART GALLERY

MAP C

Haworth Park, Manchester Road, Accrington, Lancs
Tel Accrington (0254) 33782

The Haworth Art Gallery, named after the family who gave the building and its park to Accrington in 1920, is justly famous for its collection of Tiffany glass, the largest in Europe. There is also a collection of Victorian pictures, which includes work by Leighton, Herring, Shayer and Cooper, as well as a typical Claude Joseph Vernet — 'Storm off the French Coast'.

HEATON HALL

MAP C

Heaton Park, Prestwich, Greater Manchester
Tel Manchester (061) 236 9422

The City of Manchester originally bought Heaton Park for much-needed open space. Once neglected, the Palladian Heaton Hall has been handsomely restored and largely equipped with appropriate furnishings and pictures.

Not many of the latter belonged to the Egerton family who once lived here, apart from the decorative paintings in the saloon and the cupola room by Rebecca and in the billiard room by Michael Nowosielski. The pictures which can be seen are, for the most part, work by eighteenth-century British artists, such as Richard Wilson, Hudson, Highmore, Reynolds, Raeburn, Wright of Derby, de Wilde, Dance, Ibbetson, Marlow, Wheatley and Lambert.

HERBERT ART GALLERY AND MUSEUM

MAP E

Jordan Well, Coventry
Tel Coventry (0203) 832381

Like almost all the buildings of central Coventry, the Herbert Art Gallery was built after the Second World War. It includes Sutherland's studies for the huge tapestry of Christ in Glory, which hangs in Coventry Cathedral.

There is an extensive collection here of twentieth-century British art, with Bevan, Lowry, Paul Nash, Ben Nicholson, Piper, Bomberg, Matthew Smith and Weight represented. There are also pictures of local interest, among them pictures of Lady Godiva's ride, a popular theme in the nineteenth century; by Thomas Collier, Woolner and Landseer. The Landseer is a complicated picture with the horse standing on a strip of carpet while showing interest in a spaniel and a Dutch-looking female spectator.

HEREFORD CITY MUSEUM AND ART GALLERY

MAP E

Broad Street, Hereford
Tel Hereford (0432) 268121

Across the road from Hereford's splendid cathedral, the Art Gallery is best known for its water-colour collection. In addition, with works of local interest, there are paintings by Turner, Girtin, and John and Cornelius Varley.

HEVER CASTLE

HHA MAP J

Edenbridge, Kent
3m SE of Edenbridge, off Hartfield road (B2026)
Tel Edenbridge (0732) 865224

Hever Castle is a heavily castellated and heavily restored moated stronghold. Inside the Tudor rooms which are shown to visitors are a number of portraits, mainly from the sixteenth century. Some of these are of the Bullen, or Boleyn, family, whose home this was, and one of whom was to become Queen Elizabeth's mother. There are also portraits of the Astor family who were responsible for the castle's restoration in the 1900s, and who lived here until the castle was sold to commercial interests in the 1980s.

HIGHCLERE CASTLE

HHA MAP I

Hants, near Newbury
6m S of Newbury, between Winchester (A34) and Andover (A343) roads
Tel Newbury (0635) 253210

Designed by Barry in his Houses-of-Parliament manner, Highclere Castle is the home of the

Herbert family, Earls of Carnarvon. There is a ceiling painted in a sub-baroque manner by Brompton, removed from an earlier house on this site. There is a small collection of Dutch pictures. There are also family portraits. These include work by Richardson, Hudson, Beechey, Gainsborough and Reynolds, whose contribution is a child of the family as an infant Bacchus, attended by two unconvincing and sleepy lions.

HINWICK HOUSE

HHA; GT MAP F

Wellingborough, Northants
6m SE of Wellingborough, off Olney road (A509)
Tel Rushden (0933) 53624

A modest manor, Hinwick House is opened with artless enthusiasm to a handful of visitors. It has some royal and family portraits, including pictures attributed to Gheeraerts, van Dyck, Lely, Vanderbank and Richardson.

HOLBURNE OF MENSTRIE MUSEUM

MAP I

Great Pulteney Street, Bath, Avon
Tel Bath (0225) 66669

This fine museum, with its admirable picture collection, is only a short walk from the centre of Bath, along the elegant Great Pulteney Street. The name comes from the Holburne family, whose collection began the museum. It is a well-appointed and delightful place, one of the most agreeable museums in the country to visit.

There is a group of Flemish and Dutch pictures, which includes works by Pieter Bruegel the Younger, Pickenoy, Backer and Wynants. Another group, of Italian origin, has pictures by Casali, Panini, and Langetti. It also includes an entrancing Guardi coastal scene, probably of somewhere in the Venetian lagoon.

Eighteenth-century British art is strongly and appropriately represented, with works by Gainsborough, Raeburn, Romney, Ramsay, Zoffany, Morland and Kauffmann. Stubbs's con-

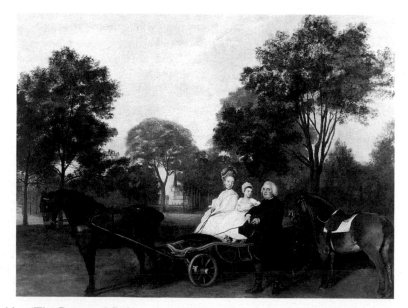

Stubbs: 'The Reverend Robert Carter Thelwall and His Family' (*Holburne Museum*)

tribution is an outstanding picture — 'The Reverend Robert Carter Thelwall and His Family'. The thickset parson, evidently a sporting man, stands by a light driving carriage, in which sit his daughter and his wife, reins in hand. The carriage-horse and the parson's cob, standing obediently behind him, are lovingly depicted. The church in the distance, one cannot help feeling, was not this robust man's primary interest.

HOLKER HALL

HHA MAP A

Grange-over-Sands, Cumbria
4m W of Grange-over-Sands, on B5278
Tel Flookburgh (044 853) 328

The collection at Holker Hall was greatly reduced by a serious fire in 1871, and has been further reduced since then by sales. A fine assembly remains, and it is strikingly well displayed and easy to see and appreciate.

There are Lowther and Cavendish family portraits in profusion. These include a splendid pair by Richmond (Lord Frederick Cavendish and his wife) and work by Johnson, Richardson, Hoppner, Reynolds (with, also, an unusual portrait group) and Wissing. There is a van Dyck self-portrait and a small collection of works by Neefs, Teniers and others, dominated by an impressive 'Storm at Sea' by Vernet.

HOLKHAM HALL

HHA MAP G

Wells-next-the-Sea, Norfolk
2m W of Wells-next-the-Sea on Hunstanton road
(A149)
Tel Fakenham (0328) 710227

The much admired Holkham Hall, set in its equally famous park, contains a magnificent collection of many treasures. The house was designed and built (between 1734 and 1762) to display this collection, which reflects the taste of a cultivated and very wealthy landowner, Thomas Coke, 1st Earl of Leicester. He had made a diligent Grand Tour and was a friend of Lord Burlington and of his protégé William Kent, the architect of Holkham.

The visitor can well be taken aback at the magnificence and the size of the entrance hall at Holkham, and then can equally be somewhat disconcerted by the predominance of sculpture in the first rooms of his progress round the house. All this changes abruptly when the drawing room is reached. Here the pictures come into their own, and the pictures at Holkham are of a high quality, worthy of their fine setting.

Rubens's 'Return of the Holy Family' is one of the first to strike the visitor — especially, perhaps, since its recent restoration. Pietro da Pietri's 'Madonna in Gloria' is another, as is Chiari's 'Perseus and Andromeda'. There are also two intriguing bird-pictures by Hondecoeter, both of which clearly have political meanings.

It is, however, the landscapes at Holkham which are the most striking feature of the collection. There is a splendid array of these, by Claude, by Gaspard Poussin, by Swanevelt, by Salvator Rosa and by others, with half-a-dozen of Roman antiquities by Vanvitelli. It is an extraordinary sensation, particularly in the landscape room, to let the eye travel from these glowing, idealised views on the walls, through the windows to the actual landscape of the park, devised to echo and reproduce the sort of landscape depicted by such as Claude.

Salvator Rosa's 'A Rocky Landscape' exemplifies the awesomeness of nature which English collectors found so attractive in his pictures — and which was likewise sometimes imitated in landscape gardening. Gaspard Poussin's 'A Storm' is a very effective treatment of a similar subject, in his own style, a menacing and forceful example of how effective this artist could be, and how easily his work could be mistaken for that of his more illustrious brother-in-law, Nicolas Poussin, as indeed was the case with this very picture at one time.

Holkham Hall is one of the great houses in

129

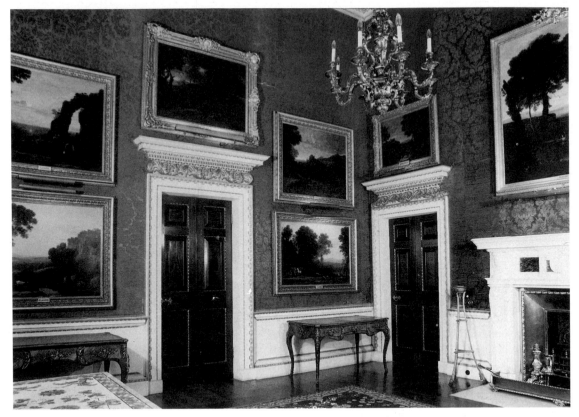

The Landscape Room (*Holkham Hall*)

which the portraits take second place, although there are many here of fine quality. Sir Edward Coke, the famous lawyer who founded the family's fortunes, was portrayed by Johnson, and by Gheeraerts. The builder of Holkham was painted by Richardson, and also by Trevisani when he was passing through Rome on his Tour. His successor 'Coke of Norfolk', a great agriculturist, was also painted in Rome, in a swashbuckling portrait by Batoni, and later by Gainsborough when the artist was nearing the end of his career.

Curiously, one of the great lures in Holkham, for art-historians, besides the dazzling original paintings, is a copy — the best surviving record of Michelangelo's lost cartoon for 'The Battle of Cascina', commissioned for the Great Council Chamber in Florence, in rivalry with Leonardo da Vinci.

HOLME PIERREPONT HALL

HHA; GT MAP F

Nottingham
5m E of Nottingham, off Grantham road (A52)
Tel Radcliffe-on-Trent (060 73) 2371

Holme Pierrepont Hall is a fine Tudor red-brick manor house, named in part after the Pierrepont family who built it. There are family portraits here, including work by Watts, and by Heins, a fashionable painter in East Anglia in the period before Gainsborough.

HOUGHTON HALL

HHA MAP G

King's Lynn, Norfolk
13m E of King's Lynn off Fakenham road (A148)
Tel East Rudham (048 522) 569

Built for Sir Robert Walpole in the 1720s and 1730s by William Kent, Houghton Hall is a large, ornately decorated and somewhat forbidding mansion. There are, of course, portraits of Walpole, by van Loo, and by Wootton, who also painted a group portrait of him with his family and friends. Other portraits here include works by Reynolds, Hoppner, Seeman and Zoffany. The great staircase is decorated with murals by Kent.

Walpole's great collection, including matchless van Dycks, was sold *en bloc* after his death to Catherine the Great of Russia, and most of it is now in The Hermitage Museum at Leningrad. The present owners of Houghton, the Cholmondeley family, though their collection includes some famous and often reproduced masterpieces such as Holbein's 'Woman with a Squirrel', do not show these in the rooms open to the public.

HOVE MUSEUM AND ART GALLERY

MAP J

19 New Church Road, Hove, E. Sussex
Tel Brighton (0273) 779410

Set in a small park, Hove Museum and Art Gallery is well known for its collection of twentieth-century British art. This includes pictures by Meninsky ('Boy with a Cat'), Gilbert Spencer ('Air Raid Warning'), Drummond, Ginner, Hodgkins, Wood, Lamb, Carline and Sickert.

From earlier times there are pictures with local associations, and work by Cotes, Beechey, Bonington and Gainsborough.

HUDDERSFIELD ART GALLERY

MAP C

Princess Alexandra Walk, Huddersfield, W. Yorks
Tel Huddersfield (0484) 513808

The Huddersfield Art Gallery is devoted to nineteenth-century and twentieth-century British art. The Camden Town Group is well represented, with work by Gilman ('Tea in a Bedsitter'), Ginner, Innes, Bevan and Sickert. From a later date, there are works by Auerbach, Bacon (a powerfully mysterious 'Figure Study II'), Bridget Riley, Blackadder and Naylor.

HUGHENDEN MANOR

NT MAP F

High Wycombe, Bucks
1½m N of High Wycombe on Great Missenden road (A4128)
Tel High Wycombe (0494) 325880

The modest Hughenden estate was bought by Benjamin Disraeli, with financial help from his political friends, shortly before he became leader of the Conservative Party in the House of Commons, in 1849. The unpretentious eighteenth-century house was transformed by his wife into Victorian Tudor, but the result is surprisingly simple and quietly dignified. It was here that 'Dizzy' hung his 'Gallery of Friendship', portraits of his political associates and friends, family portraits and, naturally, a portrait of Queen Victoria. Probably the best in this small collection is Sir Francis Grant's 1852 portrait of the statesman, a thoughtful and penetrating study which contrives to hint at the subject's foppish style as a younger man.

HUTTON-IN-THE-FOREST

HHA; GT MAP A

Penrith, Cumbria
6m NW of Penrith on Wigton road (B5305)
Tel Skelton (085 34) 500

Hutton-in-the-Forest has a number of portraits of the Fletcher and Vane families who have lived here since 1605; including examples of work by van Miereveld, Jervas and Romney. In addition, there is work by the talented self-taught amateur Lady Diana Beauclerk, whose pictures were greatly admired by Horace Walpole.

ICKWORTH

NT MAP G

Bury St Edmunds, Suffolk
3m SW of Bury St Edmunds on Haverhill road
(A143)
Tel Horringer (028 488) 270

With its massive rotunda, Ickworth is one of the strangest-looking of the great houses in England, reflecting the character of the man who built it. This was the famous Earl-Bishop, a younger son of the Hervey family who went into the church, became a Bishop (of Derry) and then inherited the Earldom of Bristol in 1779. He was an inveterate traveller, causing hotels all over Europe to change their names to Bristol in gratitude to him. He was as passionate and insatiable a collector as he was a builder and a traveller, and Ickworth was designed to display his collection: it is a long way from being a comfortable or cosy home.

Vigée-Lebrun's portrait of this 4th Earl succeeds in capturing his boyish and eccentric character. He looks wonderfully healthy, although then aged sixty, perhaps because he was at the time in the habit of walking up Vesuvius every day — the mountain is to be seen in the background. It is painful to record

that he never lived to see Ickworth completed, and that his collection was largely plundered in Italy during the upheavals of the Napoleonic Wars.

Ickworth, however, does include some stunning work. Gainsborough painted two of the naval members of the family, and he was at the top of his form when he painted the Post-Captain who was to become the 3rd Earl: in his 'undress' uniform, he leans nonchalantly, a leg elegantly cocked on an anchor. In the background lies a ship, doubtless his command, and in the distance buildings shimmer in wonderfully painted haze. Zoffany, Romney, Hoppner, Lawrence and Sir

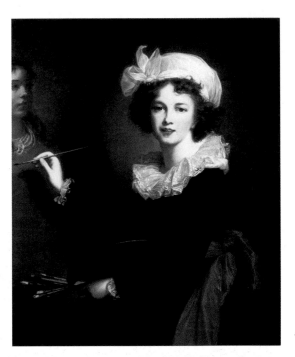

Vigée-Lebrun: 'Self-portrait' (*Ickworth*)

Francis Grant also made notable contributions to the portrait collections here. Vigée-Lebrun's self-portrait does much to explain why this admirable artist was so popular with English sitters. Although in her mid-thirties, she looks girlishly attractive and vivacious, busily engaged on a portrait of her daughter.

Hogarth's so-called 'Holland House Group' is a strange but intriguing conversation piece. It shows a group of Whig politicians, not all of

them identifiable. Lord Hervey, the author of the famous *Memoirs*, is apparently rejecting a plan held up by Henry Fox; at the same time, a parson standing on a chair, peering through a telescope at a distant church, is about to be toppled over by Stephen Fox. This was a sort of political cartoon and, while it is impossible today to understand the in-jokes, it is certainly possible to admire Hogarth's skill and wit.

In another conversation piece, by Gravelot, the same naval captain portrayed in Gainsborough's great portrait is seen taking leave of his family, with his ship, again, anchored in the background.

IMPERIAL WAR MUSEUM

MAP K

Lambeth Road, London
Tel (01) 735 8922

The Imperial War Museum was closed for eighteen months for major redevelopment, completed in the summer of 1989. It has a huge and notable collection of twentieth-century British art, formed from the work of official war artists in both World Wars. Not all of this could possibly be displayed at any one time, but you will be able to see, from the First World War, some of the work of, for example, Orpen, Sargent, Tonks, Wilkinson, Paul Nash, Dodd, Nevinson, Lamb, William Roberts and Lewis. From the Second World War you might see work by Cundall, Ardizzone, Laura Knight, Eurich, Paul and John Nash, Moynihan, Gross, Coldstream, Piper and Stanley Spencer.

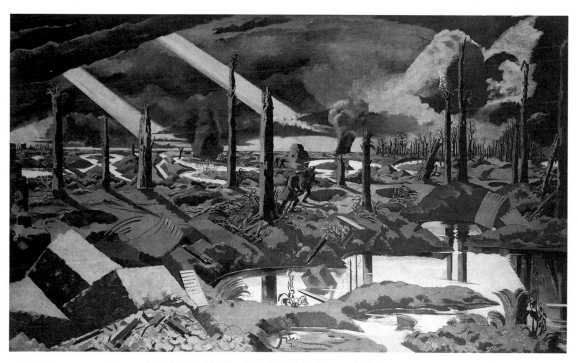

Paul Nash: 'The Menin Road' (*Imperial War Museum*)

KEDLESTON HALL

NT MAP E

Derby
4m NW of Derby off Ashbourne road (A52)
Tel Derby (0332) 842191

In the care of the National Trust since 1987, Kedleston Hall, once the Curzon family home, can well claim to be the most elegant, as well as the most complete, architectural work of Robert Adam, who designed the whole house, much of the furniture and even such details as fire-dogs and shutter-handles. Where ceilings and walls are decorated with paintings, as in the saloon, no doubt he had something to say about these as well. If the house is an architectural masterpiece, it can be said to be matched by its contents; the pictures are worthy of their setting.

Wall and ceiling paintings throughout the house are by William Hamilton, Rebecca and Zucchi. They are restrained in tone and as elegant as the house.

Artemisia Gentileschi: 'Self-portrait' (*Kensington Palace*)

There is a wide-ranging picture collection, with works by Vanvitelli, Bassano, Orizonte, Giordano, Bol, Kauffmann (with a charming 'Virgin and Child'), Cuyp, Veronese, Strozzi, Claude, Drost, Salvator Rosa, Maratta, Cimaroli, de Koninck, Snyders, Fyt and Zuccarelli.

There are family portraits by Soldi, Richardson, Lely, Dahl, Kneller and Johnson, Hone, Barber, and Arthur Devis (with a modest-sized and charming double portrait of the 1st Lord Scarsdale and his wife). That 'most superior person', the 1st Marquess of Curzon, is portrayed by von Herkomer; his first wife, in dashing style, by de László.

KENSINGTON PALACE

EH MAP K

Kensington Gardens, London
Tel (01) 937 9561

A large part of the externally unpretentious Kensington Palace is open to the public. Inside, the superb Wren-designed state apartments, some of which have ceilings painted by Kent, contain a number of pictures from the Royal Collection. These include many portraits of former royal residents of the palace, notably William III who moved here from central London with Mary II, and Queen Victoria and Queen Mary, both of whom were born and spent their childhood here. Among the many old masters on the walls — including work by Dolci, Ribera and Orazio Gentileschi — are a self-portrait of power and grace by Artemisia Gentileschi and van Dyck's 'Cupid and Psyche', almost rococo in its delicate feeling, and accounted by some the most delightful painting of his English period. (Rococo, the lighter and delicate successor to Baroque, was to become fashionable, chiefly in France, in the early eighteenth century). Lely and Kneller are both well represented, the former by a charming portrait

of Mary as Princess, the latter not only by a good portrait of the royal gardener, Henry Wise, but, somewhat unexpectedly, by a very potent full-length image of Peter the Great of Russia, painted during Peter's visit to England in 1698.

The suite of rooms adapted for the Duchess of Kent and her daughter (Queen Victoria to be) is arranged much as it was, but contains also, among other Victoriana, Hayter's very large group of the wedding of Victoria to Prince Albert in 1840.

KENWOOD

EH MAP K

(The Iveagh Bequest)
Hampstead Lane, London
Tel (01) 348 1286

When the 1st Earl of Iveagh, the head of the Guinness family, bought the then empty Kenwood House in 1925 (when he was aged 78)

van Dyck: 'Cupid and Psyche' (*Kensington Palace*)

Rembrandt: 'Self-portrait' (*Kenwood*)

it was with the twin objects of saving the house for posterity and housing his magnificent picture collection. Both were left to the nation on his death in 1927.

The splendid Adam house, in its incomparable grounds, is one of the great delights of London, and provides a setting worthy of the pictures. The house is not enormous, and never seems overpowering; the lightly furnished rooms have great interest and charm; the atmosphere is not so much of a 'stately home' as of a gallery, in which all the pictures can be seen and enjoyed in a delightful atmosphere. A visit to Kenwood is an inspiring experience.

Lord Iveagh's collection might almost have been assembled at the end of the 1700s, rather than a century later. Consisting mostly of British work of the eighteenth century, with Dutch and Flemish pictures from the previous century, the quality of the collection is superb.

Reynolds is, as one would expect, well represented: there are sixteen of his canvases here. The portraits include society ladies, such as 'Lady Mary Leslie', 'Lady Louisa Manners' and 'Lady Diana Beauclerk', the talented amateur artist so much admired by Horace Walpole; there are portraits of actresses and courtesans, such as 'Kitty Fisher as Cleopatra'; there is 'Mrs Musters as Hebe', which can be compared here with Romney's portrait of the same sitter; there is a rather absurd 'Venus Chiding Cupid for Learning to Cast Accounts', and a most interest-

ing group portrait of the children of the banker and collector J. J. Angerstein — the purchase of his pictures by the Treasury on his death in 1824 marked the start of the National Gallery's collection.

Romney too is well represented, with half-a-dozen portraits. Two of these are of his favourite model, later to become Lady Hamilton; one shows her at prayer, the other as a peasant at a spinning-wheel, both singularly inappropriate situations for the sitter. Other portraits include work by Jervas (whose double portrait includes Lady Elizabeth Finch, who was to marry the 1st Earl of Mansfield for whom the house was built), Raeburn, Hoppner (with one of his very best portraits, of 'Mrs Jordan', the actress who was

later to become the mistress of the Duke of Clarence) and Lawrence, with a rather sugary 'Miss Murray'. George Morland and Crome have pictures here, as does Wright of Derby, with one of his candle-lit studies, in this case 'Dressing the Kitten'. There are pictures by Kauffmann, Boucher, and Pater, and a classical scene by Gaspard Poussin in which one of the figures is incongrously armed with a fowling-piece. There is a recently-acquired, and admirable, Batoni portrait of 'Mrs Robert Sandilands'. There are Venetian pictures by Guardi, and work by Bellotto and by Panini. From earlier times there are two fine van Dyck portraits — a noble 'Henrietta of Lorraine' and a splendid 'Duke of Richmond and Lennox', which includes

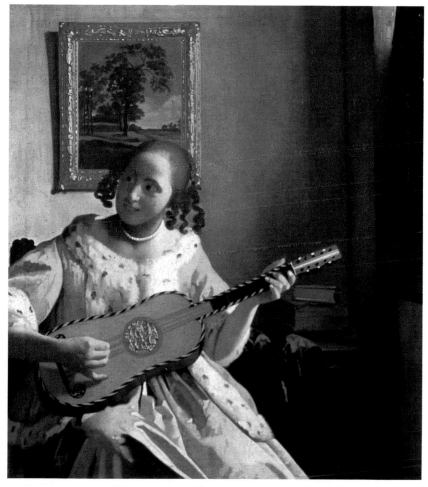

Vermeer: 'The Guitar Player' (*Kenwood*)

a favourite dog wearing a pearl collar, apparently given to the animal for saving its master's life.

For once, however, van Dyck is outshone by the man who so greatly admired his work, Thomas Gainsborough. There are a dozen of his pictures here, not all portraits. There are landscapes and such pictures as 'Greyhounds Coursing a Fox': here one can feel Gainsborough's enjoyment of this fresh and spritely picture, painted late in life. Landscape and portraiture are superbly combined in the famous 'Countess Howe', painted twenty years earlier in 1763-4. Here the wife of Admiral Lord Howe strolls along, her magical silk costume rustling in the gentle breeze; her pearl chokers, her straw 'Leghorn' bonnet and her pretty shoes all seem as natural as the landscape background; her cool patrician gaze has more than a hint of warmth and fun behind it; and the subtle black wristband emphasises the delicacy of her lace and her silk. Gainsborough never surpassed this dazzling picture.

From a later date is Turner's 'Fishermen upon a Lee Shore in Squally Weather', an early example of the sea-pieces which are so potent a feature of his work. There is a Landseer double portrait, which marks his association with the Russell family, also a rather violent 'Hawking in Olden Times'.

This fine British collection is certainly matched in quality by the pictures from the Low Countries. There is work here by Rubens, by J. B. Weenix, Wynants, van de Cappelle, and seascapes by both the Willem van de Veldes. Isaac van Ostade is here. So are Snyders, Bol, Hals, with a glowing portrait of a distinguished merchant, and Cuyp, whose 'View of Dordrecht' shows his native town with his customary clarity and robust calm in finely painted evening light. A rare artist, Claude de Jongh, has a brilliantly detailed account of London Bridge with all its houses in the 1630s.

Vermeer's 'Guitar Player' is the only example in England of this artist's work which is not in the Royal Collection or in the National Gallery. It was probably painted late in the artist's life; as is usual with Vermeer's work, a prosaic domestic scene is somehow transformed into visual poetry — measured, stately, but lively.

Rembrandt's 'Self-portrait' of about 1665 is likewise a late work. It is perhaps the noblest, in its dignified melancholy, the intensity of the scrutiny, of the last self-portraits that conclude the long series executed throughout his life.

On the first floor it has been the happy practice to stage, through the summers of recent years, often important loan exhibitions of British painting and art.

KETTLE'S YARD

MAP F

Castle Street, Cambridge
Tel Cambridge (0223) 352124

The collection at Kettle's Yard is concentrated on twentieth-century British work, and includes work by Ben Nicholson, Wood and Alfred Wallis. The collection and its display still bear the imprint of its creator, Jim Ede, a passionate collector (especially of the works of the sculptor Gaudier-Brzeska).

KEW PALACE

MAP K

The Royal Botanic Gardens, Kew, Surrey
Tel (01) 940 1171

The enchanting Kew Palace, the smallest and most unassuming of all the former royal residences open to the public, is a Dutch-style redbrick house which preserves the domestic scale of George III's family life.

There are portraits by Ramsay, Ziesenis, Brompton ('Edward, Duke of York and His Friends in Venice'), Robinson, Zoffany (portraits of George III and of Queen Charlotte), West (a double portrait of the same pair), Cotes and Dance. Other pictures include two charming conversation pieces by Laroon, several pictures by Bogdany, a favourite artist of Queen Charlotte, a view of her funeral procession by

Richard Wright, some Florentine views by Patch, and many views of eighteenth-century Kew by Schalch.

KIDDERMINSTER ART GALLERY AND MUSEUM

MAP E

Market Street, Kidderminster, Hereford and Worcester
Tel Kidderminster (0562) 66610

The Kidderminster Art Gallery is notable both for its paintings of local subjects, and for its collection of the works of Sir Frank Brangwyn.

KINGSTON LACY

NT MAP I

Wimborne Minster, Dorset
1½m NW of Wimborne Minster on Blandford road
(B3082)
Tel Wimborne (0202) 883402

The Bankes family's Restoration home of Kingston Lacy, skilfully altered by Barry in the 1830s, contains an astounding collection of pictures, very largely due to the informed enthusiasm of William John Bankes (1786–1855).

From an earlier age, however, there are Lely portraits in the library, sedate and glowing in their Sunderland frames. These were greatly admired by Reynolds when he visited the house in 1762: 'I never had fully appreciated Sir Peter Lely,' he wrote, 'till I had seen these portraits.' Indeed the pictures can readily be seen to be of the highest quality, contrasting sharply with the sombre Batoni portrait in the same room.

Other family portraits at Kingston Lacy include work by Reynolds himself, van Dyck, Lawrence, Kneller and Romney. There is also a collection of fifty-five enamel miniatures of Elizabethan worthies by Henry Bone.

William Bankes's own purchases begin with 'The Judgement of Solomon', an incomplete masterpiece now attributed to Sebastiano del Piombo, but for long thought to be the work of Giorgione — a striking and masterly composition.

Many of the Bankes family pictures are on the walls of the saloon, two stories high and not over-large, so that the triple-banked pictures are sometimes awkwardly hung. Yet they richly merit the time and trouble needed to view them properly. Dominating this splendid group are the two large and glamorous Rubens portraits of magnificent young ladies of the Grimaldi family, each a stunning *tour de force* of unmatched grandeur. Titian's noble portrait, probably of Francisco Savorgnan della Torre, is another compelling attraction. Standing out, also, among the three dozen pictures in the saloon are 'The Four Elements' from Jan Bruegel's studio, a strange allegorical portrait by Salvator Rosa, a landscape by Nicholas Berchem, and many more portraits, including a modest sketch of William Bankes by Hayter.

William Bankes was one of the first men in England to take Spanish artists seriously, buying assiduously when he visited Spain during the Peninsular War in 1812-14, and creating a Spanish room, lined with leather, in which they could be displayed. Amongst this fascinating group, Velazquez's portrait of 'Cardinal Camillo Massimi' stands out. In view of the unusual ultramarine habit (in fact the correct garb of certain Papal officials) this was not originally recognised as a portrait of a Cardinal. Yet such it is, and the Cardinal can be seen to be a cool and intelligent prelate, unusually bearded and moustached.

Rubens: 'Marchesa Caterina Grimaldi' (*Kingston Lacy*)

KINGSTON LISLE PARK

HHA MAP I

Wantage, Oxon
5m W of Wantage on B4507
Tel Uffington (036 782) 223

Kingston Lisle is an attractive house of the late seventeenth century, altered in Regency times. It has a small picture collection. This includes portraits by Gheeraerts and Sustermans, and works by Crome, Sandby, Monamy and van Goyen.

KNEBWORTH

HHA; GT MAP F

Stevenage, Herts
2m SW of Stevenage, via junction 7 on A1(M)
Tel Stevenage (0438) 812661

Knebworth has been opened to the public with an enthusiasm that seems to echo the whole-hearted Victorian Tudor exterior of the house. It was rebuilt in this style by the romantic novelist Edward Bulwer-Lytton, a conscious eccentric, as can be seen from the portrait of him, seated in his crowded study, by E. M. Ward. Other family portraits, made over three centuries, include a fine sketch by Watts of Bulwer-Lytton, as well as works by Riley, Lely and Maclise.

KNIGHTSHAYES COURT

NT MAP H

Tiverton, Devon
2m N of Tiverton, off Bampton road (A396)
Tel Tiverton (0884) 254665

William Burges's exuberant 1870s house at Knightshayes, with its bold colours, decorated ceilings and magnificent woodwork designed by J.D. Crace, makes an admirable background for the Heathcoat-Amory family pictures, which are displayed here.

There are a handful of family portraits, and pictures contemporary with the house, but the visitor will be struck by the collection of old masters and other paintings. These are few in number, approachable in size, and of the highest quality. There is a fine Claude landscape, 'Apollo and the Cumean Sibyl'. There are early works by Matteo, by Boltraffio and by Lucas Cranach the Elder. Raphael is represented by a charming detail from a cartoon. There is a simple and elegant portrait by Holbein, an early boyish self-

portrait by Rembrandt, and works by Sebastiano Ricci and Netscher. The collection is rounded off by two, most unusual, flower pictures by Constable, a peaceful Bonington landscape and a stunning Turner seascape.

Wonderfully well displayed, this is a country-house collection of rare quality.

KNOLE

NT MAP J

Sevenoaks, Kent
1m from Sevenoaks on Tonbridge road (A225)
Tel Sevenoaks (0732) 450608

Seen from its park, the medieval Knole looks more like a walled and fortified village than a house. It is indeed very extensive, though the visitor sees only about a dozen of its legendary 365 rooms. Two of these are called galleries, but could more aptly be described as corridors, in which, as in some of the other rooms, it is not easy to get a good and well-lit view of the pictures.

The 'Brown Gallery' contains one of the few surviving collections of likenesses of 'worthies' — renowned historical figures unconnected with the family. In fact, the portraits in this gallery are not of high quality. Fortunately this is not the case with the royal and Sackville family portraits. Amongst these the visitor will note particularly Lawrence's portrait of George IV, van Dyck's 4th Earl of Dorset, the 1st Earl of Middlesex by Mytens, Jervas's Dean Swift and his Joseph Addison, Kneller's 6th Earl of Dorset, Reynolds's Dr Johnson and Oliver Goldsmith, and his majestic full-length of the 3rd Duke of Dorset, who owned nearly two dozen works by the artist.

LADY LEVER ART GALLERY

MAP C

Port Sunlight Village, Wirral, Merseyside
Tel Liverpool (051) 645 3623

Founded by the 1st Lord Leverhulme as a memorial to his wife, and as the centrepiece of the garden village of Port Sunlight, which he built for the employees of his nearby soap factory, the Lady Lever Art Gallery contains a wonderful collection of pictures. Opened in 1922, it is, though retrospective, a stunning witness to High Victorian taste. Surrounded by many miles of modern industrial ugliness, the village itself is a relief to the senses; the gallery is a thrilling delight.

Leverhulme's pictures are predominantly British pictures of the eighteenth and nineteenth centuries. Starting in the 1880s and 1890s with contemporary pictures, which could be, and were, adapted for use as soap advertisements, he soon moved on to more accomplished Victorian work, to the Pre-Raphaelites, and then backwards, as it were, to the late eighteenth century. Almost every notable British artist in this 150-year period is represented at the gallery, often with a masterly piece of work.

There are several Richard Wilson landscapes, the most striking being 'Lake Scene: Castel Gandolfo'. Reynolds has half a dozen portraits and other pictures. Gainsborough has a couple of portraits. There is an exceptionally mature and exciting Turner — 'The Falls of Clyde'. Constable's single contribution, 'The Cottage at East Bergholt', is one of his most astonishing pictures, almost Impressionist in the foreground, with a thunderous sky most tellingly evoked. Stubbs's four paintings are enamels on Wedgwood plaques and include a sturdy self-portrait, appropriately astride a beautifully painted cob. There are half a dozen George Morlands, and work by Crome, Lawrence, Ramsay, Romney, Hoppner and Raeburn.

The quality of the Victorian pictures is not so

141

uniformly high. Leighton's enormous processional canvas, 'The Daphnephoria', stands out, as does his voluptuous 'Garden of the Hesperides'. Etty was clearly admired — there are six of his pictures here. Watts, Wilkie, Shee and Alma-Tadema are among the many others represented. Sargent's 'On His Holiday' superbly combines the ungainly attitude of an adolescent, and handsome, youth, with the rushing salmon river in the background and the catch thrown down with artful carelessness.

Rossetti and Ford Madox Brown are represented. Burne-Jones has several pictures here, notably 'The Beguiling of Merlin'. Millais also has half a dozen pictures, ranging from a delicate and precise 'Apple-blossom', to a sombre portrait of Tennyson and a deplorably sentimental child portrait, plainly painted when he was well past his best. Holman Hunt has his large and complex 'May Morning, Magdalen Tower', a series of portraits in a highly contrived situation, and his altogether different 'The Scapegoat'. This is one of the most celebrated of all Victorian pictures, simple in theme and phenomenally detailed in execution. Those who will feel that all the skill and immense effort that Hunt put into this picture could have been better employed — and many will feel this — will nevertheless retain an image of this touchingly absurd and absurdly touching picture.

LAING ART GALLERY

MAP B

**Higham Place, Newcastle-upon-Tyne
Tel Tyneside (091) 232 6989**

The paintings at the Laing Art Gallery are numerous, and rich in quality and variety.

The eighteenth century is well represented. Portraitists such as Ramsay, Hudson, Reynolds, Raeburn and Wright of Derby have excellent examples of their work here. Gainsborough, Lambert, de Loutherbourg are represented by

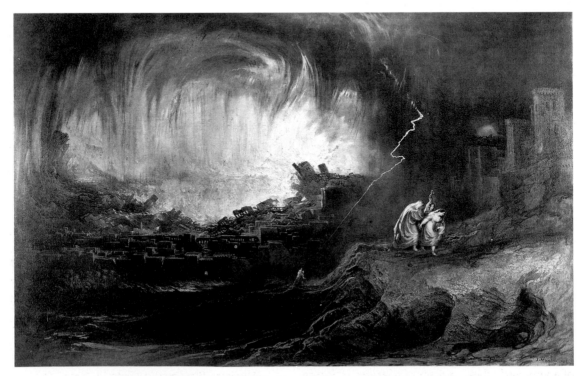

Martin: 'The Destruction of Sodom and Gomorrah' (*Laing Art Gallery*)

landscapes, as is Richard Wilson, whose view of the Alban Hills can here be compared with Locatelli's picture of the same subject. There is a characteristic view of the Thames by Samuel Scott, which can likewise be compared with work by Canaletto and by Guardi. There are two admirable genre pictures by George Morland, a delicious Constable, of 'Yarmouth Jetty', and work by Callcott, Linnell, Nasmyth and Cox, among many others.

Nineteenth-century work includes two huge Landseers, and work by Maclise, and much by Martin, as well as powerful Pre-Raphaelite pictures by Holman Hunt ('Isabella and the Pot of Basil'), Burne-Jones ('Laus Veneris'), Poynter, Alma-Tadema and W. B. Scott. One of the few nineteenth-century pictures from overseas is an early Gauguin, 'Breton Shepherdess'.

Twentieth-century work includes pictures by Wadsworth, Bomberg, William Nicholson, Orpen, Gertler (with both a still-life and, unusually, a portrait), Duncan Grant, Augustus John, Matthew Smith, Stanley Spencer (a highly original 'The Dustman' which was rejected by the Royal Academy as late as 1935), John Nash, Sickert, Hitchens, Pasmore and many more.

LAMPORT HALL

MAP F

Northampton
8m N of Northampton on Market Harborough
road (A508)
Tel Maidwell (060 128) 272

Lamport Hall, for 400 years the home of the Isham family, and set in the rolling countryside of the Midlands, is an exhilaratingly enjoyable place to visit.

A portrait (by an unknown artist) of the Elizabethan founder of the family fortunes greets the visitor in the entrance hall, the first of a series of family portraits of quality. Amongst these are examples of the work of Gascars, Bokshoorn, Kneller, Lely, D'Agar, Lawrence and Shee. The 3rd Baronet was a Grand Tourist of a very early date, and sat to Maratta in Rome

in 1677. Maratta was recognised at this time as an outstanding painter and was patronised by several Englishmen whose continental journeyings took them to Rome; his portrait of Sir Thomas Isham, with its careful indications of the subject's enthusiasm for collecting, is a forerunner of the portraits so often painted in the following century by such artists as Mengs and Batoni.

The family portraits make an eminently satisfying group in the elegant rooms in which they hang. There are royal portraits — a Lely, and versions of two large and familiar van Dycks among them — dominated by a very detailed and fascinating portrait of Anne of Denmark, by van Somer; the Queen once stayed at Lamport Hall.

Several of the Italian pictures in the house were acquired on the Grand Tour; there are examples by Gimignani, Sebastiano Ricci, Remigio, Brandi and Reni, whose 'Adoration of the Shepherds' is the outstanding picture in this group. Other notable pictures include a modest-sized and entrancing van Dyck child study — 'Christ and St John'.

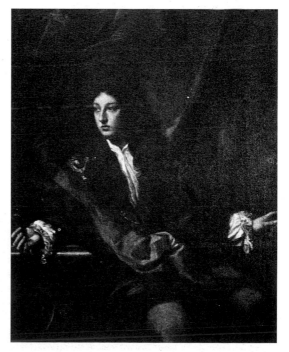

Maratta: 'Sir Thomas Isham' (*Lamport Hall*)

Lamport Hall is not a large house, but it is so well-appointed, looked-after and welcoming, and filled with such admirable and interesting pictures, that it is nothing but a pleasure for the visitor.

LANHYDROCK

NT MAP H

Bodmin, Cornwall
2½m S of Bodmin on Lostwithiel road (B3268)
Tel Bodmin (0208) 73320

Built in the 1630s, and then rebuilt in the late nineteenth century, in a wonderful situation, Lanhydrock has a fine collection of portraits of the Agar-Robartes family. Especially notable are portraits by Johnson, Kneller, Richmond, Dahl, Romney, Lely, Hudson, Jervas and Wissing — most unusually for a large house in the west country, Reynolds is not represented. It is entertaining and instructive to compare the three portraits of the wealthy Thomas Hunt of Mollington Hall (who married Mary Vere Robartes) by Kneller, by Dahl and by Hudson.

LEEDS CITY ART GALLERY

MAP D

Calverly Street, Leeds
Tel Leeds (0532) 462495

Leeds City Art Gallery is justly famous for its impressive collection of twentieth-century British art, but work from the nineteenth century can also be seen here. There are several of Brangwyn's large canvases, and paintings by such artists as Clausen, Holman Hunt, Leighton, Maclise, and Etty. Grimshaw, a native of Leeds, is well represented. Work by Cotman, Crome, de Wint, Constable, Turner can be seen, as can that of Corot, Courbet (notably with his 'Les Demoiselles de Village' of 1851), Bonnard, Sisley

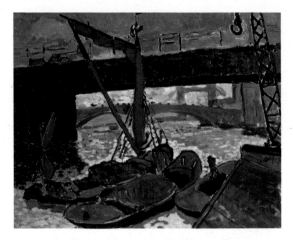

Derain: 'Barges on the Thames'
(*Leeds City Art Gallery*)

and Boudin, and many others.

Derain's Fauve 'Barges on the Thames' is another outstanding picture, but the great bulk of the twentieth-century work is by British artists. Sickert is splendidly represented, as are Stanley Spencer, Wadsworth, Yeats, Augustus John, Paul Nash, Gore, Gilman, among many more.

The gallery's famous collection of twentieth-century British sculpture is housed in the Moore gallery, opened in 1982. Henry Moore was born in the district.

LEICESTERSHIRE MUSEUM AND ART GALLERY

MAP F

New Walk, Leicester
Tel Leicester (0533) 541333

Housed in a municipal museum established soon after the passing of the Museums Act of 1845, Leicester Art Gallery is a lively and invigorating place. It has a wide-ranging collection, including Italian pictures from the fifteenth century; German, Flemish and English paintings of the sixteenth century; French and Dutch seventeenth-century work; plenty of British pic-

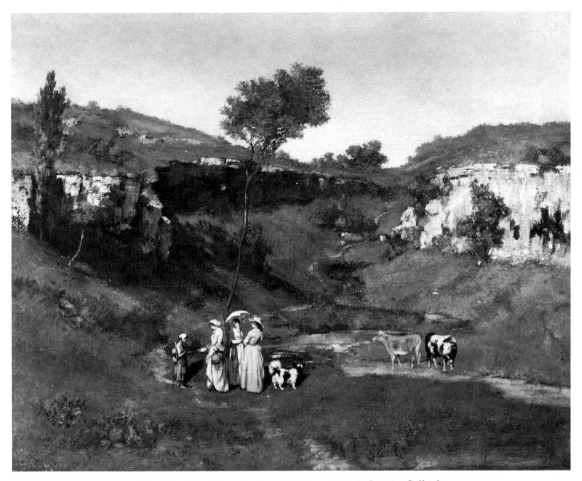

Courbet: 'Les Demoiselles de Village' (*Leeds City Art Gallery*)

tures of the eighteenth and nineteenth centuries; a striking twentieth-century collection of British work; and a most unusual assembly of German Expressionist art.

From earlier times, Monaco's 'St John Entering the Wilderness' and de la Tour's 'The Choirboy' (singing in the light of a candle) are particularly notable, as is work by artists as various as Beccafumi, Pittoni, Sweerts and van der Neer.

Good British work from the eighteenth and nineteenth centuries includes examples by Wright of Derby, Lawrence, de Loutherbourg, Wilkie, Frith, Dyce and Leighton. The Camden Town Group are well represented, especially by Sickert, Gilman, Bevan and Gore. There are some fine Impressionists — Camille Pissarro and Sisley, for example.

But the astonishing element of the collection at Leicester is the representation of German Expressionism. This began to be assembled in 1940, an amazing, deliberate and very far-sighted example of highly enlightened buying policy. Work by Nolde, Feininger and Marc, with his formidable 'Rote Frau' of 1912, is included in what is still, by a long way, the best collection of its kind in Britain.

145

Marc: 'Rote Frau'
(*Leicestershire Museum and Art Gallery*)

Camille Pissarro: 'Effet de Neige'
(*Leicestershire Museum and Art Gallery*)

LEIGHTON HOUSE ART GALLERY AND MUSEUM

MAP K

12 Holland Park Road, London
Tel (01) 602 3316

Leighton House was, for the last thirty years of his life, the home of Frederic, Lord Leighton, PRA. It has been preserved as it was in 1896, the year of Leighton's death, and is consequently an absorbing example of the atmosphere in which this highly fashionable artist lived and worked, the only artist in the history of the country to have been ennobled (and only just, as he died on the following day).

Several of his highly-finished formal works are here, now attracting critical notice after decades of disdain, but many today may still prefer the landscape sketches which are another aspect of his work — rapid working sketches in a quite different style. There are also pictures by some of Leighton's contemporaries, including Burne-Jones, Crane, G. F. Watts, Prinsep and John Millais.

The commodious house, with its large garden and huge studio, and with Leighton's superb collection of near-eastern tiles on the walls of the 'Arab Hall', splendidly evokes this late Victorian artist-grandee. Temporary loan exhibitions (often of contemporary work) are put on periodically.

LEVENS HALL

HHA MAP A

Kendal, Cumbria
5m S of Kendal on Milnthorpe road (A6)
Tel Sedgwick (053 95) 60321

World famous for its topiary garden, Levens Hall is a substantial Elizabethan house with later additions. It contains an extensive collection of family portraits of those who have lived

here — Howards, Grahames and Bagots. Lely, J. M. Wright and Owen are represented, Owen with a splendid portrait of Sir Charles Bagot, known to his contemporaries as 'Beauty' Bagot.

There are also other pictures: a version of Rubens's portrait of Anne of Hungary, a 'Holy Family' by van Aelst, a child portrait ascribed to Cuyp, a Hondecoeter, and a large number of pictures, all done at Levens, by de Wint.

LITTLE MALVERN COURT

HHA; GT MAP E

**Great Malvern, Hereford and Worcester
3m S of Great Malvern on
Ledbury/Upton-on-Severn road (A4104)
Tel Malvern (0684) 892988**

There is a modest collection of pictures at the small and charming Little Malvern Court, with notably one of Delaroche's large historical subjects — 'Lord Strafford on His Way to Execution'. Once a Benedictine Priory, the house has been altered and adapted over the centuries of its occupation by the Russell and Berington families.

LONGLEAT

HHA MAP I

**Warminster, Wilts
5 miles W of Warminster
Tel Maiden Bradley (098 53) 551**

The vast Elizabethan bulk of Longleat, the seat of the Marquess of Bath, sits splendidly in its beautiful park, where there is a great deal going on to entertain the visitors.

Those rooms in the house which are open to the public contain a large number of pictures. In the great hall, there is a series of large hunting scenes by Wootton, a series that illustrates an anecdote and which can be favourably compared with the similar paintings in the entrance hall at Althorp.

Throughout the house there are innumerable portraits. Some of the most striking of these come from near the beginning and near the end of the sequence. A very early (1567) group portrait, of the family of the 10th Lord Cobham and his family, is by the anonymous artist known as Master of the Countess of Warwick. Arranged like a family tree, this is not so much a picture as an illustrated catalogue, a thought emphasised by the three divergent lines of perspective in the background. Attributed to Eworth are two child portraits of great charm, and there is a Larkin portrait in amazing detail of the second wife of Longleat's third owner, Sir Thomas Thynne. From a much later date, the eye is caught by G. F. Watts's portrait of the 4th Marchioness, by portraits by Orpen and by Glyn Philpot, and by Sutherland's picture of the 6th Marquess.

The old masters at Longleat are dominated by Titian's 'Rest on the Flight into Egypt' and by Tintoretto's 'Ascalaphus and Proserpine'; and there is a handsome collection of Dutch pictures, which includes examples of the work of van Ruysdael, van der Poel, van Goyen, Terborch, Wouwerman, Teniers and Snyders.

LOSELEY HOUSE

HHA; GT MAP J

**Guildford, Surrey
2½m SW of Guildford, on B3000
Tel Guildford (0483) 577881**

Loseley House, a fine Elizabethan manor house, has a number of family portraits, some state portraits marking a visit by James I and his Queen, and a small portrait of Edward VI by an unknown artist. This charming picture of the Boy-King presents many problems for the expert art-historian. It is, for example, dated 1549 in the inscription on the frame, but the inscription refers to the King's coronation, which occurred in 1547. Another mystery is how the picture came to find its way into the possession of the More-Molyneux family, who still live in the

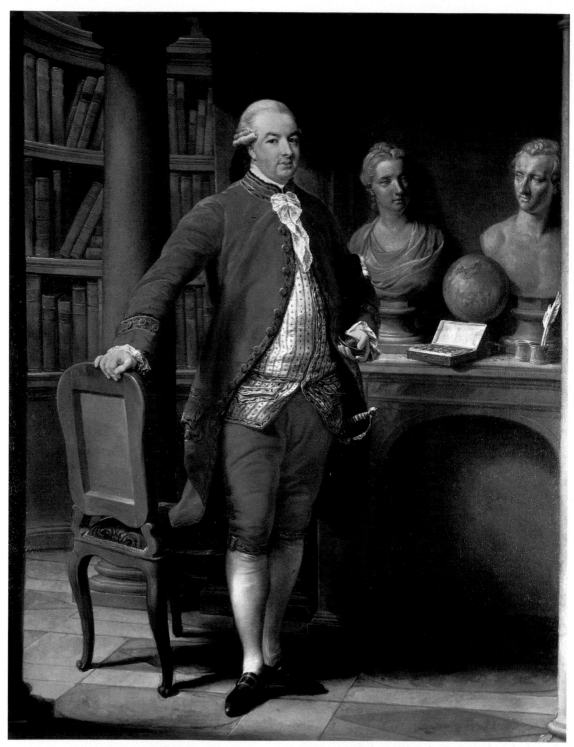

Batoni: 'Sir Thomas Gascoigne' (*Lotherton Hall*)

house. Some attractive Raphaelesque grotesque panels of about 1538 probably came from Henry VIII's long-demolished but spectacular Nonsuch Palace, and may well be by Toto del Nunziata or by one of Raphael's pupils, Bartolommeo Penni.

LOTHERTON HALL

MAP D

Aberford, W. Yorks
10m E of Leeds, on Garforth / Tadcaster road
(B1217)
Tel Leeds (0532) 813259

Lotherton Hall, like Temple Newsam, is a branch of the Leeds City Art Gallery, although it contains a number of pictures from the collection of the Gascoigne family, whose home this was until 1968. The Gascoigne collection includes an impressive Batoni full-length of Sir Thomas Gascoigne, and an earlier Roman portrait by Trevisani of Sir Edward Gascoigne. From the family collection, likewise, comes Wheatley's portrait group of the Irish House of Commons of 1780.

Among the many artefacts on display in the house is a large number of miscellaneous pictures from the City Art Gallery's reserve collection, not all of them easy to identify, but including old masters and twentieth-century British work of high quality.

LULLINGSTONE CASTLE

MAP J

Eynsford, Kent
3m N of Eynsford on Dartford road (A225)
Tel Farningham (0322) 862114

There are portraits of the Hart Dyke family to be found at Lullingstone Castle, notably a triptych of about 1575, with an eighty-year-old patri-

arch flanked by his two sons. One of the latter was also painted about twenty-five years later in a full-length of great accomplishment and style, by an unknown artist.

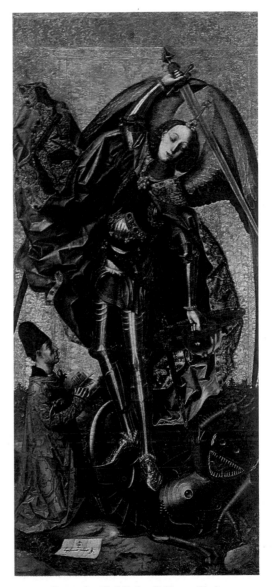

Bermejo: 'St Michael' (*Luton Hoo*)

LUTON HOO

HHA MAP F

Luton, Beds
At southern edge of Luton, off A1081
Tel Luton (0582) 22955

This much altered Adam house, still a family home, houses the Wernher collection in rooms of opulent Edwardian style, in a museum-like atmosphere.

The collection includes a small number of English pictures, mainly portraits, notably by Hoppner and Reynolds. There is a larger number of Dutch seventeenth-century pictures of high quality: Hobbema, Isaac van Ostade, van der Heyden, Wouwerman, de Hooch, Metsu, Dou, Hals, Adriaen van Ostade and Willem van de Velde the Younger are among those represented in this fine collection. Its founder Sir Julius Wernher, the diamond magnate, is portrayed by von Herkomer. His wife, later Lady Ludlow, is portrayed by Sargent.

Luton Hoo's former chapel is now converted into a picture gallery which houses, among other treasures, the famous and spectacular altar-piece of St Michael by Bermejo and works by Memlinc and Filippino Lippi.

LYME PARK

NT; GT MAP C

Disley, Cheshire
1m SW of Disley, off Manchester road (A6)
Tel Disley (0663) 62023

Lyme Park, a Palladian mansion incorporating an earlier house, has a number of Legh family portraits in its handsome rooms, with more in the long gallery on loan from the National Portrait Gallery. Work by Sargent, Richmond, Kneller, Lely, Dahl, van Loo and Beale is to be seen here.

MAIDSTONE MUSEUM AND ART GALLERY

MAP J

St Faith's Street, Maidstone, Kent
Tel Maidstone (0622) 54497

Maidstone Museum and Art Gallery is centrally situated, in a much-restored former manor house. There is a wide-ranging collection of pictures here. Much of the collection has Dutch or Italian origins, and includes works by Storck and van Bloeman.

The most striking pictures at Maidstone are a pair of Roman 'Capriccio' views by Panini. Bequeathed to the museum over 100 years ago, this pair no doubt found their way to England after purchase on a Grand Tour. Such souvenirs of a visit to Rome, compressing several actual well-known features and ruins into attractive, albeit unreal, groupings were popular with acquisitive visitors, being the eighteenth-century equivalent of the holiday home-video. This Panini pair are notably well executed, the buildings, ruins, statues and columns admirably and convincingly grouped.

MANCHESTER CITY ART GALLERY

MAP C

Mosley Street, Manchester
Tel Manchester (061) 2369422

The paintings in Manchester's handsome Barry-designed City Art Gallery come from six centuries of art. It is a splendid collection, of absorbing interest, with magnificent examples from every period.

Perhaps the best-known pictures here are the famous group of Pre-Raphaelites and other Victorian paintings. Three of these, in particular, are as striking as they are famous. John Millais's 'Autumn Leaves', while seemingly simple and understated, manages to convey intensity of

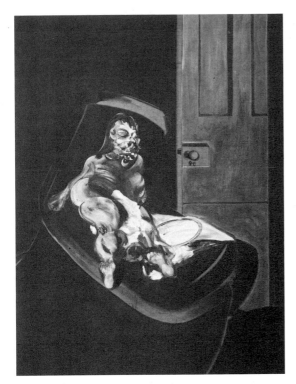

Francis Bacon: 'Portrait of Henrietta Moraes'
(*Manchester City Art Gallery*)

emotion in the contrast between the youthful girls feeding the bonfire and the dying season, so precisely observed and so lovingly depicted. Holman Hunt's 'Hireling Shepherd', on the other hand, has a strongly spelt-out message for the viewer, with the shepherd dallying with the pretty girl while the sheep are allowed to spoil the crops and harm themselves by feeding on the corn; the colours are as bright, and the detail as sharp as the message. Ford Madox Brown's 'Work' is one of the most important of nineteenth-century British pictures. It is, in effect, a political tract, oozing Victorian virtues, but by no means without human sympathy. The scene is crowded with characters from a variety of social backgrounds, each depicted with painstaking symbolism. The superb orchestration of this immensely complicated composition is as masterly as its detailed observation.

There are many other nineteenth-century artists to be seen in this richly Victorian setting: Leighton, with 'The Last Watch of Hero'; Burne-Jones; Alma-Tadema; Tissot, especially with 'Hush! (The Concert)'; Landseer, with two blessedly simple landscapes; E. M. Ward; Maclise; Frith; Etty; Egg; G. F. Watts; and Greaves, with 'Chelsea Regatta'.

Earlier British artists are here in profusion. Gainsborough is represented by portraits, and landscape, including most notably 'A Peasant Girl Gathering Faggots'. There are fine contributions from J. M. Wright, Reynolds, Romney, Palmer, George Morland, Hogarth, Richard Wilson, Joseph Wright of Derby, Zoffany, and many others. Stubbs's 'Cheetah and Stag with Two Indians' commemorates an event when a cheetah, sent from India to George III, was tested for its hunting ability in Windsor Great Park. Stubbs's usual careful animal, and human, portrayal is here married, in a powerful composition, to a ferocious tautness in the hooded cheetah, the nervous gestures of the Indian attendants, the disdainful stag and the entrancing background landscape.

Turner's large seascape 'Now for the Painter', in spite of the tedious punning title, is a wonderfully effective painting of a pair of boats off Calais, in which the lively sea and sky are depicted in a delicate, spirited and wholly convincing fashion.

There is a fine group of Dutch pictures at Manchester, none of them more impressive than van Goyen's 'Winter Scene' in which the pale cream light breaks through heavy grey skies,

Ernst: 'La Ville Pétrifiée'
(*Manchester City Art Gallery*)

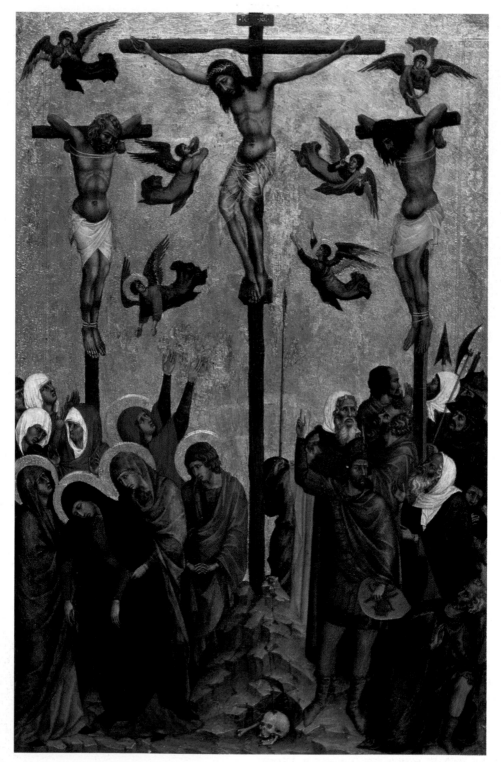

Duccio: 'Crucifixion' (*Manchester City Art Gallery*)

Millais: 'Autumn Leaves' (*Manchester City Art Gallery*)

reflecting on the ice and illuminating the huddled figures that all seem so intent on their own concerns; it is a mature and gripping work. French painting is represented by Claude's 'Adoration of the Golden Calf', and by a good Boucher landscape.

Outstanding among the treasure from the distant past is the fourteenth-century Sienese 'Crucifixion' attributed to Duccio, with its swirls of pink angels. From the opposite end, so to speak, of time are a group of pictures by Adolphe Valette, a Frenchman who taught at Manchester School of Art (where Lowry was one of his pupils) and whose unique style, corrugated and misty, is eminently suited to the Edwardian Manchester scene.

Manchester's collection of twentieth-century art is justly celebrated. There are abstracts by Ben Nicholson, as well as his 'Au Chat Botté', a fascinating picture which lies halfway between figurative and abstract painting, in which each artistic 'language' says much about the other.

Orpen's 'Homage to Manet', Francis Bacon's 'Portrait of Henrietta Moraes', Stanley Spencer's 'A Village in Heaven' and Paul Nash's 'Nocturnal Landscape' are all fine examples of their individual styles; there are equally characteristic pictures here by Bomberg, Hockney, Gauguin, Giacometti, Gore, Ernst, Nevinson, Gwen and Augustus John, Wyndham Lewis, Lowry, Steer and Sutherland amongst many more.

MAPLEDURHAM HOUSE

MAP J

Reading, Berks
4m NW of Reading, off Wallingford road (A4074)
Tel Reading (0734) 723350

The Blount family's collection of portraits at Mapledurham House is unusually strong in the early years of British portraiture, and its quality is also high. Peake, Gower, Gilbert Jackson, Johnson and van Somer are all here. Most remarkable of all is the portrait of Lady St John by the Jacobean master, William Larkin, a picture which seems to edge away from purely formal likeness towards a characterful portrait. The background of this picture, moreover, is not Larkin's usual arrangement of a curtained and carpeted interior, but a natural landscape. Though the churches and other buildings to be seen are unidentified, this may indeed be the earliest surviving English landscape.

Other portraits at Mapledurham include works by J. B. Huysmans, J. M. Wright, Jervas (with a famous double portrait of the Blount sisters, who were friends of Alexander Pope), Dahl, Kneller and Romney. There is a handful of other pictures too, including works by Wootton, Maes, Berchem and Hondecoeter.

MARBLE HILL HOUSE

EH MAP K

Richmond Road, Twickenham, London
Tel (01) 892 5115

Marble Hill House, a delightful Palladian villa on the banks of the Thames, was built for the Countess of Suffolk, the mistress of George II, and was later the home of Mrs Fitzherbert, George IV's illicit wife.

There are a number of fine paintings in its handsome, if thinly furnished, rooms. There is work by Thornhill, Mercier, Richard Wilson ('The Thames at Marble Hill'), Vanderbank, Reynolds, Hogarth, Hayman and Hudson. The Great Room at Marble Hill House echoes Inigo Jones's Single Cube Room at Wilton House; it has an overmantel and overdoors by Panini and likewise echoes Wilton House with copies of van Dyck portraits. Two unusual painters may be noticed: Gravelot — a French artist who had a great influence on English rococo, in the 1730s and early 1740s, but whose paintings are very rare — with 'Le Lecteur', and Beare, a Salisbury-based portrait painter of notable quality, whose work has quite often been confused with Hogarth's.

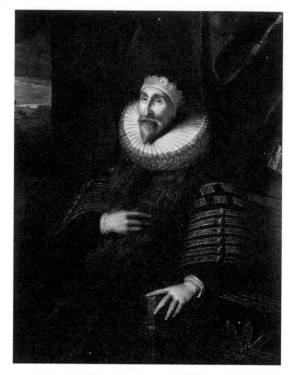

Johnson: 'Sir John Coke' (*Melbourne Hall*)

MELBOURNE HALL

HHA; GT MAP E

Melbourne, Derby
8m S of Derby, off B587
Tel Melbourne (03316) 2502

Nobody should be put off by the approach to Melbourne Hall, which seems to turn its back on the visitor, and is approached in a roundabout fashion. Once the entrance is found, pure pleasure follows both inside and outside this delightful house, a creation of the early eighteenth century and once the home of Queen Victoria's first Prime Minister.

The Coke, Lamb and Kerr family pictures here include some rare treasures, especially a penetrating, rather than formal, portrait by Johnson of Sir John Coke. Other family portraits include work by Closterman, Dahl, Jervas, Kneller, Hudson and Lawrence. There are two unusual Lely double portraits, that of the Earl and Countess of Chesterfield being an especially fine example, at once placid and intense. There are Kneller full-lengths of Queen Anne, Prince George of Denmark, and George I. There are also Bassano religious pictures, and works by Snyders, Bogdany, Hondecoeter and Monnoyer.

MELFORD HALL

NT MAP G

Sudbury, Suffolk
In Long Melford 3m N of Sudbury on Bury St
Edmunds road (A134)
Tel Sudbury (0787) 70000

This turreted, brick Tudor house was for many generations the home of the distinguished naval family of Hyde Parker, so it is not surprising to find here that many of the pictures have naval associations. There are numerous portraits of the family, the most striking being Romney's of the gallant and forthright 5th Baronet, Admiral Sir Hyde Parker. There are several pictures by Dominic Serres of actions fought by this admiral. Serres, marine painter to George III, was sent to sea with the fleet: the earliest example of an official war artist.

MEOL'S HALL

HHA MAP C

Lancs, near Southport
1m NE of Southport, off Preston road (A565)
Tel Southport (0704) 28171

There was a house on the site of Meol's Hall in the reign of King John. The estate has descended through twenty-five generations to the present members of the Hesketh family who still live here, in an unpretentious and not over-large seventeenth-century house of great charm.

The picture collection is remarkable. There are Hesketh family portraits from the eighteenth and nineteenth centuries, and these include work by Raeburn (of two Hesketh sons), a portrait apiece by Romney and Lawrence, and pairs of portraits by Ramsay, Highmore and Wright of Derby. One of Wright's paintings, that of Fleetwood Hesketh of Rossall, shows something of his originality. This is no humdrum likeness but a skilfully evocative and relaxed portrait. The pose is unusual, with Hesketh sitting casually in a characteristically English manner, with one leg cocked over the other, ankle to knee. Sporting interests and the enjoyment of outdoor life are suggested not only by the pose, but by the powder-horn in Hesketh's coat pocket. The Devis group of Roger Hesketh and his family, in contrast, has the customary stiff poses which give so many of Devis's works a charming air of amateur theatricals.

In addition there are works by Salvator Rosa,

Sandby, a life-size horse portrait by James Ward, work by Ibbetson, Zuccarelli, and an astonishing 'Creation' by Barlow, with much emphasis on a whole menagerie of animals, and Adam and Eve modestly placed in the middle-distance.

A visit to Meol's Hall is an enriching experience, where there is much to be seen in a delicious atmosphere.

MIDDLESBROUGH ART GALLERY

MAP B

320 Linthorpe Road, Middlesbrough, Cleveland
Tel Middlesbrough (0642) 247 445

Middlesbrough's Art Gallery possesses an extensive collection of twentieth-century British art, one of the best in the north of England; it includes work by Bomberg, Procktor, Redpath and Blackadder.

MILTON MANOR HOUSE

HHA; GT MAP F

Abingdon, Oxon
4m S of Abingdon in Milton, off Newbury road
(A34)
Tel Abingdon (0235) 831871

Milton Manor is an engagingly attractive place, built in 1663 and enlarged a century later. There is a number of pictures here, including some Barrett family portraits, among which pride of place is taken by a family group by Highmore.

THE MINORIES

MAP G

High Street, Colchester, Essex
Tel Colchester (0206) 577067

Founded in 1958, The Minories Art Gallery concentrates on temporary exhibitions, but has a modest but growing permanent collection, mainly of twentieth-century British art.

MIREHOUSE

HHA MAP A

Keswick, Cumbria
4½m N of Keswick on Carlisle road (A591)
Tel Keswick (076 87) 72287

The charming seventeenth-century manor of Mirehouse contains memorabilia of Wordsworth, Southey, Tennyson and other friends of the Spedding family who have lived here since 1802.

There is a small picture collection, including work by Turner, Highmore, Hudson, Vernet, Hondecoeter, George Morland and Constable.

MONTACUTE HOUSE

NT MAP I

Yeovil, Somerset
In Montacute, 4m W of Yeovil, off A3088
Tel Yeovil (0935) 823289

Montacute House is, in the opinion of many, the most ravishingly beautiful Elizabethan house in England — and the best preserved. Today it is, in effect, a house in two parts: the ground and first floors have been carefully and appropriately furnished by the National Trust, while the top floor is a west-country branch of the National Portrait Gallery.

The pictures hanging downstairs, which include a fine portrait of Edward VI, are mostly portraits of the Phelips family, who lived here for 300 years. There are examples of the work of Lawrence, Cotes, Reynolds, Hoppner, Raeburn and Johnson amongst others.

On the top floor, in the magnificent long gallery, and in its subsidiary rooms, which have all been decorated with the utmost skill and sensitivity, the National Portrait Gallery has deployed a comprehensive and appropriate collection of nearly a hundred portraits from the time of Henry VIII to that of James I. There is nowhere better to study the beginnings of English portraiture, or the history of the period, for all the main characters of the times are to be seen here.

In the early part of the period Holbein dominated portraiture in England. There are several copies of his work here, including the best early copy of his familiar image of Thomas More (the original is in the Frick, in New York). Henry VIII, in a version of the portrait at Castle Howard, is shown in his later years, a larger but less magnificent monarch than before. Queen Elizabeth appears in a splendid version of the 'Armada' portrait at Woburn Abbey, her impassive and mask-like features contrasting sharply with the detail of her astoundingly spectacular costume and jewellery. Her courtiers are here — the haughty Earl of Leicester, the imprudent Earl of Essex, the dandified Christopher Hatton. So too are the men of action such as the many-talented Sir Walter Raleigh and the ungainly Sir Francis Drake, looking thoroughly uncomfortable in his fine court clothes. The perennial wise councillor Lord Burghley is portrayed in old age.

In James I's reign a change of style is readily apparent. The portraits become less formal and mannered, but grander, though more relaxed and natural. There is a touching picture of the ill-fated Henry, Prince of Wales; as a ten-year-old Knight of the Garter — a child dressing up in adult clothes. There is also an unfamiliar rendering of the future Charles I as an awkward teenager. A family group of the 1st Duke of Buckingham, after Honthorst, presages the style of van Dyck which was to become so familiar in

Charles I's reign.

These, and many others, combine to make a visit to Montacute a wholly rewarding experience.

MOOR PARK

HHA MAP F

Rickmansworth, Herts
1m SE of Rickmansworth, off Harrow road (A404)
Tel Rickmansworth (0923) 776611

Moor Park is unique amongst stately homes. It houses a golf-clubhouse — without question the grandest in the land. The Palladian mansion was decorated by Thornhill, Amigoni, Verrio and by Cipriani. The rooms in which their spectacular work decorates the ceilings and walls are open to the public.

MOUNT EDGCUMBE HOUSE

GT MAP H

Rame Peninsula, Cornwall
Over Cremyll ferry from Stonehouse, Plymouth
Tel Plymouth (0752) 822236

Mount Edgcumbe House, once the ancestral home of the Edgcumbe family, is now in public ownership, and is the centre of a 'country park' with much to entertain the visitor. Much of the picture collection was destroyed when an incendiary bomb gutted the house in April 1941. Of Reynolds's portraits of three generations of the family, only that of the black sheep of the family survived, as it was stored in a basement. Three beautiful seascapes by van de Velde also survived.

MOYSES HALL MUSEUM

MAP G

Cornhill, Bury St Edmunds, Suffolk
Tel Bury St Edmunds (0284) 763233

The collection of paintings at Moyses Hall Museum includes portraits of local West Suffolk dignitaries by Reynolds, Wright of Derby, Kauffmann, Tissot, and many others.

MUNCASTER CASTLE

HHA MAP A

Ravenglass, Cumbria
1m SE of Ravenglass on Millom road (A595)
Tel Ravenglass (065 77) 203

Muncaster Castle, remote in far west Cumbria, is a superbly sited medieval castle, much restored and added to in Victorian times. There are many portraits here of the Pennington and Ramsden families, not all of them easy to see, or to identify. There are two splendid Ferneley pictures of the 3rd Lord Muncaster and his horses, and there are portraits here by Kneller, Hudson, Reynolds, Beechey, Hayter, Richmond and de László. Outstanding, though, are three by Watts, those of Sir John and Lady Ramsden being exceptionally fine and sensitive.

THE NATIONAL ARMY MUSEUM

MAP K

Royal Hospital Road, Chelsea, London
Tel (01) 730 0717

One of the very few national collections to have been established in the twentieth century, this museum was opened in 1971, appropriately next

157

door to the Royal Hospital. The collection illustrates the history of the British Army from 1485, and includes a large number of pictures from the eighteenth and nineteenth centuries. There are battle scenes (two by Wootton), pictures of camp life and many portraits of generals and other officers, including works by Gainsborough, Reynolds, Romney, Beechey, Raeburn and Lawrence.

THE NATIONAL GALLERY

MAP K

Trafalgar Square, London
Tel (01) 839 3321

The National Gallery is one of the great art galleries of the world, and perhaps the most representative of all, with masterpieces of all schools on display, and work from almost all the great European painters throughout history, up to the twentieth century.

The gallery first opened its doors in 1824. There was a largely fortuitous element in this event. The connoisseur, artist and collector Sir George Beaumont (1753–1827) had offered his admirable small collection of old masters to the nation, if a suitable building were to be provided to house it. This offer caused no immediate response, but it was still open when the superb collection of the banker John Julius Angerstein (1735–1823) came on the market. The government seized the opportunity. It bought Angerstein's three dozen pictures for £57,000, accepted Beaumont's also, and, in the first instance, housed them all in Angerstein's former house in Pall Mall.

Further gifts followed Beaumont's lead, and the original premises were soon overcrowded. The familiar gallery on the north side of Trafalgar Square, built on the site of the former Royal Mews, was opened in 1838; until 1869 it was shared with the Royal Academy. Designed by William Wilkins (1778–1839), the first building was very long and narrow, only one room deep behind the porticoed façade. Successive extensions have spread the gallery northwards to Orange Street; today a further extension is being built to the west, after years of controversial debate, through the munificence of the Sainsbury family.

The National Gallery is rare among collections of its kind, in that every one of its pictures is on display, unless it is being cleaned or on loan elsewhere.

There are some 2,000 pictures in all, over half of them being gifts; notable among these have been the bequests of Holwell Carr (1831), Wynn Ellis (1876), George Salting (1910), Sir Henry Layard (1916), Sir Hugh Lane (1917) and Ludwig Mond (1924). The purchase of pictures began in 1825, originally through specific Treasury grants. From 1855, an annual purchase grant was agreed, initially of £10,000 a year, increasing to what is now some £3 million. In recent years this has been enormously augmented by J. Paul Getty Jnr with a gift of £50 million.

The gallery is rightly popular, to a degree unknown among galleries elsewhere in England, attracting more than three million visitors each year. Crowds are unavoidable at any time, but they are at their greatest in the summer months; it is accordingly wise to visit the gallery in the winter — and brief visits are always best made at the earliest possible time on weekdays. It is also wise, as with all major collections, to restrict and ration your visits, perhaps concentrating on one of the groups into which the following description is divided. This is the only possible way to do justice to the masterpieces here and avoid visual indigestion. Probably for some years following the opening of the new Sainsbury building, there will inevitably be extensive rearrangements throughout the whole gallery.

EARLY ITALIAN WORK

Italian work of the thirteenth to the fifteenth century, all of which is due to move eventually into the new Sainsbury extension, today occupies something like one quarter of the main floor. This is a high proportion of the whole, and of

van Eyck: 'The Arnolfini Wedding' (*National Gallery*)

famous 'Saint George and the Dragon', in which the princess seems to have anticipated Saint George's wounding of the dragon by putting her girdle round the beast's neck, like a dog-lead; this picture is one of the very few from this date on canvas, rather than on a panel, to have survived. Uccello's 'Battle of San Romano' is also here, one of three battle-pieces he painted for the Medici family in the 1450s, the battle having been fought, against the Sienese, in 1432.

There is a superb group of works by Botticelli, a painter who was almost unknown in England until the 1850s, and then much admired by the Pre-Raphaelites. His splendid draughtsmanship can be admired in his 'Adoration of the Kings'. In his 'Mystic Nativity', painted in 1500 and his only surviving signed work, he seems to be turning away from the life-like painting which was one of the hall-marks of Renaissance Florence; here the perspective has been deliberately distorted so that the Virgin appears larger than life, in an earlier medieval manner.

The Pollaiuolo brothers, in their 'Martyrdom of Saint Sebastian', exemplify many aspects of

course constitutes in aggregate a great collection in itself.

Though the work of Giotto, traditionally held to be (with his master Cimabue) founder of modern painting in Western Europe, is represented here only by an uncertainly attributed 'Pentecost', there are three panels here from the master-work of Duccio, the first great Sienese painter: the high altar-piece of Siena Cathedral (c. 1308–11). Like Giotto, Duccio breaks away from the Italo-Byzantine manner with the introduction of a narrative style, with less concern than Giotto for the three-dimensional sense of form, but with an elegance of line and decorative colour, the influence of which can still be seen in the great Sienese painters early in the following century, Sassetta and Giovanni di Paolo, both very well represented here.

Perspective was developed in Florence in the early fifteenth century. It can be observed here in the important, monumental 'Madonna' by Masaccio. Uccello, who was obsessed by the intricacies of perspective, is represented by his

Ingres: 'Mme Moitessier Seated' (*National Gallery*)

159

Piero della Francesca: 'The Baptism of Christ' (*National Gallery*)

the Renaissance tradition. The subject was a popular one, authorising, as it were, in the depiction of the nude Saint, the study of human anatomy, one of the preoccupations of the time. Likewise the precise painting of the landscape background shows the scientific approach to painting that was current then, while the archers in the foreground, in their poses and in the detailed anatomical painting of their muscles, emphasise other Renaissance preoccupations.

Piero della Francesca's work includes his 'Nativity', a strangely disparate yet haunting composition which may be unfinished, or alternatively may have been adulterated by ill-considered and slap-dash cleaning before it was acquired by the gallery. Piero's 'Baptism of Christ', a much earlier work, is a notably beautiful composition, cool, balanced and with a wonderfully peaceful and timeless quality. Like Uccello, Piero was fascinated by the mathematics of perspective.

A complete contrast to these works is provided by Piero di Cosimo's 'Mythological Subject' and his 'Fight between the Lapiths and Centaurs', the latter taken from a legend of Ovid. This witty Florentine had a passionate interest in animals and in nature, as is to be seen in both these pictures.

One of the works by Antonello da Messina — 'St Jerome in his Study' — is influenced by the style of Netherlandish artists, such as van Eyck, whose work Antonello had probably seen in Naples; such cross-fertilisation usually took place the other way around, but the technique, the use of light, the domestic atmosphere and the scale of the picture all point in the reverse direction.

There is ample opportunity here to study the work of the Venetian Giovanni Bellini, most notably his extraordinarily life-like portrait of 'The Doge Leonardo Loredan' and the intensely moving 'Madonna of the Meadows', one of three Bellini Madonnas here. This magnificently coloured Madonna, in the peaceful Italian countryside, has a memorable wistfulness as she prays for her infant child.

Ruskin advised the use of a powerful magnifying glass and ten minutes quiet contemplation when looking at any painting by Mantegna. But, in truth, no glass is required to appreciate the extremely detailed technique of such pictures as 'The Virgin and Child with the Magdalen and St John the Baptist', where every fold of drapery, for instance, is given minute and detailed attention. The visitor can make a fascinating comparison between the styles of Mantegna and Bellini (his brother-in-law) in paintings by both of the same subject: 'The Agony in the Garden'.

Crivelli, who was active at the end of the fifteenth century, provides a good example of the way in which technique and sophistication had advanced since the time of Duccio, two hundred years earlier. This is evident in such pictures as 'The Annunciation with Saint Emidius', a complex picture, packed with detail and with incident, demonstrating a mastery of mathematically-exact perspective, rich in decoration, not without symbols, but yet not failing to give proper emphasis to the important elements in the picture — the angel Gabriel, the Saint (who is carrying a model of the town of Ascoli, of which he was patron saint) and the Virgin, composed and elegant in her peaceful and intriguing room.

EARLY NETHERLANDISH AND GERMAN WORK

This group of paintings embraces artists who worked throughout the small territories and principalities which are today absorbed into Belgium, Holland, Germany, Austria and Switzerland. The early Renaissance paintings in these North European countries and cities are very different from contemporary Italian work. Meticulous detail is manifestly important, as are sources of light, while the classical references customary in Italian Renaissance painting, when they occur, are treated much more superficially. The pictures tend to be smaller, more domestic, but filled nevertheless with symbolic references and detail.

The work of Jan van Eyck, who worked in Bruges and had a hand in the discovery of the medium of oil-painting, is well-known, with his 'Arnolfini Wedding' one of the best-known paintings in the National Gallery, and probably

the first double portrait ever. Painted in 1434, it has many of the characteristics of the North European Renaissance: the detail is meticulous — from the reflections (including that of the painter in the convex mirror in the background) to the hairs of the terrier in the foreground; the dog is, in all probability, a symbol of fidelity; the single candle burning in the chandelier is a marriage-candle, and also symbolises the all-seeing wisdom of God; the carved figure on the chair is Saint Margaret, who is associated both with brides and with pregnant women.

Bosch, Bouts, Campin (The Master of Flémalle), van der Weyden, Mabuse and Lochner, all well represented in this collection, are artists who may be relatively unfamiliar to English eyes. Pieter Bruegel the Elder is better known, often rather misleadingly called 'Peasant' Bruegel, a nickname that refers to his most frequent subjects rather than to his own background, which was well-to-do and cultivated. His 'Adoration of the Magi' is characteristically set in peasant surroundings, with a large crowd, gazing as though they were villagers at a booth at a country fair; these drolls and grotesques are pictured with a slyly satiric eye.

Memlinc, born in Germany, spent most of his working life in Bruges; his work in the gallery includes 'The Donne Triptych'. This altar-piece includes, in the centre panel, portraits of Sir John Donne, who commissioned the work, and his wife; both are shown wearing Yorkist collars of roses and suns, with Edward IV's pendant — the picture was painted about 1477. Lucas Cranach, another artist not often seen in England, is here represented by something new: 'Cupid Complaining to Venus'. It is a provocatively erotic work, the nude Venus rendered in Cranach's usual glossy detail.

Holbein, the first major painter of the Renaissance to have worked in England, is by far the most familiar artist of this group to English eyes. He is represented by a composedly forthright, but richly rewarding portrait of Christina, Duchess of Milan, painted for Henry VIII, who had the lady in mind (though so young, she was a widow) as a possible wife, a fate which, perhaps luckily for her, she escaped.

She is said to have observed that if she had two heads, Henry would be welcome to one of them. Holbein's double portrait 'The Ambassadors' is a magnificently assured and fascinating work. This very powerful picture in fact shows Jean de Dintville, French Ambassador to the court of Henry VIII, who was visited in London during 1533 by his friend Georges de Selve, Bishop of Lavaur. The costumes are detailed with enormous care, while the miscellaneous scientific and musical instruments on the hefty piece of furniture on which the two friends rest their arms illustrate some of the accomplishments expected of Renaissance aristocrats. The picture is not without symbols, however, to remind the two young and successful men of their mortal nature: the lute has a broken string, and the strange shape, apparently slung carelessly into the foreground, can be seen (but only clearly from the bottom left or top right of the picture) to represent a skull — a virtuoso exercise in the science of perspective, as indeed is the whole composition.

Other notable artists whose work is to be seen in this section of the gallery include Altdorfer (a landscape, and a most remarkable 'Christ Taking Leave of his Mother'), Baldung, Elsheimer (with a number of highly finished religious pictures on a small scale), Dürer (a portrait of his father), Massys and Gerard David.

ITALIAN PAINTINGS OF THE SIXTEENTH AND SEVENTEENTH CENTURIES

The normal definition of Renaissance, that is the revival of the arts and letters under the influence of classical models, is now customarily subdivided, with the work of Giotto the starting point, with man and his works accorded a new dignity and importance; the Early Renaissance is generally believed to have lasted to the end of the century; the High Renaissance, flourishing briefly from about 1500 to the sack of Rome in 1527, was the time when a balanced harmony of composition matched a mastery of technique and the elimination of superfluous detail.

The three greatest artists of the High

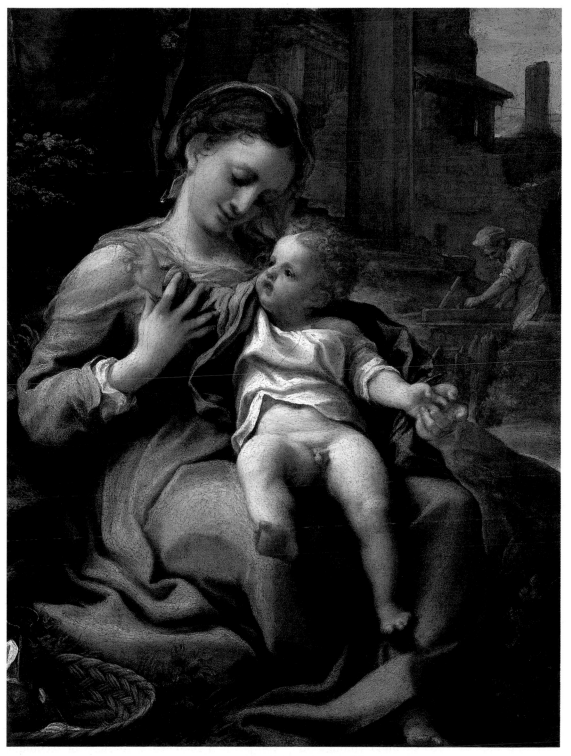

Correggio: 'The Madonna of the Basket' (*National Gallery*)

Renaissance in Italy — the eldest, Leonardo da Vinci, then Michelangelo, then Raphael, the youngest — are all represented in the National Gallery, the last with a number of pictures. These are mostly early works and include 'The Ansidei Madonna', 'Crucified Christ with the Virgin, Saints and Angels', an enchanting small 'Madonna and Child' and Raphael's celebrated portrait of his (and Michelangelo's) patron, Pope Julius II, firmly datable by the beard which the Pope only had in the years 1511-12, when he had grown it in mourning for the loss of the city of Bologna from the Papal dominions. The picture was long thought to be a copy, and only recently was it conclusively identified as the original.

Leonardo's ability to infuse his pictures with enigmatic qualities is well known. It can be seen in both his works here: in the mysterious smile of the Virgin in the 'Madonna of the Rocks' (a later version of that in the Louvre), and in the cartoon 'The Virgin and Child with Saint Anne and Saint John the Baptist', another composition involving two adults and two children, where all the figures in the group are gazing at each other in a complex web of mystery.

Michelangelo's 'The Entombment' is here. It is unfinished and the attribution is controversial, but it can readily be assumed to be a sculptor's picture. It has a haunting quality, with all Michelangelo's passionate interest in the human body.

Mannerism, a term coined in the twentieth century, describes the art, mainly in Italy, which succeeded the High Renaissance; in paintings it is characterised by a breaking of 'rules', distorting, overemphasising and elongating, for instance, the human figure and using vivid colours for emotional effect rather than for reasons of realistic description.

Bronzino, the supreme exponent of Mannerist court portraiture, worked in Florence later than these three giants, and seems to be in a different world with his 'An Allegory' (c. 1550), a complex and erotic composition involving Venus, Cupid, Time and other figures. The picture is now freed from the extraneous pieces of drapery and sprigs of leaves, prudishly added, it is supposed, in Victorian times. Certainly it is erotic, but with its flawless polish, cool colour and passionless postures, it could only be described as pornographic by a singularly cold-blooded viewer.

Sebastiano del Piombo, Andrea del Sarto, Fra Bartolommeo, Pontormo are amongst the other artists of the period to be seen, with Correggio and Parmigianino (both from Parma). Correggio's splendidly attractive 'Madonna of the Basket' is an enchanting small work, so pretty that one might be forgiven if one supposed that it was painted by a Frenchman in the eighteenth century. It is almost rococo in feeling: while Joseph is busy with carpentry in the background, the very young Virgin, surely a teenager, struggles with a wilful and recalcitrant infant Christ.

The major contribution of Venice is from two pupils of Bellini — Giorgione and Titian. Giorgione's work (such as his 'Sunset Landscape with Saints') reveals a new vision of poetic landscape, of mysterious mood, which has haunted the European imagination ever since. Titian had worked with Giorgione before the latter's premature death in 1510, but went on to produce through his long life a superb and varied harvest including religious works, mythological subjects and portraits. 'Noli me Tangere' is a famous example of his religious work. 'Bacchus and Ariadne', a fine example of a mythological subject, was originally painted to adorn the walls of Duke Alfonso d'Este at Ferrara. 'Saint George and the Dragon', 'The Vendramin Family' and 'La Schiavona' are other masterpieces by this most various, energetic and long-lived of artists, the greatest of the colourists.

Titian's two great Venetian successors, Tintoretto and Veronese, are both well represented here, the latter with several large and opulent canvases, including 'The Family of Darius before Alexander', where the artist has transferred an incident from the Persian wars of Ancient Greece to the elegance of sixteenth-century Venice. Tintoretto is not, perhaps, seen here in quite so overwhelming form as his contemporary, even with his very large 'Christ Washing the Disciples' Feet' and 'The Origin of the Milky Way', an unusual composition handled with effortless skill.

At the turn of the sixteenth and seventeenth

centuries, Caravaggio was at work in Rome, his paintings revolutionary in style, with their directly observed elements and their often dramatic lighting and theatrical atmosphere. His 'Supper at Emmaus' powerfully exemplifies these qualities. The apprehension of an actual moment, as in a close-up — the vivid astonishment of the disciples, Christ's self-controlled gesture, the basket of fruit about to fall from the table, the theatrical lighting — makes the spectator all but a participant in the action, in a hitherto unknown manner.

Other artists of the seventeenth century are richly represented: the very influential Carracci family, Domenichino, Elsheimer (who was German but who spent his last ten years in Italy), Reni, Guercino, Preti, Giordano, Mola. Most of these, in whose work the influence of Carracci or Caravaggio (or both) is visible, and indeed the other Italians in this grouping of the 'Seicento' (six hundred in Italian, meaning the 1600s or seventeenth century), were very popular in England, especially in the eighteenth century, and interest in them has revived strongly since the Second World War. Many examples of their work are to be seen up and down the country, and the images of Salvator Rosa, the Neapolitan, were to be accepted as archetypal versions of one of the three different visions of ideal landscape — the others being those of Claude and Poussin (both French but based in Rome).

REMBRANDT AND THE DUTCH, SEVENTEENTH CENTURY

In England we are fortunately very well aware of the extraordinary flowering of Dutch art in the seventeenth century. Holland's maritime strength in those days made the country prosperous; the nature of the country's social structure meant that this prosperity was not concentrated in the hands of a small aristocracy, but rather in the large middle class, which was comfortable, provident, living in modest-sized houses, music-loving, flower-loving, passionately house-proud — and eager to decorate their walls with pictures. The church, now Protestant, was no longer a major patron, its services held within bare, whitewashed walls.

Artists of genius emerged to satisfy the demand for pictures, which needed to be, for the most part, reasonably small in size. They dealt with the mundane day-to-day activities of the middle class, or amused their patrons with scenes from low-life, landscapes of their flat countryside, seascapes and river scenes from their water-based nation, portraits and still-lifes, especially of flowers.

These pictures have been enormously popular in England since the mid-eighteenth century. The artists involved are represented in innumerable country house collections and in every major public collection. The magically peaceful freshness that enriches so many Dutch pictures continues to find a response in countless English eyes.

Cuyp was one of the first Dutch artists to be valued, and has been represented in the National Gallery from the day it opened. There are several of his pictures here, including 'A Milkmaid and Cattle near Dordrecht', which embodies many characteristic Cuyp elements — the very low viewpoint of the artist, the peaceful and handsomely-painted cows, the familiar shape of Dordrecht church in the background, and the glowing evening light, reminiscent of Italy, which Cuyp never saw, but which he knew at second hand from Jan Both and other colleagues who had visited the south.

Two of the Dutch masters most admired today — Frans Hals and Jan Vermeer — did not find their way into the National Gallery's collection until late in the nineteenth century, as late as 1892 in the case of Vermeer. The reason was that these two were among the artists who were virtually unknown in England, extraordinary as this seems a hundred years later. Hals is represented by a good group of the portraits of which he was such a skilful exponent. 'A Family Group in a Landscape' is painted with his usual vivacity, but it is interesting to learn that this portrait specialist employed another artist to paint the landscape background. There are two Vermeers in the gallery, both showing young women with virginals: one is seated at the instrument, the other standing by it. In both

pictures the artist demonstrates his profound understanding of the fall of light, and his supreme ability to create and convey an atmosphere of intense stillness.

Among the many other artists represented in this section are Steen, van Hoogstraeten (with a cunning perspective peephole box), van de Cappelle, de Koninck (with a notable panoramic landscape), Jacob van Ruisdael, Avercamp, and Hobbema, whose 'Avenue at Middelharnis' has for very many years been one of the most popular pictures in the whole of the gallery's collection, seeming to hold a large audience with almost mesmeric power, perhaps due to the powerful illusion of distance created by the poplar avenue; the trees were real, and had been planted in 1664, a quarter-century before Hobbema immortalised them in this simple scene. The picture was one of the fifty-five Dutch pictures from Sir Robert Peel's collection (some seventy pictures in all), acquired by the gallery in the 1870s.

De Hooch's 'An Interior' is a perfect example of the immense skill employed in an apparently simple scene. The comfortable room looks so real, and the figures are so casually arranged, that it almost seems as though the onlooker has opened a door onto a very ordinary domestic scene. Yet this is to ignore the skill of the quietly dramatic fall of light, the cunning manner in which attention is concentrated on the upheld wine glass, placed against the darkened window for the best effect, and the way in which a flirtatious atmosphere is created, although only the back view of the young woman holding the glass can be seen.

The representation of Dutch seventeenth-century painting in the National Gallery is — most justly and satisfactorily — dominated by Rembrandt; there are more than twenty paintings here, a breathtaking collection in themselves.

This great artist, with his penetrating insight and compassion, is seen in many moods. There are religious pictures, such as the highly dramatic 'Woman Taken in Adultery', and the theatrical 'Belshazzar's Feast'. The portraits include a unique equestrian one of an officer in the Civil Guard, and the portraits of Jacob Trip and of Margaretha Trip, touching studies of dignified old age. There is the tender 'Woman Bathing in a Stream'. There is 'Saskia in Arcadian Costume', Rembrandt's happy, almost joking, tribute to his wife in the year of their marriage — a glowing, rich portrait of the wealthy and contented young woman, with no hint of her future ill-health and early death.

And there are two of the long series of self-portraits which marked Rembrandt's whole life. The first of these dates from 1640, when the artist was a successful thirty-four-year-old. He may have based this picture on the pose adopted in a relaxed portrait by Titian, then known (wrongly) as 'Ariosto' (prince of poets), which passed through an Amsterdam sale-room at this time and is now also in the National Gallery. The second portrait dates from 1669, the year of the artist's death at the age of sixty-three. The self-examination is as penetrating as ever, the face that of a man who has known professional success and failure, wealth and bankruptcy, happiness in his family life and tragedy in the early death of his children and of his young wife, but who still found fulfilment in painting, even the cheapest and most available of models — himself. In the late self-portraits many admirers feel that Rembrandt enlarged their scope to embrace one of the most eloquent accounts of the conditions of man ever achieved. Not without reason is he ranked comparable in art to Shakespeare in literature.

SEVENTEENTH-CENTURY FLEMISH, FRENCH AND SPANISH PAINTERS

Rubens opens the seventeenth century — and, indeed, northern baroque painting — with a flourish. The National Gallery has an outstanding collection of the work of this immensely versatile and industrious artist, who was also a distinguished part-time diplomat and a formidably efficient manager of his studio assistants and collaborators. He visited England, and was patronised and knighted by Charles I; his work has been popular here since that time. Every aspect of his work is to be seen in the gallery, such as the large and masterly 'Samson and Delilah' painted after his visit to Italy and

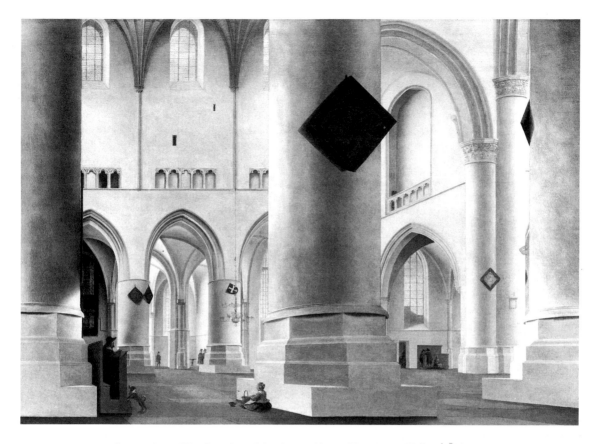

Saenredam: 'The Interior of the Grote Kirk at Haarlem' (*National Gallery*)

influenced by his study there of the antiques and of Michelangelo (in, for example, the superb detail of the muscles on Samson's back) as well as the Caravaggiesque use of three separate sources of light. His 'Minerva Protects Pax from Mars' was a gift from the artist to Charles I, after the knighthood had been bestowed, a typically crowded but assured interpretation of a mythological theme with current political implications — and no monarch in English history would have appreciated it more than the connoisseur-king to whom it was given. There are two versions of the story of 'The Judgement of Paris', the earlier one almost gauche compared with the later, showing how Rubens, after his Italian period, introduced southern warmth and sensuality into northern painting; the Rubens portrait known as 'Le Chapeau de Paille' is curiously misnamed as the subject, thought to be the elder sister of Rubens's second wife, is in

fact wearing a felt, rather than a straw, hat — she is painted with an intimate informality and liveliness, and well deserves her fame. 'Peasants and Cattle by a Stream' is another rightly celebrated picture, and one that inspired Gainsborough to paint the same subject (also to be seen in the gallery). Another splendid Rubens picture is 'A View of Het Steen', the country house which the artist bought and retired to in the last years of his life, lovingly pictured in this large and resplendent landscape, which may include a self-portrait in the man with a fowling-piece in the foreground.

The name of Rubens's one-time assistant van Dyck, who must certainly have absorbed the art of studio-management from his master, with much else, is often anglicised to Van Dyke, in view of the prodigious number of portraits which he painted during his nine years' work in England. In the National Gallery he is firmly

167

classified as Flemish, and is well represented, and not only with portraits from his English years, such as the famous equestrian portrait of Charles I, where the elevation on horseback helps the artist to portray the king, in fact a slight figure, as an imposing regal presence. There are also earlier pictures, in some of which Rubens's influence is dominant, work done before van Dyck made his lengthy visit to Italy, which was to be as inspiring to him as Rubens's own visit had been. Two outstanding recent acquisitions are whole-length portraits — a masterpiece featuring the children of Genoese aristocrats, and another of two young Cavalier courtiers (both doomed to fall a few years on in the Civil War). Other Flemish artists of the time whose work is to be seen include Jordaens, Coques, van der Meulen, and Teniers with a characteristic work, 'Peasant Playing Bowls'.

There is a superb seventeenth-century French collection at the gallery. Outstanding among them is the work of Claude, work that was to be greatly admired and vigorously purchased in the eighteenth century in England, where so many landowners saw themselves as inheritors of the classical tradition. 'The Embarkation of the Queen of Sheba' shows Claude applying the techniques developed in his landscapes to a sea-port scene, subtly graded in tone from the dark foreground to the distant, misty horizon, with classical buildings providing the framework on either side. In landscapes such as 'The Marriage of Isaac and Rebekah' groups of trees perform this function, almost as theatrical 'wings', framing the peaceful, romantically pastoral scene which Claude evokes so skilfully — an ideal world which found such a powerful response in the following century, in such matters as styles in architecture and the art of landscape gardening. One of the most famous of his late masterpieces is the dream-like 'Enchanted Castle' that was in Keats's mind when writing the 'Ode to a Nightingale'.

Nicolas Poussin is also splendidly represented here, both with landscapes, such as 'Landscape with a Man Killed by a Snake', as well as such pictures as 'Bacchanalian Revel', and also 'The Adoration of the Golden Calf', which can be seen as a biblical version (but echoing also

classical antiquity) of much the same subject. Other French artists from this period to be seen at the gallery include Philippe de Champaigne, with his immensely stylish and grand full-length portrait of Cardinal Richelieu, as well as a triple head of the same subject, reminiscent of van Dyck's triple head of Charles I, similarly painted for the benefit of a distant sculptor. Work by Gaspard Poussin, Francisque Millet, Vouet and members of the Le Nain family is also in evidence.

From Spain come a number of works by El Greco, with his strange colouring and seemingly elongated figures, though only in Spain can his most spectacular works be seen. His 'Christ Driving the Traders from the Temple' is perhaps the best-known of his paintings here; this was a subject to which the artist often returned, the theme being popular at the time of the Counter-Reformation, as it was seen as symbolic of the Church being cleansed of heresy.

Velazquez is well represented, with official portraits of King Philip IV, whose court painter he was, with the voluptuous 'Rokeby Venus' (so called because it was for a hundred years at Rokeby Park in County Durham), and religious works, which include the early, very human 'Christ in the House of Martha and Mary' — in this picture all the emphasis is not on Mary, who is seen distantly through an aperture in rapt attention to Christ, but on Martha, highly disgruntled at having to slave away in the kitchen, pounding garlic, while an interesting time is being enjoyed by everyone else in the other room.

Zurbaran and Ribera are also represented in the Spanish Collection, as is Murillo, always a popular artist in England. Here are portraits, including a sturdy self-portrait, genre scenes and religious paintings, such as 'The Two Trinities', a very late work in which Murillo's style is fully developed.

THE EIGHTEENTH CENTURY

In very much the same way as had occurred in Holland in the previous century, native artists of genius now emerged in Britain to supply the

needs of those who wanted pictures on their walls, often the walls of newly-built Palladian houses in the countryside. With few exceptions, up to this time, the most accomplished portraits in Britain had been painted by *émigrés*, artists who had come to the country, temporarily or permanently, to paint portraits of those who could afford to buy them — Holbein, Johnson, van Dyck, Lely, Kneller, Dahl are obvious examples.

William Hogarth was the first British artist to fight a long and vigorous battle against this trend. Hogarth could paint the grandest of portraits if so minded, as well as informal likenesses of stunning vivacity, such as the gallery's famous 'Shrimp Girl', where he was breaking new ground with his interest in the working classes; but his pre-eminence did not lie in the field of portraiture. He invented a new form of picture-making, with a series of scenes which, together, told a story, making several moral points.

Hogarth's novels-in-picture-form were an entirely new concept, all the more remarkable in that the printed novel was also in its infancy at the time. After 'The Rake's Progress' (in the Sir John Soane Museum), his 'Marriage à la Mode', here in the gallery, is perhaps the most famous of all Hogarth's picture-series, which became widely known at the time they were painted in the 1730s and 1740s, through circulation in the form of engravings in Britain and abroad. High-life is brutally satirised, and several moral points are made in these six pictures, in which the myriad details can be a source of great interest and speculation: is the viscount, for example, visiting the quack doctor, in the third picture, in search of treatment for his own venereal condition, for an abortion for his blowsy mistress, or for some other purpose?

Sir Joshua Reynolds, much influenced by his extensive visit to Italy in his early years, shrewdly and effectively introduced a classical note into his portraits. (Ladies often complained about his insistence on dressing them in 'nightgowns', when they would have preferred to have been recorded for posterity in modish silks and satins.) Reynolds became tremendously fashionable as a portrait painter, and most influential. He was

knighted, was the first British artist to receive an honorary degree, and was the first President of the Royal Academy. There have been examples of his work in the National Gallery from the day it opened. 'Lord Heathfield' is shown as Governor of Gibraltar, which he defended in the siege of 1779−83, in a sturdy and formal portrait; an informal likeness of Anne, Countess of Albemarle, shows Reynolds in a different vein, for this is an affectionate tribute to a member of the Keppel family, among his best and most helpful patrons in his earlier years.

Contemporary critics believed 'history' or 'epic' painting of mythical or allegorical subjects to be the supreme branch of the art. There was, however, little demand for such work by native artists in England — nor was this Reynolds's forte. He did however succeed in raising portraiture — then held to be a very minor art — virtually to the level of history painting. His use of poses and compositions based on the work of the great Italians, or on classical sculpture, was accepted by the intelligentsia of his time, not as plagiarism, but rather as quotation (as writers might quote from classical authors). They helped his work achieve resonance and intellectual respectability, as well as the variety of characterization for which he was famous.

George Stubbs made no concessions to classicism. He was as English as his name, and concentrated on accurate portrayal of people and, perhaps even more, of their horses. He reflected the passionate interest in horseflesh that has preoccupied many of the landed families of the country for generations. 'The Melbourne and Milbanke Families' is a delightful example of his straightforward craft, now ranked as comparable with the major English artists of his time.

Thomas Gainsborough was another preeminently English painter. He never crossed the Channel, but he studied assiduously, and sometimes copied masterpieces from the past, especially those of Rubens and of van Dyck. With pictures such as the very early, now enormously popular, 'Mr and Mrs Andrews' he reflected the English country gentleman's love of his own broad acres and of the countryside. The

latter was Gainsborough's private passion, which he introduced into portraits at every opportunity, and all his life he lovingly painted landscapes for his own pleasure — the gallery has several examples. The superb 'The Watering Place' can be seen to owe a great deal to Rubens's picture with the same title, which is also in the gallery. The development from his youthful traditional style to the fluid, lyrical, almost aerial treatment of paint is superbly illustrated in the late 'Morning Walk'.

The eighteenth century was also the time when those with purchasing power in Britain — the aristocracy and the landed gentry — travelled through Europe, to Rome especially, to see the relics there of the ancient world, to study art in many forms and, in some cases, to buy pictures. It was in the eighteenth century that a very high proportion of the pictures now in the National Gallery first found their way to Britain.

Some British artists followed the milords, and 'The Valley of the Dee' is a fine example of the work of Richard Wilson, who returned from a visit to Rome with the determination to paint nothing but landscapes in the classical manner.

Canaletto, always a popular artist with collectors, is appropriately represented by ten canvases, including Sir George Beaumont's own brilliant example of his work: 'The Stonemason's Yard'. This is an unusual picture displaying, not the normal façade of Venice, but a backstage view of working Venice, an aspect of the city not normally seen by the tourist.

Other eighteenth-century Italian painters whose work is to be seen in the gallery are, for the most part, those who were based in Venice — Guardi, for instance, with a group of his delicate Venetian city-scapes, and Longhi, with small-scale pictures of patrician life in Venice. Giovanni Battista Tiepolo is splendidly represented, most notably by 'An Allegory with Venus and Time', a graceful and delightful ceiling decoration, originally commissioned for a Venetian *palazzo* and 'discovered' in London in 1969: it was probably painted to celebrate the arrival of an heir, as Venus is shown as having just given birth to a baby boy (who looks as unrattled by the proceedings as his mother); the boy is being nursed, not very competently, by

the winged figure of Time, while the Three Graces shower the baby with rose-petals.

Eighteenth-century France is well represented in the gallery, though not in great depth, compared with the riches to be seen in the Wallace Collection. There are examples of the work of Watteau, Boucher, Greuze and Watteau's emulator, Lancret. Other lesser-known artists include a spectacular Drouais — his fine portrait of 'Mme de Pompadour', in which the many interests of this remarkable woman are carefully detailed. There is work by Fragonard, Rigaud, Nattier, J. L. David and Chardin. Chardin's 'House of Cards' and 'The Young Schoolmistress' are excellent examples of the modest-sized pictures of simple genre subjects which the artist was able to invest with strange significance, very reminiscent of Dutch seventeenth-century work. He shares with Vermeer an extraordinary ability to infuse a simple domestic scene both with dramatic intensity and with a powerfully peaceful atmosphere.

The eighteenth century included much of the lifetime of Goya, also well represented in the gallery, notably with his portrait, of 1812, of the Duke of Wellington, whom Goya saw in a unique manner — the great man seems younger, more vulnerable and less of the laconic military hero than in other portraits. The impact of the composition is however weakened by the muddle on Wellington's chest, which Goya was obliged to repaint in 1814 in order to bring the Duke's medals and decorations up to date. Perhaps, however, Goya's finest picture here is his 1798 portrait of 'Dr Peral', a penetrating study of an evidently tricky customer, marvellously painted in subdued tones — the most modest of means being used to most powerful effect.

THE NINETEENTH CENTURY

In the National Gallery the only British artists represented are those whose abilities stand out in the general European scene. This is especially noticeable in the nineteenth-century collection, where there are no British artists on display after the time of Constable and Turner. These have to be sought at the Tate, which was at one

time a subsidiary gallery of the National Gallery. Twentieth-century art, whether from Britain or elsewhere, is likewise to be found at the Tate.

John Constable and J.M.W. Turner are, of course, giant figures in the history of British art, and were also very influential abroad, especially in France. Born within a year of each other, they entered the nineteenth century when they were in their early twenties. Constable was in his own time an innovative painter. His passionate interest in nature, and in all the elements of landscape, and his determination to paint what he saw in the most natural and least artificial manner both tended to set him apart from his fellow-artists.

'The Haywain' is fittingly in the National Gallery, as it is a picture which epitomises both Constable himself and the English landscape. He always painted from nature, and this landscape is therefore a real scene, a view of the river Stour near Flatford Mill, with the cottage of the artist's neighbour and friend, Willy Lott; even today the scene in the peaceful Stour valley is not altogether different, and the cottage survives. The picture made a great impact when first shown at the Royal Academy in 1821, most especially the fresh naturalness of its treatment; it was also greeted with respect at the Paris salon three years later, when Delacroix and Géricault were especially impressed.

Other Constable works here include 'The Cornfield', another Stour valley picture and an evocation of agricultural England and of the beauties of nature which never lost their appeal for the artist. 'Weymouth Bay' is a sketch, painted on the spot with an entrancing freshness and liveliness. 'Cenotaph to the Memory of Sir Joshua Reynolds' is a curiosity — the memorial had been created by Sir George Beaumont at his country home, where it was sketched by Constable in 1821, but the picture was not completed for many years, and was the last of his works to appear at the Royal Academy, in 1836.

Turner did not want his work to be left to the vagaries of fashion and of taste, and willed a very large number of his paintings to the nation.

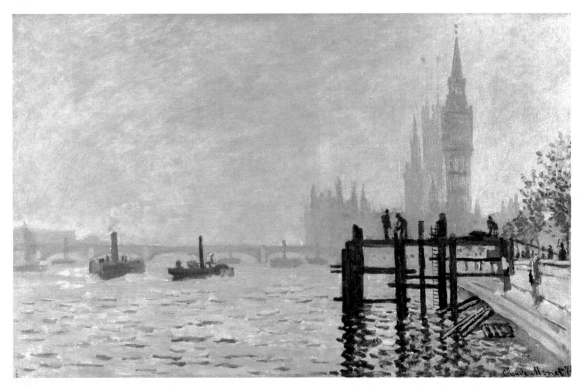

Monet: 'The Thames below Westminster' (*National Gallery*)

The great bulk of this bequest is now in the new Turner galleries at the Tate, but there are some fine examples of his work at the National Gallery. 'Calais Pier' is one of these, a large picture which recalls Turner's first and tempestuous Channel crossing of 1802. This is one of Turner's first oil-paintings; he had previously worked in water-colour, and indeed never ceased to use this medium for his sketches. Even at this early stage in his career, Turner can be seen to be striving to picture not only the complex details of the fishing boats, the English packet-boat, the figures on the pier, the stormy sea and the sky, but also the elusive quality of the atmosphere — he wants those who look at the picture to feel all that the onlooker at the actual scene must have felt.

Another of Turner's sea-pictures here is probably the best-known of all — 'The Fighting Temeraire'. The veteran ship is being towed to her last berth by a powerful steam-tug, black and menacing: old age is giving place to youth, and the old order is being supplanted by the Industrial Revolution. The misty, almost ghostly, three-decker glides away, the passing brilliantly emphasised by the majestic setting sun.

'Rain, Steam and Speed' is another celebrated picture, where the train itself and Maidenhead bridge have almost disappeared in the atmosphere; this is an astonishing picture for its date, 1844, and shows very clearly how far Turner had come and why he would be so appreciated by the Impressionist painters, who began to emerge soon after Turner's death in 1851.

There is a large and impressive group of Impressionists in the National Gallery, along with their famous precursors: Delaroche and Ingres; Delacroix, Géricault and Corot. Corot's clarity of vision and simple handling, well exemplified in his 'Avignon from the West', was to be an influence on the Impressionists, as was Courbet, in his case because of the faithfulness of his treatment of everyday subjects, such as 'Les Demoiselles des Bords de la Seine'.

Manet is well represented. 'La Musique aux Tuileries' is one of the first of his pictures to deal with contemporary life; the fashionable crowd in the Tuileries Gardens, outside the palace where

Napoleon III lived, are enjoying the music of a band: among these black-clad figures are portraits of many of Manet's friends, including Offenbach, Baudelaire and Fantin-Latour. Another of Manet's pictures here, of a much later date, is more Impressionist in technique, 'La Servante de Bocks', a fine study of the bustle of a brasserie and of the preoccupied air of the busy waitress.

Monet is represented with a variety of pictures. There is 'The Beach at Trouville', painted on his honeymoon, when he was working alongside Boudin — there are grains of sand in the paint, testifying to its having been painted on the spot. Within a month the war of 1870 had broken out and Monet fled to London, where he painted 'The Thames below Westminster', one of many studies of the Thames painted on successive visits to London. 'Water-lilies' is one of the thirty, or thereabouts, pictures of the subject which totally absorbed Monet in the last ten years of his life — the lily-pond in his garden at Giverny, an endless source of interest and fascination.

Renoir is another artist well represented here, and there are contributions from Degas, 'Douanier' Rousseau, Seurat, Sisley, Camille Pissarro (another artist who came to London in 1870), Toulouse-Lautrec, Gauguin, Matisse and Picasso. There are four van Gogh pictures here, all of them showing his tortured and twisted sensibilities, most famously with one of his pictures of sunflowers, painted in Arles in 1888. It is extraordinary to consider that this image, almost universally known, is one of the huge number of paintings which poured out in the two brief years at Arles, Saint-Rémy and Auvers, interrupted as they were by bouts of insanity.

Cézanne is another giant figure, and is very well represented at the gallery. The paintings cover a long period and range from the portrait of his father, painted in 1860, in which it is hard to discern the prosperous banker which Cézanne père actually was, through to 'Les Grandes Baigneuses', painted in the last two years of his life. Here, too, the subjects do not look very much like bathers, since the nude figures are not painted with conventional attention to anatomy; the brilliant blues and greens (highly unconven-

tional colours) are used to express the forms which the artist has seen; the triangular shape of the group of figures is echoed in the landscape, into which the figures merge. By moulding nature in this way, Cezanne prepared the way for Cubism and for much of twentieth-century art.

THE NATIONAL HORSERACING MUSEUM

MAP G

Regency Subscription Rooms, High Street, Newmarket, Suffolk
Tel Newmarket (0638) 667333

The collection at the National Horseracing Museum includes many remarkable examples of sporting art. The display is changed annually, so attention cannot be directed to individual pictures.

THE NATIONAL MARITIME MUSEUM

MAP K

Romney Road, Greenwich, London
Tel (01) 858 4422

The National Maritime Museum is a massive collection of all kinds of objects connected with Britain's maritime past — with the sea, with shipping of every kind, and with the Royal Navy. There are collections of weapons, models of ships, boats, navigational instruments, uniforms, and much more, including, of course, pictures.

Lely: 'Sir Frescheville Holles and Sir Robert Holmes' (*National Maritime Museum*)

173

van de Velde: 'HMS *Resolution* in a Gale' (*National Maritime Museum*)

The museum is strangely sited, centred on the Queen's House. This remarkable building is the centre point, when viewed from the Thames, of the splendid vista formed by Wren's Greenwich Hospital. The Queen's House is an astonishing building, designed by Inigo Jones for James I's consort Anne of Denmark. The first Palladian villa to be built in England, this elegant jewel is connected by long colonnades to two large wings, added early in the nineteenth century (originally

174

to house a school), and cunningly sited so that they are, from the river, concealed by the Wren buildings.

The pictures at the National Maritime Museum are a major collection. For four centuries Britain was a leading maritime power, and her pre-eminent position is reflected in the size and the splendour of the collection here.

The seventeenth-century collection of Dutch marine paintings is the largest in the world. Of particular note are pictures by Vroom, van Artvelt, de Vlieger, Backhuysen and the van de Veldes, father and son, who both went to sea as early war-artists. The younger Willem van de Velde's large 'Battle of Texel, 1673' is regarded as his finest work. He was present at the battle.

In the eighteenth century, English marine painting developed and is strongly represented here by, amongst others, Samuel Scott, Brooking, Swaine, Pocock and Serres. There are contributions from painters not usually associated with the open sea, such as de Loutherbourg, with his 'Glorious First of June', Richard Wilson, Zoffany and Canaletto. There is a striking and dramatic collection of topographical pictures by Hodges, who accompanied Captain Cook on his travels to record the places he discovered; his pictures convey something of the excitement created by Cook's explorations. Hodges and Dance both painted Cook's portrait.

In the nineteenth century, episodes from Nelson's life were very popular indeed with painters of narrative pictures. There are many of these in the museum, with deathbed scenes prevailing, among work by West, A. W. Devis (son of Arthur Devis, painter of portraits and conversation pieces), Chambers, Cooke, Stanfield, Brett, Wyllie, Webb, Cull, Everett and Dixon. One of the most compelling pictures in the museum is Turner's 'Battle of Trafalgar'. Turner was never afraid to tackle the largest theme.

The portrait collection, dominated by likenesses of admirals, is both extensive and distinguished. There are works by Bettes, Dobson, Lely (with a famous set of splendidly robust Admirals), Kneller, Dahl, Reynolds (with no less than fifteen portraits here, including the full-length of Admiral Keppel which made his reputation), Romney (with nine, including one of his favourite model, Nelson's mistress Lady Hamilton), Gainsborough, Copley, Kettle, Beechey, Hoppner, J. F. Rigaud, Mosnier, Danloux, Dance, Stuart and many others, including Lemuel Abbott, with his frequently copied portrait of Nelson.

There are paintings of the Second World War at sea, by such artists as Eurich, Lamb and Stephen Bone. All in all, the pictures at the National Maritime Museum are a celebration in paint fully worthy of the country's greatness at sea.

THE NATIONAL PORTRAIT GALLERY

MAP K

St Martin's Place, London
Tel (01) 930 1552

Emphatically a national institution, the National Portrait Gallery was founded in 1856 and is dedicated to the collection and display of portraits of men and women who have made outstanding contributions to British history and to civilisation over the centuries. Portraits here take all possible forms: paintings in every medium and on every possible surface, drawings, miniatures, busts, caricature, photographs. There are about 10,000 items in the collection, with about one tenth on display at any one time in the gallery, and with others loaned for display elsewhere, notably the Tudor pictures at Montacute and the Georgian at Beningbrough.

The object of the collection is historical completeness. It should not be expected, in consequence, that artistic excellence is also always achieved. Nevertheless, this is a magnificent assembly by any standards, of enormous interest and including many masterpieces of portraiture from five centuries.

The gallery is a very popular, busy and lively place, much used by parties from schools; and further crowds are attracted by frequent special exhibitions. Although the architecture (on an

awkward site — attached to the body of the National Gallery, as Henry James observed, like the bustle of a woman's dress) has created a rather confusing lay-out, everything is made very clear to the visitor. The format of the collection has always been chronological, and great care is taken, with appropriate furnishings and by other means, to suggest the correct atmosphere in each succeeding room. The effect is altogether admirable.

The starting point is the Middle Ages, when portraits first began to emerge from religious art and when monarchs were almost the only people to be portrayed. The earliest portraits here are copies made in the fifteenth and sixteenth centuries of portraits of Richard II and the Lancastrian and Yorkist kings.

Much more familiar ground is reached with the Tudors, not only with images of royalty, but with many versions of Holbein portraits, such as that of the implacable and rapacious Thomas Cromwell. There is a large version by Lockey of Holbein's celebrated (although lost) portrait group of Sir Thomas More and his family. Painted in 1593, this version incongruously includes some subsequent descendants, as can be seen by studying the photograph of Holbein's original portrait sketch alongside. Holbein's large cartoon of Henry VIII here, made for a subsequently destroyed wall-painting in Whitehall Palace, shows the king in a familiar legs-apart, aggressive pose, his formidable shoulders greatly exaggerated by his clothing, in vivid contrast to the almost willowy figure of his father Henry VII, who stands in the background.

Many of the portraits which mark the richness of the Elizabethan age are by unknown artists, such as that of the dashing courtier Robert Dudley, Earl of Leicester, his costume as elaborately detailed as that of Queen Elizabeth herself, seen here in several portraits; one of these is 'The Ditchley Portrait' commissioned from Gheeraerts by Sir Henry Lee, after the Queen had visited him at Ditchley Park — a grandly symbolic portrait in which the Queen is standing on a map of the world, her neat feet carefully planted on Oxfordshire, where Ditchley stands. It is at this point that the visitor encounters the gallery's very first acquisition (a gift of the Earl of Ellesmere), believed to be the only contemporary painting of Shakespeare, and attributed to John Taylor.

The portrait of the little-known Sir Henry Unton was commissioned (from an unknown artist) by his widow, in 1596, the resulting picture being not only a portrait but a long sequence of fascinating incidents from Unton's life in strip-cartoon fashion, ending with a detailed picture of his elaborate tomb. Another unknown artist produced a group portrait of a different kind, 'The Somerset House Conference', which shows two teams of statesmen working out the treaty of 1604 which marked the end of nearly twenty years of warfare with Spain.

The conference table is covered with a Turkey carpet, very similar to the one that appears in

Gheeraerts: 'Elizabeth I' (*National Portrait Gallery*)

Highmore: 'Samuel Richardson'
(*National Portrait Gallery*)

the portrait, attributed to Larkin, of 'George Villiers, 1st Duke of Buckingham'. Peake's portrait of his patron Henry, Prince of Wales, demonstrates his rare skill and charm. There is an admirable portrait — one of the best in the whole collection — of the Earl of Arundel by Rubens. It has to be said, however, that the National Portrait Gallery is not the best place in the country to study his work. There are portraits here — by van Dyck as well as studio work. His influence can be seen plainly in the group of 'The Capel Family' by Cornelius Johnson, but not in the rather naive background of the family's formal garden at Little Hadham.

Charles II is represented by a portrait by the little-known Thomas Hawker. Although formal in style, the pose is relaxed, and the artist is able to show, in this, perhaps the last portrait of the king to be painted, something of the adroitness of the man, and something of the character of the Medici which he inherited from one of his grandmothers. Restoration Britain is wonderfully brought to life with a series of splendid portraits, none of them more revealing than that of Pepys by Hayls, nor more accomplished than Kneller's brilliant 'Sir Isaac Newton', nor more delightful than the Vyner family group by J. M. Wright.

The early days of the eighteenth century are dominated by a group of Kneller's Kit-cat Club portraits, a selection from the series he painted of the members of this club, which included most of the leading Whig politicians of the day, such as Robert Walpole, then a rising young politician. This spirited group make a sharp contrast with Kneller's much less successful oil-sketch of the Duke of Marlborough, mounted and surrounded by many symbolic figures. A footnote to the times, so to speak, is provided by Largillière's admirable, and very French, double portrait of the exiled seven-year-old Prince James Edward ('The Old Pretender') and his sister.

As the visitor passes through the work of the eighteenth century, all the notable painters of the day can be studied, Hudson, Hone, Richardson and many more. None is more effective than Highmore, with his small portrait of 'Samuel Richardson'. Sometimes the work takes the form of conversation pieces. There are Mercier's enchanting 'Music Party' where Frederick Prince of Wales is seen playing the cello in the grounds of Kew Palace with his sisters; Zoffany's 'The Sharp Family', a spirited portrayal of another music party, this one on the Thames; and Gawen Hamilton's 'The Society of Virtuosi'.

Group portraits of another kind are represented by Copley's large picture of 'The Death of Chatham', which in fact records the great man's collapse in the House of Lords a few days before his death; this in turn is mirrored by Hickel's 1793 picture of Chatham's son in 'William Pitt Addressing the House of Commons'; and this picture is echoed again by Hayter's huge 'The Reformed House of Commons' of 1833.

Reynolds, as in so many collections, tends to dominate the eighteenth-century work. There are many portraits by him here, ranging from his very formal portrait of 'Lord Bute', and his well-known likeness of Boswell, to his intimate and domestic double portrait of Garrick and his wife.

Lawrence is best represented here by a

Kneller: 'Isaac Newton' (*National Portrait Gallery*)

brilliant sketch of George IV; Beechey by another brilliant sketch of Nelson; Romney by a picture of Lady Hamilton, whom he never tired of painting; Severn by a famous portrait of Keats, whose devoted friend he was; and both Byron and Blake are portrayed by Thomas Phillips.

The throbbing energy of the nineteenth century is splendidly reflected in groups of portraits in rooms devoted to separate themes. The room devoted to science and technology, for example, is very properly dominated by a Winterhalter 'Prince Albert', and includes such figures as 'Brunel' by Horsley, 'Darwin' and 'Huxley' by John Collier. There are also several by Watts, part of the collection-within-a-collection of Watts's 'Hall of Fame', in which the artist himself decided who was to be included. He happened to start work on this in the year of the gallery's foundation, and over forty of his portraits are now to be found there.

The present century is as vividly evoked as those that come before. The vigorous pre-1914 group includes a sumptuous full-length of Edward VII by Fildes, a delightful 'Henry James' by Sargent and a formal group in Buckingham Palace by Lavery, where George V is painted in the pose of Donatello's 'St George', but painted with such skill that the figure seems as natural as the others in the group.

The same cannot be said of Gunn's 'The Royal Family at Royal Lodge' of 1950, where all figures seem stiff and unnatural. The later twentieth century is displayed in a crowded, unconventional and effective 'show' which includes such adjuncts as moving turntables. Scores of familiar figures are splendidly on display, including Churchill, both in a marvellous Sickert sketch of 1927 and a study by Sutherland made for the portrait that was so disliked by Sir Winston, and later to be destroyed by Lady Churchill. The display is constantly changing, and forms a worthy finale to the sequence which starts with Richard II.

The gallery has an unrivalled collection of self-portraits, which would alone make a visit worthwhile. Amongst those to be seen are those of Dahl, Hogarth, Wright of Derby, Gainsborough, Stubbs (on a Wedgwood plaque),

Watts: 'Choosing', a study of Ellen Terry
(*National Portrait Gallery*)

Ramsay and Reynolds — in this case as a young man, shielding his eyes from the sun; in the present century there are examples by Bevan, Gore and Gwen John, the last a modest-sized masterpiece, showing all this quiet artist's sensitivity, determination and independence.

NAWORTH CASTLE

HHA Map A

Brampton, Cumbria
2m W of Brampton on Hexham road (A69)
Tel Brampton (069 77) 2692

Naworth Castle, apart from possessing the most astonishing Great Hall in the north, if not the whole, of England, has a modest collection of Carlisle family portraits, in which Johnson, Lely, Kneller, van Somer, Reynolds and Lavery are represented.

NEWBY HALL

HHA MAP D

Ripon, N. Yorks
4m SE of Ripon on Boroughbridge road (B6265)
Tel Boroughbridge (0423) 322583

At the delightful Newby Hall, the Adam decoration in the library is enriched by ceiling and wall paintings by Antonio Zucchi and Angelica Kauffmann, the husband-and-wife team that so often worked with Adam.

Two of the Weddell, Vyner and Compton family portraits here are outstanding. Batoni's full-length of William Weddell of 1760 is a very good example of this artist's most lively work, and Lawrence's enchanting portrait of Lady Theodosia Vyner is one of the best of his early portraits. Other family portraits in this elegant house include work by van Loo, J. M. Wright, Mengs, Sir Francis Grant and Watts. In addition, there are some sporting and other pictures.

NEWSTEAD ABBEY

GT MAP D

Linby, Notts
11m N of Nottingham on Mansfield road (A60)
Tel Mansfield (0623) 793557

Newstead Abbey was, for some 300 years, the home of the Byron family, until it was sold by the 6th, and the most famous, Lord Byron.

Many relics of the poet are preserved in the much-restored house, including a number of portraits. The best-known of these is Thomas Phillips's likeness of Byron, though this is not as famous as his portrait of Byron in the National Portrait Gallery, where the poet is romantically clad in Albanian costume. The best picture is Thomas Barber's portrait of his faithful servant Joe Murray, who was employed by the Byron family for sixty years. The most endearing picture is Clifton Tomson's portrait of Byron's dog Boatswain.

NORMANBY HALL

 MAP D

Scunthorpe, Humberside
4m N of Scunthorpe on B1430
Tel Scunthorpe (0724) 720215

Normanby Hall, the ancestral home of the Sheffield family, is owned by Scunthorpe Borough Council, whose museum has furnished this large house appropriately. There are a few Sheffield family portraits and a collection of nineteenth-century marine paintings.

NORTHAMPTON CENTRAL MUSEUM AND ART GALLERY

 MAP F

Guildhall Road, Northampton
Tel Northampton (0604) 34881

There is a miscellaneous collection of pictures at Northampton Art Gallery. There are some early Italian works, such as 'David and Solomon' attributed to Cima, and an impressive 'Belshazzar's Feast' by Fontebasso, an eighteenth-century Venetian. British paintings include work by George Morland, Crome, G. F. Watts, Sickert, John Nash, Bratby and Bawden.

NORTON CONYERS

HHA; GT MAP D

Ripon, N. Yorks
3½m N of Ripon
Tel Melmerby (076 584) 333

Norton Conyers, a very pleasing Jacobean house has portraits of the Graham family, whose home this has been since 1624. There are pictures from Lely, Batoni, Romney and Beechey — all family portraits — and there is a large group portrait of the Quorn Hunt by Ferneley.

NORWICH CASTLE MUSEUM

MAP G

Norwich
Tel Norwich (0603) 611277

Up and down the country, museums vary greatly in style and atmosphere. Nobody is likely to encounter one which presents its collection to the visitor with more panache and commonsense than the Norwich Castle Museum. It is housed inside the ancient Norman castle which has dominated the city for over 800 years. Originally designed by William Wilkins, architect of the National Gallery, the galleries are well-appointed and comfortable, and the remarkable art collection is displayed with great skill.

The bulk of this collection has associations with Norwich and Norfolk. The two most notable members of the 'Norwich School' were John Crome and John Sell Cotman, two artists who have an important place in the history of English landscape painting, the latter especially in his role of water-colourist. Both artists are well represented here, but Crome's brilliant 'Postwick Grove' and his 'Back of the Old Mill' are particularly memorable. There are also many examples of work by colleagues, families and their pupils. Other artists with local associations who are displayed here are Munnings and Seago.

An interesting, earlier, local association rests in the early sixteenth-century 'Ashwellthorpe Triptych' ascribed to The Master of the Legend of the Magdalen, featuring portraits of two Norfolk donors. There is also a small collection of Dutch and Flemish pictures. The English collection includes work by Richard Wilson, by Gainsborough, both as a portraitist and as a landscape painter, and Opie, who once had a studio in Norwich. There is a gallery devoted to modern art, including works by Sisley, Sickert, Bomberg, Davie, Allen Jones and many others.

Crome: 'Postwick Grove' (*Norwich Castle Museum*)

NOSTELL PRIORY

NT

MAP D

Wakefield, W. Yorks
6m SE of Wakefield on A638
Tel Wakefield (0924) 863892

Nostell Priory has been in the Winn family's possession since 1650. It is a Palladian house, and Robert Adam was responsible for much of the decoration.

It is one of the first houses in England to have decorative paintings by Zucchi, soon after Adam had tempted him to come to England from Italy. His work in the library, the tapestry room, the saloon and the dining room has all the graceful charm associated with this artist; this is especially true of the unusually large Roman scenes incorporated into the saloon.

There are few family portraits here, apart from those by unknown artists and a pair by Pickering (of the 4th Baronet and of his soldier brother). There is a version of Holbein's celebrated 'Sir Thomas More and His Family', the Winns being connected by marriage with More's descendants; and there is a Mytens portrait of Lord Howard of Effingham.

The picture collection also includes work by Hogarth (a Shakespearean scene), Guercino, Berchem and, above all Pieter Bruegel the Younger's 'Procession to Calvary', a signed picture dated 1602.

NOTTINGHAM CASTLE MUSEUM

MAP F

Nottingham
Tel Nottingham (0602) 411881

There is a fine collection of paintings at Nottingham Castle Museum and Art Gallery, as befits Britain's first municipal art gallery, opened in 1878.

There are religious works from the sixteenth century and earlier, including an important Dossi, 'The Christ Child'. There are some Dutch seventeenth-century works and some from France, dominated by a large 'Hercules and Diomedes' by Le Brun. Two Nottingham-born artists are well represented: Sandby, whose 'View of Nottingham from the South' was the Gallery's first purchase; and Richard Parkes Bonington, who has a room dedicated to his works, including some of his brilliant water-colours. Here the visitor can compare the skill and charm of his landscapes, and of his self-portrait, with some of his subject pictures, which can hardly fail to be seen as barely successful attempts to emulate Delacroix, with whom Bonington briefly shared a studio. Richard Wilson is represented here by a view of Snowdon.

There are a large number and wide variety of Victorian pictures, including contributions from Rossetti, Dyce, Maclise, Etty, Hayllar and Stone. From the twentieth century, Laura Knight, another Nottingham-born artist, has a

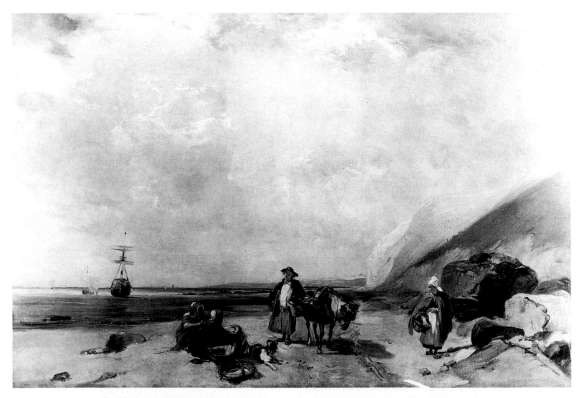

Bonington: 'Fisherfolk on the Normandy Coast' (*Nottingham Castle Museum*)

number of works, and there are pictures from, among others, Augustus John, Eurich, Stanley Spencer, Wadsworth, Ben Nicholson and Matthew Smith.

NO 1 ROYAL CRESCENT

MAP I

Bath, Avon
Tel Bath (0225) 28126

A short puff up a hill from the centre of Bath takes the visitor to Royal Crescent, arguably the finest piece of townscape in England. The corner house of the Crescent has been carefully restored to its original splendour and is suitably and elegantly furnished. The pictures that hang on its walls today include portraits by Hoare, Wootton, Beechey and Cotes.

OLDHAM ART GALLERY

MAP C

Union Street, Oldham, Greater Manchester
Tel Manchester (061) 678 4651

The Oldham Art Gallery has a miscellaneous collection of British art. There is a number of nineteenth-century paintings, many by local artists, with work by Rossetti and Watts, among others. From the twentieth century such artists as Weight and Heron are represented. 'Venus Born of the Sea-Foam' by William Stott of Oldham, represents a local late-Victorian artist, whose work is attracting attention again. Also (confusingly) there is a masterpiece here of Edward Stott (of Rochester, and no relation to William) 'The Ferry' — his work, also, is much sought after today.

ORMESBY HALL

NT MAP B

Middlesbrough, Cleveland
3m SE of Middlesbrough
Tel Middlesbrough (0642) 324188

Ormesby Hall, a plain Palladian manor house, in parkland on the southern edge of Middlesbrough, has a number of landscapes as well as some Pennyman family portraits, two attributed to Hudson, and one to Reynolds.

OSTERLEY PARK HOUSE

NT MAP K

Isleworth, Middlesex
Off Great West Road (A4)
Tel (01) 560 3918

Formerly the London home of the Earls of Jersey, Osterley Park is a superb Adam house. As so often in houses by Adam, there are decorative paintings by his collaborator Zucchi: these are to be found in the eating room and the library, and there is a similar ceiling painting, by Borgnis, in the Etruscan room. There is also a collection of pictures at Osterley, provided by the Victoria and Albert Museum, with paintings by Richard Wilson, Reynolds and Chalon.

OXBURGH HALL

NT MAP G

Swaffham, Norfolk
7m SW of Swaffham
Tel Gooderstone (036 621) 258

Many of the interesting portraits of the Bedingfield family at the lovely Oxburgh Hall are not attributed to any artist. Typical of these is the very distinctive mid-seventeenth-century picture

of Sir Arundell Bedingfield and his sister. One of the very few named pieces of work is Opie's portrait of Charlotte Jerningham, who married into the family in 1795. She was a talented amateur painter, as Opie recognised, painting her with a sketchbook and pen in her hands and looking supremely happy beneath a turban-like headdress.

OXFORD COLLEGES

MAP F

Oxford colleges, and some university buildings, are open to a limited extent. In most colleges, it is usual for the hall and the chapel to be accessible. Pictures are to be found, often in the chapels, and always in the halls.

The Sheldonian Theatre (0865 277299) has an elaborately allegorical ceiling, painted in 1669 by Robert Streeter, then Sergeant-Painter to Charles II. Illustrating the triumph of Truth and The Arts, it is the most remarkable ceiling painting by an English artist before Thornhill began work early in the eighteenth century, and it simulates the open sky (in splendid Roman summer weather) that a comparable Roman building, roofless, would have had.

Of the large number of portraits in college halls, especially notable are two by Kneller and Isaac Fuller's self-portrait at Queen's (0865 279121); the twentieth-century work at Jesus (0865 279707) includes contributions from Augustus John, Spear and Noakes; Pembroke (0865 276444) also has some notable modern work by such artists as John Ward and Organ. Holman Hunt's early version of 'The Light of the World' is to be seen in the chapel at Keble (0865 272727), and New College (0865 248451) has in its chapel a fine work by El Greco.

Christ Church (0865 276150) has an exceptional collection. The large hall has a correspondingly large number of portraits. Of the dozen Prime Ministers who were educated here, four are represented by portraits, John Millais's 'Gladstone' being the most striking. Other artists whose work can be seen include Kneller, Hoare, Gainsborough, Romney, Lawrence, Birley, Coldstream, de László, Sutherland and Moynihan.

Christ Church also has a particularly rich endowment in the form of a large bequest of old master paintings (with remarkable drawings) from a rather eccentric military man from the eighteenth century, General Guise. In the 1960s the college took the unusual step of building a gallery to house its picture collection, many of them from the Guise Bequest. Tucked into a restricted site, the gallery (designed by Powell and Moya) is as elegant as it is ingenious, and a fine setting for a collection of high quality.

Here are to be found such pictures as Tintoretto's 'Martyrdom of St Lawrence', Filippino Lippi's 'Wounded Centaur', Giovanni di Paolo's 'Crucifixion', the Master of Delft's 'Deposition of Christ' and Salvator Rosa's 'Hermit Contemplating a Skull'. Guercino, Giaquinto, Domenichino, Lotto, Mola and Zuccarelli are among the other artists represented, as is Annibale Carracci, most strikingly with a large and extraordinary 'Butcher's Shop'. A 'Head of a Virgin', a fragment of a 'Lamentation' is confidently ascribed to van der Goes. There is a Hals 'Portrait of a Lady' and 'The Continence of Scipio' by van Dyck. There is one picture here of peculiar local interest — the portrait by John Riley of 'A Scullion of Christ Church'. It is one of the earliest portrayals in the country of a working man.

PACKWOOD HOUSE

NT MAP E

Hockley Heath, Warwicks
12m SE of Birmingham, off
Stratford-upon-Avon road (A34) at Hockley Heath
Tel Lapworth (056 43) 2024

Packwood House, famous for its seventeenth-century yew garden, is mostly decorated within by tapestries. There are, however, pictures. These are not, as is so often the case, family portraits, but pictures suitable for the carefully restored house, evocative of the sixteenth and

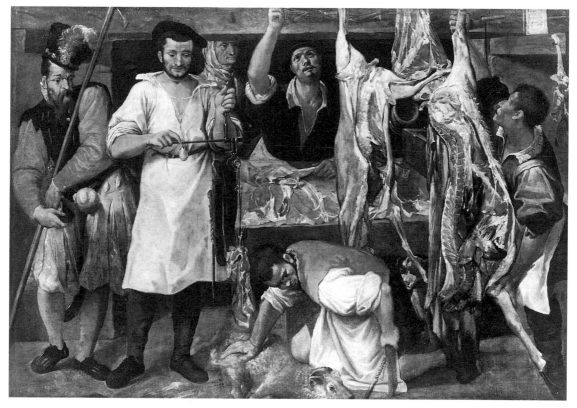

Carracci: 'The Butcher's Shop' (*Christ Church, Oxford*)

seventeenth centuries. There are royal and other portraits including work by Lacroix and Ferg, and a sprinkling of landscapes — among them, one attributed to Verrio and two to Theodore Russell.

here by Sutherland, Sickert, Wood, Hitchens, Matthew Smith and many others. Late in 1987 an important collection of 60 paintings was given anonymously to the gallery, including work by Picasso, Paul Nash, Ben Nicholson, Klee and Piper.

PALLANT HOUSE GALLERY

MAP J

9 North Pallant, Chichester, W. Sussex
Tel Chichester (0243) 774557

One of the many handsome houses in Chichester is Pallant House, a Queen Anne mansion which today is a museum and art gallery. This has an admirable twentieth-century collection of pictures, most of them bequeathed by Walter Hussey (1909–1985) Dean of Chichester, whose inspired patronage can also be appreciated in the cathedral nearby. There are notable works

PARHAM HOUSE

HHA MAP J

Pulborough, W. Sussex
3m S of Pulborough, off Shoreham road (A283)
Tel Storrington (090 66) 2021

The exterior of the mellow and welcoming Elizabethan Parham House is echoed by the wholly delightful interior, with its superb light oak panelling, its magnificent long gallery and, not least, its fine collection of pictures, in which the Tudor and Stuart portraits are of exceptional interest.

185

There are familiar portraits of Henry VIII, Edward VI and Queen Elizabeth, as well as many of Elizabeth's court, such as Leicester, Essex and Burghley. James I and his Queen, Anne of Denmark, are here, as are his sons: Charles is pictured by Mytens in adolescence, and his ill-fated elder brother Henry in an astonishing equestrian portrait attributed to Robert Peake, perhaps this artist's masterpiece.

Recent cleaning and restoration has revealed much that was previously hidden by over-painting. The Prince is shown on a white horse with an elaborate saddlecloth and harness, clad in armour with decoration that links him with the chivalric Arthurian legends. He is, however, wearing a skittish slouch hat. Also he is literally seizing Time by the forelock, Time being represented by a nude and winged figure of an old man, who is carrying the Prince's helmet and lance.

Among the family portraits and other pictures from a later age, the eye is caught by a resplendent Gainsborough portrait of Major Norton Knatchbull, by a version of Reynolds's portrait of Omai (a South-Sea Islander brought to England by Captain Cook), by Stubbs's picture of a kangaroo, by a Samuel Scott seascape, by an Arthur Devis portrait and by many more.

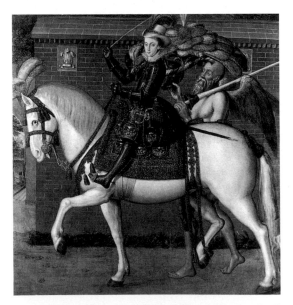

Peake: 'Prince Henry and Father Time' (*Parham Park*)

PENCARROW HOUSE

HHA; GT MAP H

Bodmin, Cornwall
4m NW of Bodmin, off Wadebridge road (A389)
Tel St Mabyn (020 884) 369

The visitor will be struck by many things when guided through the intimate charms of Pencarrow. Although there are a couple of excellent Northcote portraits, and a pair by Birley of some Molesworth-St Aubyn in-laws, he is unlikely, at this point, to feel that the pictures are exceptional or startling. The inner hall, however, contains two splendid views of the Thames by Samuel Scott, and some admirable seascapes by Brooking. The stairs are dominated by a large and extraordinarily vivacious Raeburn full-length of Sir Arscott Molesworth, the 7th Baronet, hugely enjoying himself with a gun in his hand and a spaniel at his feet. There is a version of the Bower portrait of Charles I at Antony House, and a Beale portrait of Charles II. There are also some Dutch pictures.

But even these admirable pictures do little to prepare the visitor for the splendours of the dining room where no less than eleven Reynolds family portraits gaze serenely at each other across the dinner table — surely the finest intact Reynolds collection in the country. They include no less than three of the 5th Baronet, Sir William Molesworth — a stately picture in his wedding clothes, silvery and resplendent; a small full-length in his militia uniform, in which Reynolds makes him look ardent but anything but soldierly; and a fine representation in peaceful old age.

The tour ends in the ante-room where a fine Richard Wilson landscape does its best to compete with a beautiful Arthur Devis conversation piece of 1754, in which four St Aubyn daughters are elegantly disposed in a garden with the family home of St Michael's Mount in the background.

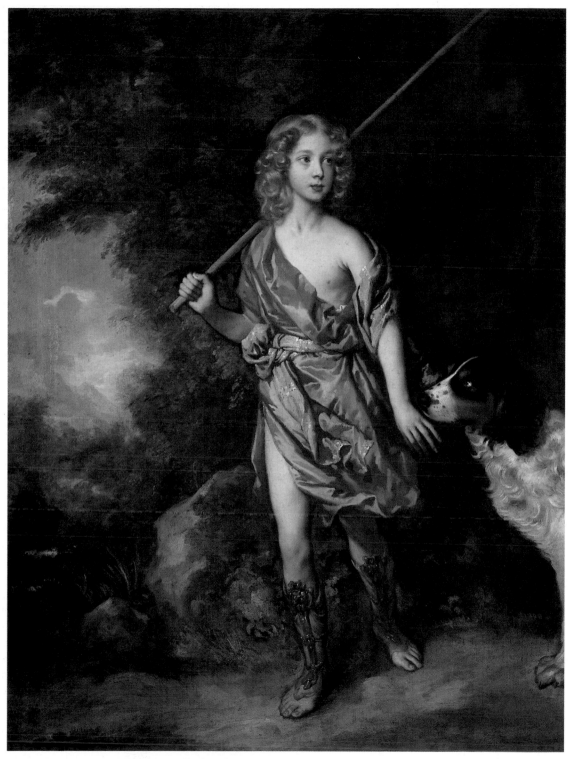

Lely: 'Earl of Romney' (*Penshurst Place*)

PENSHURST PLACE

Tonbridge, Kent
4m W of Tonbridge, in Penshurst
Tel Penshurst (0892) 870307

The pictures in the beautiful Penshurst Place, which dates from medieval times, are primarily portraits of the Sidney family, including Sir Philip Sidney. It is a large collection in which many well-known portrait painters are represented.

The portrait of Barbara, Lady Sidney, with six children is a work regarded as certainly from the hand of Marcus Gheeraerts, although one of his earliest. The family is arranged in the manner of a family-tree, as was then the custom, but it is beautifully painted, with the characteristic Elizabethan attention paid to details of costume, lace and jewellery, although here there is also sensitive depiction of character.

Lely's extraordinary portrait of Henry Sidney, 1st Earl of Romney, as a boy, is one of his best. The young Earl is pictured as an Arcadian shepherd boy, in a landscape; the style was used not infrequently at the time, but never to better effect than in this glowing and touching portrait.

PEOVER HALL

MAP C

Knutsford, Cheshire
4m S of Knutsford off Congleton road (A50)
Tel Lower Peover (056 581) 2135

Peover Hall, the ancestral home of the Mainwaring family, an Elizabethan mansion in an eighteenth-century park, has a handful of pictures on view, for the most part family portraits. There is a van Dyck double portrait of the Earl of Stafford and his secretary, Sir Philip Mainwaring, and a de László self-portrait.

PETWORTH HOUSE

Petworth, W. Sussex
In Petworth, 6m E of Midhurst
Tel Petworth (0798) 42207 or 43929

Petworth House, in its magnificent park, is one of the great houses of England with a large and well-known collection of works of art.

There are, naturally, family portraits of the Wyndham, Seymour and Percy families, whose

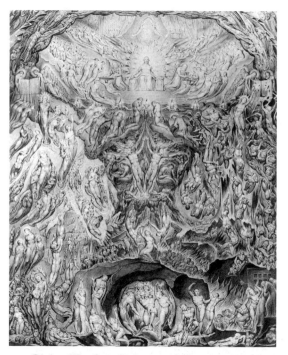

Blake: 'The Last Judgement' (*Petworth House*)

house Petworth has been. There are many of these, and the quality is high. There are contributions from Gower, Hoare, and a large number by Dahl, Lely and van Dyck — van Dyck with some exceptional paintings, such as his famous portrait of Strafford, and those of Sir Robert Shirley and of his Circassian wife, both of them in Persian costume, while the three-quarter-length of Lady Russell is often acclaimed as the finest of all his English female portraits. Another

magnificent picture is van Dyck's portrait of Anne, Countess of Bedford, with its daring and sophisticated colour scheme of black, grey and sepia, and its skill in such details as the fingers.

Simon Verelst, Reynolds, Kneller, Jervas, Closterman, Northcote, and Beechey are also represented by portraits, and there is a cluster of work by Phillips, who was a friend of the 3rd Earl of Egremont. There are few royal portraits in the collection at Petworth, apart from Lely's group of the younger children of Charles I, painted in 1647, when the King was a prisoner and the children were in the care of the 10th Earl of Northumberland.

There is a wide-ranging assembly of pictures, including eight small works by Elsheimer, depicting saints; and there is work by Titian, Claude, Gaspard Poussin, Richard Wilson, Bourgeois, Gainsborough, Callcott, Romney, Opie and de Loutherbourg. Bourdon's 'The Selling of Joseph' is a rare chance to see this artist's work in England; he was a talented painter, much influenced by Claude and by Poussin.

Fuseli: 'Macbeth and the Witches' (*Petworth House*)

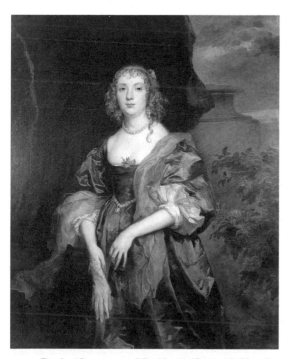

van Dyck: 'Countess of Bedford' (*Petworth House*)

The collection of Dutch pictures is both large and stimulating. Many masters are represented, including Teniers, van Uden, Hobbema, Paul Brill, Jacob van Ruisdael, Salomon van Ruysdael, Metsys, de Koninck, Snyders, Backhuysen, van der Meulen, and Cuyp, the last with a scintillating 'Landscape near Nymegen'. 'Macbeth and the Witches' by Fuseli is an example of the dramatic spectacle in which this artist specialised; his work is not often seen in country houses.

Witherington's 'A Fete at Petworth' records, accurately no doubt, one of the annual feasts provided by the famous 3rd Earl of Egremont, for the poor of the neighbourhood; it is thought that some 6000 came to the feasts, sitting down to beef and plum pudding at the huge horseshoe of tables, which can be seen in this picture, at the west front of the house.

Turner was a firm friend of the 3rd Earl, and was such a constant visitor to Petworth that he was provided with a studio in a room above the chapel. He was happy in these idyllic surroundings, and did some of his finest work at Petworth,

Turner: 'Sunset and Fighting Bucks' (*Petworth House*)

much of which is still in the house, in many cases being commissioned by Lord Egremont. It is enthralling to turn from, for example, Turner's 'Sunset and Fighting Bucks' and look through the window at the view, which Turner portrayed with such skill and revolutionary daring in the choice of viewpoint and his handling of light; the descendants of the deer Turner painted are still in the park.

PLYMOUTH CITY MUSEUM AND ART GALLERY

MAP H

Drake Circus, Plymouth, Devon
Tel Plymouth (0752) 668 000

Plymouth City Art Gallery has a picture collection which concentrates on artists from the south-west, notably Reynolds, Opie, Northcote and Haydon. There are also paintings by van Ruysdael, van Loo, Kauffmann and Zoffany. The Newlyn School, Camden Town and London Groups are also strongly represented, notably by Ginner's 'Plymouth Pier from the Hoe'. This gallery often plays host to special exhibitions, and not all these pictures can then be on display.

POLESDEN LACEY

MAP J

Leatherhead, Surrey
4m SW of Leatherhead, off Guildford road (A246)
Tel Bookham (0372) 58203 or 52048

Although there was an earlier house on the site, the visitor to Polesden Lacey today sees the creation of a formidable 'society hostess'. This was Mrs Ronald Greville, whose spectacular portrait by Carolus-Duran, Sargent's master, greets the visitor in the hall. There is an excellent picture collection, notably well displayed in the house, which skilfully preserves the atmosphere of its heyday before the First World War.

The pictures fall into three groups. There are early works, mostly Italian, among which 'The Miracle of the Founding of Santa Maria Maggiore' by Pietro Perugino stand out. There is a fine group of British portraits, including works by Richardson, Raeburn, Reynolds and Lawrence, here represented by a double portrait of two Pattison brothers, pictured with an evidently much-loved donkey. Both these groups are put somewhat into the shade by a magnificent collection of Dutch cabinet pictures, in which many artists are included, often with excellent examples of their work. Cuyp, for

example, has here 'Herdsman and Bull' which, for all its modest size, does not fail to convey the sense of peace and harmony which is his hallmark. Salomon van Ruysdael's 'River Scene' is as balanced and delicate as Jacob van Ruisdael's 'The Zuider Zee Coast near Muiden'. 'An Interior with a Dancing Couple' (also known as 'The Introduction') by Terborch is a typically charming domestic scene. It has plenty of intriguing detail to engage the attention, and was described in the 1850s as having 'in a high degree, the decorum, refinement, elegance and romance which distinguish [Terborch's] pictures above all others'. The satin-clad girl and the slightly sinister cavalier may indeed be dancing, but a ring is being slipped onto a finger of the girl's left hand, and the episode seems to attract undue attention from two of the figures in the background, the old woman and the disdainful girl.

Terborch: 'The Introduction' (*Polesden Lacey*)

PORTSMOUTH CITY MUSEUM

MAP J

Museum Road, Portsmouth, Hants
Tel Portsmouth (0705) 827261

Although housed in a grim-looking Victorian barrack-block, Portsmouth Museum and Art Gallery is a lively place. There are local views and sea-pictures by such artists as Stanfield, Serres and others, and there is a spirited twentieth-century collection, including works by Sickert, Burra, Wadsworth, Duncan Grant, Bell, Keith Grant and William Scott.

POUNDISFORD PARK

HHA; GT MAP H

Taunton, Somerset
3½m S of Taunton, off Honiton road (B3170)
Tel Blagdon Hill (082 342) 244

Poundisford Park is a Tudor manor house, originally H-shaped but added to over the centuries. There are portraits here, of connections of the Vivian-Neal family who now live here, including work attributed to Kneller and by Batoni, Closterman, Dandridge, Lawrence and Sir Francis Grant. There is also a Pourbus portrait of Vincenzo Gonzaga, Duke of Mantua.

POWDERHAM CASTLE

HHA MAP H

Exeter, Devon
8m SW of Exeter off Dawlish road (A379)
Tel Starcross (0626) 890 243

Powderham Castle, the home of the Courtenay family for six hundred years, has a notable assembly of family portraits. There is work here attributed to Holbein, work by J. M. Wright,

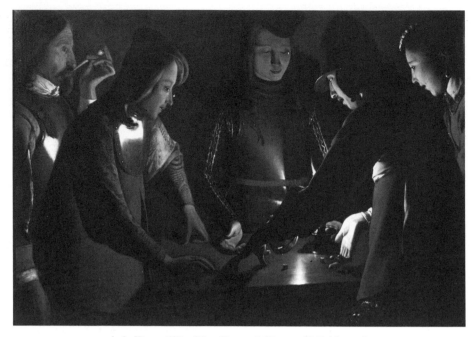

de la Tour: 'The Dice Players' (*Preston Hall Museum*)

Kneller, and Richmond. Hudson, who was born in the west country, painted a large group of the 1st Viscount Courtenay and his family as well as separate portraits of his wife and two of his children.

There are also several pictures by Richard Cosway: an unusual collection, as he is far better known as a fashionable miniaturist. In 1798 he painted a triple portrait of three of the thirteen daughters of the 2nd Viscount; again, in 1805, he painted three more of their sisters. Earlier, in 1792, he painted a full-length portrait of the 3rd Viscount in the van-Dyck-like masquerade costume which he had worn at his coming-of-age ball, a splendid picture which hangs over the fireplace in the beautiful 1790s music room.

PRESTON HALL MUSEUM

MAP B

**Yarm Road, Stockton-on-Tees, Cleveland
Tel Stockton-on-Tees (0642) 781184**

Preston Hall is very proud of its famous Georges

de la Tour picture, discovered by chance in the museum in the 1970s after being ignored for forty years. It is now carefully displayed behind glass in a darkened room — one of the only three de la Tour works on public display in Britain.

'The Dice Players' is a late masterpiece, and certainly deserves this care and attention. The standing players are soldiers, and there are two onlookers. The light comes from a candle on the table, concealed by an arm, and the figures are treated with great simplicity. The rapt attention of all concerned gives an air of compelling calm.

PRESTON MANOR

MAP J

**Preston Park, Brighton, E. Sussex
Tel Brighton (0273) 603005**

Preston Manor, an eighteenth-century house with an Edwardian interior, stands in Preston Park and is a branch of the Brighton Museum and Art Gallery. The pictures in the collection maintained here include 'A Virgin and Child'

by Nicolas Poussin, portraits by Etty and Orpen, and landscapes by Leader, Adams and many more.

THE QUEEN'S GALLERY

MAP K

Buckingham Palace Road, London
Tel (01) 930 4832

This modest-sized gallery is built in the former chapel of Buckingham Palace, which was damaged in air raids in World War II; it was opened in 1962. While having no permanent collection, it is usually found to have on show a remarkable temporary exhibition from the extraordinarily rich Royal Collection.

RABY CASTLE

MAP B

Barnard Castle, Durham
5½m NE of Barnard Castle, on Bishop Auckland road (A688)
Tel Staindrop (0833) 60202

A medieval castle adapted in the eighteenth and nineteenth centuries, Raby Castle, the home of the Vane family, has an impressive picture collection.

There is a first-rate group of sporting pictures, in which Wootton, Marshall, Chalon, Sartorius and John Herring the Elder are represented — Herring most strikingly with 'The Raby Stableyard and Ponies'. The precise accuracy of his draughtsmanship can still be appreciated, as

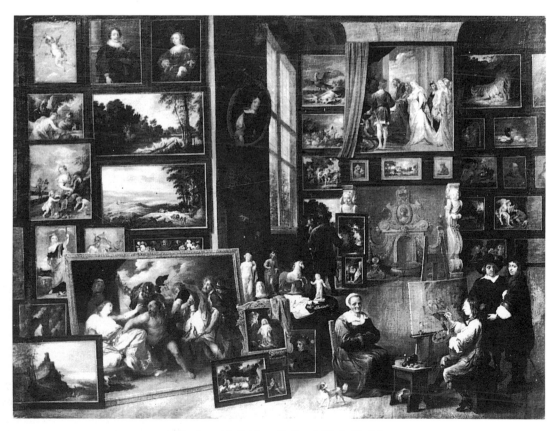

Teniers: 'Artist in a Gallery' (*Raby Castle*)

193

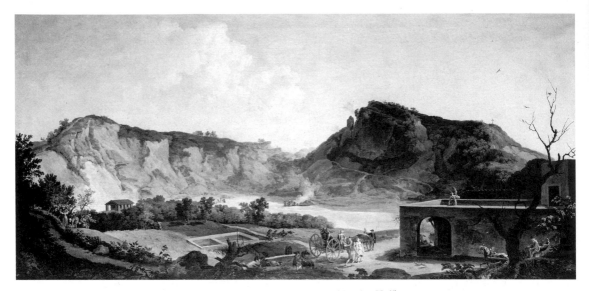

Vernet: 'Italian Landscape' (*Ragley Hall*)

the stableyard is unchanged since 1823, when Herring painted this careful but entertaining picture, soon after he had given up driving coaches, on the advice of a perceptive passenger.

There is work by the Ricci family, by Giordano, two interiors by de Hooch, seascapes by Backhuysen and by Claude Vernet. Teniers's highly entertaining 'Artist in a Gallery' is one of several pictures he painted of this subject (he was a curator of pictures in the Low Countries), and is a source of endless fascination and speculation for art historians.

Not all the portraits are easy to study or to identify. There is work by Kneller, Hoare, de Vos, Amigoni, Vanderbank, Reynolds, Wissing, J. M. Wright, Honthorst, Miereveld, Lely, Walker (the preferred portraitist of the Parliamentary side in the Civil War), Johnson, Soest, and many more, with Hoppner's '1st Duchess of Cleveland' standing out firmly in a high-class collection.

RAGLEY HALL

MAP E

Alcester, Warwicks
2m SW of Alcester on Evesham road (A435)
Tel Alcester (0789) 762090

Ragley Hall is the home of the Seymour family. It was a member of this family, the 4th Marquess of Hertford, who built up the Wallace Collection, so that the fine possessions at Ragley come as no surprise. Standing on a hilltop, Ragley seems very imposing to the visitor, something which the huge, and astonishing, pink-and-white entrance hall does nothing to dissipate; but the rooms of the house seem reassuringly domestic.

There are some religious pictures and some landscapes, but the bulk of the picture collection is of royal and family portraits. The former are dominated by two splendid portraits of the Prince Regent: an intimate likeness by Lawrence, and a sumptuous full-length state portrait by Hoppner. The family portraits, many from the eighteenth century, are dominated by a large group of portraits by Reynolds. The Dutch paintings include a fine 'Raising of Lazarus' by Cornelis van Haarlem, and there is a good

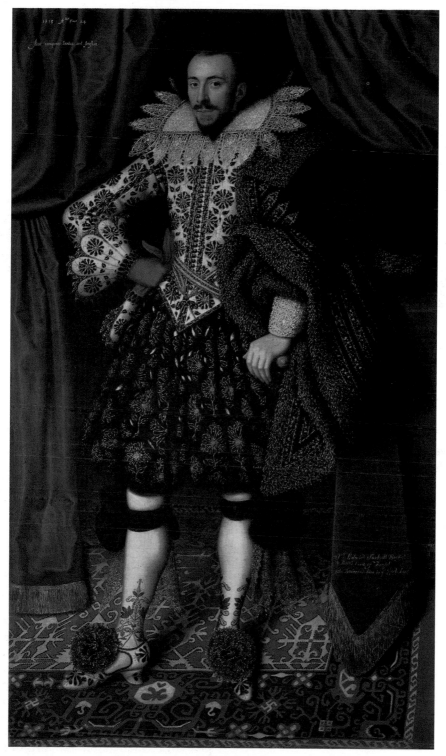

Larkin: '3rd Earl of Dorset' (*The Ranger's House*)

Vernet landscape. The present Marquess of Hertford, unlike the majority of stately-home dwellers, is a courageous patron of living artists, as can be seen on the south staircase at Ragley Hall, which is enveloped by an ambitious mural of 'The Temptation' by Graham Rust.

THE RANGER'S HOUSE

EH MAP K

Chesterfield Walk, Blackheath, London
Tel (01) 853 0035

Once called Chesterfield House, The Ranger's House is a handsome early-eighteenth-century mansion standing at the highest point of Greenwich Park, overlooking Blackheath. Occupied by a succession of distinguished personages, the house is now in public ownership; it contains a notable group of pictures, particularly rich in seventeenth-century portraits, once owned by the Earls of Suffolk and Berkshire at Redlynch and known as the Suffolk Collection.

This includes a famous series of nine full-length seventeenth-century portraits known as 'The Berkshire Marriage Set', two male and seven female which could have been commissioned to mark a wedding or some other event. The uniform frames and inscriptions are eighteenth-century. Now attributed to Larkin, these portraits are wonderfully accomplished, if highly mannered, and the elaborate and spectacular clothes of all the subjects are handled with the greatest possible attention to detail; all the figures stand on similar Turkey carpets with heavy swags and folds of drapery in the background. Together, they are an astonishing spectacle.

There are further portraits by Johnson, Lely, Kneller, Sustermans, Antonio David and Hudson; and there are other paintings, including work by Bloemaert, by Bol and by Annibale Carracci.

RIVERHILL HOUSE

GT MAP J

Sevenoaks, Kent
2m S of Sevenoaks on Tonbridge road (A225)
Tel Sevenoaks (0732) 452557

The Rogers family, who live at Riverhill House, have a modest collection of family portraits which includes work by Severn, Llewellyn and Sir Francis Grant.

ROCHDALE ART GALLERY

MAP C

Esplanade, Rochdale, Greater Manchester
Tel Rochdale (0706) 47474

Across the road from England's most fantastic-looking town hall stands the recently modernised Rochdale Art Gallery. This houses a collection of British painting from the eighteenth to the twentieth century, in which such artists as Clausen, Laura Knight and Augustus John are represented, as well as numerous local painters. It is frequently largely taken over by temporary exhibitions.

ROCKINGHAM CASTLE

HHA MAP F

Corby, Northants
2m N of Corby on Uppingham road (A6003)
Tel Corby (0536) 770240

The very popular Rockingham Castle has a collection of portraits, like many another country house. Among them are some fine examples, such as the family portraits by Dobson and Reynolds, and Joos van Cleve's portrait of Francis I (remarkably like Henry VIII, whom he met at 'The Field of the Cloth of Gold').

Lely's 'Lady Catherine Sondes' is a fine and glowing example of this artist at his best, and Zoffany's group of the children of the 1st Lord Sondes, with cricket gear, has all the precise charm for which Zoffany is famous. There are some hunting scenes by Marshall, country scenes by George Morland, and a Constable landscape sketch.

What is utterly unlike the vast majority of country houses is the room full of modern pictures. This is a complete surprise, all the more so as artists of the quality of Sickert, Augustus John, Segonzac, Matthew Smith and Herman are to be found here.

ROKEBY PARK

HHA MAP B

Barnard Castle, Durham
Between Barnard Castle and A66
Tel Teesdale (0833) 27268

In elegant eighteenth-century Rokeby Park, there are portraits of the Morritt family, who have lived here since 1769. There is work by Vanderbank, Jervas, Kent, West and Reynolds. There is a Pellegrini 'Venus Disarming Cupid' and a copy of the famous Velazquez 'Rokeby Venus', which has been in the National Gallery since the early years of the twentieth century.

ROSSENDALE MUSEUM

MAP C

Haslingham Road, Rawtenstall, near Burnley,
Lancs
Tel Rossendale (0706) 217 777

Situated in a former mill-owner's house and park, the Rossendale Museum has a collection of nineteenth-century paintings, with work by Frith, Cox and Shayer among many others.

ROUSHAM HOUSE

MAP F

Steeple Aston, Oxon
7m W of Bicester on Chipping Norton road
(B4030)
Tel Steeple Aston (0869) 47110

Celebrated most of all for its landscape garden by William Kent, the seventeenth-century Rousham House has many portraits of the Cottrell-Dormer family who still live there. As Masters of Ceremonies through eight reigns, the family had access to Court painters. There are portraits here by Johnson, Dobson, Wright, Lely, van Loo, Kneller, Dahl, Seeman, Reynolds and West. Kent painted a ceiling and there are some landscapes, including examples by Jacob van Ruisdael and Paul Brill.

ROYAL ACADEMY OF ARTS

MAP K

Burlington House, Piccadilly, London
Tel (01) 734 9052

Famous for its series of exhibitions, the Royal Academy has a large permanent collection, mainly of Diploma works presented by Academicians elected since 1770. Unhappily, this collection is never seen by the public. There are, however, ceiling paintings by West in the entrance hall, with roundels by Kauffmann, both painted originally for Somerset House. The 'Fine Rooms' above this hall are sometimes opened for various purposes, and there are ceiling decorations in them, some attributed to Kent, and others by Sebastiano Ricci.

ROYAL ALBERT MEMORIAL MUSEUM

MAP H

Queen Street, Exeter, Devon
Tel Exeter (0392) 56724

The fine art collection of the Royal Albert Memorial Museum is particularly strong in the works of artists of local origin. These include Hayman, with a self-portrait, Northcote, Abbott, Towne, Haydon, Hudson and Reynolds. Other

Frith: 'The Fair Toxophilites'
(*Royal Albert Memorial Museum*)

artists represented here include Richard Wilson, Joseph Wright of Derby, J. M. W. Turner, and Frith with a well-known portrait of his three daughters practising archery — 'The Fair Toxophilites'. There is also a fine assemblage of twentieth-century British art, with the Camden Town Group especially well represented.

THE ROYAL INSTITUTION OF CORNWALL

MAP H

River Street, Truro, Cornwall
Tel Truro (0872) 72205

The Royal Institution of Cornwall, Truro, has a modest permanent collection including work by Opie, who started as a local child prodigy, and became known in London as the 'Cornish Wonder'. His double portrait, dated 1786, known as 'Gentleman and a Miner' is now known to portray Thomas Daniell, a wealthy Truro mine-owner and philanthropist, who is examining in a disbelieving manner a specimen of copper ore being shown to him by an enthusiastic 'Captain' Morcom. Among Opie's other work here is a fine portrait of his fellow artist Wilkie. There is also a good representation of the Newlyn School. Not all the permanent collection is permanently on display, as there are frequent special exhibitions mounted at Truro.

ROYAL NAVAL MUSEUM

MAP J

HM Naval Base, Portsmouth, Hants
Tel Portsmouth (0705) 733060

Among the numerous displays in this large museum, which is housed mainly in former naval store buildings near to HMS *Victory*, is a collection of pictures. Amongst the portraits here are an admirable example of Hudson's work and several portraits of Nelson, the best being that painted by Füger in Vienna, when Nelson was travelling home from Italy with Sir William and Lady Hamilton. There are also many battle scenes by such artists as W. L. Wyllie, Harold Wyllie, Pocock, Carmichael and a series of World War II pictures by David Cobb.

Thornhill: Ceiling detail of Painted Hall (*Royal Naval College*)

ROYAL MUSEUM AND ART GALLERY

MAP J

**High Street, Canterbury, Kent
Tel Canterbury (0227) 452747**

Canterbury's Royal Museum and Art Gallery focuses on paintings of local interest. These include such works as Stothard's 'Canterbury Pilgrims' and Opie's 'Death of Becket'.

ROYAL NAVAL COLLEGE

MAP K

**King William Walk, Greenwich, London
Tel (01) 858 2154**

Built as Greenwich Hospital (the naval equivalent of the army's Chelsea Hospital) and now housing the Royal Naval College, the magnificent Wren buildings include the Painted Hall and Chapel which are open to the public.

The immense Painted Hall is unquestionably the masterpiece of Thornhill, who worked here from 1708 to 1727. His great design is in three parts. The largest of these is the Lower Hall, where the ceiling is the finest example of English decorative baroque painting, notable for its sense of design, its drama and its exuberance: William and Mary are shown attended by such figures as Peace, with an olive branch, Tyranny, crouching beneath the King's feet, and so on, in enormous and complex detail. In the smaller Upper Hall, George I and his family are similarly surrounded by allegorical figures.

In the chapel, there is a very large altar-piece by West — 'St Paul Shaking off the Viper'.

THE ROYAL SHAKESPEARE THEATRE COLLECTION

MAP E

**Stratford-upon-Avon, Warwicks
Tel Stratford-upon-Avon (0789) 296655**

The collection is housed in the Picture Gallery, part of the Shakespeare Memorial building which was erected in the 1880s. After a fire in the 1920s, a new theatre was built adjacent to the old one. The Swan Theatre was opened in 1986 in the rebuilt shell of the burnt-out original theatre; the gallery is once again in its original position as part of the theatre entrance. The collection includes a wide range of every sort of item associated with Shakespeare and with the Royal Shakespeare Theatre Company. This elaborate display occupies much of the floorspace of the gallery, and has the unfortunate side-effect of making it hard to see the pictures adequately.

Those interested in Shakespeare's personal appearance should look at the well-known 'Flower' portrait of him, still often reproduced but now believed by most to be a later copy based on the posthumous engraving by Droeshout, rather than *vice versa*.

Scenes from Shakespeare's plays were frequently used by nineteenth-century narrative painters, and there are many of their paintings in the gallery, with work by Maclise, E. M. Ward and Gilbert among many others; John Millais and Ford Madox Brown are also represented.

Earlier painters whose work can be found here are Northcote, Wheatley, Callcott, Clint, West, Opie, Romney, Kauffmann, Stothard, de Loutherbourg and Zuccarelli, some of these connected with an ambitious attempt by Boydell, in the late eighteenth century, to encourage a native school of 'history painting' in London. Fuseli has several paintings here, the most striking being a version of his very dramatic 'Weird Sisters'.

Rossetti: 'Venus Verticordia' (*Russell-Cotes Art Gallery*)

There is a modest amount of later work, in which paintings and portraits by Laura Knight, Philpot, Sickert and Ruskin Spear are to be found.

RUSSELL-COTES ART GALLERY AND MUSEUM

MAP I

East Cliff, Bournemouth, Dorset
Tel Bournemouth (0202) 21009

The Russell-Cotes Art Gallery and Museum is housed in the former home of its founder (Sir Merton Russell-Cotes), a late Victorian Italianate villa in a fine position. The paintings here are distributed through the rooms which house the museum's miscellaneous collection. Most of the pictures are from the nineteenth century, and many famous names are represented, including Landseer, Frith, Leighton, Rossetti, Long and Etty (with several charac-

teristic and sumptuous nudes). From an earlier age there are a handful of Dutch pictures, and works by Wheatley, Crome, Richard Wilson, George Morland and Gainsborough. The twentieth century is represented by the contrasting styles of Munnings and Sutherland, but it is to the increasing numbers of fans of Victorian Academic painting that this intriguing place is most attractive.

SAINSBURY CENTRE OF VISUAL ARTS

MAP G

University of East Anglia, Norwich
Tel Norwich (0603) 56060

Designed by Norman Foster, the Sainsbury Centre is one of the foremost high-tech buildings in England. As such, and rejecting as it does all earlier conceptions of a gallery, the building tends to overshadow its contents. These include a fine permanent collection of twentieth-century paintings, interspersed among many other treasures. It is exciting, stimulating and thoroughly rewarding; it expresses the highly individual and acute taste of its founders, Sir Robert and Lady Sainsbury, ranging over all periods and every continent, in search of the qualities they most value in art. They are among the very few patrons with the serene confidence to commission portraits of themselves from Francis Bacon.

ST AIDAN'S CHURCH

MAP K

Old Oak Common Lane, East Acton, London
Tel (01) 743 5732

This modern church building, dedicated in 1961, contains a number of works of art; these include a large 'Crucifixion' by Sutherland.

ST ANDREW'S CHURCH

MAP F

Chinnor, Oxon
4m SE of Thame, on B4009 Watlington to Princes
Risborough road
Tel Kingston Blount (0844) 51309

This large fourteenth-century village church was given a series of large paintings by James Musgrove, Rector from 1750–78. They represent the disciples and the four evangelists; they are reputed to have been painted by Thornhill and are supposed to have come from St Paul's Cathedral. There is also a copy of a Titian altar-piece here.

ST LAWRENCE WHITCHURCH

MAP K

Whitchurch Lane, Stanmore, London
Tel (01) 952 0019

Isolated amongst extensive suburban sprawl, this church has the best preserved baroque interior in the country. Apart from the tower, which is older, it was built in 1715 by the 1st Duke of Chandos, who was at the time rebuilding a large mansion nearby. The Duke employed a number of artists to decorate the interior. The ceiling of his private box at the west end of the church has a 'Transfiguration', probably by Bellucci, to whom the panels flanking the altar are also attributed. The ceiling of the nave has eight panels by Louis Laguerre. Verrio painted the panels which flank the organ, and Brunetti decorated the adjacent family mausoleum. The church is not large, and the effect of all this splendidly restored work gives it a unique and most rewarding atmosphere.

ST MATTHEW'S CHURCH

MAP F

Kettering Road, Northampton
Tel Northampton (0604) 713615

About a mile from the centre of Northampton, St Matthew's is a very remarkable church with a reputation for courageous commission of works of art of many kinds from living artists. A powerful influence in this policy came from Canon Walter Hussey, much of whose collection can be seen at Pallant House, Chichester, where he was to be Dean after his time in Northampton. It was he who was responsible for commissioning (besides the controversial 'Madonna and Child' by Henry Moore) Graham Sutherland's 1946 'Crucifixion', which hangs in the church, a splendid example of this artist's work, powerful and memorable.

ST NICHOLAS CHURCH MUSEUM

MAP I

St Nicholas Street, Bristol
Tel Bristol (0272) 299771

The bombed church of St Nicholas has been turned into a Museum of Ecclesiastical Art. It is dominated by Hogarth's altar-piece of the Ascension, originally painted for another Bristol church. Hogarth was vociferous in his protests about the use of foreign artists for work of this kind; it may be doubted if this altar-piece, though far from negligible, proves his point.

ST OSYTH'S PRIORY

MAP G

Clacton-on-Sea, Essex
3m W of Clacton on B1027
Tel Clacton-on-Sea (0255) 820492

At St Osyth's Priory there is a small number of pictures from the Fitzwilliam family collection. This group is dominated by Stubbs, and his pictures here are in turn dominated by his 'Whistlejacket', a life-size portrait of a famous stallion. Many will think that this astounding picture is more of a curiosity than a work of art, and that the other Stubbs pictures here are more attractive, such as his 'Foxhounds in a

Landscape'. There are also a portrait of Stubbs by Humphry and a number of family portraits.

ST PAUL'S CATHEDRAL

MAP K

Ludgate Hill, London
Tel (01) 248 2075

Itself a magnificent work of art, St Paul's contains decorations within the dome by Thornhill. These are in monochrome picked out with gold, as restrained in tone as the cathedral itself, and illustrate episodes in the life of St Paul. They can best be seen by paying a fee and going up to the Whispering Gallery, either by lift or by walking

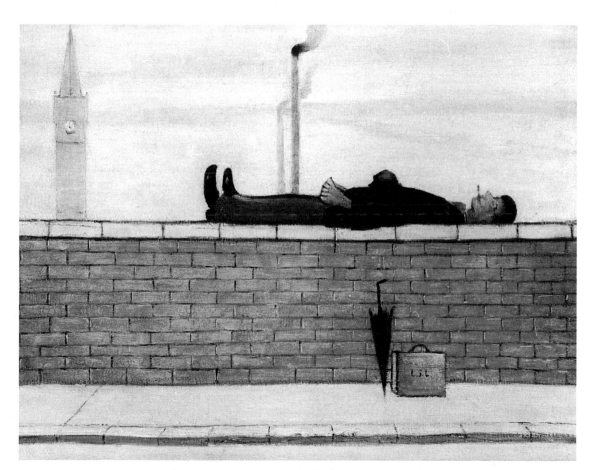

Lowry: 'Man Lying on a Wall' (*Salford Art Gallery*)

203

up 259 shallow steps. Not far from the doorway to these stairs hangs a version of Holman Hunt's 'The Light of the World', painted in 1900, forty-six years after the artist had painted his first version of the picture, which still hangs in Keble College, Oxford.

SALFORD MUSEUM AND ART GALLERY

MAP C

Peel Park, The Crescent, Salford, Greater Manchester
Tel Manchester (061) 736 2649

A surprise is in store for the unwary visitor to the Salford Museum and Art Gallery. The ground floor of the museum is a reconstructed street of shops from the turn of the century, highly convincing, dark and fascinating. From here a staircase leads up to the art gallery.

A large room is devoted to L. S. Lowry, part of whose artistic education took place at the Salford Art School, then next door to the gallery. This is the largest collection of Lowry's work — over three hundred pictures are held, with much memorabilia. The visitor cannot leave this wonderful display, arranged with the utmost skill, without feeling that he knows a great deal about this most individual and humane of artists — his immensely long apprenticeship, his humility, the intensity of his feelings, his humour, accessibility and wisdom.

Lowry's large scenes of scurrying figures in an industrial townscape are joined here by less familiar work: his strange, empty and powerful landscapes, and his even stranger, but no less intense and empty, seascapes. The whole is a wonderful memorial.

In addition there are many works from British artists of the nineteenth century and of the twentieth. Ward, G. F. Watts, Maclise and Clausen are among the Victorians represented. From the twentieth century, William Roberts, Sutherland, Hitchens, Duncan Grant, Bell, Matthew Smith, Lamb, Augustus John, Sickert

and many others can be seen. The basic celebration remains that of Lowry, whose reputation grows steadily brighter, despite the rather disdainful assessment by some professional art-historians.

SALTRAM HOUSE

MAP H

Plymouth, Devon
3m E of Plymouth, on Exeter road (A38)
Tel Plymouth (0752) 336546

The picture collection at Saltram is of exceptional interest for three reasons. First, there happen to have been few pictures in the house when it was inherited by Lord Boringdon in 1768, apart from Parker family portraits by Gheeraerts, Hudson and others. Secondly, the collection then formed was built on the advice Lord Boringdon received from his great friend Joshua Reynolds, who grew up nearby at Plympton. Thirdly, little was added to the collection after this Lord Boringdon's death, although a few pictures were sold in later years. Consequently the visitor today sees, more or less intact, the collection of a late-eighteenth-century country nobleman, gathered on the advice of England's premier artist of the time.

These unusual circumstances have had a striking effect on such rooms as the morning room. Here the pictures are hung triple-tiered in the customary eighteenth-century cabinet-fashion, and with copies of old masters alternating with spirited Reynolds family portraits.

Reynolds painted no less than eight portraits for his life-long friend and boon companion. One intimate portrait shows him in his park, lounging relaxed and happy with a gun in the crook of his arm. His double portrait of his patron's two children shows Reynolds at the height of his powers, a ravishing picture which contrives somehow to avoid sentimentality while remaining tender, delicate and affectionate.

Other portraits of the time include several by Stuart, two admirable works by Northcote and a

series of classical subjects by Kauffmann. Yet it is the Continental pictures that are most striking — de Hooch's 'Tavern Scene', Rubens's head of Francesco Gonzago, Vanvitelli's 'Ponte Rotto' and many more. Altogether, the pictures are fully worthy of their setting in this handsome house and its Adam decoration.

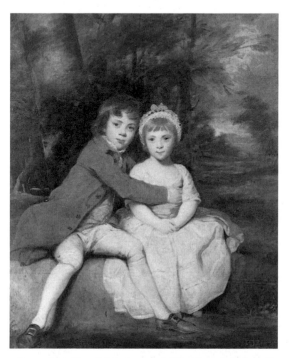

Reynolds: 'Lord Morley and His Sister' (*Saltram*)

SANDRINGHAM HOUSE

MAP G

King's Lynn, Norfolk
8 m NE of King's Lynn, off Hunstanton road (A149)
Tel King's Lynn (0553) 772675

The Sandringham estate was bought by Queen Victoria, in 1862, as a private country residence for the Prince of Wales (later Edward VII). The existing house was rebuilt a few years later in Victorian-Jacobean style. Opened to the public since 1977, Sandringham will be found by many visitors to be a surprisingly unshowy house,

light, airy and comfortable. While the cream of the royal picture collection is not to be found here, there are family portraits by von Angeli, Winterhalter, Barraud, Sohn and others.

SAMUEL JOHNSON BIRTHPLACE MUSEUM

MAP E

Breadmarket Street, Lichfield, Staffs
Tel Lichfield (054 32) 24972

The Samuel Johnson Birthplace Museum includes some paintings among its collection. One of these, a portrait of Johnson as a young man, is sometimes ascribed to Reynolds. Another is Hoare's portrait of Johnson's early friend and local benefactor, Gilbert Walmsley.

THE SCIENCE MUSEUM

MAP K

Exhibition Road, London
Tel (01) 589 3456

The Science Museum is popular and crowded, even though its galleries cover no less than eight acres. It is, naturally, primarily concerned with artefacts, but also holds an extensive collection of paintings in its galleries. These include such works as de Loutherbourg's 'Coalbrookdale by Night', a celebration of the Industrial Revolution painted in 1801, 'The Munition Girls' of 1918 by Forbes, 'A Manufacturing Town' by Lowry and Hudson's portrait of the celebrated clockmaker George Graham.

SCARBOROUGH ART GALLERY

MAP D

**The Crescent, Scarborough, N. Yorks
Tel Scarborough (0723) 374753**

Founded since the Second World War, and housed in an elegant early-nineteenth-century house, Scarborough Art Gallery has a fine collection. Its best pictures came from Tom Laughton, the hotelier brother of the actor Charles Laughton. These include nineteenth-century work by Etty, Martin, and others, continuing through to work by such artists as Hitchens and Matthew Smith. There are five splendid paintings by Grimshaw, who lived at one time in Scarborough, and a large 'Jezebel and Ahab' by Leighton, who was born a short distance from the gallery.

SHEFFIELD ART GALLERIES

MAP D

**Graves Art Gallery
Surrey Street
Tel Sheffield (0742) 734781
Mappin Art Gallery
Weston Park
Tel Sheffield (0742) 26281**

The city of Sheffield is the fortunate owner of two galleries — the Graves and the Mappin — which were both started by local benefactors

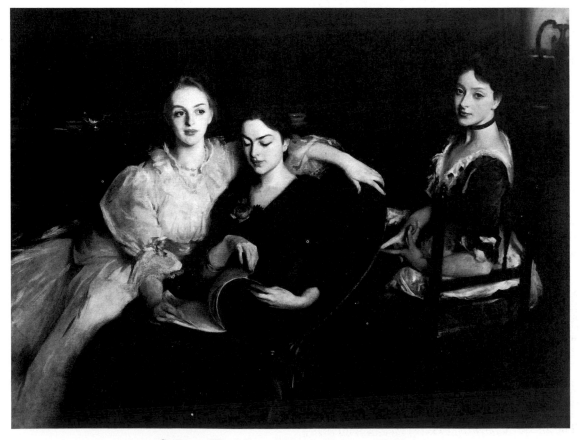

Sargent: 'The Misses Vickers' (*Graves Art Gallery*)

and collectors. These collections largely consist of British work from the eighteenth century, although such European artists as Murillo, Legros, Daubigny and Boudin are represented, as are Mytens, Ribera, van der Neer, Corot and Cézanne.

From the eighteenth and early nineteenth centuries, George Morland, Gainsborough, Constable, Turner and Linnell have paintings here, as does Wheatley, with his portrait of the 2nd Duke of Newcastle, 'The Return from the Shoot', which shows the Duke hacking home after a day's shooting, incongruously wearing his Garter star. There is a large number of Victorian works, including pictures by Crofts, Pettie, Stanfield, Goodall, Maclise, Stone, Frith and John Millais. Burne-Jones's 'The Hours' is perhaps the most notable contribution from this era.

In the twentieth-century collection, few visitors are likely to miss Gwen John's 'Corner of the Artist's Room', a simple but artful painting, poignant, slightly mysterious, wistful and very memorable. Matisse's 'Femme au Peignoir' is another compelling picture, as is Wood's 'La Plage Hotel, Treboul'. Other British twentieth-century artists to be found in these handsome galleries are Sickert, Lavery, Fry, Ravilious, Gilman, Gore, Orpen, Stanley Spencer, Paul Nash, Sutherland, Vaughan, Bratby, Hockney, Peter Blake, Hoyland and Allen Jones.

Near to the Graves Gallery, in the city centre, is the small and jewel-like Ruskin Gallery. This is not so much a picture gallery as a place which seeks to teach visitors how to look — look at pictures, buildings, at nature, or indeed anything — with a glittering display of objects and works.

SHELDON MANOR

HHA MAP I

Chippenham, Wilts
1½m W of Chippenham, off Bristol road (A420)
Tel Chippenham (0249) 653120

The medieval Sheldon Manor, opened with striking and hospitable enthusiasm, has among its

pictures two from the Victorian era which will catch the eye of the discerning visitor.

There is a charming portrait of the three-year-old William Otter Gibbs by Horsley. The child's pose echoes the familiar legs-apart stance given to Henry VIII by Holbein, while the attentive (and beautifully painted) family dogs suggest some Landseer influence.

Tissot is best known for his scenes of late-Victorian high society, but he had earlier painted with a Pre-Raphaelite precision and attention to detail, as in his picture here — 'Marguerite à l'Eglise', illustrating a scene from Goethe's Faust. It will be a surprise to those familiar with the *louche* atmosphere of his later work.

SHERBORNE CASTLE

HHA MAP I

Sherborne, Dorset
On southern border of Sherborne, off Dorchester road (A352)
Tel Sherborne (0935) 813182

Sherborne Castle is an awkward-looking house, an H-shaped extension of an Elizabethan mansion. There are many Digby family portraits to be seen, by Kneller, Reynolds, Eastlake, Francis Grant and others. However, the most memorable picture here is not a portrait, but can perhaps be described as a portrait group. This is the famous painting by Peake of Queen Elizabeth I in procession. It is complex, detailed, charming, mannered and highly entertaining, showing the Queen carried precariously (and presumably symbolically) shoulder-high by a team of courtiers who seem to be concentrating more on posing elegantly than on the task in hand.

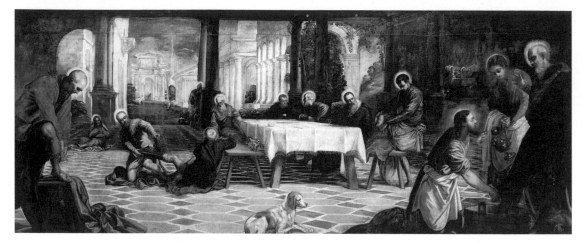

Tintoretto: 'Christ Washing the Disciples' Feet' (*Shipley Art Gallery*)

SHIPLEY ART GALLERY

MAP B

**Prince Consort Road, Gateshead, Tyne and Wear
Tel Tyneside (091) 4771 495**

The Shipley Art Gallery, dating from the First World War, is named after its founder and chief benefactor, a Newcastle solicitor who made a fortune and amassed a large and varied collection.

Shipley's main interests were seventeenth-century Dutch and Flemish paintings and nineteenth-century British art. Among the former group, those particularly noteworthy are Teniers's 'Tavern Scene', a highly characteristic work, 'The Temptation of Adam and Eve' by Joachim Wtewael, 'Concert of Birds', a pair of paintings on copper by Jan van Kessel the Elder, work by Bamboccio and others. Among the Victorian works are to be found three by Grimshaw, notably 'Autumn Regrets', an evocative scene in a park, 'The Poor Teacher' by Redgrave and Deverell's 'Scene from *As You Like It*'.

In addition, there are works by such artists as Sebastiano Ricci and by Canaletto. There is, above all, Tintoretto's noble 'Christ Washing the Disciples' Feet', which was given to St Nicholas Church (later to become Newcastle Cathedral)

in 1815, and was acquired for the gallery in 1986.

SHUGBOROUGH

NT MAP E

**Milford, Stafford
13½m SE of Stafford, off Rugeley road (A513)
Tel Little Hayward (0889) 881388**

The pictures at Shugborough are dominated by the numerous views of the park, and of its many monuments, as well as the house, by Nicholas Dall. The Anson family portraits include work by Hayter and Reynolds; and there are many other pictures to be seen, including work by Zuccarelli, de Loutherbourg and Francis Grant.

THE SIR ALFRED MUNNINGS ART MUSEUM

MAP G

**Castle House, Dedham, Essex
Tel Colchester (0206) 322127**

Castle House, the artist's home for the last forty years of his life, is preserved as a memorial to Sir

Alfred Munnings. Those who only know his sometimes slick later work may well be surprised and delighted by the exuberance and simplicity of the work from his younger days in the countryside.

SIR JOHN SOANE'S MUSEUM

MAP K

13 Lincoln's Inn Fields, London
Tel (01) 405 2107

Sir John Soane (1753–1837) left his house as a museum, stipulating that nothing should be changed. His great collection of architectural bits and pieces, sculptures, books and odd antiquities is crammed into the complex interior of his home. Among this endearing collection are his pictures, most of which are in the Picture Room, which is equipped with hinged walls (like huge cupboard doors) to enable several layers of pictures to be displayed in a relatively small space.

The most famous of his pictures are the originals of the two Hogarth series — 'The Rake's Progress' and 'The Election' — twelve in all. Numerous engravings of these series were made. They have to be 'read' for their telling detail as much as looked at, for they are moral stories in pictures, like novels by Henry Fielding, as it were, in paint (Fielding was a great admirer of Hogarth). They are ancestors of the strip-cartoon. Other pictures here include works by Canaletto, Reynolds, J. M. W. Turner, John Jackson, Callcott, Beechey and Lawrence, whose striking portrait of Soane was one of his last works.

Sir John Soane's is totally unlike other museums, and eminently worth a visit; the impact, both of the place itself and of such pictures as the Hogarths, is memorable.

SIZERGH CASTLE

NT MAP A

Kendal, Cumbria
3½m S of Kendal on Lancaster road A6/A591
Tel Sedgwick (0448) 60070

At Sizergh Castle there are many Strickland family portraits. These include work by, or attributed to, Riley, Kneller, Dahl, Romney, Hoppner, Raeburn and Opie. The most remarkable portraits, however, are those of the Stuart family, whose self-imposed exile to France was shared from 1688, voluntarily, by Sir Thomas and Lady Strickland. The Stricklands acquired, in their time at the French court, six Stuart royal portraits by Largillière and Alexis-Simon Belle.

SLEDMERE HOUSE

HHA MAP D

Driffield, Humberside
8m NW of Great Driffield, on Molton road (B1252)
Tel Driffield (0377) 86637

Apart from sporting pictures by members of the Herring and Ferneley families, among others, the great bulk of the pictures at Sledmere House are Sykes family portraits. Among the most striking of these are those by Lawrence, especially his large triple-portrait of the 3rd Baronet with his wife and his brother. There are portraits too by von Maron and Pine, and an admirable equestrian picture of the 4th baronet by Francis Grant. Outstanding, even in such company as this, is Romney's entrancing double portrait of the 2nd baronet strolling past, spectacles in hand, with his evidently devoted wife, and equally devoted dog. A new fir-plantation and an eye-catching folly are in the background. Sometimes known as 'The Evening Walk', this magnificent portrait shows Romney's masterly capabilities at their very best, combining insight with elegance, poise with urgency, character with tenderness. Lady Sykes's beautiful white

satin dress is painted with enormous skill, particularly in the subtle way it reflects the red of her husband's swallow-tail coat.

SMITH ART GALLERY

MAP C

**Halifax Road, Brighouse, W. Yorks
Tel Brighouse (0484) 719222**

The Smith Art Gallery has some Dutch and Flemish seventeenth-century paintings, but the collection chiefly consists of nineteenth-century British work, including pictures by Faed, Stone, Calderon, Niemann, Pyne, Elmore, Horsley, Leighton and Stanfield.

SOMERLEYTON HALL

HHA MAP G

**Lowestoft, Suffolk
5m NW of Lowestoft off B1074
Tel Lowestoft (0502) 730308**

There is much to attract the visitor to the early-Victorian Somerleyton Hall, both inside and outside the house. There are family portraits here, but the visitor's eye will tend to be caught more surely by the small group of fine pictures spread through the rooms open to visitors. These include a biblical study by Reni; a double portrait of Rembrandt and his wife Saskia by Rembrandt's pupil Bol; and a sketching group by Wright of Derby, with his characteristic bold use of light. Also here is a handsome pair of pictures by Stanfield, commissioned for the house, and recording incidents in the Napoleonic Wars.

SOUTHAMPTON ART GALLERY

MAP I

**Civic Centre, Southampton, Hants
Tel Southampton (0703) 223855**

Founded in 1939, the Southampton Art Gallery, well endowed from the start, and well advised, has built up a very remarkable collection indeed. In its handsome galleries, displayed with skill and panache, there is a most rewarding collection accessible to the art lover.

Modern British art is very strongly represented. The collection of work by the Camden Town Group is reputedly the best outside London. The visitor will not fail to revel in works by such artists as Augustus John, Gwen John, Steer, Sickert, Gertler, Stanley Spencer and many more.

Old masters include a fourteenth-century

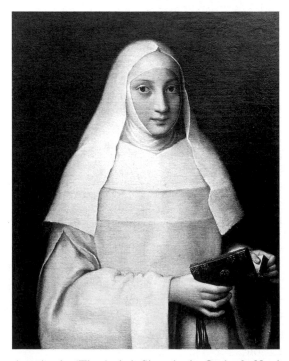

Anguissola: 'The Artist's Sister in the Garb of a Nun'
(*Southampton City Art Gallery*)

altar-piece by Nuzi, an extensive landscape by de Koninck, a 'Holy Family' by Jordaens, and 'The Artist's Sister in the Garb of a Nun' by Sofonisba Anguissola. From the eighteenth century are to be found works by Wilson, Morland, Romney, Reynolds and Lawrence. Gainsborough is there too, with a masterly portrait of the 2nd Lord Vernon.

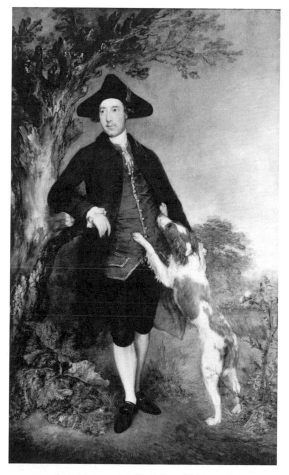

Gainsborough: '2nd Lord Vernon'
(*Southampton City Art Gallery*)

The nineteenth century in England and France is represented by Turner, by Martin, by the Pre-Raphaelites and by such artists as Renoir, Monet, Sisley, Camille Pissaro and Boudin, the last with a hauntingly beautiful 'Moonlit Seascape'.

SQUERRYES COURT

HHA MAP J

**Westerham, Kent
Tel Westerham (0959) 62345 or 63118
On western edge of Westerham, on Oxted road
(A25)**

Squerryes Court is a delight. A late-seventeenth-century redbrick house of modest size, light and airy, it contains the fine collection of the Warde family who have lived here for 250 years.

The family portraits include works by Riley, Dahl, Kneller, Vanderbank, Arthur Devis, Opie, Romney, Dandridge and Barraud. There is a robust family hunting group by Wootton, and John Warde appears in a picture by Stubbs of the Arab horse he had been commissioned to paint. Barraud also painted this same John Warde years later, when he weighed twenty stone but still hunted vigorously.

There is a splendid group of Dutch pictures, with many masters represented, among them van der Helst, van Goyen, Hondecoeter, Steen, Egbert van Heemskerck, Jacob van Ruisdael and Steenwijk. Assembled in one room, many of them of modest size, this group is very easy to appreciate and profoundly impressive.

Zuccarelli's 'A View of Mr Clayton's House at Harleyford' is an unusual departure for this artist, better known for the '*capricci*' which appear in numerous houses up and down the country. Harleyford Manor belonged to John Warde's brother-in-law and still stands by the Thames near Marlow looking very much as it does in Zuccarelli's picture, accurate enough as far as the house and its distance from the river are concerned, but with the hills in the background exaggerated.

There is also a number of larger pictures, including two extensive classical scenes by Giordano, and works by Dolci and others, including one of van Dyck's religious pictures — 'St Sebastian'. There are also portraits and relics of General James Wolfe, a neighbour and family friend.

211

Giordano: 'Triumph of Bacchus and Ariadne'
(*Squerryes Court*)

STANDEN

NT MAP J

East Grinstead, W. Sussex
1½m S of East Grinstead off B2110
Tel East Grinstead (0342) 23029

Standen is an intriguing late-Victorian house, designed by Philip Webb and packed with William Morris wallpapers and textiles. It contains William Nicholson portraits of James and Mary Deale, for whom the house was built, and many water-colours and other pictures appropriate to this setting.

STANFORD HALL

MAP F

Swinford, Leics
7½m NE of Rugby, off B5414
Tel Rugby (0788) 860250

This William-and-Mary mansion, the home of the Cave family, has many family portraits, including portraits by Kneller and by Hudson, some royal portraits and an absorbing collection of Jacobite relics and pictures.

STANLEY SPENCER GALLERY

MAP J

King's Hall, Cookham-on-Thames, Berks
Tel Bourne End (06285) 26557

This small gallery, with a changing exhibition of Spencer's work, is a few yards from his birthplace in the village in which he lived and worked for much of his life, and which features in many of his pictures.

STANTON HARCOURT MANOR

HHA MAP I

Stanton Harcourt, Oxon
9m W of Oxford, in Stanton Harcourt
Tel Oxford (0865) 881928

While Stanton Harcourt Manor is not open with great frequency, it is a place of such charm that any planning involved will be richly rewarded. Alexander Pope worked here for a time, and his presence can be felt, as well as seen, in the admirable portrait by Kneller which hangs here. The same artist painted some of the Harcourt family portraits, as did Mytens, Lely and Reynolds.

This is not a house where the family or royal portraits dominate the collection. There are pictures ascribed to Bellini and to Velazquez. There is a large and complex sea-picture by Willem van de Velde the Younger and his brother Adriaen; in fact, the latter is thought to have done much of the work, as there are errors in the details of the shipping, which are unlikely to have been made by the more experienced Willem. A pleasure boat which the city of Amsterdam gave to Charles II features prominently, once leading people to suppose that the picture records the King's embarkation from Holland in 1660.

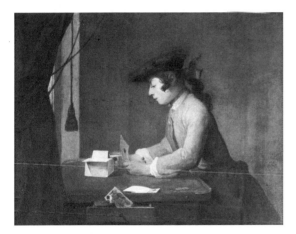

Chardin: 'The House of Cards' (*Stanton Harcourt Manor*)

'The House of Cards' by Chardin is much admired, a skilful interior in which the light thrown on to the concentrating boy and the cards on the table comes from a high window almost hidden by heavy curtains.

There is also a fine array of landscapes, with pictures ascribed to Rubens, and pictures by Jacob van Ruisdael and by Salomon van Ruysdael. There are views by Sandby of Stanton Harcourt and of the family's former home at Nuneham Courtenay — both of these pictures being rare oil-paintings by this artist, who usually worked in water-colours.

STANWAY HOUSE

HHA MAP E

Broadway, Glos
5m SW of Broadway on B4077
Tel Stanton (038 673) 469

In appearance, Stanway House is everybody's idea of a perfect Cotswold manor house. Within its walls there are a number of pictures, including portraits by Romney, Raeburn, G. F. Watts and Poynter, among others.

STOCKPORT ART GALLERY

MAP C

Wellington Road South, Stockport, Greater Manchester
Tel Manchester (061) 480 9433

Stockport's Art Gallery, which incorporates a War Memorial, has a collection of paintings which includes paintings by Leader, Lowry and Bratby.

STONOR PARK

HHA MAP F

Henley-on-Thames, Oxon
5m NW of Henley-on-Thames, on Watlington road (B480)
Tel Turville Heath (049 163) 587

Stonor, a beautiful, secluded, almost secret, place among the Chiltern beechwoods, has for over eight hundred years been the home of the Camoys family, staunch Catholics who often suffered greatly for their faith. Some of this history is reflected in the contents of the house.

Family portraits include works by Kneller, J. M. Wright, Riley and Romney. There are pictures by Ludovico and Agostino Carracci; and

there are two notable Venetian works, a portrait of a man in a plumed hat and a sketch of a doge's coronation by Andrea Vincenti.

STOURHEAD

NT MAP I

Mere, Wilts
3m NW of Mere, in Stourton off Frome
road (B3092)
Tel Mere (0747) 840348

Stourhead, world-famous for its landscaped garden, also has a notable array of pictures within its Palladian walls, mainly a collection made in the eighteenth century. There is a very large, and almost indigestible, number of family portraits of the Hoare family of bankers who lived here for over two hundred years, with works from such artists as Wootton, William Hoare (no relation), Reynolds and Leighton.

There are good pictures by Maratta, Cigoli ('Adoration of the Magi'), Batoni, and Mengs ('Octavian and Cleopatra'). There are flower pictures by Monnoyer. Also, in view of the magnificent landscape beyond the walls, it is no surprise to find that favourite landscape painter of the eighteenth-century collector here — Nicolas Poussin, as well as his brother-in-law Gaspard Poussin with his 'A Landscape with Eurydice'.

STRATFIELD SAYE HOUSE

HHA MAP J

Basingstoke, Hants
6m NE of Basingstoke, off Reading road (A33)
Tel Basingstoke (0256) 882882

The great Duke of Wellington, given a large sum by a grateful government after the victory of Waterloo, bought the Stratfield Saye estate, where he settled down, making the house as comfortable as was then possible. Today, its well appointed rooms are a great pleasure to visit.

The Duke reserved the cream of his picture collection for Apsley House, his London home, where they can still be seen. Some, however, are at Stratfield Saye, chiefly a number of Dutch cabinet pictures including works by Cuyp, Maes, Terborch, van Goyen and Teniers. Murillo is also represented, and there is a Tintoretto 'Ascension'. There are family portraits here, with other pictures that have associations with the great man. These include some fine sporting pictures and pictures of horses, one of the latter by Landseer and one by Haydon of the Duke's famous charger 'Copenhagen'.

SUDBURY HALL

NT MAP E

Derbys, near Uttoxeter
6m E of Uttoxeter on Derby road (A50)
Tel Sudbury (028 378) 305

There are many pleasing surprises at Sudbury Hall. One of these is a most unusual feature in a Restoration house, a long gallery. This beautiful room is lined, in the usual manner, with family portraits. In many cases, the likenesses of the Vernon family here are somewhat overshadowed by the extraordinary plasterwork of the ceiling, at once delicate, elegant and entertaining — but this stricture does not apply to the contributions of J. M. Wright, whose work here, as elsewhere, has an unusual liveliness and depth of feeling.

In the saloon, the family portraits are set into the panelling, and it is noticeable how some of them, especially those by Vanderbank and by Hudson, are dressed in van Dyck style, emphasising the eighteenth-century interest in and admiration for van Dyck.

There are a number of Seeman portraits at Sudbury. Other artists represented here are Kneller, Hoppner and Lawrence, the last with a handsome pair of full-lengths. A further unusual feature of this house is the ceiling and mural paintings of Laguerre.

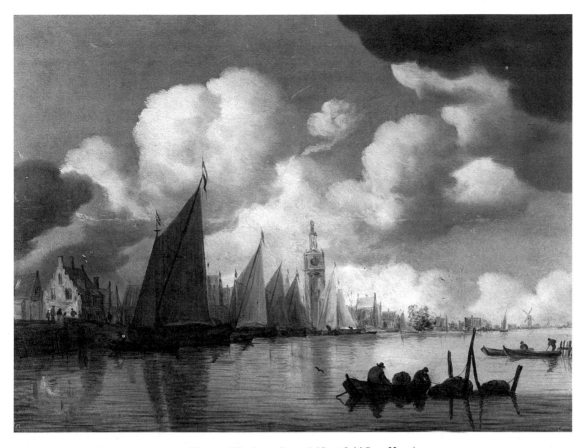

van Goyen: 'Harbour Scene' (*Stratfield Saye House*)

SUDELEY CASTLE

HHA MAP E

Cheltenham, Glos
6m NE of Cheltenham on Broadway road (A46)
Tel Cheltenham (0242) 602308

There is much to interest the visitor at medieval Sudely Castle, not least the pictures. The house was once occupied by Katherine Parr, Henry VIII's sixth, and surviving wife. The visits of her stepdaughter, the future Queen Elizabeth, are marked by a portrait and by an extraordinary picture, perhaps by Lucas de Heere. This is a sort of political cartoon, such as used to appear weekly in *Punch*, and is a complicated, though entertaining, comment on the Protestant succession. Henry VIII sits uncomfortably in the centre, sceptre in one hand, and passing the sword of justice to his kneeling son Edward VI. Meanwhile the King is being approached on both sides. On the one hand his daughter Mary, with her Spanish husband Philip II, nervously appears, although accompanied by Mars, very much the god of war, fully armed and wielding a bludgeon. On the other side, Queen Elizabeth sweeps in, hand in hand with 'Peace', who is trampling on weapons of war and is followed by 'Plenty' who is carrying both a large cornucopia and the Queen's train.

Other artists — mostly more celebrated for artistic quality than de Heere — represented by work at Sudeley include van Dyck, Rubens, Steen, Jacob van Ruisdael, Claude, Turner (an exceptionally fine Thames-side landscape) and Eastlake. Perhaps the most striking picture at Sudeley is 'The Lock' by Constable, one of the

large pictures he painted of the Stour valley, happily still today much as it was when Constable knew it. It is a wonderfully controlled picture, perfectly conveying Constable's delight in the beautiful countryside under the Suffolk sky, with Dedham church in the background, beyond the red-waistcoated central figure straining to open the lock gate while a colleague holds up the barge, and a ploughboy and a dog contemplate the activity.

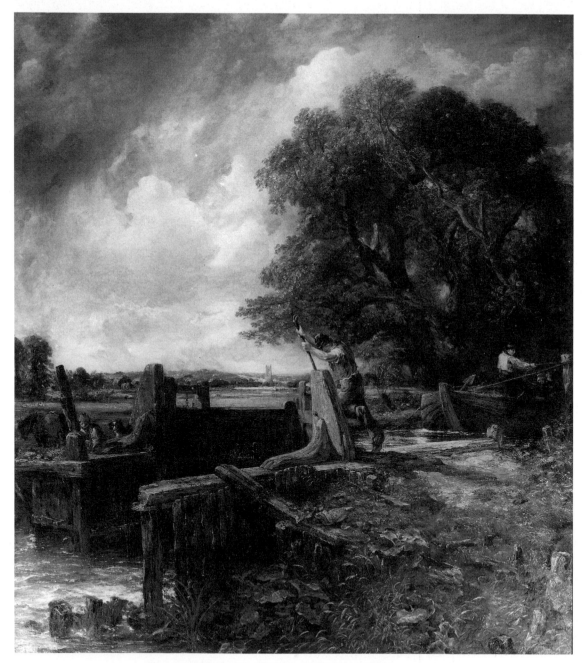

Constable: 'The Lock' (*Sudeley Castle*)

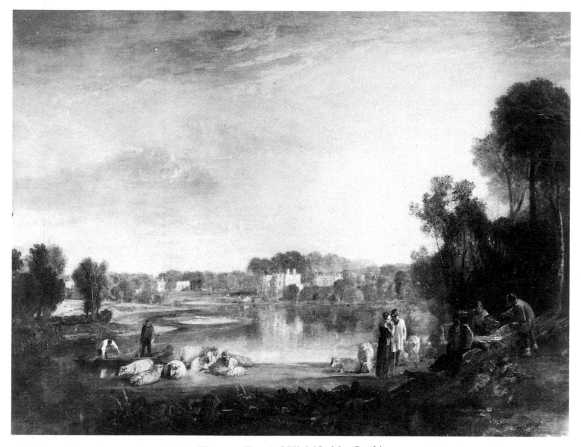

Turner: 'Pope's Villa' (*Sudley Castle*)

SUDLEY ART GALLERY

MAP C

Mossley Hill Road, Liverpool
Tel Liverpool (051) 724 3245

The Sudley Art Gallery is housed in a handsome early-nineteenth-century house which was once the home of the Holt ship-owning family. It contains the complete collection of George Holt (1825–96). He began collecting in the 1860s, buying contemporary British pictures. From this beginning, his interest moved backwards, as it were, so that as well as Leighton, Landseer, Stanfield, and many more, earlier painters are well represented too. There are portraits by Reynolds, Lawrence, Opie, Raeburn, and there

is a particularly splendid Gainsborough study of dignified old age — his 'Viscountess Folkestone'. There is an enchanting Bonington, 'Fishing Boats in a Calm', and several paintings by Turner; the most notable of these is his 'Rosenau' dating from 1841, the year of Queen Victoria's marriage to Prince Albert, whose family seat was at Rosenau Castle. It is a fine picture and an interesting example of Turner's cunning exploitation of topical interests.

Holt's interests also extended to the Pre-Raphaelites. There are pictures in the collection by Rossetti, Burne-Jones, Holman Hunt and Millais, as well as Alma-Tadema and a work ('Gethsemane') by Dyce.

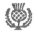

SULGRAVE MANOR

MAP F

Northants, near Banbury
7m NE of Banbury off Northampton Road
(B4525)
Tel Sulgrave (029 576) 205

Sulgrave Manor is a modest house. The home of the ancestors of George Washington, it is well kept and contains many family relics, with some portraits of Washington.

SUNDERLAND MUSEUM AND ART GALLERY

MAP B

Borough Road, Sunderland, Tyne and Wear
Tel Sunderland (078351) 41235

The Sunderland Art Gallery has an assembly of British art from the nineteenth century. There is a strong emphasis on local topography and on local artists, but Landseer and Lowry are here too.

Clarkson Stanfield, born in Sunderland, is represented by an admirable and vigorous example of his work — 'Chasse Marée off the Gulf Stream Light', in which his knowledge of the sea and shipping is used to excellent effect.

SUTTON PARK

HHA
MAP D

Sutton-on-the-Forest, N. Yorks
8m N of York on Helmsley road (B1363)
Tel Easingwold (0347) 810249

Sutton Park is by no means an enormous house, but it has a great deal of unpretentious charm. The Sheffield family picture collection could well be described in the same words: there are family portraits by Wissing, D'Agar and Highmore; a number of pictures by Samuel Scott, with one by Canaletto, who so greatly influenced him; and a solitary self-portrait by West.

SWINDON MUSEUM AND ART GALLERY

MAP I

Bath Road, Swindon, Wilts
Tel Swindon (0793) 26161

Built in the 1960s, Swindon Art Gallery houses a lively collection of twentieth-century British painting, including works by Ben Nicholson, Sutherland, Wadsworth, Bell, Bevan and many others.

SYON HOUSE

HHA
MAP K

Park Road, Brentford, Middlesex
Tel (01) 560 0881

Syon House, one of the Duke of Northumberland's homes, built on the site of a monastic foundation, is named after Mount Zion in Palestine. Standing in a Thames-side park opposite Kew Gardens, its plain, battlemented exterior gives no hint of the splendid Adam interior, sumptuous and delightful. The magnificent furnishings are enlivened by a picture collection of merit, including two landscapes by Zuccarelli, and Rubens's 'Diana Returning from the Hunt'.

There is a large number of royal and family portraits, including works by Lely, Gainsborough, Reynolds, Stuart, Wissing and de László. Many of these, it has to be said, are awkwardly placed. The best displayed are the Stuart portraits, among which are works by Miereveld, Mignard, Huysmans, van Somer, Hanneman and van Dyck. There is a touching, if not very accomplished, double portrait by Lely of Charles I and

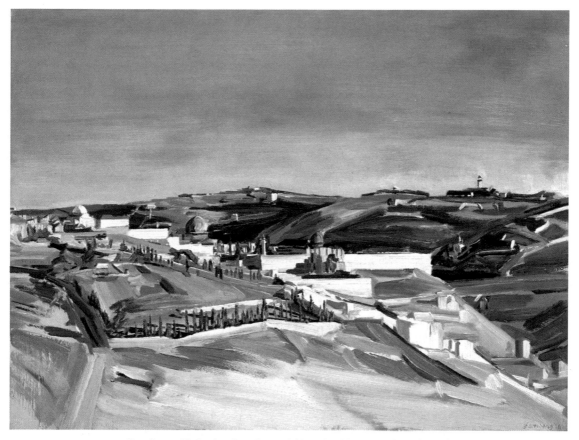

Bomberg: 'Palestine Landscape' (*Swindon Museum and Art Gallery*)

his second son, 'The Clouded Majesty', painted at Syon in 1647, when the King, then a prisoner at Hampton Court, had been allowed to ride over to Syon, where his children were likewise held.

THE TATE GALLERY

MAP K

Millbank, London
Tel (01) 821 1313

Within fifty years of the founding of the National Gallery in 1824, the nation had acquired a large number of pictures. Among other sources, these came from the Chantrey Bequest for the purchase of works by living British artists, from the Vernon and the Sheepshanks collections, and from the Turner Bequest (some three hundred oil paintings, nearly two-thirds of them incomplete, and nearly twenty thousand watercolours). No permanent home was found for any of these until 1891, when Sir Henry Tate, the millionaire whose fortune was based on lump sugar, offered his own collection, and a large sum for a building, on condition that the government would find a suitable site. The site of the former Millbank Prison was put forward and 'The National Gallery of British Art' opened in 1897 as a satellite of the National Gallery. It has, however, always been known as 'The Tate'.

There have been several extensions. Tate himself paid for the first of these; the art dealer Sir Joseph, later Lord, Duveen paid for another two; the Gulbenkian Foundation for another; most recently, the Clore Foundation has funded the galleries which house the Turner Collection, opened in 1987.

Although slightly off the mainstream of London's tourist track, and not very well served by public transport, the Tate is a very popular place. Many temporary exhibitions are held here, either in the galleries on the central axis of the main building, or in galleries normally assigned to the permanent collection. The lighting, guidebooks, shop, and restaurant are all of the highest quality, matching the pictures which hang on the walls.

As the building has changed and expanded, the purposes of the Tate have altered. Originally the intention was to display 'Modern British Art', defined at the time as work from 1790. Today the gallery is, in effect, in three parts. These are: the British Collection, a comprehensive assembly of British art from the sixteenth century until about 1900; the Modern Collection, which embraces work by British artists born from 1860 onwards, together with foreign work from Impressionism onwards; and lastly, the Turner Collection, the great artist's work of a lifetime gathered in its fine new galleries.

All three of these parts are on a large scale. Wise visitors do not attempt to tackle all three parts during a single visit; the parts will accordingly be described separately. Bear in mind that as the gallery owns many more paintings than it can possibly exhibit, pictures are often brought in and out of store to add variety to the display. While this makes the Tate one of the most exciting of the country's galleries, it does mean that even some of its most famous pictures may not always be on the walls. They could be temporarily in store, on loan to an exhibition, or in its satellite gallery in Liverpool.

THE BRITISH COLLECTION

There are many examples here of the extraordinary pictures produced in Britain towards the end of the sixteenth century, in a style that was not fashionable elsewhere in Europe at the time or earlier: realism in the features was combined with rigidity of stance and an almost diagram-like approach to the elements of a portrait. Gower's two portraits, 'Sir Thomas Kitson and Lady Kitson' (rare examples of documented

work by this artist) and the anonymous 'The Cholmondeley Sisters' are notable, as is Gheeraerts's masterpiece, 'Captain Thomas Lee', which strikes a slightly different note.

Peake's portraits of the two ladies of the Pope family, made in the early years of the seventeenth century, look old-fashioned alongside the work of contemporary artists trained abroad, such as van Somer, Mytens and Johnson. 'The Saltonstall Family', attributed to des Granges, is a memorable provincial example, dated about 1637, of a style that was already archaic; yet it

Beckmann: 'Carnival' (*Tate Gallery*)

includes touches of the new realism, a movement away from the diagram towards a well-composed picture.

The artistic explosion in Britain caused by the arrival of van Dyck is exemplified by his shimmering, graceful, relaxed but imposing 'Lady of the Spencer Family'. Dobson's skill in assimilating this style can be seen in his portrait of 'Endymion Porter'; and an echo, so to speak, can be seen in J. M. Wright's 'Sir Neill O'Neill'.

Lely's dominance of the Restoration years came in part from the skill with which he organised a large studio with its army of assistants: his 'Two Ladies of the Lake Family' is a fine example of his work at its magnificent best, relaxed but sumptuous, grand and tender. Kneller, likewise a great organiser, is similarly represented by some excellent examples of his work.

Early landscapes make their tentative appearance, such as the bird's-eye views of Griffier, while Siberechts's 'Landscape with Rainbow, Henley-on-Thames' is a landscape proper. Landscape painting took further steps in the eighteenth century, partly as an extension of the especially British art of the sporting picture, usually involving horses. Wootton was an early exponent, and is well represented at the Tate, as is the less well-known, almost 'primitive', Seymour, with such pictures as 'A Kill at Ashdown Park' of 1743. Lambert was one of the first British artists to devote himself exclusively to landscape painting, his 'View of Box Hill' being a good example of his admirable skill.

Conversation pieces also were popular at this time. Joseph van Aken and Mercier were two foreign-trained artists who pursued this line with dexterity, while the Preston-born Arthur Devis went his own way, with his small-scale and very appealing work which has a doll-like charm of its own: 'The James Family' is a splendid example. Scenes from novels, such as the series by Highmore for Richardson's *Pamela* were another new development, as were the first of the Shakespearean scenes — Hayman's 'The Wrestling Scene from *As You Like It*' is an early example. Many of these artists are also represented among the portrait painters of the day, alongside such as Vanderbank and Hudson.

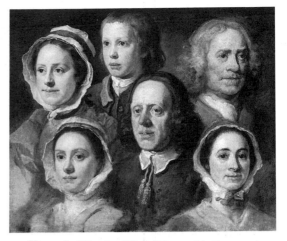

Hogarth: 'Heads of Six of Hogarth's Servants'
(*Tate Gallery*)

Hogarth dominates the mid-eighteenth-century assembly at the Tate, being especially well represented. There are admirable examples of his work of many kinds, from modest portrait and conversation pieces to grand pictures, such as his 'Archbishop Herring' in which Hogarth deliberately set out to emulate and out-paint Kneller and van Dyck. There are theatrical pictures, such as his first success, 'Scene from *The Beggar's Opera*' of 1728. His splendid picture of the heads of his six servants is an enthralling private picture, tender and affectionate, with none of the biting satire that so often infused his painting. The latter mood is to be seen here too, notably in 'O the Roast Beef of Old England', and in his magnificent oil sketch for 'The Wedding Dance'. This was for a projected, but never completed sequel to the famous 'Marriage à-la-Mode' series. 'The Wedding Dance' is full of life and of movement, with telling detail. The dancers are all observed with brilliant sardonic humour, all recorded with immense skill and verve.

The second half of the eighteenth century in Britain was dominated by four outstanding artists, Richard Wilson, Stubbs, Reynolds and Gainsborough, among a host of others. Samuel Scott is one of these, represented here by an admirable sea picture from his earlier days, 'Admiral Anson's Action off Cape Finisterre' and by some of the Thames-side pictures in which he later emulated Canaletto, with great

Picasso: 'Three Dancers' (*Tate Gallery*)

success, and never more than in his masterly 'An Arch of Westminster Bridge'. Also represented are such artists as Zuccarelli, Zoffany, Cotes, with a notable portrait of Paul Sandby, Barry, Wheatley, Marlow, West, Gavin Hamilton, Copley (especially with 'The Death of Major Peirson'), Romney ('Lady Hamilton as Circe'), Kauffmann, Hoppner, Raeburn, George Morland, Ibbetson, de Loutherbourg and, right at the end of the century, Lawrence, especially here with his sparkling portrait sketch of 'Princess Lieven'. Wright of Derby shows here both his interest in sources of light, with his 'Moonlight with a Lighthouse', and his skill as a portrait painter with 'Sir Brooke Boothby', in which Boothby, clasping a volume of Rousseau, is seen stretched on the ground in the pastoral manner of an Elizabethan poet, stressing the newly fashionable cult of nature.

Richard Wilson's years of study and work in Italy gave his landscapes something previously lacking in British painting, namely an understanding that landscape itself was capable of being infused with dramatic or poetic emotion. While his classical landscapes, such as 'Rome: St Peter's and the Vatican from Janiculum' are admirable essays, it is in his British, and even more in his native Welsh landscapes that his power is seen to great effect: his 'Llyn-y-cau, Cader Idris' is a fine example.

George Stubbs took the art of the horse-painter and sporting artist to new and never surpassed heights, extending his range from this starting point, to dramatic animal scenes ('Horse Frightened by a Lion'), and rustic scenes, such as 'Reapers', in which all is observed with precision and recorded with grace. His knowledge of anatomy gave to paintings like 'Mares and Foals in a Landscape' the greatest possible exactitude, but his native skill made them into graceful, harmoniously balanced compositions.

Reynolds bought to portrait painting, such as the magisterial 'Admiral Viscount Keppel', tremendous skill and self-confidence. He was able to fit ordinary persons into his concept of the Grand Manner without overdramatising

Stubbs: 'Haymakers' (*Tate Gallery*)

them and making them look ridiculous. A perfect example of this skill is to be seen here: in 'The Graces Decorating Hymen', Reynolds places three attractive Montgomery sisters in stylised classical attitudes, dresses them in vaguely classical robes, but succeeds in making the whole an enormously attractive picture, a lively chain of movement, with the central garland of flowers used to great effect.

Gainsborough was as English as Hogarth or Stubbs; he never went to Italy (which had so affected Reynolds) but he had made a close study of old masters, especially van Dyck. His love of the countryside is displayed here in several masterly landscapes, and landscape often found its way into his portraits, as in 'Sir Benjamin Truman' a wonderful portrait of the master-brewer; here is a tough and forceful commercial magnate, somewhat truculent, with a very sharp eye and humanised by the delightful landscape in which he stands. This masterpiece of formality can happily be contrasted with the quiet grace and loving skill displayed in 'The Artist's Daughter Mary'.

A section of the Tate is devoted to 'The Sublime and the Exotic', a grouping which has a fascination all its own, and which includes work by Barry, West, Opie, de Loutherbourg ('An Avalanche in the Alps' being an especially fine example of this artist's work), and the full-blooded Mortimer, notably with his 'Sir Artegal', a picture which goes a long way to explain Mortimer's contemporary reputation as 'the English Salvator Rosa'. Fuseli, however, dominates this group, most notably with his extraordinary 'Titania and Bottom', a nightmare picture of hideous power, quirky and very memorable. (It should be mentioned here that the Tate presents a unique opportunity to study the drawings and colour prints of that extraordinary English visionary artist, William Blake.)

With Constable, the visitor returns to reality and the finest possible evocation of the English countryside, from which Constable scarcely strayed throughout his life. The Tate has a very handsome collection of paintings from every period, from studies and preliminary sketches to the large canvases for which he is most famous. His 'Scene on a Navigable River (Flatford Mill)'

was the first of these, based on the delightful Stour valley of his boyhood and youth, which remained such a potent source of inspiration. This is the happiest of pictures, with quiet rustic life going on along the banks of the river under the broad Suffolk sunlit sky. Later pictures, including those with a Hampstead or a Brighton background, tend to have stormy skies and choppy seas, reflecting in part the struggle for recognition which tormented Constable in his later years.

His abundant abilities were outstanding in a period of great skill in landscape painting by such artists as Linnell, Danby, Crome, Cotman, Callcott, James Ward (most evidently with his gigantic 'Gordale Scar'), Eastlake, Bonington, Cox, de Wint, Stanfield and William Collins, all of whom are well represented in this section.

With the opening of the Turner galleries, it has become possible for more of the Tate's large number of nineteenth-century subject paintings to be put on display. The huge and spectacular canvases of Martin are especially evident, such as 'The Great Day of His Wrath', the artistic equivalent of a fire-eating preacher's sermon. Wilkie's Teniers-like pictures such as 'The Blind Fiddler' from the early years of the century found many followers, such as Mulready. Others to be noted are Etty, Landseer, Danby, Egg, Dadd and, most notably, Frith, whose 'The Derby Day' was one of the most famous paintings of the century in Britain, and described by Ruskin as 'a kind of cross between Leech and Wilkie, with a dash of daguerreotype here and there, and some pretty seasoning with Dickens's sentiment'.

The Pre-Raphaelites are strongly represented at the Tate. The Pre-Raphaelite Brotherhood, a very English artistic movement, originally emerged from discussions between Rossetti, Hunt and Millais: its influence was greatest in its techniques — bright colours, extreme details and so on, rather than its insistence on serious subjects and highly elaborate symbolism. Rossetti's 'Annunciation' is a startling treatment of this subject, while Millais's 'Christ in the House of His Parents' caused an appalled sensation in its day, being called 'mean, odious, repulsive and revolting' by none other than

Charles Dickens, who certainly did not object to ultra-realism in the printed word. Millais's 'Ophelia' is one of the best-known of the Pre-Raphaelite pictures; the detail is recorded with uncanny precision and Ophelia herself has a half-alive expression which adds much to the power and fascination of the picture. There is much work, too, from other members of the Pre-Raphaelite Brotherhood, as well as those who were influenced by their work: Holman Hunt, Dyce, Deverell and Ford Madox Brown, Hughes, Windus, Morris are all well represented. Henry Wallis's 'Chatterton' is as well known as the artist is little known; and there is a fine representation of Burne-Jones's work, especially his best known 'King Cophetua and the Beggar Maid'.

The tail end of the British Collection is by no means an anti-climax, including as it does work by Leighton, Alma-Tadema, Waterhouse ('The Lady of Shalott'), Millais (the enormously popular 'Boyhood of Raleigh'), Watts (especially 'Hope'), Clausen, Orchardson and Fildes. Tissot is well represented with characteristic pictures of high society. Sargent puts in an appearance, as does Whistler, with a number of his prophetic river scenes, which aptly complete the collection, looking forward as they do to modern art.

THE TURNER COLLECTION

With the opening of the Clore Gallery, entirely devoted to the work of J. M. W. Turner, belated but highly effective justice is done to the most extraordinary artist in British history, whose work is one of the most outstanding achievements of the nineteenth century. Magnificently displayed in their resplendent new galleries (designed by the celebrated architect — and one of the most controversial — James Stirling), Turner's works of a lifetime can be seen and appreciated as never before.

Turner was born in 1775 and started exhibiting at the age of fifteen, still in the age of Gainsborough and of Reynolds; he died in the year of the Great Exhibition amid the novelties of the Pre-Raphaelite Brotherhood.

His earliest works were timid, if accomplished, water-colours, but he rapidly left these behind, developing a more positive and fluent technique; his first oils show something of the influence of Richard Wilson, Wright of Derby and de Loutherbourg. At the turn of the century he deliberately set out to emulate such masters as van de Velde, Claude and Nicolas Poussin, soon absorbing the lessons they had to teach and adapting them to his own highly individual style. He embarked on the series of tours which led on to the topographical work (and the engravings from them) which were to be his perennial bread and butter. Such pictures from this time as 'The Thames near Walton Bridge' have a directness which rivals that of Constable. 'Crossing the Brook', a Claudean landscape which is in fact a scene in Devonshire, is a masterpiece of his early style, as is 'The Shipwreck', which demonstrates his abiding interest in the sea and shipping.

Turner visited Italy in 1819, for the first time. Overwhelmed by the clear light, his response was exuberant, with his pictures at once showing a new boldness and individuality of style, as well as a growing interest in the effects of light, which absorbed him increasingly, as has been the case with many great artists. His most accomplished landscapes are the Petworth series, in which there is a delicate balance between the reality of the scene and the bursts of light with which Turner illuminated it.

It is sometimes thought that his later pictures, those of the 1840s, are in fact abstract; this is, however, to misunderstand his intentions. His working methods were extraordinary. His habit was to return to a picture again and again, usually completing his exhibited pictures when they were already hanging on the gallery walls. Many of the works in his studio at his death, which he bequeathed to the nation and are the basis of the Tate's collection, were therefore unfinished. The delicate light, painted in thin colours as in a water-colour, was often his starting point. The unfinished 'Norham Castle' is a magical picture, in which the misty Tweedside castle is barely seen through the astonishingly real atmosphere. Both the use of colour — blue castle, red cow, and so on — and the style were revolutionary. The public at the time did not see the unfinished work, but the exhibited pictures such as 'Snowstorm: Steam-

boat off a Harbour's Mouth' were almost as revolutionary. It is astonishing that they were recognised, by such as Ruskin, as works of great power and importance, while there were no followers or imitators. Then, as today, Turner stands alone.

THE MODERN COLLECTION

In their own time, the Impressionists sought to escape from the traditional art which surrounded them and thereby find a new truth; they were very largely ignored or derided by their contemporaries — indeed, the word 'Impressionist' was fastened onto the group as a derisive nickname in 1874. They have, of course, long been recognised as the decisively important artistic movement of the late nineteenth century.

The Impressionists were also the first in the whole series of movements which have enlivened the hundred and more years since the first Impressionist exhibition in 1874. Cubism, Surrealism, Abstract Expressionism, Pop Art — these are only some of the revolutionary movements which have come, and gone, with a rapidity which all too easily bewilders the ordinary art lover. The Modern Collection of the Tate Gallery is the only place in Britain where it is possible to begin to come to terms with the ceaselessly shifting scene. The collection, though uneven in its representation of the many movements, illustrates all of them to a greater or lesser extent. It is wise to try to absorb this glittering kaleidoscope in parts. In this way it is possible to pick up at least a smattering of each artistic language in turn, before the senses are dulled by overexposure.

The Impressionist and Post-Impressionist pictures at the Tate form a prelude to the Modern

Turner: 'Snowstorm: Steamboat' (*Tate Gallery*)

Collection, with a small, but representative collection of work by the well-known masters such as Monet, Cézanne, Seurat, van Gogh and Gauguin, as well as the less familiar O'Conor and Bonnard. There is a particularly fine group of pictures by Bonnard, including the apparently artless, but in fact masterly 'The Bowl of Milk'. Fauvism — a 'movement' which emerged in Paris in 1905, characterised by violent colours, flat patterns and distortions (*Les Fauves* means 'the wild beasts') — makes its appearance with work by its leading exponents, Matisse, Dufy and Derain, whose work includes the well-known 'Pool of London' of 1906, where the brilliant colours are in glorious conflict with the actual drabness of the scene.

Expressionism, a movement largely pioneered by German and Austrian artists in the early years of the century, embodies the idea of using distortion (of form or of colour) as a means of expressing extreme emotion. Here there are many examples to be seen, notably those of the Norwegian Munch, Beckmann (with his extraordinary 'Carnival' of 1920), Grosz, Kokoschka, Rouault and Soutine. Modigliani is to be found hereabouts as well.

British art from 1880 to 1920 starts with work by such artists as Clausen and Forbes; this is followed by the French-trained American Sargent, who certainly absorbed some of the precepts of the Impressionists. Conder, Pryde and William Nicholson's work contrasts with that of Steer and Sickert, in whose paintings the discoveries of Impressionism became integrated. Augustus John is represented by some early pictures; his sister Gwen's work includes her splendid, touching and dignified self-portrait of 1900. The Camden Town Group, formed originally around Sickert, and usually credited with introducing Post-Impressionism to British Art, included Lucien Pissarro, Bevan, Gilman, Gore, Ginner and Duncan Grant, all of whom might equally be classified as Post-Impressionists, while Matthew Smith, with his rich and idiosyncratic colours, seems to belong to the Fauves.

Continental influences, however, seem not to have affected such artists as Gertler and William Roberts, while Stanley Spencer was always utterly English, in his minutely observed and powerfully dramatic paintings, such as 'Swan Upping' and the 'Resurrection', which Spencer saw as taking place in the churchyard of Cookham-on-Thames; this theme and this place were to be constant and powerful influences on the artist throughout his life.

The founders of Cubism were Braque and Picasso, who developed the style from aspects that they saw in the work of Cézanne. Cubism, the forerunner of all abstract art, involved combining several super-imposed views of an object in order to represent its actual form, rather than a single surface view of it. There are also earlier works by Picasso, such as 'Girl in a Chemise' of 1905. Braque's 'Clarinet and a Bottle of Rum on a Mantelpiece' (of 1911) is an almost colourless and near-abstract work which exemplifies the Cubist ideas. There are also works in, or strongly influenced by, this style by Gris, Robert Delaunay and Léger, whose 'Still-life with a Beer Mug' (1921/2) seems to anticipate the world of Op Art and Pop Art.

'The Three Dancers' (1925) is another of Picasso's works to catch the eye; it is an extraordinary, violent and ferocious nightmare of a picture, painted when a friend of the artist had died, sparking off memories of an earlier, and violent, episode in which another friend had killed himself.

Futurism (involving glorification of machines and war) a movement originated by Italians, finds a modest place in the Tate's collection, with works by Severini and Balla, while Vorticism (an English variety of Cubism) is more widely represented, with pictures by Lewis, Wadsworth, William Roberts and others, such as Nevinson, who were associated with this short-lived movement. That the movement was influential can be seen in Bomberg's 'The Mud Bath', a powerful and individual picture of 1914.

Abstract Art had its origins before the First World War, when artists such as Kandinsky, van der Leck and Mondrian took Fauve, Expressionist and Cubist ideas beyond the point where it was thought necessary to have any subject, in the traditional sense, for a picture. There are appropriate examples of their work, and of such artists as Malevich and Moholy-Nagy, as well as British artists who took up this

theme, such as Lewis and Wadsworth and, briefly, Bell and Duncan Grant, who soon returned to figurative work, unlike Ben Nicholson.

Dada (a brief, hysterical forerunner of surrealism, anti-art in any form), Surrealism (a 1920s movement involving painting from the irrational dictates of the subconscious) and Fantastic Art (closely allied to Surrealism) are represented by notable works by Chagall ('The Post Reclining'), Chirico, Duchamp, Ernst ('The Elephant Celebes'), Magritte, Delvaux, Miró, Dali and others.

The British Collection of 1920 to 1945, which overlaps with these exotic continental movements, includes work which was relatively untouched by them, such as the paintings of John Nash, Coldstream (and the Euston Road School — an English group which turned away from Surrealism and abstract painting to a more realistic approach), and the primitive painter Alfred Wallis. Other artists absorbed something of what was going on, often adapting it to their own vision, in some cases pushed ahead by those Europeans who were obliged to flee from Fascism to Britain or the United States in the 1930s. Amongst these were Paul Nash, Hitchens, Burra, Richards and Moynihan, all well represented here, as are such artists as Lowry, Colquhoun and Minton.

After the Second World War, Léger, Picasso and Matisse continued to dominate in their own separate ways, Matisse now using the medium of paper cut-outs, such as 'The Snail' of 1953, the year before his death. Others who made their mark at this time included Buffet, Dubuffet and Tàpies, amongst many others. But the centre of gravity of artistic innovations had shifted across the Atlantic, again partially assisted by the work of refugees. Abstract Expressionism, perhaps best described as automatic painting, allowing shapes to emerge, was the first style to emerge, often on a very large scale, close to mural-painting, with such artists as Pollock, Gorky, de Kooning, Gottlieb, Newman and Rothko.

Pop Art (based on the acceptance of artefacts, mass advertising, etc. as valid art forms in themselves) started in Britain, led by Richard Hamilton soon to be followed by Peter Blake,

Kitaj and Hockney, among others, but found its fullest expression in America, with the work of Jasper Johns, Rauschenberg, Warhol and, perhaps most strikingly, Lichtenstein. Again it is possible to observe here the interplay between the continental and transatlantic movements and the work of British artists, such as Sutherland, Freud, Davie, Hilton, Lanyon, William Scott, Francis Bacon and Auerbach. It can be also be seen in the pictures of Kitchen Sink painters (so-called in their beginnings in the 1950s), such as Bratby, Jack Smith and Middleditch.

TATE GALLERY LIVERPOOL

MAP C

Albert Dock, Liverpool
Tel Liverpool (051) 709 3223

Opened in the early summer of 1988, the Tate Gallery Liverpool is the home of the national collection of modern art in the North of England. Partly devoted to groups of work which will change annually, there is also an area of works from the Tate Gallery on a semi-permanent basis, here for two or three years. Since some 85% of the Tate's collection has, in recent years, been hidden from public gaze in the store-rooms of the gallery, there is plenty of admirable work available for this new space. Attention cannot, however, be directed here to individual pictures, as the display will change, year by year.

TATTON PARK

NT MAP C

Knutsford, Cheshire
2m N of Knutsford on Manchester road (A5034)
Tel Knutsford (0565) 54822

Situated a few miles from Manchester, Tatton Park, with its fine house standing in a deer park,

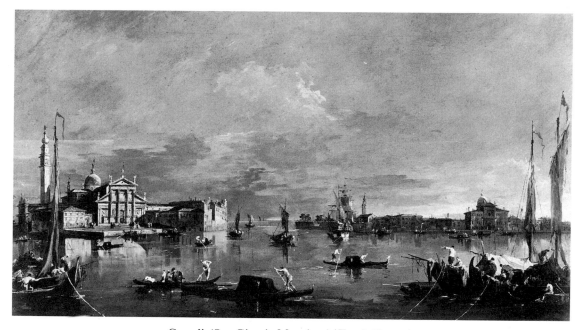

Guardi: 'San Giorgio Maggiore' (*Temple Newsam*)

has been developed in many ways for the enjoyment of the visitors who come here in their thousands. The house, which is very plain outside, but very ornate within, is well-adapted to display its treasures, which include pictures of rare quality.

Portraits of the Egerton family, who lived here, including those acquired through marriage, are naturally an important part of the collection, though not the most striking part. There is however an unusual portrait of a young Englishman in Venice; this is by Nazzari, and portrays Samuel Egerton, wearing a splendid embroidered coat against a conventional Venetian background featuring the Dogana. Venetian, as opposed to Roman, eighteenth-century portraits of Englishmen are comparatively rare. This one exists because Egerton was working in Venice at the time, as an apprentice in an English merchant's business. The merchant was none other than Joseph Smith, later to become the famous Consul Smith, who was to be Canaletto's impresario, and whose own collection was acquired by George III for the Royal Collection. The two splendid views of Venice by Canaletto at Tatton Park came into the collection through this same connection. They are early examples of the type of picture which was to become enormously popular in England, and led to Canaletto's subsequent visits to the country where he had found so many patrons.

Most of the pictures at Tatton Park, however, were acquired in the nineteenth century, and largely reflect a taste for seventeenth-century pictures. Pride of place should go to a van Dyck altar-piece 'The Martyrdom of Saint Stephen', and the visitor will also be struck by work ascribed to Guercino, Salvator Rosa, Murillo, de Heem, van der Neer, Berchem, Wouwerman and Frans Pourbus the Younger. Nicolas Poussin and Chardin are represented too, as are Rosalba, West and Leader.

Family portraits include examples of the work of Eworth, Dahl, Beechey and Herkomer, and there is a splendid Lawrence. Under a skylight at the top of the house is an anonymous series of portraits of Cheshire gentlemen of the eighteenth century — ten rich, powerful and confident squires, who look as though they thoroughly enjoyed their dominance of the county.

TEMPLE NEWSAM

MAP D

Leeds
5m E of city centre, off Garforth road (A63)
Tel Leeds (0532) 647321

Temple Newsam, like Lotherton Hall, is a branch of the Leeds Art Gallery. The many rooms of this large house are only partially furnished and provided with appropriate pictures. It has to be said that the latter are not always easy to identify.

Some of the pictures are family portraits of the Ingram family whose home this house once was. Mercier is especially well represented here, as is Marco Ricci, with some notable seascapes. Among the other pictures are works by Stubbs, Highmore, Knapton, Wright of Derby, Cotes and Reynolds. Also Ibbetson is here, with de Loutherbourg, Guardi, Giordano, Jacob van Ruisdael and many more.

THOMAS CORAM FOUNDATION FOR CHILDREN

MAP K

40 Brunswick Square, London
Tel (01) 278 2424

The Thomas Coram Foundation is a delightful surprise. Tucked away in a Bloomsbury backwater is a small office-block, built in 1937, into which is built the Court Room and the Gallery that once graced the now-demolished mid-eighteenth-century Foundlings Hospital which stood on this site. The Foundlings were abandoned babies, whose plight, in the turmoil of the London of those days, attracted the benevolent attention of a retired shipwright with a modest fortune, Thomas Coram. He made enormous efforts to establish an institution where the abandoned babies could be maintained and brought up. As a result, after many years, the Foundlings Hospital was built.

William Hogarth was a founder member of the Hospital's Court. He gave pictures to the hospital, as did many others — Reynolds, Gainsborough, Ramsay, Hudson, Wilson and Highmore among them. (Hogarth envisaged the collection as helping to publicise the achievement of British artists.) It is these pictures that can be seen and enjoyed in the supremely quiet and elegant surroundings of the Foundation.

They include Hogarth's 'March to Finchley' and 'Moses Brought before Pharaoh's Daughter'. Among a set of small roundels in the Court

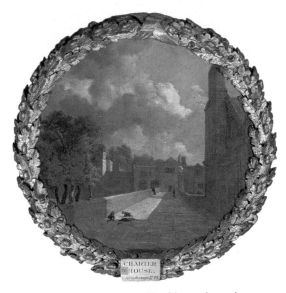

Gainsborough: 'The Charterhouse'
(*The Thomas Coram Foundation*)

Room is one of Gainsborough's most enchanting early works, a view of the Charterhouse.

Dominating all is Hogarth's magnificent portrait of Thomas Coram, painted in 1740, an important landmark in the history of English portrait painting which has been said to look back to van Dyck and forward to Lawrence. The painting is at the same time dashing and precise. The subject is made to look both a shrewd businessman and a kindly philanthropist; one can well appreciate why Hogarth said that he enjoyed painting it more than any other of his portraits. It is as beguiling as its surroundings.

Hogarth: 'Captain Thomas Coram' (*The Thomas Coram Foundation*)

TORRE ABBEY

MAP H

**The Kings Drive, Torquay, Devon
Tel Torquay (0803) 23593**

There is a mixed bag — some would say a very mixed bag — of pictures at Torre Abbey, mainly from the Victorian era. Among them, no visitor will fail to be struck by Holman Hunt's 'The Children's Holiday', one of his most accomplished and polished compositions.

TOWNER ART GALLERY

MAP J

**Borough Lane, Old Town, Eastbourne, E. Sussex
Tel Eastbourne (0323) 21635**

At Eastbourne, the Towner Art Gallery, comfortably housed in a Georgian manor house, has a large permanent picture collection. There are works by Mortimer, a native of the town, and there is a major collection of the work of Ravilious, who lived nearby. Also there are pictures by many other twentieth-century artists, notably Wood ('PZ134' and 'Fair at Neuilly'), Burra ('Soldiers' Backs') and Richards ('Poissons d'Or').

TOWNELEY HALL

MAP C

**Burnley, Lancs
½m SE of Burnley on Todmorden road (A671)
Tel Burnley (0282) 24213**

Towneley Hall, for six hundred years the home of the family of that name, was given to Burnley at the unusually early date of 1902. The rooms house the town's museum, with the pictures, for

Holman Hunt: 'The Children's Holiday'
(*Torre Abbey*)

the most part, assembled in two admirable galleries on the top floor, created from former bedrooms and nurseries.

By far the best known picture here is Zoffany's famous 'Charles Towneley and his Friends in the Park Street Gallery, Westminster'. The picture purports to show Towneley in the library of his London house, surrounded by his collection of marbles (now in the British Museum), with his dog at his feet and with three friends. In fact no room at the house was large enough to contain all the marbles shown; but the pieces are accurately recorded and, no doubt, Towneley and his friends are portrayed with equal precision.

In the customary elegance of the eighteenth century, the picture shows something of the scholarship and knowledge of the English country gentleman as a collector. The Towneleys like many Lancashire families were Roman Catholics. Charles Towneley was educated at Douai, and made lengthy visits to Italy. It was

in Florence that he met Zoffany.

The Zoffany, however, stands rather alone at Towneley Hall, as the great bulk of the pictures are from the nineteenth century; among them are works by Cox, Alma-Tadema, Long, de Wint and Etty.

TRERICE

NT MAP H

Newquay, Cornwall
3m SE of Newquay on St Austell road (A3058)
Tel Newquay (063 73) 5404

The ancestral home of a famous Cornish family, the Arundells, Trerice is a beguiling Elizabethan stone mansion of modest size, tucked away in a secluded valley. Its picture collection includes several Stuart portraits, notably a sensitive likeness of Charles I by Henry Stone. There are also pictures by Steen, van Os, Snyders (with a large and typical still-life of fruit, vegetables and animals), Shayer and John Herring.

TUNBRIDGE WELLS MUSEUM AND ART GALLERY

MAP J

Mount Pleasant, Tunbridge Wells, Kent
Tel Tunbridge Wells (0892) 26121

The Tunbridge Wells Art Gallery has a Victorian collection, including works by Leslie, Creswick, Solomon, Hardy and others.

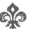

UPPARK

NT MAP J

W. Sussex, near Petersfield,
5m SE of Petersfield on B2146
Tel Harting (073 085) 317 or 458

Sir Matthew Fetherstonhaugh was a methodical man. He tended to buy, in the 1750s, pictures in pairs and in sets to hang in his newly-decorated house of Uppark. This stands in a superb position on the South Downs, probably built by Talman in the 1690s. He bought a set of six large pictures by Giordano which illustrate the story of the prodigal son. Likewise he acquired a set of four splendid seascapes by Vernet — 'The Four Times of Day'. There is a pair of Italian landscapes by Zuccarelli. There is a set of eight Arthur Devis family portraits, small pictures with the sitters self-consciously placed in sparsely furnished rooms or in gardens.

Sir Matthew was one of Batoni's earliest and surely his favourite patron. In Rome in 1751-52 he himself sat to Batoni twice, as did his beautiful wife. He was joined in Rome by his brother and his sister-in-law, by his wife's brother and by her step-brother, and all four of them also sat for Batoni. Not content with this, Sir Matthew also bought two delightful Batoni pictures, entitled 'Meekness' and 'Purity of Heart'. Twenty-five years later his son, Sir Harry, also sat for the same artist when he in turn visited Rome — but this time there was only one picture.

All of these, and other admirable pictures hang very happily in the handsome interior of Uppark, which looks much as it must have done in the 1770s. For a house of this size — by no means large — the collection, predominantly Italian in origin, is unsurpassed in quality.

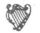

Zoffany: 'Charles Towneley in His Gallery' (*Towneley Hall*)

THE UNIVERSITY OF HULL ART COLLECTION

MAP D

**The Middleton Hall, University of Hull
Cottingham Road, Hull
Tel Hull (0482) 465192**

The University of Hull's Art Collection, established in 1963 and high in quality, concentrates on British art from 1890 to 1940. There are paintings by Conder, Steer ('Star and Garter Hotel'), Augustus John, Sickert, Gore, Gilman, Ginner, Drummond, Lucien Pissarro (who emigrated to Britain), Bell, Duncan Grant, Paul Nash, Ben Nicholson and Stanley Spencer, among many others.

UNIVERSITY OF LIVERPOOL ART GALLERY

MAP C

**3 Abercromby Square, Liverpool
Tel Liverpool (051) 709 6022**

The University of Liverpool's Art Gallery is housed in an early-nineteenth-century merchant's house. It contains a wide-ranging collection which includes Turner's 'Eruption of the Souffrier' and an early Augustus John masterpiece, 'Professor John Macdonald Mackay'.

UPTON HOUSE

NT MAP E

**Warwicks, near Banbury
7m NW of Banbury on Stratford-upon-Avon road
(A422)
Tel Edge Hill (029 587) 266**

Upton House shares with Waddesdon Manor a most unusual feature in a country house: there are no family portraits. The house was bought, and then reconstructed, by the 2nd Lord Bearsted, to house the collection which he subsequently gave to the National Trust in 1948.

The pictures cover an exceptionally wide range, from early Netherlandish, to Dutch and Flemish Italian and French, as well as English pictures. It has been pointed out that nearly all this large, varied and admirable assembly is concerned with human beings, with their relationships with each other and with the world around them over the centuries. There is much to be seen at Upton. The pictures are skilfully and sympathetically displayed, but time is required to make the best use of a visit to this delightful collection.

From the Flemish and early Netherlandish section of the collection, the visitor is unlikely to miss a striking triptych by Bosch, 'The Adoration of the Magi', a picture filled equally with interest, charm, puzzles, fascinating detail and skill in painting. Other especially notable pictures in this group include Pieter Bruegel the Elder's grisaille (that is, monochrome painting) 'The Dormition of the Virgin'; Gerard David's 'Madonna and Child'; 'St Jerome in a Landscape' and 'St John the Baptist' by the Master of the St Lucy Legend; 'An Unknown Man' by Memlinc; 'The Virgin and St Joseph at Bethlehem' by Jan Provost, 'An Unknown Man' by van der Weyden. Pictures of this antiquity and of this quality are all too rarely seen in country houses.

With the Dutch seventeenth-century pictures, of course, the visitor is in much more familiar territory, and will be struck with the standard of the Upton pictures. Especially striking are van de Cappelle's luminous 'River Estuary', van Goyen's 'River Scene', Metsu's famous 'The Duet', Meurant's 'A Landscape with Cottages', Jacob van Ruisdael's 'Le Coup de Soleil', Salomon van Ruysdael's 'Country Road', a number of Steen's pictures, including his 'Five Senses', Wouwerman's 'Landscape with Dunes and Figures', and Saenredam's supremely sensitive 'Interior of the Church of St Catherine, Utrecht'.

Normally unfamiliar in country houses, also, are such pictures as Holbein's 'Young Man in

Pink', Giovanni di Paolo's 'Presentation of the Virgin', and works by Domenico Tiepolo and Tintoretto. There is a modest-sized but magnificent El Greco panel 'El Espolio'. There is a number of French pictures, with work by Boucher, Greuze and others. More familiar territory, again, is reached with the works of Guardi and of Canaletto, both of whom are well represented at Upton.

British pictures include examples of portraiture. Beechey, Hayman, Highmore, Hogarth, Hoppner, Lawrence, Opie, Raeburn (with 'The Macdonald Children'), Romney and Reynolds are all represented. There are several portraits and groups by Arthur Devis and a delightful picture of 'Skating at Upton' by his brother Anthony.

Stubbs has three magnificent pictures here: 'The Haymakers', 'The Reapers' and 'The Labourers'. This trio, all the same size, are splendid compositions, robust and truthful, 'The Labourers' including what must be the oldest, tiredest and most miserable horse Stubbs ever painted. In these pictures Stubbs is showing an interest and concern for the ordinary countryman; this was unique at the time, and in a sense mirrors Hogarth's interest in townsfolk, as can be seen in his 'Morning' and 'Night' at Upton.

Constable and Gainsborough are both represented by small and ravishing landscape sketches. There are works to be seen also by George Morland, Smirke, Zoffany, Wootton and Richard Wilson; and there is a sparkling group of sporting pictures, including notable examples of the work of Ferneley, John Herring the Elder, Laporte, Marshall and Sartorius.

USHER GALLERY

MAP D

Lindum Road, Lincoln
Tel (0522) 27980

This twentieth-century gallery, designed by Sir Reginald Blomfield, has a collection of pictures of local interest, dominated by the work of Peter de Wint.

VALENCE HOUSE MUSEUM

MAP J

Becontree Avenue, Dagenham, Essex
Tel (01) 592 2211

Valence House is a seventeenth-century manor house, now a local history museum. Amongst the exhibits there is a remarkable series of portraits of the Fanshawe family, once local landowners. Gheeraerts, Dobson, Lely, Kneller and Richardson are amongst the artists represented.

THE VICTORIA AND ALBERT MUSEUM

MAP K

Cromwell Gardens, South Kensington, London
Tel (01) 589 6371

Affectionately known as 'the V and A', this gigantic museum has been described as a 'sublime attic'. This phrase does perhaps go some of the way to describe the size and the scope of the collections, which embrace no less than a comprehensive display of Western and Oriental decorative and applied arts from the earliest times through to the present day. The phrase also does something to suggest the amazingly higgledy-piggledy manner in which successive additions of galleries have been assembled over the years, in a seemingly haphazard fashion, on five different levels, with any number of strange corners, unexpected staircases and delightful surprises.

This is the largest decorative art museum in the world, and an almost endless source of fascination and delight. Although it was first thought of, by the Prince Consort, as a 'Museum of Manufactures', it has acquired a large number

Le Nain: 'Landscape with Figures' (*Victoria and Albert Museum*)

of pictures, sometimes, it seems, in an absent-minded way. Some of these are to be found in the Primary Galleries, where masterpieces of all the arts and crafts are gathered in groups, with the best of each period, style and nation on show together in evocative displays.

Thus, one of the rooms in the sequence entitled 'Continental Art 1570–1800' has Dutch seventeenth-century furniture, with its walls hung with work by such artists as Neefs, Teniers, Molenaer and Bruegel. Another nearby room has, on loan, a small group of the pocket-size copies made by Teniers of some of the masterpieces in the collection of the Archduke Leopold Wilhelm, whose picture curator he was; these intriguing curiosities were originally created as the basis of a series of engravings, to be published in book form.

Another of the many rooms has exquisite French furniture of the eighteenth century, enhanced by paintings by Pater, by Lancret and by Boucher — in Boucher's case by a portrait of his most enthusiastic patron, Madame de Pompadour.

Similarly, the English Art 1750–1900 galleries carry work by Gainsborough, Reynolds, West, Kauffmann, Lawrence, Raeburn, and Batoni. Paintings by Wheatley, de Loutherbourg, Northcote, Beechey and Opie embellish the Regency rooms, Opie's contribution being an entertaining picture of a boy in an outsize top hat, an early record of this type of headgear. On Level 4 and on the Grand Staircase there is further work from the nineteenth century from Wilkie, Stanfield, Dyce and Etty.

It is intriguing to notice how well such works

as Landseer's 'Newfoundland Dog' seem to fit into the crowded galleries of Victorian furniture. These make a fascinating contrast with those rooms decorated by William Morris and his friends and collaborators Burne-Jones and Poynter.

All these paintings in the Primary Collection are, however, only a small part of the artistic work here. The Raphael Cartoons (in the original meaning of full-size drawing for a painting or a tapestry), on loan from the Royal Collection, have their own gallery, properly so in view of the unique status of these astonishing works. They were originally painted around 1515, having been commissioned by Pope Leo X for use in the Sistine Chapel — today the resulting tapestries are in the Vatican Gallery. The tapestries were made in Brussels, working from Raphael's cartoons, which then remained in Brussels for more than a century until Charles I bought them, for the newly-established Mortlake tapestry workshops. Seven out of ten of the original cartoons survive. They are among the most distinguished examples in the world of High Renaissance art, forcefully imaginative while harmonious in temper, fresh in colour, clear in purpose and majestic in conception.

In the separate Henry Cole Wing there is the Ionides Bequest, a wide-ranging group embracing Tintoretto, with a self-portrait, Delacroix, with the 'Good Samaritan', Ingres, Degas, Fantin-Latour, Corot, Courbet, the Pre-Raphaelites and Watts, whose group of portraits of members of the Ionides family are among the freshest and most attractive likenesses he painted.

Constable: 'Salisbury Cathedral' (*Victoria and Albert Museum*)

238

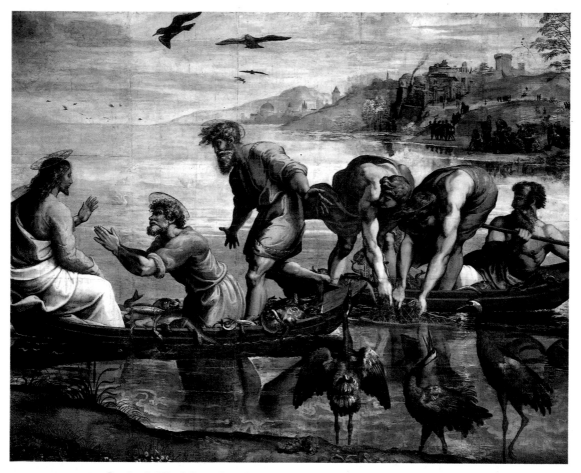

Raphael: 'The Miraculous Draught of Fishes' (*Victoria and Albert Museum*)

European painting here includes a Barbizon School collection (a group of French landscape painters whose aim was exact and unprettified renderings of peasant life and scenery), and works from many artists and many countries. Work from Both, van Goyen, Teniers, and many others is to be seen, together with pictures by Greuze, by de Chavannes and by Delaroche. A footnote, so to speak, to this collection is provided by Gainsborough's experimental landscape transparencies painted on glass.

Finally, the top floor of the Henry Cole Wing is devoted to Constable. There are countless treasures in the V and A, but nothing surpasses this exhibition. There are scores of works here. It is the most comprehensive collection of Constable's work in existence.

Arranged chronologically, and beautifully displayed, each group of pictures is annotated with most helpful notes. Constable's methods, thoughts and development can be studied at peaceful leisure in ideal surroundings. It is, for example, intriguing to notice that the difference between the sketches and the finished work of his early days gradually evaporates as he, like every artist, learnt to improve his technical mastery.

Landscape dominates these rooms, as it dominated Constable's life. His influence on French nineteenth-century painters is plain to see — the work he did at Brighton manifestly looks forward to Boudin, to an almost startling degree. Some of his finest pictures are here, as well as innumerable sketches and studies: 'Boat Building at Flatford', 'Salisbury Cathedral from the Bishop's Grounds', 'The Cottage in a Cornfield' and 'Brighton Beach with Colliers'.

VICTORIA ART GALLERY

MAP I

Bridge Street, Bath, Avon
Tel Bath (0225) 61111

There are some old masters here, notably 'Adoration of the Magi' attributed to van der Goes, but the main collection is of paintings by local artists from the eighteenth to the twentieth century, including a number of Sickert, a frequent visitor to Bath.

THE VYNE

NT MAP J

Basingstoke, Hants
4m N of Basingstoke, between Sherborne St John
and Bramley
Tel Basingstoke (0256) 881337

A house of compelling charm and grace, The Vyne was built in the early sixteenth century, and was acquired by the Chute family in the 1650s. It was modified then, and again two hundred years later. The mid-seventeenth-century alterations included the addition of the earliest-known classical portico to an English country house.

There are Chute family portraits by Mathias, Carriera and Muntz, who also contributed a number of topographical pictures and land-scapes, including some overdoors. Other pictures are to be seen, by Oudry, Pether, Locatelli and Ferretti, with a 'Last Supper' in the private chapel.

WADDESDON MANOR

NT; GT(in part) MAP F

Aylesbury, Bucks
6m NW of Aylesbury on Bicester road (A41)
Tel Aylesbury (0296) 651211

There need be no hesitation in describing Waddesdon Manor as unique. No other house in England is remotely like it. In the first place, it is extraordinary to find a mock-French-Renaissance chateau (completed in 1884) sitting on a Buckinghamshire hill-top, surrounded by gardens, terraces and magnificent trees. It is

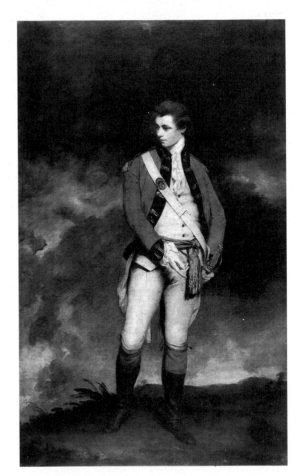

Reynolds: 'Captain St Leger' (*Waddesdon Manor*)

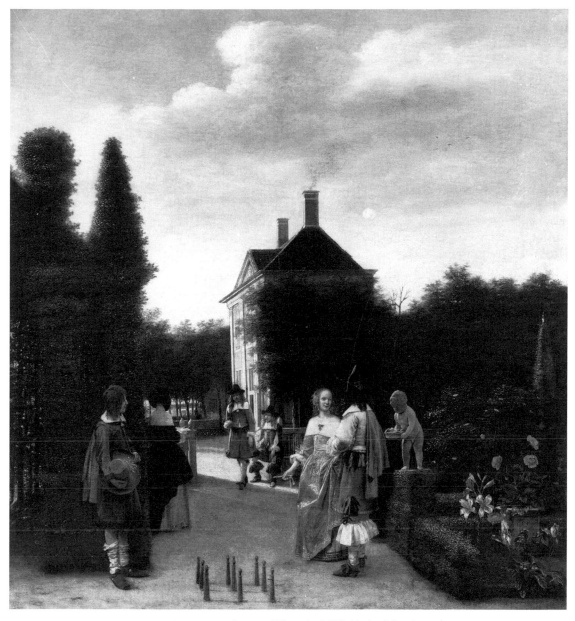

de Hooch: 'A Game of Ninepins' (*Waddesdon Manor*)

even more extraordinary to find within the doors of this oddity something very like the Wallace Collection on a smaller scale. Although Rothschilds lived here for eighty years, it seems more like a supremely comfortable museum than a home. The rooms are thronged with priceless treasures — porcelain, sculpture, armour, furniture, carpets and much more. All is of the highest quality.

This certainly applies to the pictures, which fall into four main groups: late medieval and Renaissance paintings; Dutch and Flemish pictures of the seventeenth century; French eighteenth-century paintings; and English eighteenth-century portraits.

Among the seventeenth-century work, all of it admirable, there are four Cuyp landscapes, including a notable 'View on the Maas' and 'A

241

Landscape with Figures, Cattle and Dogs', an unusually complex picture from this artist, with more activity and movement than is customary, but handled with Cuyp's unerring mastery. Rubens's 'Garden of Love' is unusual also: it is modest in size, spirited and entertaining, even Rabelaisian, and filled with life and enjoyment — all the male figures are thought to be self-portraits, all the females Rubens's wife. One of the most appealing of the Dutch pictures, perhaps the finest of a very fine collection, is de Hooch's 'A Game of Ninepins': this has a completeness, poise and tranquillity that is wonderfully satisfying.

French eighteenth-century pictures are not often to be seen in English country houses; those at Waddesdon are most unusual, including work by Oudry, Pater, Lancret, Guérin, Greuze, Boucher, Fragonard and Vigée-Lebrun. Perhaps the most appealing is Watteau's small, spirited and touching 'Harlequin, Pierrot and Scapin', in which the artist somehow contrives to introduce something of the underlying sadness of the clowns' lives.

There are ten Reynolds portraits at Waddesdon. The artist himself was very proud of his 'Mrs Sheridan as St Cecilia', which he regarded as his finest picture. Others might question this judgement, but it is certainly one of those rarities — a formal portrait that yet appears relaxed. There is interest, too, in 'The Duchess of Cumberland' — the lady's elopement with the royal Duke gave rise to the Royal Marriage Act of 1772, still in force, by which members of the royal family may not marry without the monarch's permission. Reynolds succeeds in capturing the Duchess's bewitching character. Both Reynolds and Gainsborough painted the actress Mrs Robinson, a mistress of the Prince of Wales: their portraits can be compared here. There are half-a-dozen more Gainsboroughs, including one of the same Prince of Wales (later to become George IV), a mature and splendid 'Lady Sheffield', and a tender and affectionate portrait of 'Master Nicholls', a famous picture which has the nickname of 'The Pink Boy'. In addition, there are works by Romney, Highmore, Hudson and Wheatley.

Outside these main four groups, no description of Waddesdon would be complete without the mention of Guardi. The very first pictures the visitor encounters are two huge views of Venice, the largest pictures he ever painted, which can be compared here with a number of small portraits and Venetian sketches.

WAKEFIELD ART GALLERY

MAP D

Wentworth Terrace, Wakefield, W. Yorks
Tel Wakefield (0924) 370211

Wakefield's modest-sized Art Gallery, housed in a former vicarage, has a fine collection, admirably displayed. From the past, there are works by Romney, Mercier and others, notably Tissot, with his delightful 'On the Thames' in which the customary ease of the Victorian leisured class is contrasted with the bustling work of the Port of London. From the twentieth century, there are splendid works by Duncan Grant, Fry, William Roberts, Ginner, Ben Nicholson and Matthew Smith. The quality of these pictures complements the work of the sculptors Henry Moore and Barbara Hepworth, both of whom were born nearby.

WALKER ART GALLERY

MAP C

William Brown Street, Liverpool
Tel Liverpool (051) 207–0001

The Walker Art Gallery's large and very impressive collection is housed in a handsome neo-classical building in the heart of Liverpool's city centre. The collection covers the centuries, and includes many masterpieces. There are plans to re-arrange the pictures over the next few years.

There is an especially large, and excellent,

assembly of early Italian (owing much to the local collector, Roscoe) and northern European painting. Outstanding among the many admirable works, perhaps, is the jewel-like 'Christ Discovered in the Temple' of Martini, from 1342. Sometimes known as 'Christ Returning to his Parents after Disputing with the Doctors', this panel, possibly one half of a diptych, is an unusual subject, in which Christ is made to look as truculent as any other frustrated boy.

De' Roberti's 'Pietà', on the other hand, is a familiar subject. Here it is treated with a wealth of nervous sensibility and deep pathos: the precise painting of the two principal figures contrasts with the dream-like quality of the triple crucifixion in the background. Elsheimer's 'Apollo and Coronis' is small and exquisite, not unlike a miniature in its appeal. Other early masters to be seen here include Joos van Cleve, Cranach, Mostaert, Granacci, Montagna, Bassano, Bordone, Veronese and Bellini; and there is a panel ascribed to Michelangelo.

European painting from the two centuries from 1600 is powerfully represented. There is a fine Rubens 'Virgin and Child with St Elizabeth and the Infant Baptist'. Bor, Salomon van Ruysdael, and van Goyen are among those with handsome contributions, as are Murillo, Mengs, Salvator Rosa and Nicolas Poussin, with one of the most beautiful of all his works, 'The Ashes of Phocion Collected by His Widow'.

The miniaturist Hilliard is thought to have painted the life-scale painting here of Queen Elizabeth. Known as the 'Pelican' portrait, this is an example of the then customary preoccupation with clothing and jewellery, which are painted with extraordinary precision, in sharp contrast to the formal and mask-like rendering of the features. The Queen's father, Henry VIII, is shown here in a good contemporary copy of Holbein's famous lost original, with the king in the familiar robust and aggressive pose.

It is not easy to think of a British artist of note from the seventeenth and eighteenth centuries

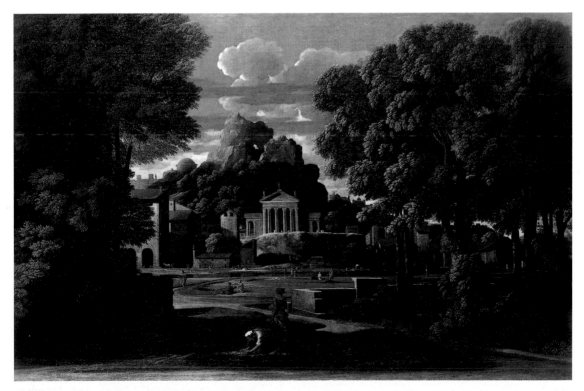

Poussin: 'The Ashes of Phocion Collected by His Widow' (*Walker Art Gallery*)

who is not to be found at the Walker. The visitor will be struck by the large and assertive Charles II by Kneller: the picture is a signed and dated version. John Riley is represented by a full-length 'Bishop of Rochester'; Richardson by a portrait of his son; Hogarth by his dramatic, even melodramatic 'David Garrick as Richard III'. Zoffany has an elaborate group here — the very large 'Family of Sir William Young'. Arthur Devis's contribution is 'Mr and Mrs Atherton'. Mr Atherton was mayor of Devis's home town of Preston, which may be the reason for the room in which the couple are depicted being much more completely furnished than is usual with this artist, who also includes a pet dog. There are several pictures by Wright of Derby, the most striking being his hugely enjoyable portrayal of fireworks in 'Easter Monday at Rome'. Stubbs is well represented, especially by 'Molly Longlegs and Her Jockey' and a charming picture of a monkey. Richard Wilson's 'View of Snowdon from Llyn Nantle' is a serenely classical masterpiece.

There is a large nineteenth-century assembly, mainly devoted to Victorian narrative pictures. Here Maclise's 'Death of Nelson' can be directly compared with West's equally large and elaborate treatment of the same subject. Possibly the best known of all English narrative pictures — Yeames's 'When did you last see your Father?' — is here, as is Crofts's 'Evening of Waterloo'. G. F. Watts is strongly represented, with a dozen pictures to be seen. Landseer's most striking picture here is a dashing portrait sketch of Sir Walter Scott; there is a landscape by J. M. W. Turner, which borders on abstract art; a lovely Constable 'Sea Shore'; and an admirable Cox 'Flying the Kite'. The Pre-Raphaelites, and those influenced by them, are here: John Millais, Ford Madox Brown and Burne-Jones, for example. Brett's 'The Stonebreaker' is here, in which ultra-meticulous detail illuminates a simple subject and a majestic landscape background; it delighted Ruskin. Moore's 'Summer Night' represents admirably the 'Aesthetic' movement.

French and British art of 1850–1930 is here grouped together. Degas's 'Woman Ironing', a delicate study of the effects of light, is one of the

Martini: 'Christ Discovered in the Temple'
(*Walker Art Gallery*)

outstanding pictures in this group. Cézanne's contribution is an unusual one — 'The Murder'. Monet, Seurat, Matisse and others are contrasted with such British artists as Gore, Steer, Bevan and Sickert, with one of his fascinating music-hall studies: 'The Old Bedford'.

British twentieth-century art rounds off this comprehensive collection. Work by Augustus John, Spencer, Wood, Smith and many others is to be seen. Munnings is well represented by a 1912 picture — 'St Buryan Races'; Paul Nash's powerful 'Landscape of the Moon's Last Phase' is here; so too is Gilman's 'Mrs Mounter'. Not a few of the modern pictures, such as Hockney's 'Peter Getting out of Nick's Pool', were prize-winners at the biennial John Moores' Liverpool Exhibitions held in this gallery. When one of these shows is being held, visitors may not be able to see many, perhaps not any, of the gallery's permanent collection of twentieth-century art.

de' Roberti: 'Pietà' (*Walker Art Gallery*)

THE WALLACE COLLECTION

MAP K

Hertford House, Manchester Square, London
Tel (01) 935 0687

The Wallace Collection is one of the most remarkable collections of fine and decorative art in the world. It is especially rich in seventeenth-century masters, in French eighteenth-century painting, furniture and porcelain, and in European arms and armour. It was largely assembled by the 4th Marquess of Hertford. He was a passionate collector who lived most of his life in Paris as a recluse and died unmarried, leaving the collection and his fortune to his bastard son Sir Richard Wallace. It was the latter who brought it all to England, and adapted Hertford House to accommodate it. It was Wallace's widow who bequeathed the collection to the nation in 1897, one of the stringent conditions being that nothing should be added to it — nor, of course, removed from it.

Hertford House somehow contrives to retain the atmosphere of a great town house rather than that of a museum. It is supremely comfortable and peaceful; all can be seen with conspicuous ease and the labelling is both tactful and informative. In short, it is nothing but an enthralling delight.

The Wallace Collection is best known for its assembly of French pictures, furniture and *objets d'art* of the eighteenth century, probably the best outside France in these fields. There are some two dozen canvases by Boucher, some of them large tapestry designs and displaying all the romantic eroticism for which the artist is best known; others are smaller, but no less accomplished, such as 'The Modiste' and the small-scale, startlingly candid, but supremely graceful and delicate portrait of Mme de Pompadour. Watteau is also very well represented, notably with 'The Music Party', 'Halt during the Chase', 'Gilles and His Family' and 'La Toilette' — all magnificent examples of the sensibility and delicate skill he displayed in his short life. Less well-known French artists of the eighteenth century are to be found here in profusion, such as Fragonard (particularly with 'The Swing'), Pater, Claude Vernet ('Storm with a Shipwreck'), Oudry, Nattier, Prud'hon and Mme Vigée-Lebrun, with two characteristically lively portraits. Greuze is represented on a lavish scale: his 'Mlle Sophie Arnoud' is perhaps the most striking of his pictures here, while his 'Innocence' enjoyed enormous popularity in the last century. Lancret, also, is well represented, with 'Mlle Camargo Dancing' the outstanding work.

There are seventeenth-century pictures from France, with de Champaigne particularly well represented; his 'Annunciation' and his 'Adoration of the Shepherds' are among his most ambitious religious pictures. The single Nicolas Poussin picture is of especial interest to lovers of the work of Anthony Powell, for it is none other than 'A Dance to the Music of Time', which provided the title for his great novel-sequence, and is described in the second paragraph of the first book in the sequence, *A Question of Upbringing*.

Nor is this the end of the French aspects of the Wallace Collection, for there are many early

nineteenth-century pictures here, several of them the work of artists rarely, if at all, seen elsewhere in England. Delacroix's 'Execution of the Doge Marino Faliero' is perhaps the dominant work in this group, filled with drama and energy. Amongst others, the work of Corot ('Macbeth and the Witches'), Couture, Decamps, Delaroche, Desportes, Diaz de la Pena, Géricault (especially with 'A Cavalry Skirmish'), Marilhat, and Meissonier is to be seen, with much by Horace Vernet, grandson of the better-known Claude-Joseph Vernet.

Away from France, there is work from Italy, with work by Cima ('St Catherine of Alexandria'), Carlo Dolci, Domenichino, Foppa (especially with his wonderfully relaxed and engaging 'The Young Cicero Reading'), Luini, Salvator Rosa, Andrea del Sarto and Sassoferrato, whose 'Mystic Marriage of St Catherine' is possibly the finest picture by this artist in England; and there is Titian's 'Perseus and Andromeda', a picture which was painted for Philip II of Spain but which found its way into van Dyck's collection. Murillo is extensively represented, as is Velazquez, notably with 'Don

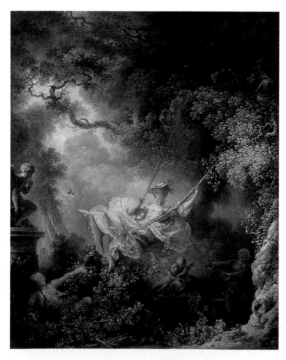

Fragonard: 'The Swing' (*Wallace Collection*)

Baltasar Carlos in Infancy' and the masterly 'Lady with a Fan'. There is a large group of Venetian scenes by Canaletto and by Guardi, affording an opportunity to compare these two artists extensively.

English artists included in the Wallace Collection are few in number, although the pictures are high in quality. There are portraits by Hoppner, Gainsborough and Romney. Some of Reynolds's best-known work is here, such as his touching and sensitive portrait of 'Nelly O'Brien', 'The Strawberry Girl', which the artist regarded as one of his most original works, and 'Miss Jane Bowles', a girl with a puppy that goes some way to anticipating Landseer; there are portraits of the Seymour family and of others. Lawrence is represented by portraits also, with one of Lady Blessington and with an informal likeness of George IV at ease on a settee with a top hat and gloves beside him — Lawrence thought this his best likeness of this talented but wayward man. Wilkie, Landseer and Stanfield are to be found here, as is the best collection in the country of the work of Bonington.

Seventeenth-century work from the Low Countries includes paintings from a very large number of artists, and includes work of the highest class. Rubens is represented by his 'Rainbow Landscape', by 'Christ on the Cross', by 'Christ's Charge to Peter' and by a number of sketches for altar-pieces and other preparatory works. Rembrandt, likewise, has a pair of careful early portraits, of 'Jan Pellicorne with His Son Caspar' and 'Susanna Pellicorne with Her Daughter'; his self-portrait here is also of a comparatively early date, with the artist looking self-confident and assertive; there is a characteristically tender and affectionate portrait of his son Titus. There is also a 'Landscape with a Coach', a powerful evocation of threatening autumn weather, and his 'Good Samaritan'.

Other notable contributors to this part of the Wallace Collection include Berchem, Bol ('The Toper'), Terborch, Cuyp (with several works, notably his delightful 'The Avenue at Meerdervoort, Dordrecht'), Dou, van Dyck, and Hals, with the collection's most famous single work. 'The Laughing Cavalier': a baroque portrait of great splendour, whose name is somewhat mis-

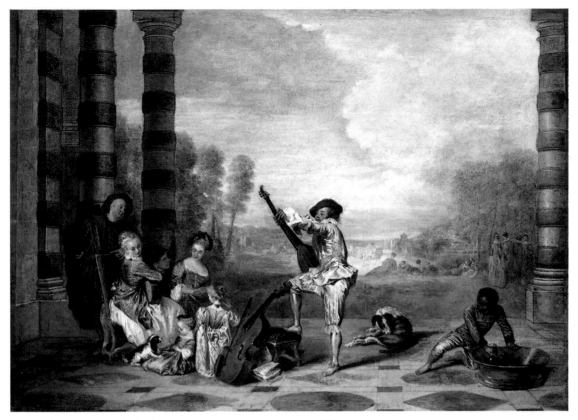

Watteau: 'The Music Party' (*Wallace Collection*)

leading as the subject is certainly not laughing, although he does look pleased with himself. There are four works by Hobbema, pictures by van der Heyden, de Hooch (especially with an enchanting domestic scene 'Boy Bringing Pomegranates'), Maes, Metsu, van der Neer ('River Scene by Moonlight' and 'A Skating Scene'), Netscher (especially 'The Lace-Maker'), Potter ('The Milkmaid'), Pynacker, van Ruisdael, Steen ('Harpsichord Lesson', in which the picture of Venus and Cupid on the wall gently underlines the tactfully erotic mood), Wynants, Jan Weenix, J. B. Weenix, Willem van de Velde the Younger (notably 'Dutch Man-of-War Saluting') and Teniers whose many contributions include four of the small copies which he made of the Archduke Leopold Wilhelm's collection.

WALLINGTON HOUSE

NT MAP B

Cambo, Northumberland
20m NW of Newcastle-upon-Tyne on B6342
Tel Scots Gap (067 074) 283

There are Blackett and Trevelyan family portraits at Wallington, including work by Johnson, Hudson, Arthur Devis, Gainsborough and Reynolds. One of Reynolds's paintings here is an exceptionally fine full-length of Sir Walter Calverly Blackett, painted in 1762, and at once relaxed and majestic.

The main interest at Wallington, however, centres on the central hall, built in the 1850s and decorated by William Bell Scott with eight fresco panels illustrating episodes (true or legendary) in Northumbrian history. Scott's interest and

247

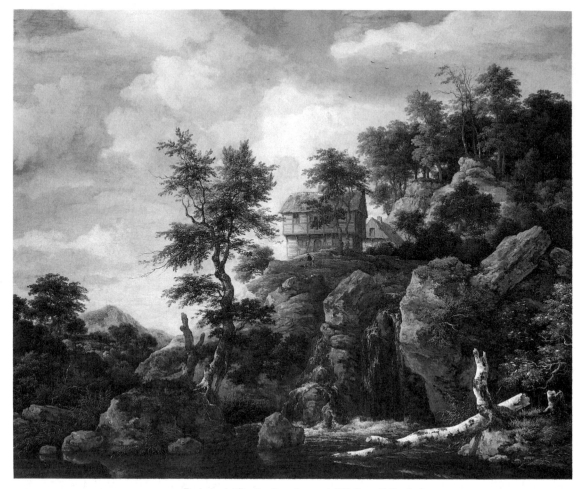

van Ruisdael: 'Rocky Landscape' (*Wallace Collection*)

belief in the Pre-Raphaelite tenets can be studied here in great detail.

WALSALL MUSEUM AND ART GALLERY

MAP E

**Lichfield Street, Walsall, W. Midlands
Tel Walsall (0922) 650000**

Walsall Art Gallery, up to 1973, had a characteristic small municipal collection of nineteenth-century British paintings by such artists as Crome, Cox, Frith and Maclise, with a few Dutch pictures. The situation was transformed by the bequest of the Garman-Ryan collection, formed by Sir Jacob Epstein's widow, with the sculptor Sally Ryan. As well as many of Epstein's portrait bronzes, with drawings and paintings by the sculptor, the collection includes works by his friends, such as Matthew Smith and especially Lucian Freud (who married Epstein's daughter). There are also paintings he had bought in his lifetime: a Degas portrait, landscapes by Monet, Renoir and Bonnard amongst many others. The whole makes a coherent and fascinating display.

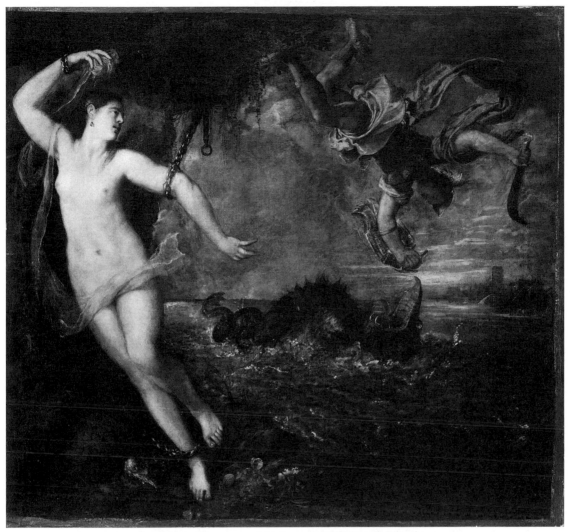

Titian: 'Perseus and Andromeda' (*Wallace Collection*)

WARRINGTON MUSEUM AND ART GALLERY

MAP C

Bold Street, Warrington, Cheshire
Tel (0925) 30550

Warrington Art Gallery has a miscellaneous collection, mainly of British art from the nineteenth century. Local artists such as Fildes are represented, and there are works by Brangwyn, among many others.

WARWICK CASTLE

MAP E

Warwick
Tel Warwick (0926) 495421

Now under the aegis of Madame Tussaud's, Warwick Castle looks very much as a castle is expected to look — powerful, dominating and sinister. Poor lighting and other problems do not help the visitor to see the pictures clearly; this is unfortunate as there are (despite a considerable dispersal, including the famous Canalettos, be-

249

fore the Tussaud take-over) fine pictures here, with an admirable group of seventeenth-century portraits by, or attributed to, Kneller, Lely, Dobson and van Dyck. One of the van Dycks, a half-length of Queen Henrietta Maria, was later transformed into a full-length, possibly by Reynolds himself. There is a dramatic picture of a shipwreck by the younger Willem van de Velde, very different from the calm shipping scenes for which he is best known.

WARWICK DISTRICT COUNCIL ART GALLERY AND MUSEUM

MAP E

Avenue Road, Leamington Spa, Warwicks
Tel Leamington Spa (0926) 26559

At Leamington Spa there are, among pictures of local interest, some Dutch and Flemish pictures, such as the fine 'Self-portrait by Candlelight' by Schalken. There are also some striking twentieth-century paintings, mainly English, by such artists as Bevan, Bell, Stanley Spencer, Duncan Grant, Piper and Lowry.

WATFORD MUSEUM

MAP F

194 High Street, Watford, Herts
Tel Watford (0923) 32297

At Watford Museum, the emphasis is on the work of Sir Hubert von Herkomer, who lived, and ran a famous art school, at nearby Bushey.

THE WATTS GALLERY

MAP J

Down Lane, Compton, Guildford, Surrey
3ms W of Guildford, just off Portsmouth Road
(A 3)
Tel Guildford (0483) 810235

The Watts Gallery was built in 1903-4, shortly before the death of G. F. Watts, whose career coincided almost exactly with the reign of Queen Victoria. Several large rooms contain a representation of Watts's work from all periods of his life, ranging from a portrait of his father, painted when he was sixteen, to work left unfinished at his death. The quality varies from some rather pedestrian allegorical and symbolic paintings to remarkable portraits, such as the ravishing pic-

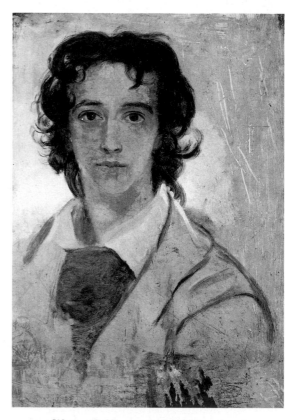

Watts: 'Self-portrait Aged Seventeen'
(*The Watts Gallery*)

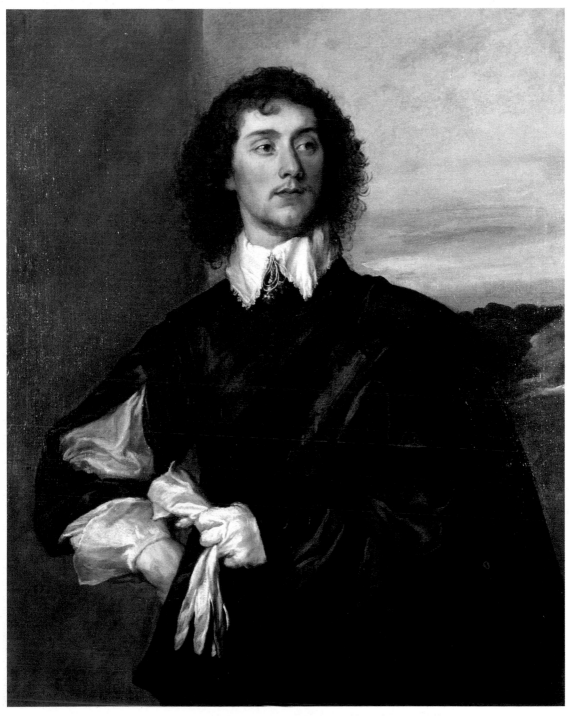

van Dyck: 'Sir Thomas Hanmer' (*Weston Park*)

ture of Watts's early patron, Lady Holland, painted in 1844. Watts's vision, and his stature, is under re-assessment — if many of his works still seem turgid, the virtues of his more successful paintings (apart from the portraits which have always been respected) are becoming increasingly recognised — even in sale-room prices.

WESTON PARK

HHA MAP E

Telford, Shropshire
6m E of Telford on Cannock road (A5)
Tel Weston-under-Lizard (096 276) 207 or 385

The Earl of Bradford's Weston Park is an enormously attractive seventeenth-century house, in equally attractive surroundings, where there is much to entertain the visitors who come here in large numbers.

There are some sporting pictures which reflect the family interest in horseflesh over the centuries. There are pictures by John Ferneley and by many others, dominated by a magnificent example of Stubbs's work.

The family portraits include a number of the highest quality. Van Dyck's portrait of Sir Thomas Hanmer is as much admired today as it was by John Evelyn who noted (on 14 January 1685) that it was 'one of the best he ever painted'. Restrained in colour, it is nevertheless intensely powerful with a magical sense of arrested movement. There is a roomful of women's portraits, many of them by Lely, and these include his splendid portrait of the builder of Weston, Lady Wilbraham. In addition there is work by J. M. Wright, Riley, Cotes, Wissing, Dahl, Kettle, Reynolds, Hoppner, Romney, Constable (somewhat unusually), Hayter and Sir Francis Grant.

There is a further group of royal and other portraits. Some of these, most of them of modest size, are gathered in an unusually interesting group. This includes Holbein's 'Sir George Carew', and work by Clouet, Mor, Honthorst, Johnson, Riley and Hoppner again, Kneller and Gainsborough.

Lastly there is a wide-ranging picture collection to be seen at Weston. This includes a pair of splendid seascapes by Vernet, and pictures by Bruegel, Brouwer, Teniers, Reni, Salvator Rosa, Claude, Dou, Castiglione, Gerolamo Bassano, Leandro Bassano and Storck.

WEST PARK MUSEUM

MAP C

Prestbury Road, Macclesfield, Cheshire
Tel Macclesfield (0625) 613210

West Park Museum was given to Macclesfield by the Brocklehurst family. It includes a collection of nineteenth-century British painting, some portraits of the Brocklehursts, scenes of Cheshire, and work by the Macclesfield-born Charles Tunnicliffe.

WEST WYCOMBE PARK

MAP F

High Wycombe, Bucks
3m NW of High Wycombe, in West Wycombe on Oxford road (A40)
Tel High Wycombe (0494) 24411

The Dashwood family, who built the Palladian house at West Wycombe, still live there. Some of the ground-floor rooms are shown to visitors, who will probably find the pictures less remarkable than the many frescoes and painted ceilings, the work of Giuseppe and Giovanni Borgnis, who worked at Wycombe for many years in the 1750s and 1760s.

There is an interesting series of views of the house by Daniell, recording the appearance of the house at the end of the 1770s, each picture featuring the widely different aspects of the four façades. Daniell is best known today, not for such topographical records as these (admirable as they are), but for his paintings and aquatints of India deriving from the time he spent there from 1785.

WHITWORTH ART GALLERY

MAP C

University of Manchester, Oxford Road, Manchester
Tel Manchester (061) 273 4865

The University of Manchester's Whitworth Art Gallery is sumptuously equipped and wonderfully adapted to the display of its fine collection of British art of the eighteenth, nineteenth and twentieth centuries.

Many artists' work is to be found here, much of it of the highest quality. Its especial strength is the very important collection of water-colours, prints and wallpaper, from which a changing selection is always shown — but there are also splendid oil paintings. The visitor will not fail to be arrested by Lawrence's portrait of Richard Payne Knight. This seems to be far removed from his more familiar stylish and sometimes grandiose male portraits. It has an urgent feeling of momentarily arrested movement, and a truthfulness in its pleasing portrayal of an interesting, but scarcely handsome, scholar and benefactor.

From the large twentieth-century collection, there are works to be seen by Bacon (with a portrait of Lucian Freud), Hodgkin, Bridget Riley, Freud himself, Ben Nicholson, Paul Nash, Burra, Lowry, Matthew Smith, Sutherland, Hitchens, and many more.

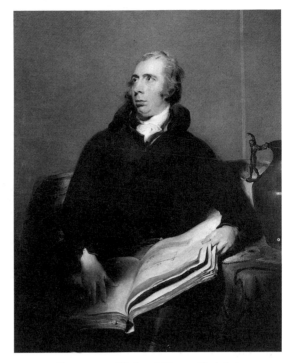

Lawrence: 'Richard Payne Knight'
(*Whitworth Art Gallery*)

work of the Pre-Raphaelite movement, all of the highest quality. Many of the pictures are by members of the Pre-Raphaelite Brotherhood, fully in tune with the atmosphere of the house. To be seen here are works by Ford Madox Brown, Leighton, Holman Hunt, Burne-Jones (his 'Love among the Ruins', on loan from Upton House, is particularly striking), Ruskin, Spartali, John Millais, Rossetti, Poynter and Watts, notably with his portrait of 'Mrs Nassau Senior'.

WIGHTWICK MANOR

NT; GT MAP E

Wolverhampton, W. Midlands
3m W of Wolverhampton on Bridgnorth road
(A454)
Tel Wolverhampton (0902) 761108

Built in the late 1880s for the Mander family, Wightwick Manor was wholly decorated with materials from William Morris's firm. The house is preserved intact, a living monument to the

THE WILLIAM MORRIS GALLERY AND BRANGWYN GIFT

MAP K

Lloyd Park, Forest Road, Walthamstow, London
Tel (01) 527 5544

William Morris was born and brought up at Walthamstow, and lived at the house which now contains the William Morris Gallery, where

Burne-Jones: 'Love among the Ruins' (*Wightwick Manor*)

every aspect of this extraordinary man's life is celebrated. Among the collection are pictures by many friends and collaborators, such as Burne-Jones, Alma-Tadema, Ford Madox Brown, Holman Hunt, Rossetti, as well as Sickert and Brangwyn, who gave a collection of his own and others' pictures in memory of Morris.

WILLIAMSON ART GALLERY AND MUSEUM

MAP C

**Slatey Road, Birkenhead, Merseyside
Tel Liverpool (051) 652 4177**

The Williamson Art Gallery, named after its principal benefactor, has a collection of British art from the nineteenth and twentieth centuries. There are works by Cotman, David Roberts and Pettie, among others. Philip Wilson Steer, who was born in the district, is represented by a good selection of his paintings and there are no less than sixty-six works by the Scottish artist John Finnie who worked on Merseyside.

WILTON HOUSE

HHA; GT MAP I

**Salisbury, Wilts
2½m W of Salisbury on Exeter road (A30)
Tel Salisbury (0722) 743115**

Home of the Herbert family, Earls of Pembroke, Wilton House is one of the best-known of England's great houses, admired for centuries as much for its collections as for its Inigo Jones design and for its incomparable position on the river Nadder, with its famous, much painted and much photographed Palladian bridge.

The picture collection is best known for its old masters and for its matchless collection of van Dyck portraits.

Especially noteworthy are such paintings as 'The Rape of the Sabines' by Pietro da Cortona, Bloemart's 'Shepherd and Shepherdess', several canvases by Samuel Scott, two admirable landscapes of Wilton by Richard Wilson, 'The Bird Trap' by Pieter Bruegel the Younger and 'A Winter Scene' by his brother 'Velvet' Bruegel.

There are portraits by Clouet, a 'Madonna' by Giovanni Battista Salvi and Mario Nuzzi, landscapes by Claude and by Rubens, work by

Lotto and by Panini. By Andrea del Sarto there are 'Virgin and Child with St John and Two Angels' and 'Christ Carrying the Cross', 'The Nativity' by van der Goes, two pictures by Wouwerman, as well as work by Mabuse, Netscher, and van Leyden. 'The Assumption' by Rubens is to be seen, as is 'Democritus' by Ribera, a noble work in which the muted colours do nothing to detract from the power and spirit which is so effortlessly conveyed. Lastly there is Rembrandt's tender and affectionate study of short-sighted old age, his 'Portrait of His Mother'; the onlooker can at once sense that all the tiresome failings of the flesh are forgotten and put on one side in the study of the Bible in which the old lady is so patiently engaged.

There are royal and family portraits at Wilton House, by Lely, by Greenhill, Honthorst, Reynolds, Batoni and Lawrence, but van Dyck dominates the portraits here, as no other col-lection in the country is dominated.

The Double Cube Room, possibly the most famous room in England, was built to Inigo Jones's designs, for the specific purpose of accommodating effectively the noble series of portraits which van Dyck had earlier painted. His huge group (17' by 11') of the 4th Earl of Pembroke and his family is the largest of his pictures. The Earl and his second wife, sombrely clad, seem content to leave the limelight to the glittering, and much more prominent, figures of the next generation — sons, daughters, son-in-law and daughter-in-law, a superbly balanced and elegant group of young aristocrats, attended by three small angels representing other children who had died in infancy.

Also in the Double Cube Room are familiar van Dyck portraits of Charles I, of his Queen, a version of the well-known group of the children of Charles I, and further family portraits. In the

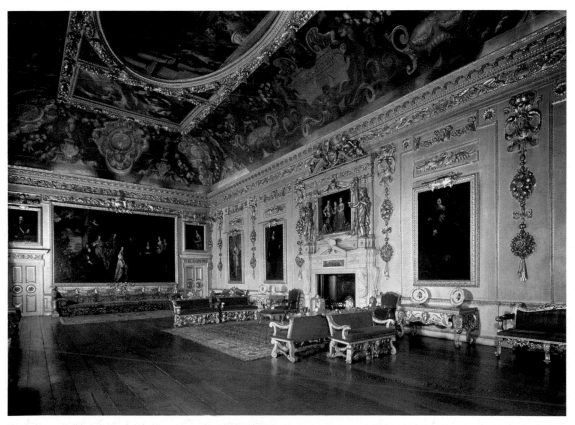

The Double-Cube Room (*Wilton House*)

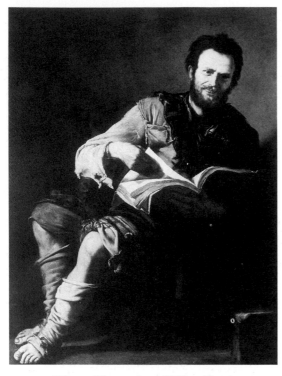

Ribera: 'Democritus' (*Wilton House*)

Single Cube Room are yet more van Dycks, and family portraits by Lely, Richardson and Wissing, with a footnote in the shape of a portrait of van Dyck by Jervas. The ceilings in both these rooms are decorated by work by Emmanuel de Critz, Giuseppe Cesari and others, the whole combining to make a stunning effect, unsurpassed and memorable.

Sadly, from 1988 until possibly 1991, the Double and Single Cube Rooms will be closed for restoration, and the van Dycks will either be in store or housed at the National Gallery.

WIMPOLE HALL

NT MAP F

Cambridge
8m SW of Cambridge on A603
Tel Cambridge (0223) 207257

Kipling's only daughter Elsie Bambridge, who lived at Wimpole Hall for forty years from 1936,

and who left it to the National Trust, spared no expense in looking after the splendid house and in filling it with appropriate furnishings and pictures. The collection reflects her taste: she was always glad to acquire portraits of earlier aristocratic owners and their families.

There are a number of sporting pictures by Wootton, portraits by Ramsay, Richardson, Romney, Mercier, Kettle, Cotes, Reynolds and Kneller. There are landscapes too, and other paintings by Locatelli, Jan Weenix, Arthur Devis, Tissot and Marshall. The chapel is decorated, in exuberant baroque style by Thornhill, a highly successful piece of work; his 'Adoration of the Magi' on the east wall has been described as 'the most notable baroque rendering of a religious subject by an English painter'.

WINDSOR CASTLE

MAP J

Windsor, Berks
Tel Windsor (0753) 868286

The familiar outline of the royal residence of Windsor Castle, visible from many miles around, combines power and a romantic air: one cannot imagine a more castle-like castle in appearance. Walking up the outer ward of the castle, passing under the immense and forbidding Round Tower, the visitor can well be surprised by the elegance and splendour of those state apartments that are open to the public. These are mostly rooms built in the reign of Charles II to replace earlier medieval work, and were, in some cases, redecorated by George IV, who restructured the whole castle into its present majestic shape.

Climbing an imposing staircase, and traversing a vestibule, the visitor today passes at once into the enormously impressive Waterloo Chamber. This room was designed, under George IV, to commemorate the Battle of Waterloo (18 June 1815) and to house the great series of paintings which the King had commissioned from Sir Thomas Lawrence, of monarchs, statesmen and soldiers who had combined to defeat

Copley: 'The Princesses Sophia, Mary and Amelia'
(*Windsor Castle*)

certainly did so in a memorable manner and with great style.

Some more large rooms follow this thunderous overture, which include a number of royal portraits, mainly Knellers, before the visitor moves into a suite of smaller rooms, from Charles II's time, some of which retain their original ceilings painted by Verrio. Here, too, the visitor encounters more portraits, of royal and other personages. Many of these are of rare quality. Some are so familiar, such as the Holbein of the Duke of Norfolk, that it is necessary to make a distinct effort to realise that this is indeed the original picture.

There is a room full of a stunning assemblage of van Dyck's work. Here are his two original groups of Charles I's children. There must be scores of copies and versions of these two pictures in country houses throughout England. These originals glow with subtle richness; the future Charles II, here a ten-year-old boy, clearly delights in his fine clothes and his assured status as the eldest child. Van Dyck's famous triple portrait of Charles I is also to be seen. It was done to be sent to Rome, to enable Bernini to

Napoleon. This is a unique and memorable collection, which is not, like George IV himself, without its faintly comical aspects — the monarchs and attendant statesmen get far more attention than those who bore the heat and burden of the day. One wonders why, for example, the Pope is included in this galaxy, and one remembers that George IV became so obsessed with Waterloo that he seemed to have persuaded himself that he was actually present at the action. But Lawrence rose to the occasion; the portraits can be pensive and overcast with melancholy at the follies of mankind, as in those of Lord Liverpool and Lord Castlereagh; they can be simply magnificent, as with that of the victorious Duke of Wellington; or dramatically grandiose, as with the astonishing portrait of George IV himself. For all his absurdities, George IV was a man of taste and vision. He was right to commemorate Waterloo, and he

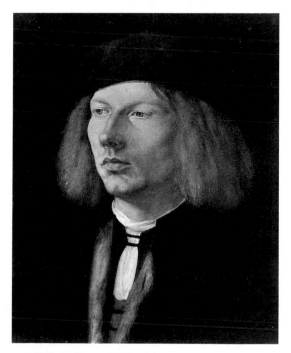

Dürer: 'Portrait of a Man' (*Windsor Castle*)

257

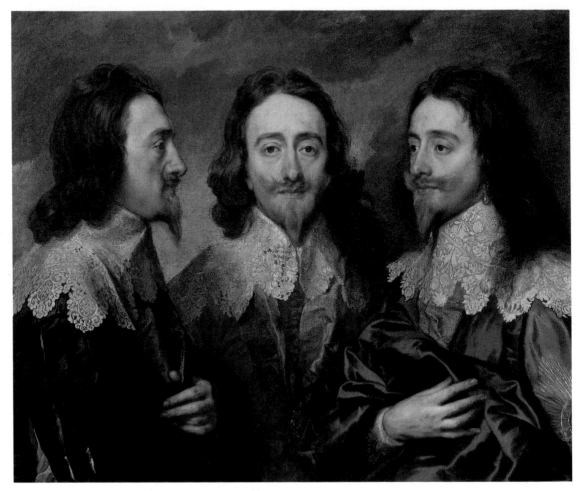

van Dyck: Charles I in three positions (*Windsor Castle*)

make a portrait bust of the King, without having to travel to London to effect this commission. The picture remained in Rome until the end of the eighteenth century, when it was brought back to this country by a collector who, one imagines, had no difficulty at all in persuading George IV, as Prince Regent, to buy this masterpiece, a marvellous piece of work.

Another modest-sized room holds an anything but modest selection from the Royal Collection. There are two by Rubens, one of them a knowing and splendidly assured self-portrait. There are two Rembrandts, one of them an especially memorable portrait of his mother, a loving and compassionate evocation of old age. Originals by Holbein, Dürer, and others are also shown here.

Almost at the end of the visitor's tour, there is a whole room devoted to Rubens and his school. Rubens's equestrian portrait of King Philip II of Spain, who married Queen Mary I of England, peers uneasily at the onlooker, puzzled and filled with sadness. There is a fine, large 'Holy Family' which manages to be at once powerful, peaceful and moving. In his young days, van Dyck was an associate of Rubens, and his contribution to the treasures in this room is 'St Martin Dividing His Cloak', a complex, spirited, and very Rubenslike religious picture. Among the many other things to be seen here, the Royal Collection of superb old master drawings should also be mentioned; a selection is always on view in a separate exhibition.

Naturally enough, only a fraction of the full

Lawrence: 'Pope Pius VII' (*Windsor Castle*)

glories of the Royal Collection can be seen in the rooms which the royal family opens to visitors; but it is an immensely worthwhile fraction. It must be remembered that this famous royal residence is the most visited dwelling in England. While great care has been taken to guide the huge crowds of visitors around, nobody should pay Windsor a visit during the peak summer months if it can be avoided. In November, for example, the place is no more crowded than any popular house; in August it is thronged to bursting point, with large crowds waiting on the north terrace, and an anything but peaceful atmosphere, in which it is hard to give the pictures the time they so richly deserve.

WOBURN ABBEY

MAP F

Woburn, Beds
1m E of Woburn
Tel Woburn (052 525) 666

For over 300 years, Woburn Abbey has been the principal country home of the Russell family, the Earls, and subsequently Dukes, of Bedford. It is called an abbey, because there was originally a Cistercian abbey here, which came into the hands of John Russell, the 1st Earl of Bedford, who had held many high appointments under Henry VIII, as his fee for acting as an executor of the King's will when the latter died in 1547. Living there from some eighty years later, successive Earls and Dukes embellished the old monastic buildings, until the 4th Duke started afresh, demolishing everything and building the present house on the site of the old abbey, in the mid-eighteenth century.

Woburn is everything that a ducal palace should be — stately, elegant, secluded and well-appointed. Approached through its large and handsome deer park, no house in the country is opened to visitors with more zest and enthusiasm. This has led, generally speaking, to there being a large number of visitors; the resulting ropes, and so on, naturally do not always make it easy to see the pictures. It will be found that the family portraits are given great prominence. But the portraits are indeed splendid, and include one of the largest family collections of those painted in the early days, before the arrival of van Dyck in this country revolutionised the art. Van Dyck himself is well represented, as are Lely, Kneller, Hoppner and Gainsborough. There is a complete room full of Reynolds's work, with examples of his most grandiose, as well as his most endearing work. Lady Elizabeth Keppel, who married into the Russell family, came from a family who were staunch early patrons of Reynolds; her naval brother not only took the young Reynolds to Italy, a very important step in his artistic education, but was also the subject of the full-length portrait (now in the National Maritime Museum) which established the artist's reputation in London. Lady Elizabeth is portrayed wearing the costume she had worn at the wedding of George III; it is a splendidly effective portrait, skilfully including classical allusions, while remaining wonderfully balanced and lively.

The Tudor dynasty, whom the Russells served so assiduously, and by whom they were so richly rewarded, are pictured at Woburn in a series of fine portraits: Jane Seymour, Henry VIII's third wife, in a good version of Holbein's portrait; King Philip II of Spain with his wife Mary Tudor, ascribed to Eworth; and there is the 'Armada' portrait of Queen Elizabeth.

The bulk of the picture collection was acquired to embellish the rebuilt Woburn Abbey in the second half of the eighteenth century. Many Dutch and Flemish masters of the previous century are well represented including Steen, Cuyp, Teniers, and Willem van de Velde the Younger. These pictures were popular and fashionable at the time: around 1800, the 6th Duke was obliged to pay as much as 1200 guineas for Cuyp's 'Fishermen on the Frozen Maas'. Cuyp's 'Nijmegen on the Waal' is a celebrated example of his work. Hills, such as those found at Nijmegen, are rare in Holland; this made the place of strategic importance in many wars, but also a favourite subject for Cuyp, who excelled himself with this glowing and peaceful picture.

Canaletto was also fashionable at the time the house was rebuilt. The 4th Duke certainly went

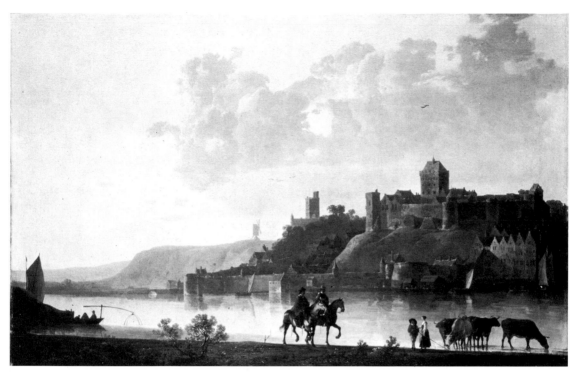

Cuyp: 'Nijmegen on the Waal' (*Woburn Abbey*)

the whole hog when he commissioned the views of Venice from this artist that are assembled, almost two dozen of them, in the Canaletto Room. Even the greatest admirers of this artist may come to feel that this feast is visually indigestible. The 4th Duke may perhaps have had this feeling too, as he was not one of those who commissioned work when Canaletto later visited England.

There is a Rembrandt self-portrait, as well as a portrait of an 'Old Rabbi'; there is a Cuyp self-portrait; there are some pictures by Claude Vernet — 'The Sunset' and 'The Storm'; there are religious pictures by, amongst others, Murillo and Sebastiano Ricci. Yet the visitor may very well leave Woburn feeling that the two finest pictures he has seen are the Velazquez portrait of a Spanish Admiral and van Dyck's of the Dean of Antwerp.

WOLVERHAMPTON ART GALLERY

MAP E

**Lichfield Street, Wolverhampton, W. Midlands
Tel Wolverhampton (0902) 24549**

Proudly placed in the centre of the city, Wolverhampton's Art Gallery has an extensive collection of British art, in which J. M. Wright, Danby, Herring, Gainsborough, Raeburn, Highmore, Morland, Zoffany, Wheatley are all represented, as is Richard Wilson, with an extraordinary landscape of Niagara Falls, which, alas, he never saw — he was able to develop this fine picture from a sketch given to him by an army officer who had seen the falls.

WORCESTER CITY MUSEUM AND ART GALLERY

MAP E

**Foregate Street, Worcester
Tel Worcester (0905) 25371**

Worcester's handsome gallery has a wide range of British painting, based on the work of artists who were locals, at any rate at the start of their careers; Leader, Cox, Bates, Callow, Ibbetson, Laura Knight, Woodward and de Wint are among the artists whose work is well represented here.

WORTHING MUSEUM AND ART GALLERY

MAP J

**Chapel Road, Worthing, W. Sussex
Tel Worthing (0903) 39999**

Worthing Museum and Art Gallery has a varied collection of pictures, including work by Holman Hunt ('Bianca'), Gilman, Ginner, Gore, Sickert, Hitchens and Vaughan, with 'The Trial', a powerful picture derived from Kafka.

YORK CITY ART GALLERY

MAP D

**Exhibition Square, York
Tel York (0904) 623839**

York City Art Gallery's collection covers the centuries. From early years there are pictures from the Low Countries and from France and Germany, as well as Italy; the most striking picture of this group is certainly Domenichino's

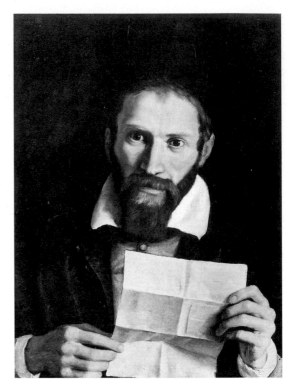

Domenichino: 'Monsignor Agucchi'
(*York City Art Gallery*)

'Monsignor Agucchi' — a relaxed and 'unofficial' portrait of a friend, rather than a formal representation of a patron. There is work by Beccafumi, Feti and Cavallino, among others.

British art of the seventeenth and eighteenth centuries is well represented. Notable here are Edward Bower's portrait of Lord Fairfax, Lely's enchanting portrait of the eight-year-old Lady Charlotte Fitzroy, pictures by Mercier, who lived in York for twelve years, and a large double portrait by Cotes. There are landscapes by Wootton and by Marlow.

There are Victorian narrative pictures in profusion, and a small number of French Impressionist pictures. The nineteenth century, however, is to some extent dominated by the room devoted to the work of William Etty, a native of York, whose statue stands outside the gallery. There are many of his familiar nudes, as warm and evocative as ever, and there are also still-lifes and portraits of great appeal — relaxed, uncontrived and skilful.

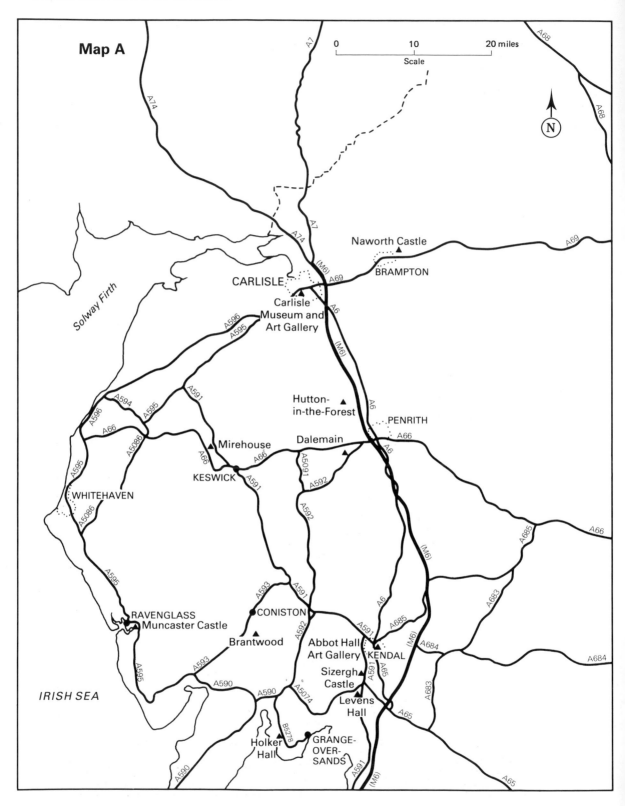

Map A

Scale
0 10 20 miles

N

Solway Firth

A74

A7

A68

A69

Naworth Castle

BRAMPTON

CARLISLE

Carlisle
Museum and
Art Gallery

A596

A595

A591

A594

A596

A595

A66

A5086

A595

A5086

WHITEHAVEN

Mirehouse

KESWICK

A66

A591

Hutton-
in-the-Forest

Dalemain

PENRITH

A66

A6

A5091

A592

A592

A685

A66

A683

(M6)

A6

RAVENGLASS
Muncaster Castle

CONISTON

Brantwood

A593

A591

A592

Abbot Hall
Art Gallery KENDAL

Sizergh
Castle

Levens
Hall

A591

A6

A685

(M6)

A684

A683

A684

A65

A595

A593

IRISH SEA

A590

A5074

Holker
Hall

B5278

GRANGE-
OVER-
SANDS

A590

A590

A591

(M6)

A65

264

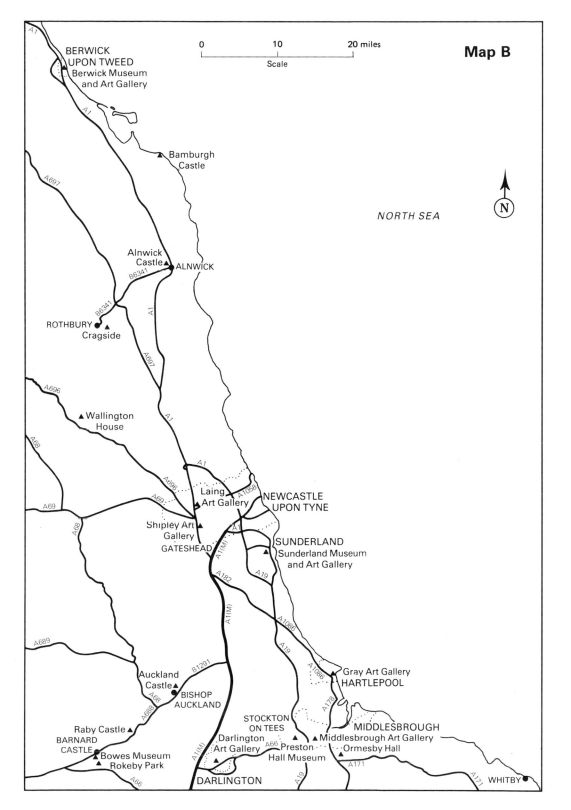

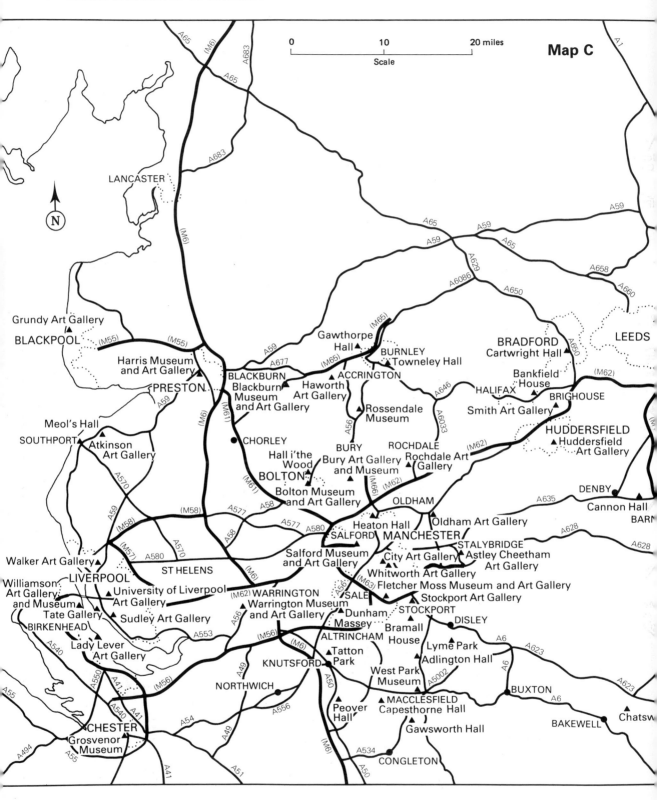

Map C

0 10 20 miles
Scale

N

LANCASTER

A65 (M6) A683 A65 A683 A1

A59 A65 A59 A65 A658 A660 A659

A629 A6086 A650

Grundy Art Gallery
BLACKPOOL (M55) (M55)

Gawthorpe Hall (M65) BURNLEY Towneley Hall BRADFORD Cartwright Hall LEEDS

Harris Museum and Art Gallery A59 A677 (M65) ACCRINGTON Bankfield House HALIFAX BRIGHOUSE
PRESTON BLACKBURN Blackburn Museum and Art Gallery Haworth Art Gallery Smith Art Gallery HUDDERSFIELD

Meol's Hall A59 (M6) (M61) A56 Rossendale Museum A646 A6033 Huddersfield Art Gallery
SOUTHPORT Atkinson Art Gallery BURY ROCHDALE (M62) DENBY
Hall i'the Wood CHORLEY Bury Art Gallery and Museum Rochdale Art Gallery Cannon Hall BARN

A570 BOLTON Bolton Museum and Art Gallery (M62) A635
A59 (M58) A577 A58 OLDHAM A628
Walker Art Gallery (M58) A58 A580 Heaton Hall Oldham Art Gallery STALYBRIDGE A628
A570 SALFORD MANCHESTER Astley Cheetham Art Gallery
Williamson Art Gallery and Museum (M57) A580 ST HELENS Salford Museum and Art Gallery City Art Gallery
LIVERPOOL University of Liverpool Art Gallery (M6) (M62) WARRINGTON Whitworth Art Gallery Fletcher Moss Museum and Art Gallery
Tate Gallery Sudley Art Gallery Warrington Museum and Art Gallery SALE Stockport Art Gallery
BIRKENHEAD A553 Dunham Massey STOCKPORT DISLEY
A540 Lady Lever Art Gallery (M56) (M6) ALTRINCHAM Bramall House Lyme Park A6 A623
A550 A41 Tatton Park Adlington Hall A6 A623
A55 A540 A56 KNUTSFORD A49 A50 West Park Museum A5002 BUXTON A6
NORTHWICH A556 Peover Hall MACCLESFIELD Capesthorne Hall BAKEWELL Chatsw
A494 CHESTER A54 A49 Gawsworth Hall
Grosvenor Museum A41 A51 (M6) A534 CONGLETON A50

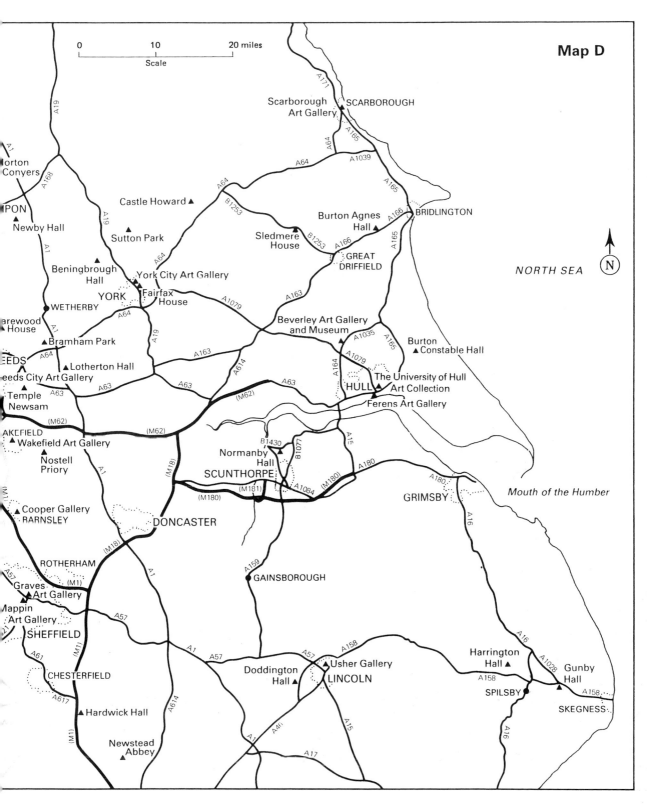

Map D

0 10 20 miles

Scale

Scarborough Art Gallery SCARBOROUGH

lorton Conyers

PON

Newby Hall

Castle Howard ▲

Sutton Park

Burton Agnes Hall ▲

BRIDLINGTON

Sledmere House

GREAT DRIFFIELD

Beningbrough Hall

York City Art Gallery

YORK Fairfax House

WETHERBY

NORTH SEA

N

Beverley Art Gallery and Museum

Burton Constable Hall ▲

arewood House

Bramham Park ▲

EEDS

Lotherton Hall ▲

eeds City Art Gallery

HULL

The University of Hull Art Collection

Temple Newsam

Ferens Art Gallery

AKEFIELD

Wakefield Art Gallery ▲

Nostell Priory

Normanby Hall

SCUNTHORPE

GRIMSBY

Mouth of the Humber

Cooper Gallery ▲
BARNSLEY

DONCASTER

ROTHERHAM

GAINSBOROUGH

Graves Art Gallery ▲

Mappin Art Gallery

SHEFFIELD

CHESTERFIELD

Harrington Hall ▲

Gunby Hall ▲

Doddington Hall ▲ Usher Gallery ▲
LINCOLN

SPILSBY

SKEGNESS

Hardwick Hall ▲

Newstead Abbey ▲

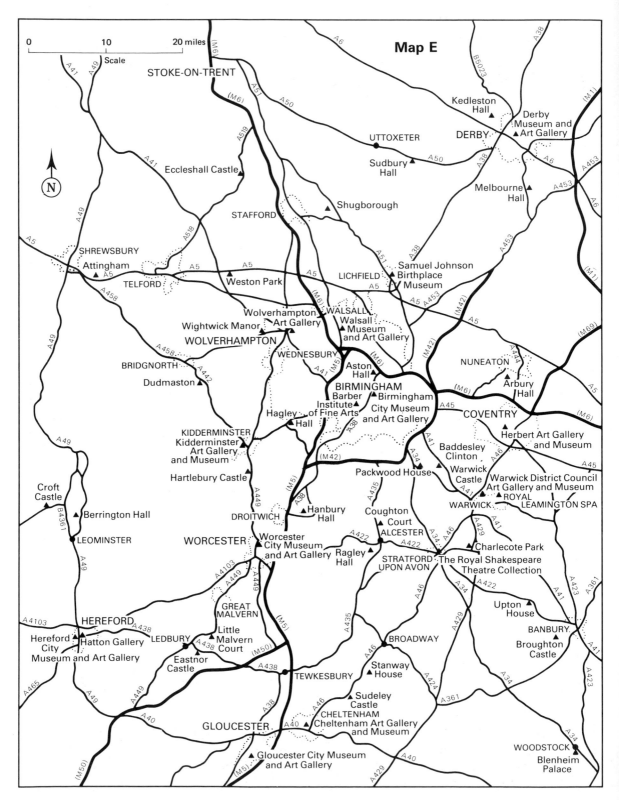

Map E

0 10 20 miles
Scale

N

STOKE-ON-TRENT

Eccleshall Castle

STAFFORD

Shugborough

UTTOXETER

Sudbury Hall

Kedleston Hall

Derby Museum and Art Gallery

DERBY

Melbourne Hall

SHREWSBURY
Attingham

TELFORD

Weston Park

LICHFIELD

Samuel Johnson Birthplace Museum

Wolverhampton Art Gallery

WALSALL
Walsall Museum and Art Gallery

Wightwick Manor

WOLVERHAMPTON

WEDNESBURY

BRIDGNORTH

Dudmaston

Aston Hall

NUNEATON

Arbury Hall

BIRMINGHAM
Barber Institute of Fine Arts

Birmingham City Museum and Art Gallery

COVENTRY

Hagley Hall

Herbert Art Gallery and Museum

KIDDERMINSTER
Kidderminster Art Gallery and Museum

Baddesley Clinton

Warwick Castle

Warwick District Council Art Gallery and Museum

Hartlebury Castle

Packwood House

Hanbury Hall

ROYAL LEAMINGTON SPA

WARWICK

Croft Castle

DROITWICH

Coughton Court
ALCESTER

Charlecote Park

Berrington Hall

LEOMINSTER

WORCESTER
Worcester City Museum and Art Gallery

Ragley Hall

STRATFORD UPON AVON

The Royal Shakespeare Theatre Collection

HEREFORD

GREAT MALVERN

Upton House

BANBURY

Hereford City Museum and Art Gallery

Hatton Gallery

LEDBURY

Little Malvern Court

Broughton Castle

Eastnor Castle

BROADWAY

TEWKESBURY

Stanway House

Sudeley Castle

CHELTENHAM
Cheltenham Art Gallery and Museum

GLOUCESTER

WOODSTOCK

Blenheim Palace

Gloucester City Museum and Art Gallery

268

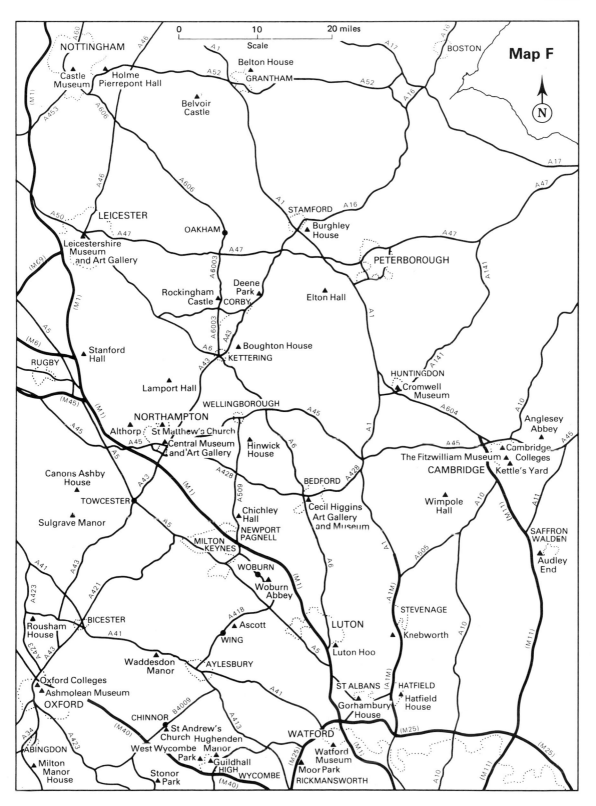

Map F

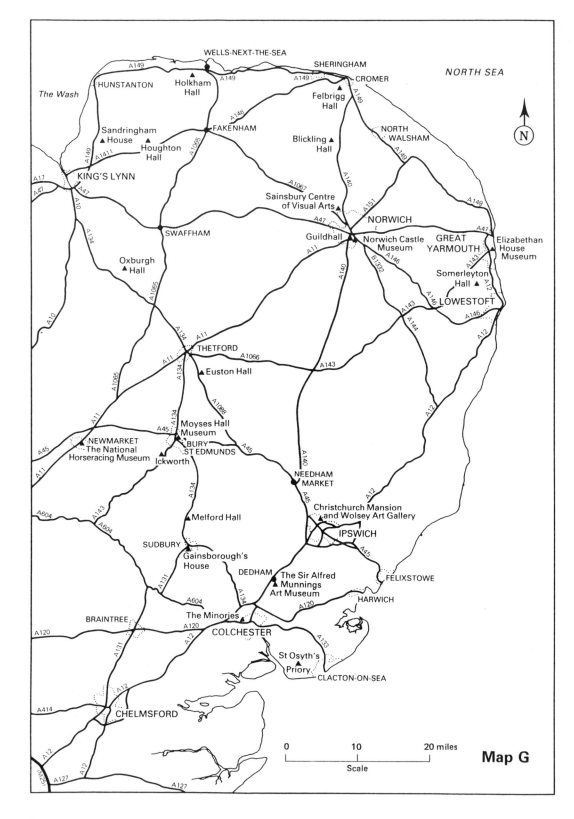

Map G

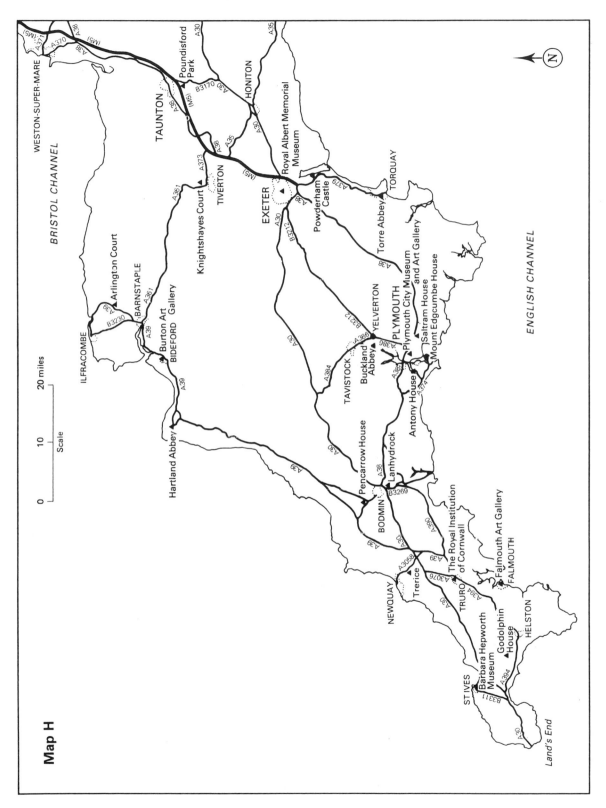

Map H

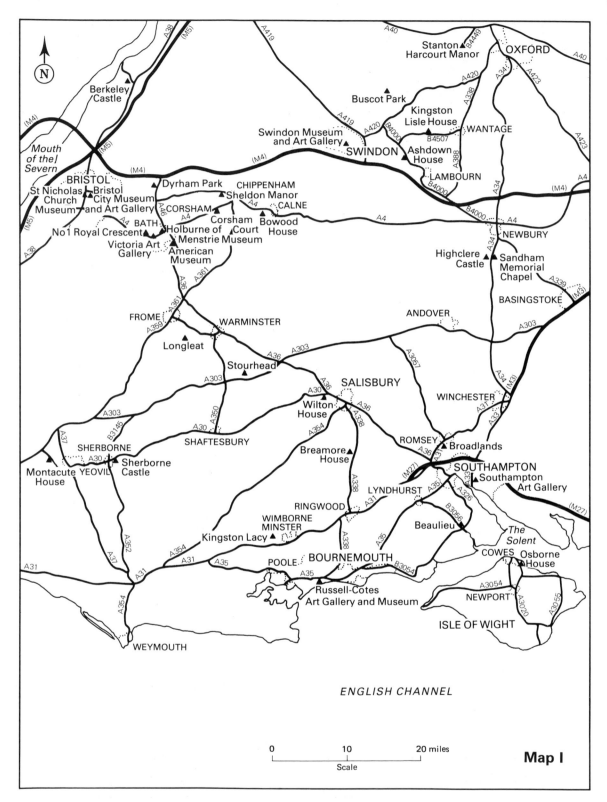

N

Berkeley
Castle

Mouth
of the
Severn

Stanton
Harcourt Manor

OXFORD

Buscot Park

Kingston
Lisle House

WANTAGE

Swindon Museum
and Art Gallery

SWINDON

Ashdown
House

LAMBOURN

BRISTOL
St Nicholas
Church
Museum

Bristol
City Museum
and Art Gallery

Dyrham Park

CHIPPENHAM

Sheldon Manor

CALNE

NEWBURY

CORSHAM

BATH

Corsham
Court

Bowood
House

No 1 Royal Crescent

Holburne of
Menstrie Museum

Victoria Art
Gallery

American
Museum

Highclere
Castle

Sandham
Memorial
Chapel

BASINGSTOKE

FROME

WARMINSTER

ANDOVER

Longleat

Stourhead

SALISBURY

WINCHESTER

SHERBORNE

SHAFTESBURY

Wilton
House

Montacute
House

YEOVIL

Sherborne
Castle

Breamore
House

ROMSEY

Broadlands

SOUTHAMPTON

Southampton
Art Gallery

LYNDHURST

RINGWOOD

WIMBORNE
MINSTER

Kingston Lacy

Beaulieu

The
Solent

COWES

Osborne
House

POOLE

BOURNEMOUTH

NEWPORT

Russell-Cotes
Art Gallery and Museum

ISLE OF WIGHT

WEYMOUTH

ENGLISH CHANNEL

0 10 20 miles
Scale

Map I

Map J

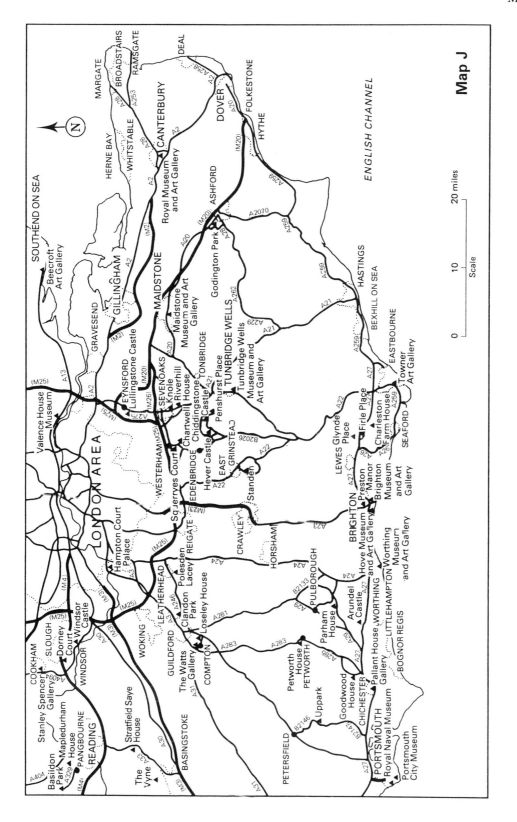

Scale

0 10 20 miles

ENGLISH CHANNEL

LONDON AREA

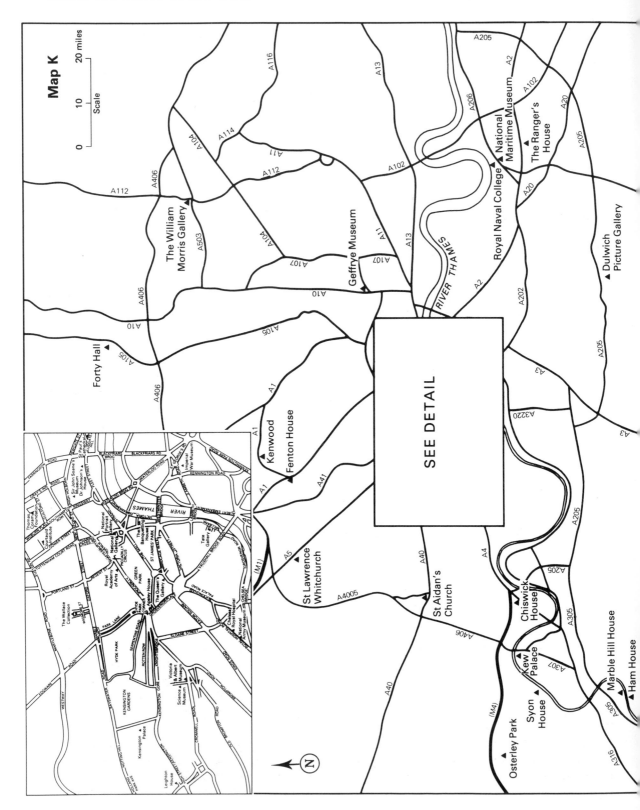

Map K

Scale

0 10 20 miles

A112
A406
A114
A104
A116
A11
A112
A13
A205
A206
A102
A2
A20
A205

The William Morris Gallery
A503
A104
A107
A11
A107
A13
A10
Geffrye Museum

RIVER THAMES
Royal Naval College
National Maritime Museum
The Ranger's House
A20
A2
A202
A205
Dulwich Picture Gallery

Forty Hall
A105
A406
A10
A105

SEE DETAIL

A1
Kenwood
Fenton House
A41
A1
A5
St Lawrence Whitchurch
A4005
(M1)
A40
St Aidan's Church
A406
A4
A40
(M4)
Osterley Park
Syon House
Kew Palace
Chiswick House
A205
A305
A307
A316
Marble Hill House
Ham House
A3220
A43
A3
A205
A206

N

274

ACKNOWLEDGEMENTS

The author wishes to thank the following for advice, hospitality and help of many kinds in assembling this book: Mr and Mrs Peter Agnew; Miss Glynis Alder; Mr and Mrs David Apperly; Mrs Kathleen Apperly; Mr Mark Bainbridge; Miss Jane Baker; Judge and Mrs Christopher Beaumont; Mr and Mrs David Blomfield; Mr and Mrs Peter Boissier; Mr Charles Boycott; Mrs Jo Brogden; Ms Noelle Brown; Mrs M.E. Carmichael; Mrs Hilary Clack; Miss J.Collier; Mr J.D. Culverhouse; Miss J.A. Cunningham; Mr and Mrs John Dagger; Mr G.P.S. Drye; Professor C.R. Dodwell; Mr Richard Doughty; Mrs Pamela Dubreil; Mr P.F.D. Duffie; Ms Sally Dummer; Mr J.W. Durrands; Mrs Margaret Eggleston; Miss R. Featherstone; Mr David Fraser; Mrs Hazel Gage; Mr B.T. Galloway; Mr and Mrs Noel Gibbs; Mr Michael Goodall; Mr Richard Green; Mrs S.E. Green; Mr Francis Greenacre; Mr Andrew Greg; Miss Rosamund Griffin; Mr Robin Harcourt-Williams; Mr Julian Herbert; Mr J.R. Hills; Mrs Sarah Hollis; Mr W.F.P. Hugonin; Mr Edward Hulse; Mrs Anne Hunt; Ms Clare Hunter-Craig; Mr R. Innes-Smith; Mr Richard Jefferies; Mr F.C. Jolly; Ms Susanna Kerr; Mrs Olga Kirk; Mr Alastair Laing; Mr W.J. Larkworthy; Mr D. Legg-Willis; Mr Norman Lilley; Ms Catrina Lucas; Mrs Margaret Mallen; Mr Hugh Marles; Ms Sandra Martin; Mr Colin Masters; Mrs Caroline Merriam; Professor Hamish Miles; Ms Corinne Miller; Mr Frank Murdoch; Miss Gill Nock; Rear-Admiral and Mrs J.B. Noel; Mrs Bette Parker; Mrs Sue Parkes; Miss J. Player; Mrs G.K. Quarm; Mrs Nicolette Ratcliff; Mr Leslie Retallick; Mrs Judith Sandling; Ms Michelle Seviour; Mrs Charlotte Sheard; Ms Nicola Sherriff; Mrs Cynthia Simons; Mr Richard Slee; Miss Vicky Stowe; Mrs E. Tatman; Mr Philip Vainker; Mr and Mrs Dennis Walker; Mr Neil Walker; Mrs Norma Watt; Miss Lavinia Wellicome; Mrs Gill Weston; Miss Lucy Whitaker; Mr and Mrs David White; Mrs Joan Wilson; Mrs Sheila Woodward; Mr D.P.S. Wrench.

The author wishes to render profound thanks to his wife for immense help, support, companionship and encouragement through a three-year gestation.

Pictures from Kensington Palace, Hampton Court Palace and Windsor Castle are reproduced by gracious permission of Her Majesty the Queen.

The thanks of the author and publishers are also due to the following for permission to reproduce pictures from the collections indicated: Lake District Art Gallery and Museum Trust (Abbot Hall Art Gallery); the Duke of Northumberland and English Life Publications Ltd, Derby (Alnwick Castle); the National Trust (Anglesey Abbey); the Trustees of the Victoria and Albert Museum (Apsley House); Lord Daventry and English Life Publications Ltd, Derby (Arbury Hall); the National Trust (Ascott); The Ashmolean Museum; English Heritage (Audley End); The Barber Institute of Fine Arts, the University of Birmingham; the National Trust (Belton House); the Duke of Rutland (Belvoir Castle); Berwick-on-Tweed Museum; City of Birmingham Museums and Art Gallery; the Duke of Marlborough (Blenheim Palace); the Duke of Buccleuch (Boughton House); Durham County Council (The Bowes Museum); the Royal Pavilion, Art Gallery and Museums, Brighton; City of Bristol Museum and Art Gallery; the National Trust (Sandham Memorial Chapel, Burghclere);

Indexes

Index by County

Note: map references are in bold type

Artists Index

Note: page numbers in italic type refer to illustrations

General Index

Note: Page numbers in italic type refer to illustrations